SYNCHROMISM

and American

Color Abstraction

1910-1925

SYNCHROMISM
and American
Color Abstraction
1910-1925

GAIL LEVIN

GEORGE BRAZILLER · NEW YORK
IN ASSOCIATION WITH
THE WHITNEY MUSEUM OF AMERICAN ART

This book is published in conjunction
with the exhibition "Synchromism and
American Color Abstraction, 1910–1925,"
organized by the Whitney Museum of
American Art, and supported by a grant
from the National Endowment for the Arts.

Dates of the exhibition

Whitney Museum of American Art, New York
January 24–March 26, 1978

The Museum of Fine Arts, Houston
April 20–June 18, 1978

Des Moines Art Center
July 6–September 3, 1978

San Francisco Museum of Modern Art
September 22–November 19, 1978

Everson Museum of Art, Syracuse
December 15, 1978–January 28, 1979

Columbus (Ohio) Gallery of Fine Arts
February 15–March 24, 1979

Designed by James Wageman
Printed in the U.S.A. by Eastern Press, Inc.
First edition

PHOTOGRAPH CREDITS
Photographs of the works of art
reproduced as plates have been supplied,
in the majority of cases, by the owners
or custodians of the works, as cited in
the checklist. The following list applies
to photographs for which an additional
acknowledgment is due.

Oliver Baker, 111
Will Brown, 23, 42, 164
Chisholm & Kenyon, 152
Geoffrey Clements, 1, 14, 16, 25, 38,
39, 40, 45, 57, 59, 60, 61, 62, 64, 65,
66, 67, 69, 70, 71, 73, 74, 75, 76, 77,
78, 79, 80, 83, 85, 86, 87, 88, 89, 90,
93, 98, 99, 103, 105, 117, 127, 128, 130,
136, 137, 143, 153, 158, 162, 163, 165
Jacques Faujour, 54, 82, 84, 96, 97
Etienne Hubert, 125
Jacqueline Hyde, 81
James O. Milmoe, 37
Parker Studios, 129
Eric Pollitzer, 6, 7, 8, 11, 19, 122, 144,
145, 148, 149, 160
Nathan Rabin, 150
John Schiff, 91, 92, 141, 156
Bill J. Strehorn, 101, 102
Soichi Sunami, 113
Joseph Szaszfai, 138

Library of Congress Cataloging in Publication Data

Levin, Gail, 1948–
 Synchromism and American color abstraction, 1910–1925.
 Issued in conjunction with an exhibition of the same
name organized by the Whitney Museum of American Art.
 Bibliography: p.
 1. Synchromism (Art)—United States. 2. Painting,
American. 3. Painting, Abstract—United States.
I. Whitney Museum of American Art, New York. II. Title.
ND212.5.S9L48 1978 759.13 77–21051
ISBN 0–8076–0882–3
ISBN 0–8076–0883–1 pbk.

Contents

Acknowledgments

Without the generous help of a great number of individuals, this project could not have been realized. I want especially to thank Henry M. Reed, who unselfishly put his entire collection and extensive archives at my disposal. His knowledge and enthusiasm have proven invaluable. Morgan Russell's widow, Suzanne Binon Russell, and her daughter, Simone Joyce, shared their recollections of the artist and provided important documentary material. William C. Agee graciously made available the rich body of information he assembled in his pioneering work on Synchromism. Stanton Macdonald-Wright's widow, Jean Sutton Macdonald-Wright, made available the artist's unpublished diary, letters, and other manuscripts. Andrew Dasburg and his son Alfred V. Dasburg provided important recollections and documentary information. It was a pleasure to visit Sonia Delaunay and share her memories and archives of the Synchromist period in Paris. My conversations with the late Leon Kroll were also very helpful. Flora Irving, President of the Whitney Museum of American Art, helped me in researching Gertrude Vanderbilt Whitney, her grandmother and Morgan Russell's patron. I am also grateful to William Rubin, who first encouraged me to present the results of my research on Synchromism.

To the many public and private collectors who have been willing to lend such important works, I extend my deepest gratitude. I would also like to express my appreciation to the following for calling my attention to collectors, research resources, and art works: Faber Birren, Noëmi Blumenkranz-Onimus, Richard J. Boyle, Doris Bry, Myriam Cendrars, Arthur A. Cohen, Aileen Cramer, Susan Cumins, Charles and Lisa Daugherty, James Demetrion, Gertrude Dennis, Anne d'Harnoncourt, Bernard Dorival, Bella Fishko, Dr. Moritz Jagendorf, Christopher D. Kent, Robert Lewin, Lydia Malbin, Fanette Meyers, George Neubert, Sybil H. Pollet, Michael St. Clair, Anne Saÿen, Robert Schoelkopf, Hélène Seckel, Michel Seuphor, Patrick L. Stewart, Jr., Barbara Wolanin, and Judith K. Zilczer.

I wish to thank the staff at the Whitney Museum. I appreciate the enthusiastic support of Tom Armstrong, Director, as well as the devoted participation of so many others. Doris Palca provided encouragement and tireless assistance. Anita Duquette was helpful on locating photographs. Jill Sussman, my secretary, assisted in many ways. I thank especially those who volunteered their time including: Maggie Ferdon, Frank Glaser, Tom Hudspeth, Debra Kent, Karen Lebergott, and Tara Reddi. I would also like to thank Arno Kastner, Librarian at the Whitney Museum, as well as the entire staff of the library at the Museum of Modern Art. Thanks are due, too, to the Archives of American Art, the Beinecke Rare Book and Manuscript Library, Yale University, and the Firestone Library, Princeton University.

Both William Innes Homer and William C. Agee took time from busy schedules to read this manuscript and make useful suggestions for which I am especially grateful. I have also benefited from conversations with John I. H. Baur, Milton Brown, and Lloyd Goodrich. Finally, I thank Margaret Aspinwall of the Whitney Museum and Mary Laing of George Braziller, Inc., who skillfully edited this book.

For the content and conclusions of the book, I am, of course, responsible. In writing it, I have been conscious that, owing to the vast amount of documentary material and the limitations of both time and the length of this text, it could not be a definitive study. Rather I hope to shed light on a fascinating and still little-known passage in the history of American painting, and encourage further study of these artists and issues.

Introduction

Synchromism, the first American avant-garde painting to attract attention in Europe, has generated controversy and confusion since its debut in Munich in June 1913, in Paris the following October, and in New York in March 1914. It was conceived by Morgan Russell, a twenty-seven-year-old American expatriate, who was joined by Stanton Macdonald-Wright, a fellow American four years his junior. Morgan Russell intended nothing less than to change the course of Western painting.

Synchromism, meaning "with color," was a term he chose for its analogy with "symphony" to indicate his own emphasis on color rhythms. This was one of the earliest attempts to create paintings composed of abstract shapes and colors.

Russell and Macdonald-Wright presented their ideas in essays written for three Synchromist exhibition catalogues of 1913 and 1914, included here in full for the first time. They boldly attacked Orphism and claimed to have pursued the use of color beyond that in Impressionism, Cubism, and Futurism. Their assertions were further exaggerated by the numerous writings of the critic Willard Huntington Wright, Stanton's brother. The provocative nature of these texts is even more remarkable when contrasted with recent attempts to dismiss the entire movement as nothing more than a footnote to Orphism.

To some extent such attempts are a result of the comparative neglect that Synchromism has suffered in studies of twentieth-century art. Yet a wealth of documents related to Synchromism survives, particularly in the extensive unpublished papers of Morgan Russell—his correspondence and a remarkable series of notebooks that record his thoughts and sketches—and in the unpublished letters written by Russell, Macdonald-Wright, and others. A fair evaluation of the movement depends on the interpretation of these documents. A major step in this direction was William C. Agee's pioneering study *Synchromism and Color Principles in American Painting 1910–1930*, written for an exhibition of this title held in 1965 at M. Knoedler and Co. in New York. Since this exhibition, however, remarkably little attention has been paid to Synchromism. Agee organized a circulating exhibition on Synchromism for the Museum of Modern Art, New York in 1967. In 1975, I presented the initial findings of my research on Russell in a small exhibition, "Morgan Russell: Synchromist Studies, 1910–

1922," at the Museum of Modern Art. Macdonald-Wright was given retrospectives in 1956 at the Los Angeles County Museum of Art, in 1967 at the National Collection of Fine Arts, Washington, D.C., and in 1970 at the Art Galleries of the University of California at Los Angeles.

Although Russell and Macdonald-Wright exhibited jointly in California museums in 1927, 1931, and 1932, their work, particularly that of Russell, had fallen into obscurity by 1950, when a New York art dealer, the late Rose Fried, chose to show their work along with that of Patrick Henry Bruce in an exhibition entitled "3 American Pioneers of Abstract Art." This grouping was perpetuated in Agee's exhibitions in 1965 and 1967. Some writers have incorrectly identified as Synchromists Bruce and other artists whom Agee included. While certain Americans such as Thomas Hart Benton actually responded to the impact of Synchromism, others like Bruce and Arthur Burdett Frost, Jr., were directly influenced by the French artists Robert and Sonia Delaunay. Still other Americans, such as Georgia O'Keeffe and Max Weber, experimented independently with color abstraction. The two founders of Synchromism are therefore presented here with other American artists who worked contemporaneously in a variety of modes of color abstraction.

The work of Robert and Sonia Delaunay is also included so that its relationship to that of these American modernists can be evaluated. The Delaunays' early use of the term "Synchrome" and Sonia Delaunay's assertion that she and Robert invented Synchromism deserve our attention. The relationship of Synchromism and other American color abstraction to Orphism and Simultaneism requires further examination and definition. A similarity of style does not imply direct influence. Rather it is necessary to identify both common and disparate sources and intentions among the artists involved.

The Synchromists, as well as other artists who created some of the first non-figurative paintings, relied upon the impact of color for expression. As one analyzes these works, the artists' methods of evolving to pure abstraction become more apparent, further illuminating what has been one of the most puzzling issues in the development of modern art. Ultimately, continued study of this period should offer greater insights into the sources and methods of our first abstract artists.

1 · Prelude to Synchromism

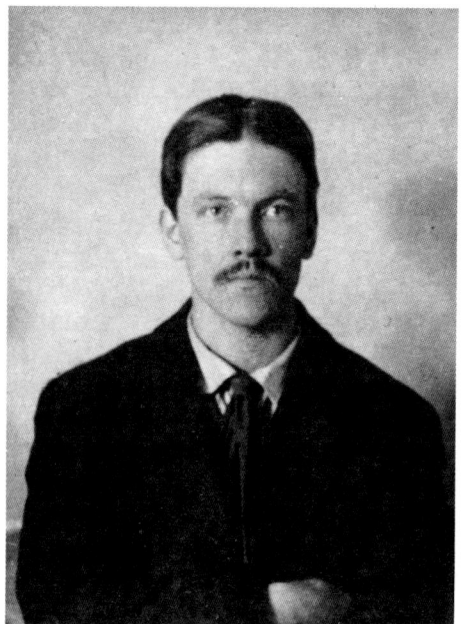

Fig. 1. Morgan Russell in Paris, c.1909.

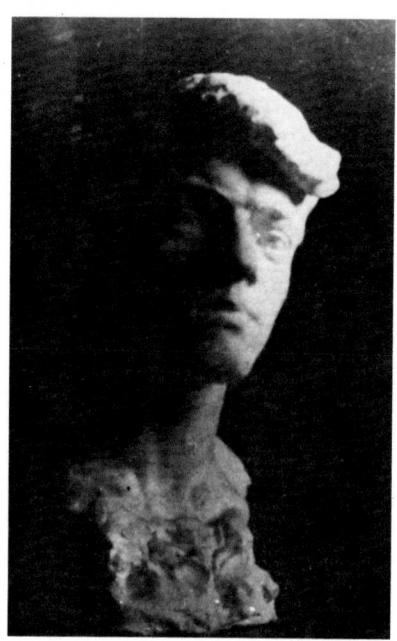

Fig. 2. A lost self-portrait bust by Morgan Russell, probably sculpted in 1906 in James Earle Fraser's class at the Art Students League.

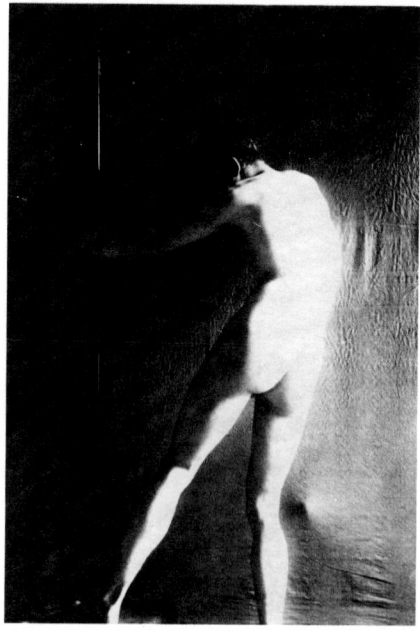

Fig. 3. Russell posing as a model, c.1903–04.

In the decade preceding the start of the First World War, young American artists flocked to Paris to study. More than their compatriots of previous generations, they soon began to emulate artists of the French avant-garde. Even those who entered the traditional institutions upon their arrival tended to rebel, turning for guidance to the leaders among the French moderns who were also developing a following among artists in Germany, Russia, and elsewhere in Europe. When the Americans returned home, they found a receptive if limited milieu for their work. They were, on the whole, crusaders with a fervent message to convey, who battled the reticence they found among the art establishment and the public.

In 1906, at the age of twenty, Morgan Russell traveled abroad for the first time (Fig. 1).[1] He determined that he would give up the study of architecture, his father's profession which he had pursued for two years, in order to study sculpture and painting. He visited Paris and Italy where he was overwhelmed by Michelangelo's heroic nudes. When he returned to New York, Russell enrolled in James Earle Fraser's sculpture class at the Art Students League, where he had posed as a model during 1903–04 (Figs. 2, 3).

It was probably during this work as a model that Russell first met Gertrude Vanderbilt Whitney (Fig. 4), who was then one of Fraser's students. At the time, Russell was sharing quarters with Arthur Lee, a classmate of Mrs. Whitney.

Another classmate was Andrew Dasburg, who was to become a close friend of Russell. Mrs. Whitney appears to have encouraged Russell to take up painting, for the back of his tiny landscape (Pl. 51) is inscribed with her address: "Ma première peinture Old Westbury L. I. Printemps—Eté 1907. Morgan Russell."[2]

During part of the summer of 1907, Russell stayed in a house in Woodstock, New York, with Andrew Dasburg, who was then studying painting with Birge Harrison (1854–1929).[3] They had both previously studied drawing and anatomy in the night class of George B. Bridgman (1864–1943) at the Art Students League. During the day, Russell had supported himself by modeling for other artists and working in a restaurant.

Probably in the fall of 1907, Russell began to study painting with Robert Henri, who would prove to be an important inspiration. Henri stressed individual expression in his teaching rather than the traditional formulas. He had a significant impact on Russell and others among his students such as Patrick Henry Bruce, Andrew Dasburg, Arthur Burdett Frost, Jr., Stuart Davis, and Arnold Friedman, all of whom went on to experiment with abstraction. Russell and Henri continued to be friends and corresponded occasionally after Russell settled in Paris in 1909.

In the spring of 1908, Russell went again to Paris. About

this time, he met Leo Stein and his sister Gertrude (Fig. 5), and through them he was first introduced to Matisse and Picasso. Since the Salon d'Automne of 1905, from which Leo purchased Matisse's *Woman with the Hat*, the Steins' legendary collection and Saturday soirées had gained an important place among avant-garde artists in Paris. During the winter of 1907–08, their sister-in-law Sarah Stein was instrumental in organizing the short-lived but influential Académie Matisse.

Matisse's dramatic freedom with color and form, which came to be labeled Fauvism, was a significant lesson for a number of young American artists, not just for those who studied with him or met him at the Steins' home.[4] Among the American artists on whom Matisse's work had an important influence were Morgan Russell, Max Weber, Arthur B. Carles, H. Lyman Saÿen, Arthur Burdett Frost, Jr., Patrick Henry Bruce and Alfred H. Maurer.

In 1908, Russell also met and admired the work of Rodin, who had a studio in the Hôtel Biron where the Académie Matisse was then located; apparently Russell joined the Matisse painting class that spring.[5] He returned to New York around the fall of 1908.[6] By late 1908, Mrs. Whitney had generously provided Russell with a subsistence allowance, enabling him to live in Paris and devote himself to his art. She continued this until the end of 1915.

In the spring of 1909, Russell settled in Paris, and began to study sculpture with Matisse. Several photographs of his work of the winter of 1909–10, with corrections made in ink by Matisse, have been preserved among Russell's papers (Fig. 6). His preoccupation with sculpture lasted until the fall of 1910. In the Louvre, he studied ancient Assyrian and Egyptian sculpture, as well as the *Slaves* by Michelangelo, in particular the *Dying Slave* (Fig. 7), which he sketched from various viewpoints (Pls. 63, 64). Russell made many other sketches after Michelangelo, whose work he knew well from his various trips to Italy. The feeling for three-dimensional form that Russell acquired during this period, coupled with his regard for Michelangelo's genius, greatly influenced his subsequent development as a painter.

Although none of Russell's early sculpture has survived, numerous photographs indicate that it was traditional in style and emphasized the heroic male nude.[7] The importance Russell attached to his sculpture is demonstrated in his first Synchromy, *Synchromy in Green* [*Synchromie en vert*], now lost but first exhibited in the Salon des Indépendants of 1913 (Fig. 8). Among the sculptures depicted in this painting, the plaster headless *Torso*, from the autumn of 1910, was evidently one of Russell's favorites as it also appears in a sketched self-portrait and in a photograph of him in his studio (Figs. 9, 10; Pl. 61).[8]

Among Russell's earliest enthusiasms in Paris were the

Fig. 4. Gertrude Vanderbilt Whitney in her studio on Macdougal Street, New York City, c.1917. Photo Jean de Strelecki.

Fig. 5. Leo, Gertrude, and Michael Stein in the courtyard of 27 rue de Fleurus, Paris, c.1906. Cone Archives, Baltimore Museum of Art.

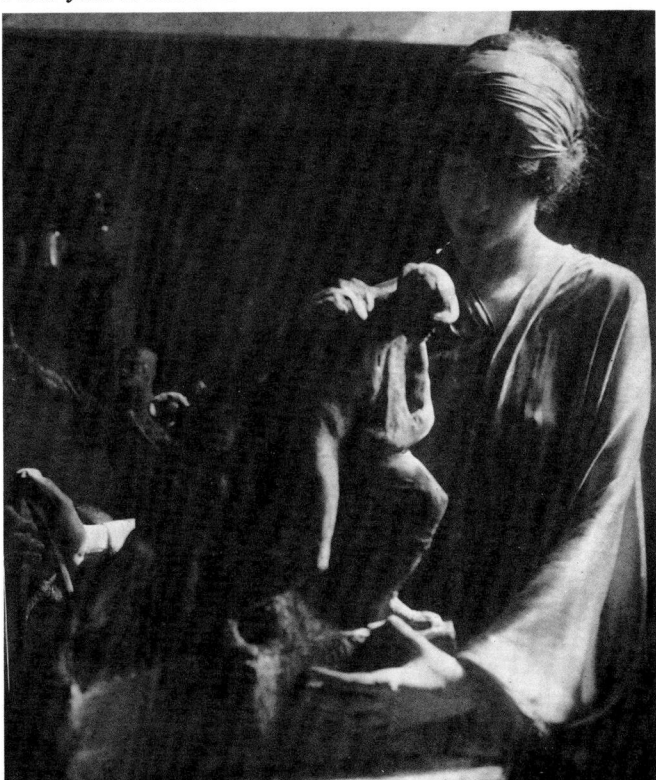

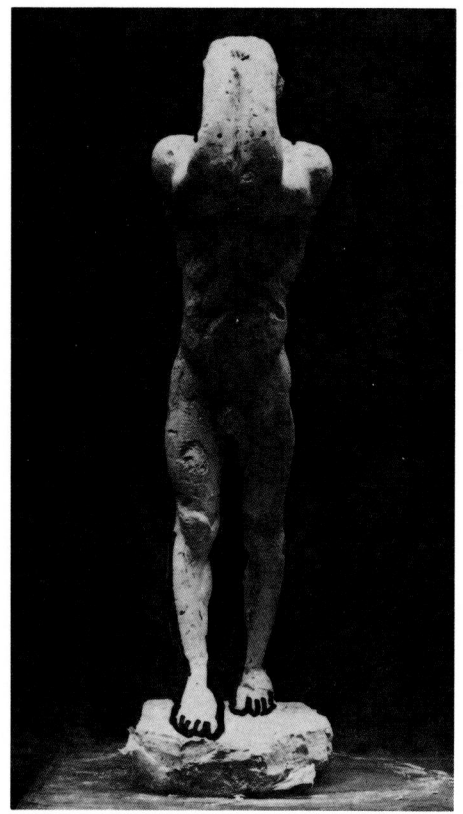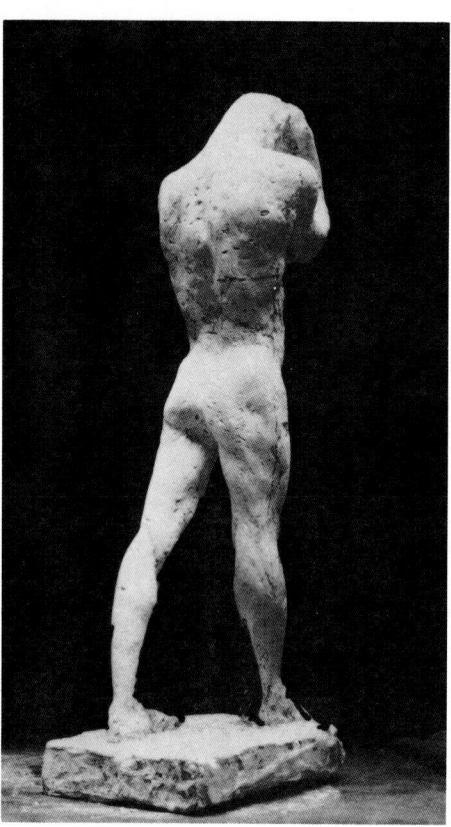

Fig. 6. Photographs of a sculpture by Morgan Russell with ink corrections made by Matisse, c.1909–10.

Fig. 7. Michelangelo, *Dying Slave*. Louvre, Paris.

paintings of Claude Monet, whom he called a "master of light." Writing to Andrew Dasburg in late August 1908, Russell remarked upon the nearly thirty paintings by Monet which he had recently seen at the Durand-Ruel Gallery.[9] Russell suggested that an artist should forget about "beautiful color" and consider "his palette as the light in front of him ranging from deep purples and violets thru the blues, green, warm green, y[ellow], o[range], r[ed], purple reds, etc." He felt that he was just then learning the "anatomy of light," which he described as consisting of "the tones of the spectrum in the various hues and intensities." Russell's study of Monet's work is best demonstrated by his own painting *The Bridge,* done about 1908 (Pl. 52). Here he tried to treat the sky, bridge, and water in a consistent manner as Monet would consider "all quantities, objects, distances, etc. as so much light." Russell's emphasis on color as light suggests at this early date the direction his painting would take with his invention of Synchromism.

Yet in this same letter Russell exclaimed: "Monet is not the only one: wait till you get acquainted with Gauguin, Cézanne, and the younger men, Matisse, etc. . . ." Russell's own interest in Cézanne developed in part under the guidance of his close friend Leo Stein. Together with Dasburg, who joined him in Paris from mid-1909 until August 1910, Russell worked on still lifes directly inspired by *Apples [Pommes],*

a small Cézanne composition painted in 1873–77, which he borrowed from Leo Stein (Pls. 55, 56). Leo wrote Russell from Fiesole, Italy, on June 26, 1910, instructing him on "pure qualities of form":

I noticed at Rome that nowhere on the ceiling has Michelangelo attained to the sheer expression of form that is often achieved in his drawings. I believe that nowhere is it as complete as in those apples of Cézanne's. Cézanne must for the . . . general public always remain a painter of still life because there only could he "realize" in the ordinary sense of the word without sacrificing his aesthetic conscience.

Russell's involvement with Cézanne's work is also indicated by the first painting he exhibited, *Nude Men on the Beach [Hommes nus sur la plage]* of 1910, shown in the Salon d'Automne of that year (Pl. 53).[10] Russell credited Cézanne's work with helping him to discover "what was rhythm in color." As he wrote to Dasburg on October 27, 1910, he finally realized that "it was and could be nothing other than the play of lights and shadow . . . warm and cold light." Russell praised Cézanne's solidity and his rich and forceful color. He also stressed the necessity to "feel form if you will paint light," and he wrote, "a painting should be a flat presentation of light and in this way only will one preserve the flatness of the canvas and convey the sensations of mass and solidity."

12

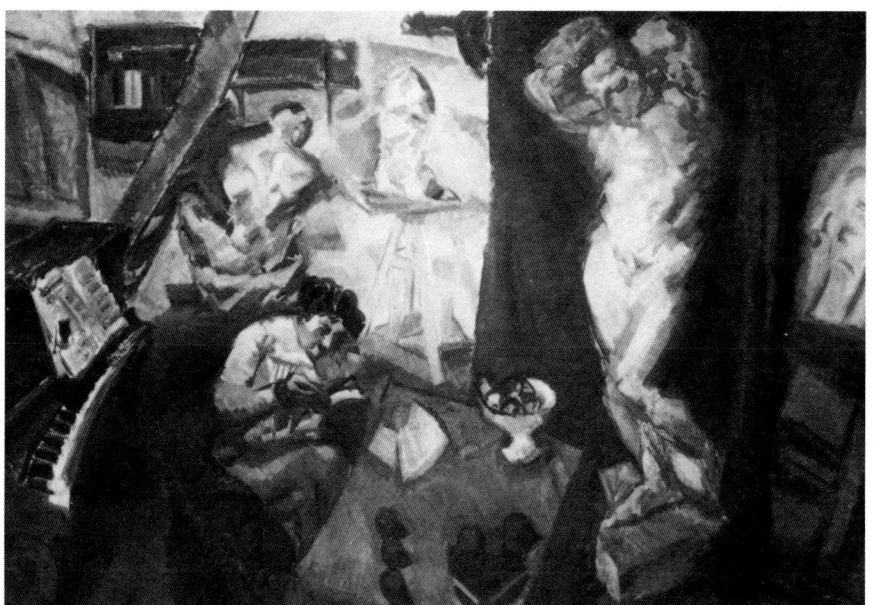

Fig. 8. Morgan Russell, *Synchromy in Green,* 1912–13, now lost.

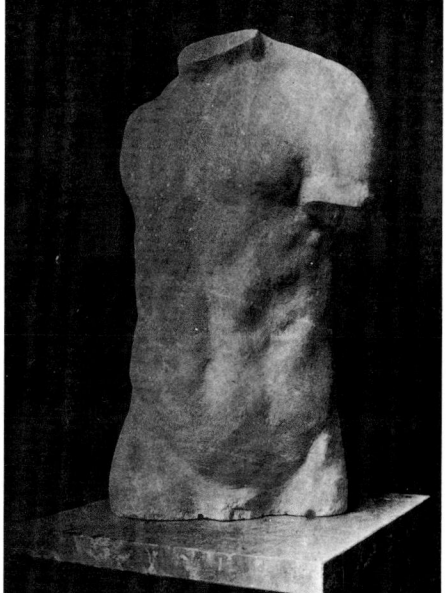

Fig. 9. Morgan Russell, *Torso,* 1910.
Formerly collection of
Gertrude Vanderbilt Whitney, now lost.

Fig. 10. Barely visible, Morgan Russell stands behind his
sculptures in his Paris studio, c.1910. In the background at
the right is a cast or model after Puget's *Ecorché.*

Fig. 11. Morgan Russell, lost painting of a female nude, c.1909.

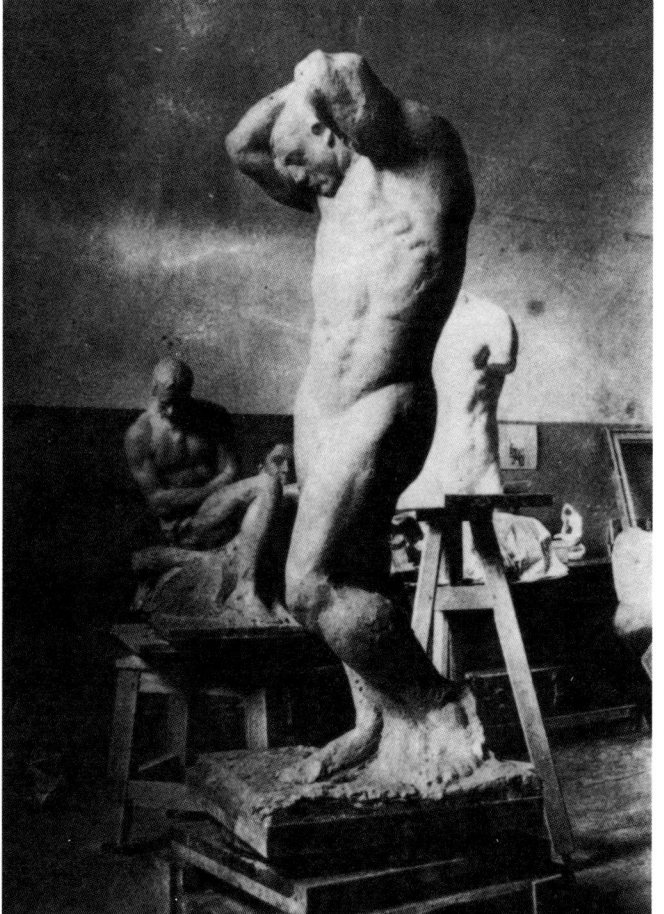

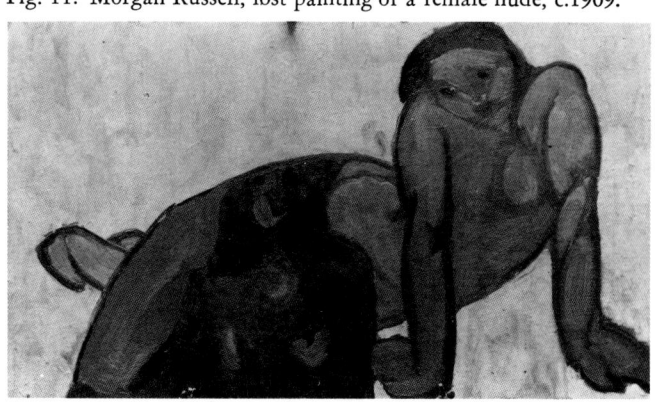

Russell's thinking about color and light became more
complex as he continued to study Cézanne's painting and a
book of his letters. On August 7, 1911, he wrote to Dasburg,
"The field of light in all its chromatic richness that a painter
is called upon to organize and deal with is as tense—as
mutually dependent in all its parts as the figure that a sculptor
models."

Nowhere is Matisse's influence more evident than in Russell's
lost painting of a reclining female nude, which we know only
by a photograph (Fig. 11). Both the painting and Russell's
watercolor sketch for it (Pl. 59) immediately recall the nudes
in Matisse's paintings of 1907–09, such as *Le Luxe I* of 1907
or *Nymph and Satyr* of 1909. Russell probably painted the
picture in 1909 when he was closest to Matisse. The intentional
primitive simplicity of the nude did not recur when Russell
returned to painting the human figure in the 1920s.

During his visits with Leo and Gertrude Stein, Russell also met Picasso and saw much of the artist's work. His *Still Life with Fruit and Glass* of about 1911–12 may reflect his knowledge of Picasso's painting of 1908 of the same subject, then owned by the Steins (Pl. 57).[11] Russell was not, however, attracted to Picasso's dark palette at this time, preferring Matisse's brilliant colors. On the other hand, he so liked the composition of Picasso's *Three Women* of 1908, which he saw at the Steins' before they sold it to the Russian collector Sergei Shchukin, that he made a pencil sketch of it (Pl. 60). This painting may be the source of the triangular "pie-wedge" shapes that Russell utilized so frequently in his abstract Synchromies. In this *Study after Picasso's "Three Women"* of about 1911, Russell's careful concentration on the triangles which appear in the lower right corner defining the woman's thigh is apparent. In his notebook of May 1912, he also made a specific reference to what he considered the usefulness of Cubism: "The cubist method is a means of keeping a firm tight grasp on the organization as a whole—the parts being strongly and intimately held together in this whole and never as isolated representational detail."

In 1911, two things happened, both of which would greatly affect the development of Synchromism. Russell began to attend the classes of the Canadian Ernest Percyval Tudor-Hart (1873–1954), who taught him much about color theory, and through his friend Lee Simonson (1888–1967), he made the acquaintance of Stanton Macdonald-Wright,[12] who also joined the Tudor-Hart class (Fig. 12).

Macdonald-Wright had been living in Paris since the late summer of 1907 when, at the age of seventeen, he arrived with his new wife and mother-in-law. In his native Charlottesville, Virginia, his family had provided him with private tutors in painting from the time he was five years old.[13] They moved to Santa Monica, California in 1900, and by 1904–05 he had enrolled at the Art Students League in Los Angeles where he studied under Warren T. Hedges. Hedges had formerly taught in New York with Robert Henri. Like Russell, Macdonald-Wright learned Henri's slashing technique and benefited from an approach to painting that was less traditional than most. He studied in Paris at the Sorbonne for eighteen months and then briefly at the Académie Colorossi, the Académie Julian, and the Ecole des Beaux-Arts before enrolling in Tudor-Hart's classes.

When they met, Macdonald-Wright shared Russell's admiration for Cézanne. Macdonald-Wright had, in fact, purchased four Cézanne watercolors soon after arriving in Paris. None of the early paintings Macdonald-Wright produced in Paris is known to be extant, though photographs of lost works such as his painting of a nude woman reclining of about 1908–09 or his *Self-Portrait* of 1908 indicate that, like Russell, he experimented with both Impressionist technique and with Cézannesque forms (Figs. 13, 14). From 1911 to 1914, Macdonald-Wright spent much of his time in a Mediterranean

villa in Cassis, France. Lee Simonson, a painter and later a noted set designer, recalled in his memoir that during the summer of 1912, he and Stanton planned to paint the nude in the open air.[14] Both young men were devoted to the work of Cézanne; a photograph shows Macdonald-Wright's lost Cézannesque *Self-Portrait with Simonson,* which probably dates from about this time (Fig. 15). Macdonald-Wright noted on the back of the photograph that this was his first really deep and harmonious canvas, and that the curtain was vermilion, the figures blue and yellow, and Simonson's jersey a beautiful green.

Critics have claimed that Synchromist theories and forms were "heavily dependent upon Delaunay,"[15] but Macdonald-Wright and Russell actually developed their intense interest in color theory and its application in the classes of Percyval Tudor-Hart at his school of painting in Paris, which they attended during 1911–13. Two other Americans, George Carlock (died 1918) and John Edward Thompson (1882–1945) studied with Tudor-Hart as early as 1905. Carlock was a close friend of Russell, Thomas Hart Benton, Lee Simonson, the Steins, and Marsden Hartley.[16]

Tudor-Hart was deeply involved with color theory, particularly that propounding a mathematical analogy between color and music, and was later to publish several articles on his work.[17] Years afterwards he recalled: "I was considered revolutionary as regards my own paintings and drawings, and certainly as regards my teaching."[18]

Writing to Macdonald-Wright over a decade later, in December 1922, Russell referred to "old Tudor-Hart and all his complicated systems and academic humbug," but he was willing, even then, to admit that he had probably assimilated much from Tudor-Hart's teachings. Indeed, there are many references to Tudor-Hart in Russell's notebooks, including evidence of the former's practice of collecting and marking his students' notes from class. Russell mentioned "Mr. T-H," for instance, in his notebook of July 1912 as he was developing his crayon studies for his *Synchromy in Deep Blue-Violet* [*Synchromie en bleu violacé*] (Pls. 67, 68): "I asked him . . . if it was not logically possible to paint by translating light by yellow, shadow by blue and the weaker graduations between the two by the greens, blues, oranges, and reds." Russell also wrote in this notebook: "I pay homage to M. T.H. and . . . the help I had from him."[19]

Tudor-Hart taught his musical system of color harmony based on a purely psychological rather than physical group of equivalents.[20] He claimed that pitch in sound related directly to luminosity in color, that tone in sound equaled hue in color, and that intensity of sound corresponded to saturation of color. He explained: "The twelve chromatic intervals of the musical octave . . . have corresponding sensational and emotional qualities to those of the twelve chromatic colours."[21] These theories were immediately important to both Russell and Macdonald-Wright and would continue to interest them for years to come.

Fig. 12. Stanton Macdonald-Wright in France, 1912. Photo, collection of Michel Seuphor.

Fig. 13. Stanton Macdonald-Wright experimented with Impressionist techniques in this painting of a female nude, c.1908–09, now lost.

Fig. 14. Stanton Macdonald-Wright, *Self-Portrait,* 1908, now lost.

Fig. 15. Stanton Macdonald-Wright, *Self-Portrait with Simonson,* c.1912, now lost.

On November 5, 1912, Russell wrote in his notebook: "Color and light must be entirely melted into one and felt as such—and light must be expressed as it is felt in us as color." He wrote here of seeking to create "painting capable of moving people to the degree that music does." At this time, he proposed to achieve this effect in painting by the "division of canvas in the sense of the movement of the light in measures of equal distance but broken up variously with certain rythmic character."

As Russell sought a means to merge color with light, he began to conceive of a new medium which would go beyond traditional painting. In September 1912, in a notebook annotation, he dreamed of "something that is entirely in character with modern development" in order to express his "new vision." His idea for a kinetic light machine was first expressed in this notebook:

Have but one but [goal]—that of (as result of confidence in new vision) bringing it forth, or perfecting it—of making it take form. It is so closely connected with modern tendency, as for instance, even if art should take a form other than canvasses, it would give in part the solution. Imagine waves of light—color—divided in measure for the composer and executant and given in time as well as space. . . .

Then, as if writing a manifesto for an upcoming exhibition, Russell explained:

What gave birth to this idea—first—simply a vague image of that which I felt a painting should or at least might be—Next the search for a solution of the problem of color and light or a "rationale" of color.

By July 1912, Russell realized that his studies had begun to point in a new direction. He noted in the draft of a letter intended for his patron Gertrude Vanderbilt Whitney that he expected to realize "a new vision in painting." In April 1913 he wrote in his notebook of his quest for a new and personal style of art:

The necessity of being strongly of one's own time—your work to reflect intensely le rythm *of our time and not be retrospective, or neo-this and that—and the influences must be completely assimilated to this end—one does art but this art must be isolated from life—even tho it may not be understood by the masses of one's own time it can still have quality to the greatest degree and will always be appreciated by the leading spirits of the time.*

Russell's notion of an intellectual elite or "the leading spirits of the time" reflects his discussions with Leo Stein, who considered himself apart from the masses. In a letter from Fiesole, Italy, dated July 9, 1910, Leo had challenged Russell to develop a greater imagination:

I think you might make a good painter, for the interpretive mind may have considerable power and I think yours has, but I have seen no evidence of the imaginative impulse that could

lead beyond. I said that you had in my opinion a certain measure of invention, but invention falls far short of real imagination.

Robert Henri, whose guidance Russell greatly valued, wrote him a long, encouraging letter from New York on May 2, 1910, commenting that he wished he could "step into your workshop and see for myself your investigations into what's new and what's old in art." Delighting in the success of the Exhibition of Independent Artists that he had recently organized in New York, Henri added: "I would like very much to see more of what's doing in Paris—not the big salons—I have no hopes of them—but what the searchers are doing." Arriving at a time when Russell was working under the influence of Matisse, Henri's letter no doubt encouraged him to look for his own artistic personality:

The world will see many fashions of art and most of the world will follow the fashions and make none. These cults—these "movements" are absolutely necessary or at any rate their causes are—for somewhere in their centres are the ones who bear the Idea—are the ones who have questioned "But what do I think" and how shall I say it best. . . .

Henri's message to Russell was clear and his emphatic suggestion that the artist seek his own idea was one that Russell followed. Yet even Henri could concede that: "Most people like to be *in* a movement. Its always warm inside and. . . . Its quite cool to be out by your self." Three years later when he joined forces with Macdonald-Wright to exhibit as the Synchromists, Russell took Henri's suggestion to heart that "most all human beings, be it the commonplace or the minority—advance guard, want company enough to keep warmth and courage up."

Russell, writing to Henri fifteen years later, on June 21, 1925, from Aigrement, France, paid tribute to his former teacher as "the man who had more to do with the tempering of my character (if indeed it is tempered!) than any other." Recognizing Henri's valuable "moral" influence, Russell wrote:

. . . all you ever taught or said was so intelligent and undogmatique, the accent you put on it all was so true that it is applicable to the practice of any art or any direction a given art may take and so serves always. You gave us also your own heat and inspired us with what I like to call the habit of creative spunk. . . .

In Paris one event that captured Russell's attention and undoubtedly provoked his own ambition was the Futurist exhibition at the Bernheim-Jeune Gallery in February 1912. Russell's interest in Futurism was such that he saved the catalogue, along with numerous other catalogues, manifestoes, and newspaper clippings about the movement.[22] Futurism represented to Russell the kind of group solidarity to which Henri had alluded and suggested that Russell, too, might create a movement capable of influencing others. He set about inventing the new work necessary and finding the means to publicize his discovery.

2 · Genesis

The germ of Synchromism lay in Morgan Russell's idea that he might create paintings based upon sculptural forms interpreted two-dimensionally through a knowledge of color properties. In his notebook dated July 1912 (Pl. 62), Russell wrote:

Light is projection and depth—not a balancing of forms around a center as sculpture. And yet so in sculpture projecting and receding forms. Perhaps a translation of a great work of sculpture, as color and shade, placed in a hollow would give the basis of the problem.

Russell seems to have tried out this concept in a watercolor sketch which, on first glance, appears to be non-figurative (Pl. 4). However, a recognizable subject is detectable if one studies a pencil sketch after Michelangelo's Florence *Pietà* found in his notebook dated August 1912 (Pl. 65), and thus executed just a month after he had recorded the idea in the quotation above. Russell conveyed many of the projecting and receding forms of the *Pietà* (Fig. 16) in his sketch, yet he omitted as much detail as he included. Emphasizing the V-shaped cowl and collar, and the shoulders of Joseph at the

Fig. 16. Michelangelo, *Pietà*, Cathedral, Florence.

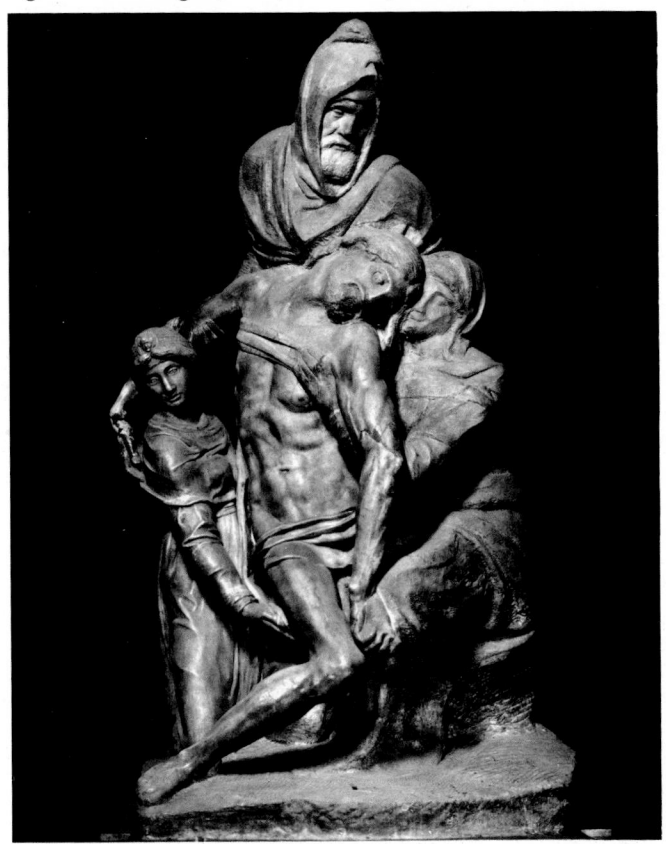

top, he barely indicated the limp body of Christ with the projecting right leg. He included little more than the supporting arm of either the Magdalene on the left or the Madonna on the right. The pencil sketch would seem to imply that only the rhythmic flow of the three-dimensional forms and their projections and recessions interested Russell. In this same notebook he theorized:

Place in mind or vision clearly the subject as form—the points nearest you in projection—those furthest and side projections and seize the order of this . . . the sentiments of the whole as color and as line. And in working ignore, forget the linear outlines of objects—never will you arrive at complete expression in painting until this habit is lost. . . .

In the watercolor sketch after Michelangelo's Florence *Pietà* Russell also emphasized a double V shape at the top of the composition which corresponds to the cowl and collar of Joseph in his pencil sketch (Pl. 65). A red, orange, and yellow projecting curve approximates the form of Christ's limp left arm in the original *Pietà*. Although in the lower half of the composition Russell has painted shapes that might relate to legs, in the sculpture itself only Christ's right leg is visible. Perhaps Russell's unusual means of creating an abstract composition from a three-dimensional figural model is due to his conception of himself as a "sculpteur manqué."[1] In his notebook dated August 1912, Russell stated with assurance:

There is a need for form that has not existed since the Renaissance. One point of real departure in color like the manifestation of light—by consequence the kind of light which has never been done—of a sublime beauty. . . .

Although Russell reminded himself in this notebook to "make the form and the space with waves of color—as Michelangelo does with waves of form," he did not intend to convey the figure in actual movement, but rather expected to realize "a rhythmic basis to color."

The figural basis of Synchromist abstractions, in general, and Russell's work of 1912–14, in particular, can be compared with František Kupka's early development of abstractions from a figural motif. However, the two artists had very different concerns. Kupka (1871–1957), a Czech painter who settled in Paris in 1896, came to be associated with Orphism.[2] While Russell and Macdonald-Wright stressed sculptural solidity and three-dimensional depth, Kupka "devised a system of large colored planes . . . which are not equivalent to shading or modeling and which dictate the rhythmic structure of the composition."[3] Both Russell and Macdonald-Wright would have seen Kupka's *Planes by Colors, Large Nude* of 1909–10 exhibited in the Salon d'Automne of 1911, as well as his non-

figurative *Fugue in Red and Blue* in the Salon d'Automne of 1912. Yet Kupka's view of painting as "a specifically two-dimensional non-illusionistic activity" contrasts with the sculptural and spatial concerns Russell sought to integrate into his abstract paintings through the use of color principles. Kupka's interest in the depiction of motion also places him closer to Italian Futurism than were the Synchromists. Russell's own desire to convey movement was limited to what could be expressed by color rhythms; he was to develop this idea further in his project for a kinetic light machine.

Although Russell made no specific reference in his writings to Wassily Kandinsky's *Art of Spiritual Harmony*, which appeared first in German in mid-December 1911,[4] Kandinsky's emphasis on conveying spiritual feeling in art was then of current interest. Artists like Robert Delaunay and Marsden Hartley in Paris discussed Kandinsky, and Stieglitz published translated excerpts from his treatise in the *Camera Work* issue of July 1912. Russell wrote in his notebook dated August 1912:

Make lines colors . . . never paint "the thing" or the subject. Paint the emotion not illustration . . . a few curly lines and do depth, rythm light . . . a few little spectrums, dark violets and lights. . . .

Russell was also speculating that the significant artistic expression of the future would focus not on objective reality, but on formal considerations. He wrote in his notebook dated September 1912 of the following necessity:

. . . to forget the object entirely, yes to forget it—to put it out of our mind entirely and think only of planes, lines colors, rythms etc. emotional visual quality . . . Some artists sacrifice or ignore these qualities and accent the fact—but one must do the contrary, accent the rythm the rapport and let the object suffer. Keep the "music" at all costs—the palpitation or undulation—sacrifice the fact.

In Russell's still lifes of 1912–13, he began to substitute color harmonies for local color, letting "the object suffer" (Pls. 2, 3, 58). He did not, however, give up representation in his earliest Synchromist paintings.

Synchromy in Green [*Synchromie en vert*] of 1912–13 was the first painting to be exhibited under the label Synchromism when Russell showed it in the Salon des Indépendants of 1913, March 19–May 18 (Fig. 8). Actually it represents the interior of Russell's studio, and includes, as previously noted, examples of his own sculpture. The critic Willard Huntington Wright, Macdonald-Wright's brother, explained:

. . . all the light forces were treated in their purely emotional phases. The canvas lacked the complete visualisation and the solid space-construction which characterise his later work, and furthermore it revealed many traces of the academic composition. However, had there been critics possessed of artistic prescience they straightway would have sensed in it a new force in painting.[5]

From the photograph it would appear that *Synchromy in Green* was similar to *Synchromy in Yellow* [*Synchromie en jaune*] of 1913 (Pl. 5). In this work the objects and Russell's sculpture are constructed by juxtaposed areas of bright, prismatic colors which animate the entire composition. Years later, Macdonald-Wright summarized Russell's methodology in the first Synchromy as building solid forms "by means of light":

. . . on rotund objects illuminated from the viewer's direction, he made his highlights yellow and graded them toward shadow through greens and blues on one side, on the other through oranges, reds and purples. For him local color, as such, did not exist, and this left him free to play with the use of a pure color gradation. . . . He called this method the "orchestration of tonalities" and, as we are cognizant of solidity only by means of light, this process produced an intense form.[6]

Macdonald-Wright, who had not yet adopted "Synchromy" as a title, exhibited two works in the Salon des Indépendants of 1913, *Dawn* [*L'Aube*] and *Noon* [*Midi*], neither of them extant. According to Willard Wright, they were "formal compositions of nude figures painted in three or four flat planes of pure colour, and recalled Matisse and Cézanne more strongly than they presented a new vision."[7] Wright went on to criticize these paintings and Russell's *Synchromy in Green*: "From the standpoint of efficient visualisation all three Synchromist works were failures, or at least they were indications of incomplete progress."[8] But he also noted the dramatic evolution of Synchromism from these tentative works to the first Synchromist exhibition in June 1913:

. . . both men realised that this was only a start, and set diligently to work on the canvases for their first exhibition which was booked in Munich for June of that year.

Between their first pictures and those of a few months later there was to be noted an advance both in conception and in application. Russell's small colour planes, applied wholly from the standpoint of light, expanded and took on a new effectiveness. His form became more abstract, and his colour more harmonious. Also his compositions were more compact, though they were ordered rather than rhythmically organised. Macdonald-Wright's progress was similar.[9]

Macdonald-Wright's *Still Life with Skull* of 1912 (Pl. 6) is not so bold in color as Russell's still lifes of the time. Yet Macdonald-Wright soon pushed his color beyond that of the Fauvists and Post-Impressionists when he included dramatic spectral passages in his *Portrait of Jean Dracopoli* of 1912 (Pl. 7).

Although the Delaunays' influence on the development of Synchromism has been exaggerated, both Russell and Macdonald-Wright knew Robert and Sonia Delaunay and were undoubtedly interested in their early advances toward color abstraction. They may have first met the Delaunays at the home of Gertrude and Leo Stein, since all four artists frequented the

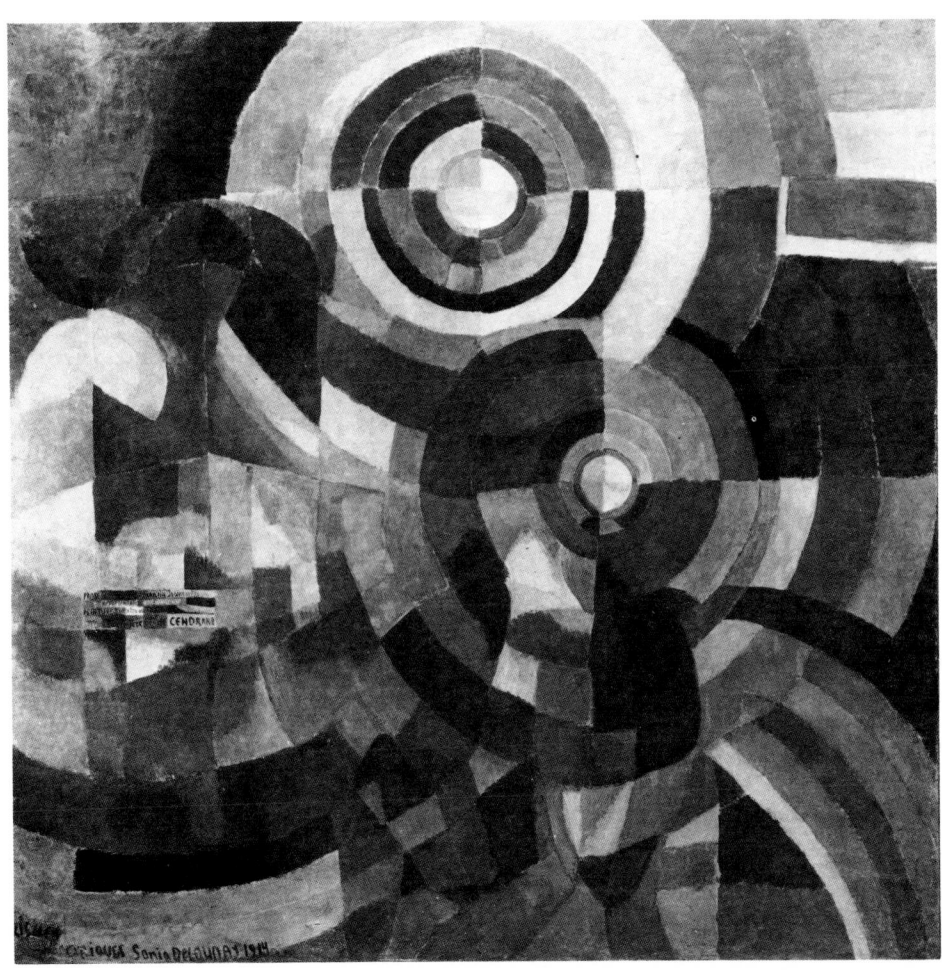

Fig. 17. Sonia Delaunay,
Electric Prisms, 1914.
Oil on canvas, 93¾ x 98¾".
Musée National d'Art Moderne, Paris.

Stein household, particularly before 1912. Gertrude Stein wrote to a friend in 1912: "We have not seen much of the Delaunays lately. There is a feud on. He wanted to wean Apollinaire and me from liking Picasso and there was a great deal of amusing intrigue."[10] She wrote to Alfred Stieglitz in 1913 that she preferred the American Marsden Hartley's work to that of Robert Delaunay. She called Delaunay "a neo-impressionist" and grouped him with other artists who, "following out Van Gogh and Matisse, are really producing a disguised but poverty-stricken realism; the realism of form having been taken away from them they have solaced themselves with the realism of light."[11]

For Sonia Delaunay, in her nineties and still living in Paris, a mere mention of Synchromism elicited the response: "We [she and Robert] invented it."[12] There is indeed some question over who first used the term Synchromism. Robert Delaunay noted that Sonia met with her young friend Smirnoff from St. Petersburg during the summer of 1912.[13] The Russian academic returned to St. Petersburg, and in 1913 delivered a public lecture on "The Simultaneous" in the famous artists' cabaret called The Stray Dog. Sonia produced colorful posters for this event which significantly included the words "Représentation Synchrom[e]" (Pl. 125). With handwritten letters and curved areas of a variety of colors, the poster used words as images in a formal sense—as abstractions themselves.

This project may have prepared Sonia to undertake the illustration and cover of Blaise Cendrars' *La Prose du Transsibérien et de la petite Jehanne de France* (Pl. 31).[14] Cendrars completed his poem in February 1913, and the book was published in October 1913, paid for by Cendrars' sudden inheritance. This "first Simultaneous book" represents a close collaboration by the artist and the man who frequently called himself "the poet of the Simultaneous." Simultaneity suggested modernity, motion, machines, and the obliteration of the traditional succession in time and space. Measuring over six and a half feet high and fourteen inches wide and folding up accordian style, Sonia Delaunay's design for Cendrars' poem has an immediate impact on the viewer. Its complex colored shapes echo the rhythms of the poem itself. Sonia's small sketch for an unexecuted poster for the book includes the words "présentation synchrome" (Pl. 126). "Représentation synchrome" occurs in a notice she designed to advertise her collaboration on Cendrars' publication; at Robert's suggestion, she later painted it as a small part of her monumental canvas, the nearly eight-foot-square *Electric Prisms* [*Prismes électriques*] (Pl. 127; Fig. 17).

The original intention of the two collaborators was that the completed edition of 150 copies would, if laid end to end, reach to the top of the Eiffel Tower. The project was not a commercial success, and Sonia Delaunay and Cendrars divided the balance of the edition between themselves. (One such example was presented to Morgan Russell in 1917 by Cendrars in exchange for a portrait.) Sonia Delaunay later recalled: "This was a new vision of the world which, in fine art as in poetry, was to revolutionize traditional ideas."[15]

In addition to Sonia Delaunay's use of the term *synchrome* in 1913, Robert Delaunay referred to "action synchromique" in his article "La Lumière," which was written during the summer of 1912, translated into German by Paul Klee and published in *Der Sturm* in early 1913.[16] The first recorded use of the word "Synchromisme," however, appears to be Russell's in October 1912, when he wrote in his notebook:

The point of departure to be forms, spaces or volumes—the light that renders same—this is all—color—depth will result —that is you interpret or exalt the experience of light by color and this exaltation with lines, rythms will give the volumes. . . . This is cubisme, Futurisme, Synchromisme and any isms possible for many years, perhaps centuries.

Writing to Andrew Dasburg in New York on March 12, 1914, Russell gave the following account of his invention:

The word was born (please don't say Synchronisme which does not apply to painting, the termination is "chrome", "color") by my searching a title for my canvas last year at the Salon—a title that would apply to painting and not to the subject. My first idea was of course, Synphonie but on looking it

up to see if it could reasonably be applied to a picture I found that Syn. was "with" and "phone" sound—the word "chrome" (why I don't know) immediately flashed in my mind— (I knew it meant color)—and there you are. . . .[17]

The fact that the Delaunays had used closely related terminology, possibly at a slightly earlier date, does not, of course, make Synchromism a direct outgrowth of their art. Robert Delaunay's *Windows* of 1912, at first sight a pure abstraction, contains vestiges of architecture and the Eiffel Tower (Pl. 123). His *The First Disc* of late 1912 (Pl. 124), reproduced in *Montjoie!* in the spring of 1914, was not publicly exhibited until 1922.[18] Its monumental flatness is totally alien to Morgan Russell's desire at the same date to base an abstract painting on the forms of a great work of sculpture. Delaunay, who used various hues to convey a picture of luminous colored light, meant his paintings to be perceived immediately or simultaneously. The Synchromists, however, were far more concerned with using color to express form. Thus, for them, unlike Delaunay, a painting did not necessarily have immediately to tell all but, on the contrary, might "develop into time like music," with initial rhythms leading to further revelations of form.[19]

Although Russell and Macdonald-Wright were aware of the Delaunays' color experimentation, they both held that it had not been pushed far enough beyond Impressionism. On July 6, 1912, for instance, Russell wrote that Robert Delaunay was "only a slight variation of older work." By contrast, the two Americans viewed themselves as creating a new and distinct style of painting, one that, in the extravagant words of Willard Huntington Wright, "embraces every aesthetic aspiration from Delacroix and Turner to Cézanne and the Cubists."[20]

3 · Debut: Munich and Paris, 1913-1914

Morgan Russell and Stanton Macdonald-Wright first exhibited together as Synchromists at Der Neue Kunstsalon in Munich from June 1 through June 30, 1913. Russell wrote to Dasburg on June 15, 1913 from Switzerland, where he was resting after the frenetic, noisy opening in Munich: "The object is less to sell . . . than to get our work, which presents a particular and new interest before the public before imitators clever at assimilating and very numerous get a hold of it."

In Munich, Russell and Macdonald-Wright put up posters that they handpainted with an abstract design closely related to Russell's most radical work of this time (Pl. 1). Macdonald-Wright later reminisced about the attention this first exhibition received:

All the posters which we put up on the kiosks in Munich, we

had to have 2 sets of them, as all the Germans took them as souvenirs. . . . We got up the second day, and there were none there! We had to go to work and get a whole new outfit of them made. And they had great arguments, and several physical battles of one kind or another over Synchromism. And that's about as much as I know of it. . . . Except . . . after that show, there was a German company of some kind that wanted to buy all of our pictures. But as we were then in process of getting ready to exhibit at Bernheim-Jeune in Paris, we didn't sell any.[1]

Macdonald-Wright also recalled that "a platform was placed in the Neue Kunstsalon for use by speakers for and against our claims."[2] Only twenty-nine paintings were exhibited. Of these, Willard Huntington Wright wrote that "there were

Fig. 18. Morgan Russell, *Small Synchromy in Green,* 1913. Formerly collection of Jean Dracopoli, now lost.

Fig. 19. Stanton Macdonald-Wright's lost painting of Michelangelo's *Dying Slave.* Reproduced from the Synchromists' Munich exhibition catalogue, 1913.

canvases in the Munich Exhibition which were almost unrecognizable as nature," but that the first "wholly abstract canvas" was not exhibited until the Bernheim-Jeune exhibition the following October in Paris.[3]

All four works reproduced in the Munich catalogue, including Russell's *Synchromy in Green* (Fig. 8), are representational figurative paintings. Russell and Macdonald-Wright each included a painting depicting the back view of Michelangelo's *Dying Slave* in the Louvre (Figs. 18, 19). Russell called his *Small Synchromy in Green* [*Kleine Synchromie in grün*]; he painted it in Paris in early 1913 and later sold it to his friend Jean Dracopoli. From the broken planes of light and dark in the black-and-white photograph, one can imagine that these now lost paintings were alive with bright colors. Most, if not all, of the works from this first exhibition are destroyed or not yet rediscovered.

Russell's *Drei Apfel* listed in the catalogue was probably his

Three Apples of 1910 (Pl. 56). This small oil painting on cardboard was inadvertently preserved on the back of the artist's *Archaic Composition No. 2* of 1915–16 which Stieglitz acquired from the Forum Exhibition of 1916 (Pl. 95). *Geranium No. 1* and *Geranium No. 2,* now lost, are probably the works of 1912 depicted in extant photographs labeled as belonging to Russell's friends Leo Stein and B. D. Conlan respectively (Figs. 20, 21).

Macdonald-Wright's lost, seated-figure *Portrait of Jean Dracopoli* reproduced in the catalogue depicted the artist's friend contemplating a robust female nude of monumental proportions, recalling the Synchromists' admiration for the baroque rhythms of Peter Paul Rubens (Fig. 22). His emphatic *Portrait of Jean Dracopoli* of 1912, still extant, allows us to imagine the tenor of Macdonald-Wright's work at this time (Pl. 7).

In their essay in the Munich exhibition catalogue, *Ausstel-*

Fig. 20. Morgan Russell, *Geranium No. 1*,
painted in Switzerland in the summer of 1912.
Formerly collection of Leo Stein, now lost.

Fig. 21. Morgan Russell, *Geranium No. 2*,
painted in Paris in the autumn of 1912.
Formerly collection of B. D. Conlan, now lost.

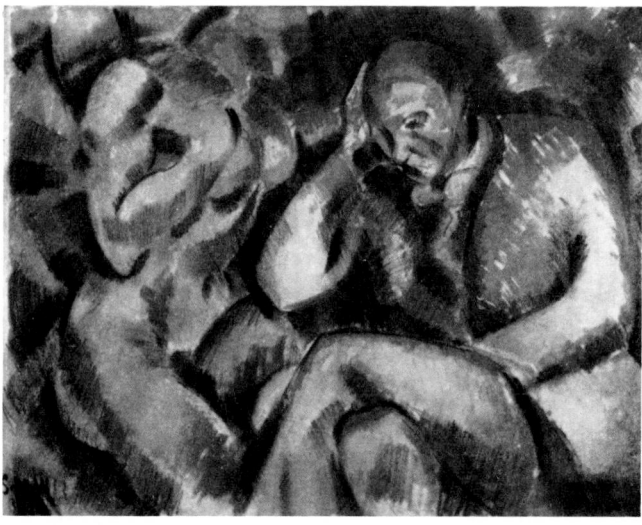

Fig. 22. Stanton Macdonald-Wright, *Portrait of Jean Dracopoli*,
now lost. Reproduced from the Synchromists'
Munich exhibition catalogue, 1913.

lung Der Synchromisten, Russell and Macdonald-Wright
stressed the limitations of both the Impressionists and Cézanne;
they also found fault with the dynamics of Futurism. They
boasted that they alone had found a unique means of combin-
ing shape and color to achieve a spiritual exaltation equivalent
to that produced by music. Additionally, they explained that
they were able to modify color to express spatial solidity (as
in the work of Macdonald-Wright). These were provocative
claims.

Russell composed a letter in his notebook of July 1912 to
send to his patroness, Mrs. Whitney; in it he explained that he
planned to distinguish himself from all the other Americans in
Paris who were only "trying to equal in a small way some
older work." In his notebook of August 1912, he reminded
himself to tell her that he hoped for an exhibition in Paris
and that his "ambition will not stop at anything else." A
little over a year later, with the Synchromist exhibition at the
Bernheim-Jeune Gallery (October 27–November 8, 1913),
Russell's hopes were realized.

Included in the Bernheim-Jeune exhibition was one very
large—10′4″ by 7′6″—purely abstract painting, *Synchromy in
Deep Blue-Violet [Synchromie en bleu violacé].* The painting
was lost to sight for many years and only survives in a much
restored form.[4] But the study exhibited with it (Pl. 9), and a
smaller, possibly later version known as *Synchromy to Light,
No. 2* (Pl. 8), as well as various intermediate stages (Pls. 69,
70), and even the earliest notebook sketches (Pls. 67, 68) have
survived to document this work, the first abstract Synchromist
painting.

Writing about his abstract Synchromies to Stanton Mac-
donald-Wright on October 20, 1925, Russell revealed the
importance that he had come to place on his *Synchromie en
bleu violacé:*

*I've learned and realized lately that that picture was the begin-
ning and end of that art as far as I'm concerned and that I
should have gone on doing others, not on the same motif, but
on the idea, the same general proportional feeling. . . .*

The studies for this major work and Russell's explanations of
it help to explain the basis of Synchromism.

In the Bernheim-Jeune exhibition catalogue, Russell dedi-
cated the *Synchromie en bleu violacé* to Mrs. Whitney to
express his deep appreciation for her generosity to him. He
accompanied the dedication with a quotation from the Book
of Genesis (in French): "And God said: 'Let there be light.'
And there was light. And God saw that it was good; and
God divided the light from the darkness." Writing to Mrs.
Whitney in December of 1913, Russell explained that this
painting was a "Synchromie to light." In addition to dedicat-
ing this major painting to Mrs. Whitney, he sent to her in
New York most of the pictures from the Bernheim-Jeune
exhibition, to offer as "a humble gift" those that she might
accept. He had sold only one work in the Bernheim-Jeune
show, and Mrs. Whitney chose not to accept any for herself—
not even the *Synchromie en bleu violacé* about which he earn-
estly explained:

*The big canvas which I took the liberty of dedicating to you is
the heart of my development and I consider that it belongs to
you—It has haunted me for years and was what I wanted to see
you about last fall. I hope you like it or come to like it for
otherwise I shall be obliged to beg your pardon for the dedi-
cace. Am enclosing a little analysis of the big synchromie which
you may care to look at after you have seen the original.*[5]

Russell titled the little booklet that he constructed to send

to Mrs. Whitney a "Harmonic Analysis of the big Synchromie in Blue-Violacé." On each tiny page he either carefully illustrated a principle of his design with a sketch or explained an abstract concept in words. Mrs. Whitney did save this little document (Pl. 71) and a letter Russell wrote the following day to explain "why the big picture was a synchromie to light":

In my effort to organize a rhythmic ensemble with the simplest elements of light I could not help but have as a result an artistic synthese of the motion experienced by the first eye that opened on this world of varied color and light that we all are so familiar with and which has a basis, as far as we humans are concerned, the spectrum, and not the yellow white disk of the sun.

Russell's evolution since 1910 when he had painted still lifes after Cézanne's *Apples* was dramatic; he now described his *Synchromie en bleu violacé* as "the bursting of the central spectrum . . . on one's consciousness" and proclaimed:

If modern painting is to express anything greater than a few apples or portraits it can only be something of this sort— The modern consciousness demands something profoundly organique. . . . A sort of human being flying thru space pointing at a round white disk can no longer mean "let there be light" to us although it did to the contemporaries of the mightiest genius that ever touched the artist's tool.[6]

Morgan Russell's reference to Michelangelo as the "mightiest genius" is a telling one. In "Harmonic Analysis," he divulged: "I have always felt the need of imposing on color the same violent twists and spirals that Rubens and Michelangelo etc. imposed on form. . . ." In *Modern Painting*, Willard Wright described *Synchromie en bleu violacé*:

. . . the composition was very similar to that of the famous Michelangelo Slave whose left arm is raised above the head and whose right hand rests on the breast. The picture contained the same movement as the statue, and had a simpler ordonnance of linear directions; but save in a general way, it bore no resemblance to the human form.[7]

Wright was referring, of course, to Michelangelo's *Dying Slave* (Fig. 7) in the Louvre which, as we have seen, Russell sketched many times. In these sketches Russell concentrated on the figure's contrapposto, fascinated by the imaginary spiral running through the entire figure (Pls. 63, 64). It is this spiral that Russell borrowed as a means of organizing his *Synchromie en bleu violacé* around a principal rhythm. In the two crayon sketches (from his notebook dated July 1912) leading to this work (Pls. 67, 68) the curves were slight and tentative, but in an early oil sketch (Pl. 70) for his *Synchromie en bleu violacé,* Russell exaggerated the curve and countercurve into a form resembling a question mark and similar to the form found in the Munich poster (Pl. 1). Another study, in oil on graph paper, demonstrates how Russell worked on a more subtle central break in the direction of the

curve as it descended from the top of the composition (Pl. 69).

In his notebook dated May 1912, nearly a year and a half before *Synchromie en bleu violacé* was first exhibited, Russell drew a tiny pencil sketch, no bigger than a postage stamp (Pl. 66), for this work. The adjacent notes confirm that it is a study for his first fully abstract painting which he subtitled "Synchromie to light." Next to a large, rough unidentifiable sketch on this same page Russell noted, "light pushing back the dark," and around the sketch for the *Synchromie en bleu violacé* he wrote: "This felt as *profundeur* not surface seen— more and more as you develop it spectrally and as idea—have it mean depth, projection and movement and thus all form."

In his "Harmonic Analysis," Russell sketched his principal rhythm and followed this with a diagram of "Development in depth," which he explained as a "brusque interruption of the movement which continues its way on the opposite side" (Pl. 71). He next pointed out a "Second theme or rhythm broken completely with a fragment higher up," and wrote:

The rest is necessarily elaboration to furnish matter to the rest of the canvas and give the necessary complexity to the whole so as to render less obvious the dominating rythm—i.e. to serve as resistance to this latter and its seizure by the mind.

He then illustrated "the four points of support or the base in violitish blue," and chose blue-violet as the "tonic" or dominant tone and "orange-red as under-dominant." Russell noted: "This makes two tonalities or contrasts in red orange and blue violet on top and yellow and purple on bottom balancing around central tonality of Blue Violet and yellow." He identified "yellow as the tonic's (violet blue) dominant," and explained that "the rest are colors needed to throw out these three and the green fills the gap in the central rythm and gives the sense of continuity."

Though Russell wrote in "Harmonic Analysis" that "never in painting has color been composed in the same sense," he was obviously familiar with some of the same basic color theory that French artists from Seurat to Robert Delaunay had read, such as Michel-Eugène Chevreul's *De la Loi du contraste simultané des couleurs* and Ogden Rood's *Modern Chromatics.*[8] Russell asserted in the Bernheim-Jeune exhibition catalogue:

One often hears painters say that they work on the form first, in the hope of arriving at the color afterwards. It seems to me that the opposite procedure should be adopted. In [Synchromie en bleu violacé], I have worked solely with color, its rhythms, its contrasts, and certain directions motivated by the color masses. There is no subject to be found there in the ordinary sense of the word; its subject is "dark blue," evolving in accordance with the particular form of my canvas.[9]

In the painting Russell has actually relied on indicating form in space by the use of color principles. For example, warm colors (such as orange-red) appear to advance, and cool colors (such as blue-violet) appear to recede. He has, by now,

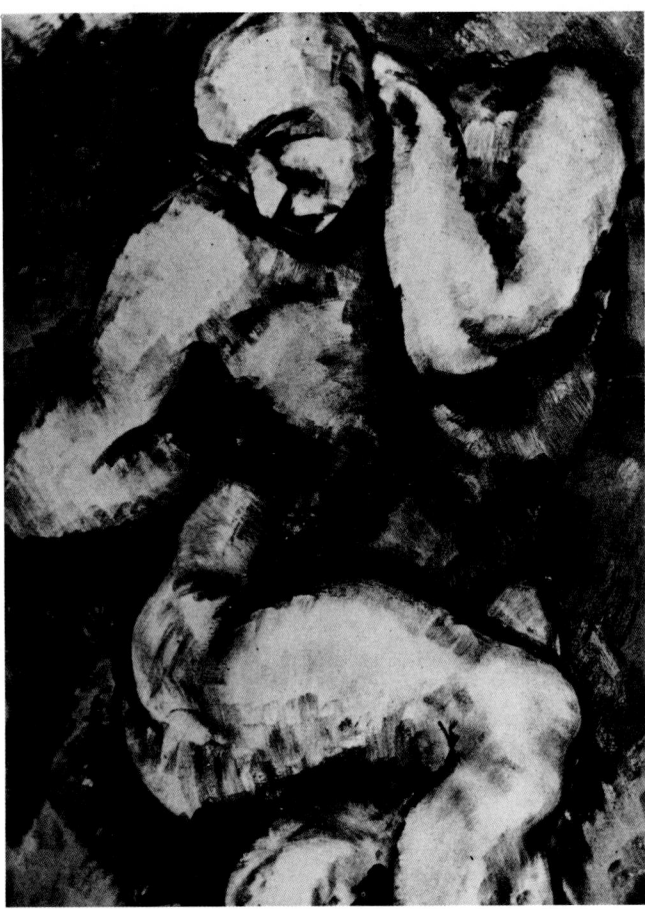

Fig. 23. Stanton Macdonald-Wright, *Nude*, c.1913, now lost.

also understood that he could heighten the value or luminosity of the yellow, reds and oranges, and thereby increase the illusion of the projection of these warmer colors. By surrounding the central yellow shape with its complement, blue-violet, as two of his "four points of support," Russell has applied Chevreul's law that when two complementary colors are placed side by side, the effect of contrast harmony is increased.[10] Thus, in "Harmonic Analysis," Russell concluded that *Synchromie en bleu violacé* "is only a composition of color and light, the form being but a simple order of projections and hollows."

Synchromie en bleu violacé was certainly the key painting in the Bernheim-Jeune exhibition, indicating the abstract direction that Synchromism would take. Russell's impressive innovation was not immediately picked up by Macdonald-Wright, who later admitted:

. . . in Russell's and my Munich, Paris and New York exhibitions I had no non-objective works. Furthermore, I maintained that the theories that produced such works could well lead, in the hands of the inept, to aimless "free" decoration, haphazard musical effusion and, at worst, a disordered kaleidoscopic effect. As I remarked in the original synchromist catalogue (1913), "I find difficulty in imagining a form that is not the result of some visual or sensory contact with nature." At the same time, I condemned illustrative subjects and literary bypaths.[11]

With the exception of Russell's abstract *Study for Synchromie en bleu violacé*, the works reproduced in the catalogue of the Bernheim-Jeune exhibition were representational figurative paintings and are either lost or destroyed. Macdonald-Wright's *Nude* is a bulky figure writhing with Michelangelesque energy (Fig. 23). His *Synchromate en vert* presents once again the familiar form of Michelangelo's *Dying Slave* (Figs. 24, 7). According to the artist's recollection years later, this picture, which measured nine by four feet, was painted in 1912 and sold the same year to Jean Dracopoli, making it "the first synchromy to be bought by a collector."[12] If this dating is correct, one assumes that the work was not labeled a Synchromy when it was first painted, since Macdonald-Wright did not employ the term for the two pictures he exhibited in the Salon des Indépendants of 1913.

Among the other works in the Bernheim-Jeune exhibition which are identifiable today is Russell's *Three Apples* [*Trois Pommes*] shown previously in Munich (Pl. 56). His *Nature morte—Etoffe pourpre et quelques bananes* is possibly *Still Life with Bananas* (Pl. 3), and his *Nude in Yellow* [*Nu en jaune*] may be *Synchromy in Yellow* (Pl. 5). If not the same ones exhibited at the Bernheim-Jeune Gallery, these works are certainly characteristic of those first Synchromist paintings.

The catalogue of the Bernheim-Jeune exhibition contained a general introduction by both artists as well as an individual statement by each explaining his own intentions (see Appendix). All five thousand copies of the catalogue were exhausted the first day, and the essays were read as a kind of manifesto of Synchromism. The introduction was an aggressive statement which understandably aroused animosity among Russell's and Macdonald-Wright's contemporaries in Paris. They wrote that they chose the name Synchromism not to designate a school but to avoid being misclassified under some inappropriate label. They dismissed Cubism and Futurism and specifically denigrated Orphism:

A superficial resemblance between the works of this school and a Synchromist canvas exhibited at the last Salon des Indépendants has led certain critics to confuse them: this was to take a tiger for a zebra, on the pretext that both have a striped skin.

By the spring following the Bernheim-Jeune exhibition, at the Salon des Indépendants of 1914, critics grouped the artists working with pure abstract color either around Robert Delaunay as the Simultaneistes or around Morgan Russell as the Synchromists.[13] Russell was exhibiting *Synchromy in Orange: To Form*, his major project following the exhibition at Bernheim-Jeune (Pl. 12).

Like Russell's *Synchromie en bleu violacé*, this painting was also loosely based on his studies, both drawn and sculpted,

which relate to Michelangelo's *Dying Slave* (Pls. 63, 64). The figural basis of *Synchromy in Orange: To Form* has been consistently ignored. This is particularly surprising since Russell originally listed his painting in the catalogue of the Salon des Indépendants as *Synchromie en orange: La création de l'homme conçue le résultat d'une force génératrice naturelle.*[14] Comparing it with Russell's sketch after Michelangelo's *Dying Slave,* one can easily recognize a form similar to this figure in contrapposto in the center of the colorful composition. The lower left leg is an emphatic purple curve and continues up to a two-toned blue thigh. This curve is worked out on the lower right in Russell's smaller outline sketch of the slave. Higher up, the belly area is given a striped treatment within a curvilinear shape. Above the lower torso, only the painted frame-like border serves to contain the surging rhythm of abstract forms which no longer correspond to the *Dying Slave.*

Although one can see faint diagonal lines across the torso of Russell's sketch of the *Dying Slave,* his pencil sketches, many of which are found in his notebook dated February–March 1914, provide the clearest indication of his method in designing this composition. Several of these small sketches relate most directly to a Michelangelesque figure Russell sketched from life (Pls. 74, 77). His sculpture of this figure was, as we have seen, included in the painting *Synchromy in Green* (Figs. 10, 8).

Even in two rough pencil studies for *Synchromy in Orange: To Form,* Russell has used the figure in contrapposto as the focus of cascades of rhythmic lines and shapes (Pls. 78, 79). He conceived of the navel (indicated by the circular lines) as a kind of central vortex from which the various other forms evolved. This can be seen most clearly on two facing pages in his notebook dated February–March 1914 (Pl. 80). While the left-hand figural sketch leaves the central area empty, the right-hand sketch develops for this space what Russell referred to in another notebook of 1914 as:

. . . the placing of the looker into the middle of the "whirlwind" of the picture. For this there must be points of convergence or lines in more than one direction—toward as well as from the looker and top and bottom and each side as well as in front of him.

Above this spiral "whirlwind," Russell has sketched a tiny version of the central figure of *Synchromy in Orange: To Form.* Here the substitution of a cluster of triangular wedges for the top half of the figure (as is the case in the final painting) is more clearly visible. Another pencil sketch (Pl. 74) makes the point very clearly by juxtaposing two views of the male figure Russell sculpted (Fig. 10) with the painting's geometric central image.

From the reproduction of this in *Montjoie!* in March 1914, and from Russell's notes on the back of an early photograph, it is apparent that he continued to revise his largest canvas after its controversial debut. Still visible today on the painting itself are his faint pencil notes "BV–RO" (blue-violet–red-

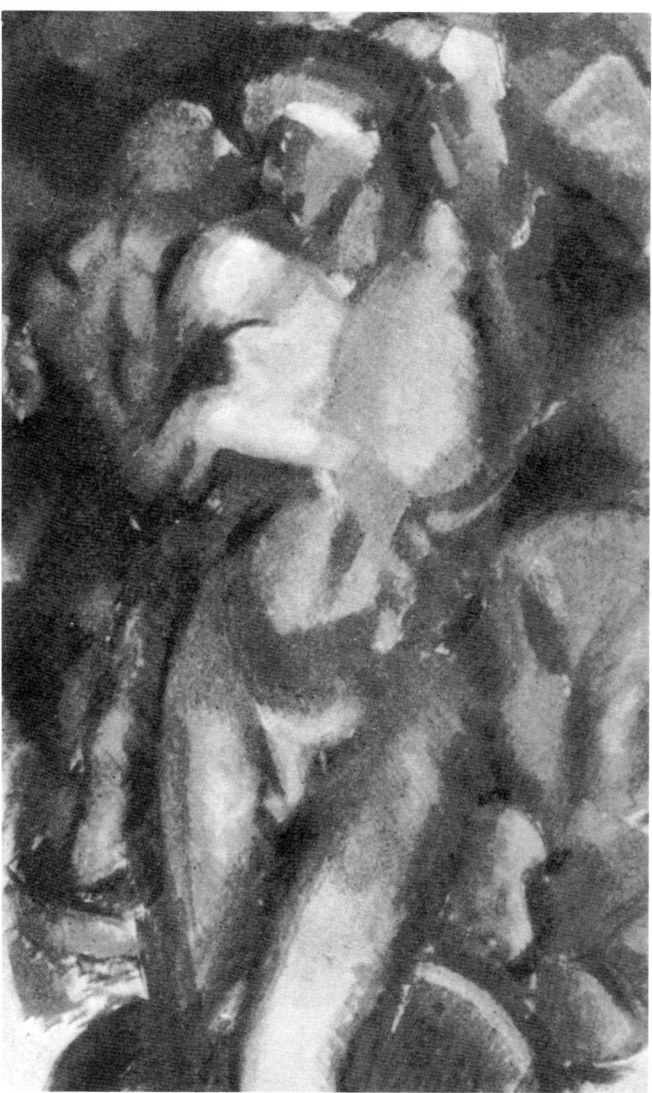

Fig. 24. Stanton Macdonald-Wright, *Synchromate en vert,* 1912. Formerly collection of Jean Dracopoli, now lost. Reproduced from the Synchromists' Paris exhibition catalogue, 1913.

orange) and other less legible writing. In addition to this early photograph (one print of which also contains a very rough sketch of *Synchromy in Orange: To Form* on the back), two interesting line drawings on tissue paper have survived (Pl. 85). Russell appears to have traced the outlines of the central figure of *Synchromy in Orange: To Form* from a photograph, probably with the intention of revising these shapes.

Russell carefully considered each passage of *Synchromy in Orange: To Form.* Several pencil drawings of specific passages have survived. One, working out the serpentine curves that flow vertically down the right side of the painting (Pl. 84), further develops a motif from a watercolor sketch in Russell's notebook dated August 1913 (Pl. 88). Another drawing is

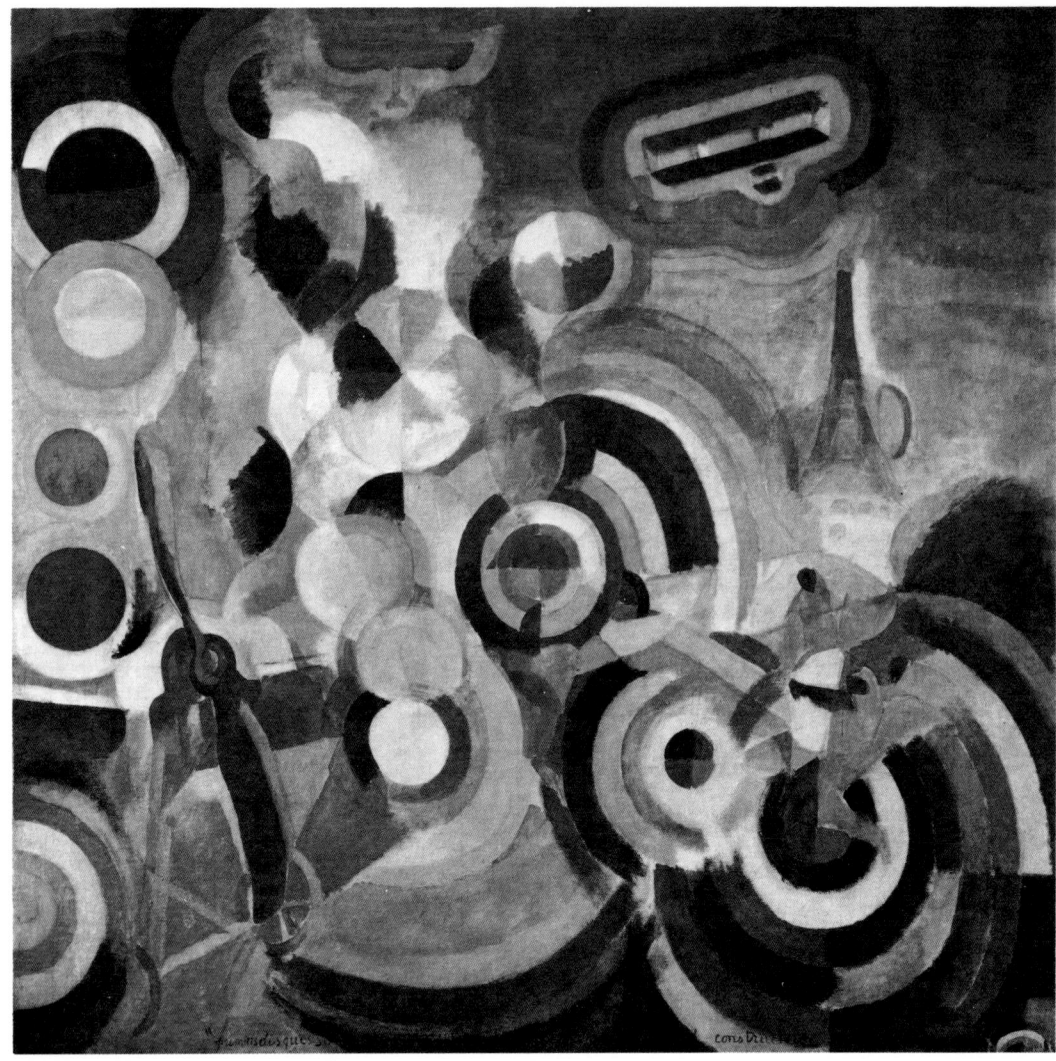

Fig. 25. Robert Delaunay,
Homage to Blériot, 1914.
Oil on canvas, 98⅝ x 99″.
Kunstmuseum, Basel.

of the upper left corner of the painting (Pl. 83). This sketch also indicates Russell's concern with color values and light contrasts.

Russell's organization of color in *Synchromy in Orange: To Form* appears to have been influenced by Rood's suggestion in *Modern Chromatics* that color harmony could be obtained through the use of triads of colors which are located within areas divided by 120 degrees on the color wheel. Thus, an artist could choose a dominant color triad or keynote and then minor color chords or triads from the rest of the color circle. The title of *Synchromy in Orange: To Form* announces that orange is the principal color; the dominant triad, then, is red-orange-yellow as it appears emphatically just to the right of the figure in the center of the composition. Elsewhere, the minor triads of yellow-green-blue and blue-violet-red occur and refer to the dominant triad. These color combinations are particularly apparent along the right side of the canvas where the familiar S curve, or spiral rhythm, undulates from the top down. Russell has varied this scheme with the introduction of

white and black, which he liked to use to emphasize projection and recession respectively.

In spite of the emphasis Russell placed on color and its importance in *Synchromy in Orange: To Form*, only one color study for this major painting is known to exist (Pl. 75). This oil sketch is so roughly executed that its relation to the painting is not easily recognizable. The verso, another pencil sketch of the central figure in *Synchromy in Orange: To Form*, provides a clue (Pl. 76). Yet if one begins at the blue circle in the center of the oil study and compares this focal point to the abdomen area of the painting's central figure, many of the forms and colors correspond. The central yellow triangle is immediately obvious in both works, as are the cascading curves of color along the right sides. The white triangular space peaked in black (then bordered by blue and brown) is also clear on the left side of the composition. The loosely painted study indicates succinctly the basic color rhythms of the finished painting.

Although Russell probably rushed to complete his largest

Synchromist painting in time to show it in the Salon des Indépendants, his revisions may also have been in response to some of the negative criticism the picture received in the French press. For example, in his comments on the Salon of 1914 Arthur Cravan had written: "Morgan Russell tries to veil his impotence behind the processes of Synchromism. I have already seen his exhibition at Bernheim-Jeune. I do not discover any quality in him."[15] Roger Allard, writing for *Les Ecrits Français,* had evidently not grasped the figural basis of the painting: "M. Morgan Russell has maliciously dedicated 'to Form' a vast synchromy which celebrates in an orange mode the creation of man conceived as the result of a natural generating force."[16] Others viewed Russell's painting with less seriousness. The newspaper *Le Matin* reported on its front page for March 25, 1914, the visit of French President Raymond Poincaré to the Salon des Indépendants. Poincaré was described as stopping in perplexity in front of Russell's imposing *Synchromy in Orange: To Form* and demanding to be told what it represented.

Undoubtedly Russell took the criticism and ridicule seriously. He did not regard his *Synchromy in Orange: To Form* as a completely successful work. In a notebook dated 1914, he wrote:

The particular sort of joy or ecstasy that a certain chord and form combination is capable of arousing can not be produced if you give it but once surrounded on all sides by other combinations just as interesting and of more or less the same size and attractiveness. It is better to repeat them perhaps slightly varied. . . . Also interesting parts that is your intention to convey must be isolated by more or less neutral or negative surroundings—i.e. lacking contrasts and rich variety of form. If the Syn. in Orange with its powerfully balanced tonalities had been worked with regard to this last observation it would have produced a much greater effect and would have done justice to itself.

Macdonald-Wright also exhibited one work in the Salon des Indépendants that year, his *Synchromate en pourpre,* then in Dracopoli's collection but now lost, as are the works shown by Patrick Henry Bruce and Arthur Burdett Frost, Jr. Robert Delaunay exhibited his grandiose *Homage to Blériot* (Fig. 25) and Sonia Delaunay her equally monumental *Electric Prisms* (Fig. 17).

Russell's *Synchromy in Orange: To Form* attracted much attention in Paris, and his fame reached its peak in the spring of 1914. The competitive spirit between the Simultaneists or Orphists and the Synchromists also reached its high point during the Salon des Indépendants. A rivalry developed which reputedly was less than amicable.[17] Russell even claimed that the Delaunays' use of the name Simultaneism instead of Orphism to describe their style was in reaction to the Synchromists' criticism.[18] For all that, the Synchromists were not unmindful of Robert Delaunay's work, particularly after their own was so frequently (often unfavorably) compared to his in the press.[19] Morgan Russell took the opportunity at the Salon to make at least three sketches of Robert Delaunay's *Homage to Blériot* (Pls. 89, 90), two of which contain extensive notations of color. Yet Delaunay's flat discs, which cancel out most of the spatial illusion, were contrary to Russell's own commitment to the rendering of solid volumes in space. Delaunay's devotion to the airplane and the propeller in *Homage to Blériot* and in other, earlier works appears to have inspired Macdonald-Wright as late as 1920 when he painted *Aeroplane: Synchromy in Yellow-Orange* (Pl. 21). While the Salon des Indépendants was going on, though, Macdonald-Wright had returned to New York and was arranging for a Synchromist exhibition there.

4 · New York, 1914-1916

The first exhibition of Synchromism in America opened in New York City at the Carroll Galleries at 9 East 44th Street, on March 2, 1914. Arranged on only four days' notice, the exhibition was later described by Macdonald-Wright as a complete fiasco.[1] He felt that his brother (Fig. 26), then editor of *The Smart Set* magazine, had, by his put-downs of other artists and movements, made Synchromism seem ridiculous in the press.

"Impressionism to Synchromism," Willard's most provocative article, had appeared in *The Forum* magazine as early as December 1913.[2] It managed to dismiss summarily nearly every artist and style preceding Synchromism, though it recognized the importance of Impressionism:

Color juxtaposition was the main issue. Color had always been used merely for dramatic reinforcement or for decorative effects. These new men opened the eyes of all serious-minded artists to an entirely new conception in the making of a painting. The struggle to carry on this idea has been the history of painting for the last thirty years.

Wright recognized that Cézanne had been an important influence but had "become a fetish," a primitive who "always remained an archaic." Of contemporaries, Wright credited only Matisse as "the man who has shaken to the foundations the habits of modern painting," but who, in spite of his "real imagination," "lacked a sense of rhythm." The Intimists Vuil-

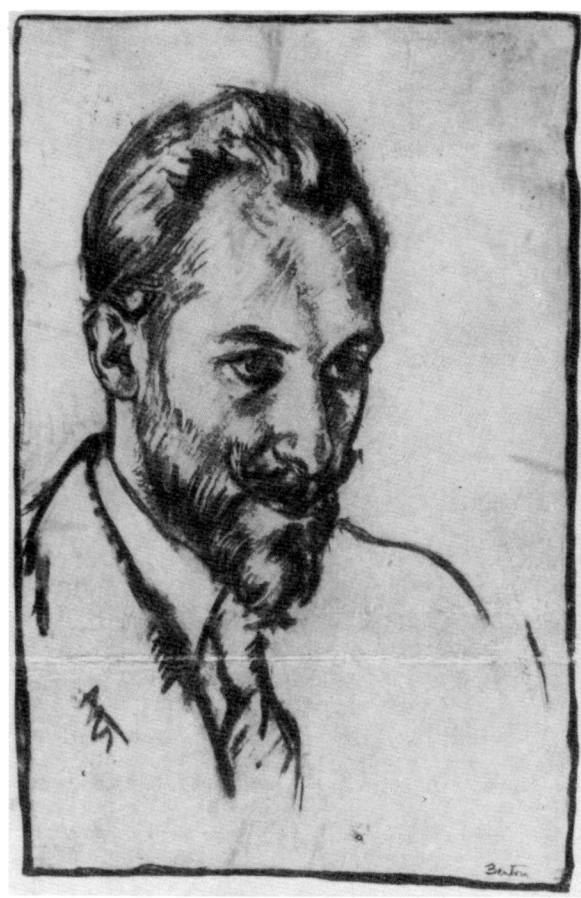

Fig. 26. Thomas Hart Benton, *Sketch of
Willard Huntington Wright,* c.1915, now lost.
Willard Huntington Wright scrapbooks,
Princeton University Library.

[*sic*] having been wooed even to the name, Synchromism."
It is no wonder that these sweeping claims and criticisms
caused the Synchromists to be taken less seriously than they
might have been at the occasion of their New York debut the
following March.

The catalogue, *Exhibition of Synchromist Paintings by
Morgan Russell and S. Macdonald-Wright,* which had to be
quickly produced, contained neither reproductions nor a list
of the works shown. This led Russell, who had not been
involved in organizing the exhibition, to wonder just which
of his paintings Macdonald-Wright had included of those he
had sent over for Mrs. Whitney to see after the Bernheim-
Jeune exhibition. Furthermore, Russell's close friends Andrew
Dasburg and Arthur Lee felt that Macdonald-Wright was
taking all the glory as the inventor of Synchromism, and they
wrote this to Russell. The letters exchanged across the Atlantic
caused misconceptions and Russell grew indignant. Writing to
Dasburg that March to thank him for his support, he declared:

*The present Salon des Independants is divided in interest
according to all the papers between myself under the name
Synchromisme and Delaunay under that of Simultaneous. After
our knocks he had to get a new trade mark—Orphisme being
buried by yours truly—Bruce, of course, remains his very
obedient disciple—and I am given a lot of disciples whom I
never met or know but who have been influenced, all of which
does not cast the very best kind of glory on "Syn." Synchro-
misme has just the importance that the work of Morgan Rus-
sell has no more, no less—Don't give me the occasion to say
this again—[Here follows the account of Russell's invention of
the word Synchromism, quoted in Ch. 2.]—When I tell you
how W. started at the twelfth hour to do something new
because I had naturally arrived at doing so, and got a variation
on mine as Carlock, Stein, and many others know. W. offered
to pay the expense of a show if I would consent to expose
with him otherwise there would never have been a show of
two or a movement called Synchromisme or, if so, it would
have been connected alone with my name.*[3]

Macdonald-Wright heard from Dasburg directly that he
had written to Russell to protest the attention Macdonald-
Wright and his brother were getting at Russell's expense.
Macdonald-Wright then wrote Russell and assured him that his
pictures hung in the best places; he had included Russell's
Small Synchromy in Green (Fig. 18), *Synchromie en bleu
violacé* and the study (Pl. 9) for it, a small nude (sketch),
a violet landscape, a flower piece, a yellow-orange woman with
her feet in the water, and other work. Russell felt better on
hearing these details, and the two remained friends. Unfor-
tunately, there is no indication of exactly which of his own
works Macdonald-Wright included. He had also written to
Russell that Arthur Lee was quite enthusiastic about Synchrom-
ism, but that Dasburg seemed nervous. His own closest artist
friend and supporter in New York at this time was Thomas
Hart Benton, and Benton's remarks on the exhibition (accord-

lard and Bonnard were "mediocrities," Picasso "an amateur
metaphysician on the loose," and Cubism "a craze for the
static and the solid, for the immovable and the geometric."

Wright had little respect for the two movements with which
the Synchromists saw themselves competing for attention in
Paris—Futurism and Orphism. The first "owed much of its
fury to the flying machine craze and auto speeding," and had
"succeeded only in giving us a disordered display of lines and
colors." "The results of Orphism," he stressed, "are little more
than those of Impressionism enlarged and attenuated." De-
launay had only "moderate talent," and "his immense canvases
give off a distinct feeling that the intrinsic elements of the
work are diluted."

Of Synchromism, on the other hand, Wright proclaimed
that it seemed "destined to have the most far reaching effects
of any art force since Cézanne" and that it offered a *"practical*
solution for those problems which have been pending for
years." It condemned the decorative use of color and instead
allowed each color to have "a separate and distinct meaning of
its own as form and light." Wright boasted that "the Synchro-
mists' influence is beginning to be felt in Paris, Delaunay

ing to Macdonald-Wright, his brother had arranged for Benton to dress as an apache and slink around the gallery⁴) offer one of the best eyewitness reports:

Due to the rather exaggerated claims made in the Synchromist "Manifesto," which was circulated at the exhibition, New York artists, by and large, ignored the truly logical aspects of the work and gave it little support. Some resentment was felt, especially by those who had had Parisian training, that two unknown Americans should have had the effrontery to set up a school in Paris in competition with their Parisian "superiors." A number of coloristic similarities between the Synchromist paintings and those of Orphism, a spectral school initiated by the French painter Robert Delaunay, led to accusations of plagiarism. Many Americans at this time were so slavishly imitating French painting that all deviations from it were regarded as being in "bad taste." However, enough curiosity was aroused for quite a number of artists to visit the exhibition. . . .⁵

The exhibition, although not a commercial success by any means, was reasonably well received by the *New York Times.* The reviewer, who felt that the catalogue was helpful and that Willard Wright's "explanations of those qualities in colors that enable them to express solid forms or open space are perfectly intelligible to a painter if not to the general public," found fault chiefly in the large-scale Synchromies shown in the cramped gallery space.⁶

Macdonald-Wright also told Russell that he had written the catalogue and included a foreword by Willard and a joint manifesto (see Appendix). From their letters, it is apparent that they supplied Willard with much of what he wrote on art. The foreword restated the claims they had made in the Bernheim-Jeune essay and challenged American artists:

With them [the Synchromists] an art is born whose power to create emotion surpasses other contemporary painting, just as the modern orchestra surpasses the harpsichord. They have brought into modern painting something tangible and concrete to take the place of vague speculations. They have shown in what direction the efforts of painting should turn.

Macdonald-Wright, having returned to America shortly after the Bernheim-Jeune exhibition, just after his father's death, expected to inherit part of his estate. To his dismay, he and Willard were left out, and the estate went entirely to his mother. Depressed to be financially stranded in New York, which he hated, he first planned to write a musical comedy to earn money. He also met Mrs. Whitney and attempted to convince her to support him as well as Russell. He found her to be both intelligent and charming but was unsuccessful in winning her patronage, though one review of the Carroll Galleries exhibition (Fig. 27) stated that Russell and Macdonald-Wright were "two young men who are proteges of Mrs. Harry Payne Whitney."⁷ Dejected and disheartened, Macdonald-Wright tried for work as a translator. Meanwhile, as he wrote to Rus-

'SYNCHROMIST' ART NOW ASSAILS EYE

Young Men Under Patronage of Mrs. H. P. Whitney Give Exhibition.

LARGE SPLASHES OF COLOR FOUND

Futurists and Cubists Outdone by Exponents of Brand New Movement.

The latest assault on the optic nerves and the conventional viewpoint as to what constitutes pictorial art arrived in New York yesterday in the form of an exhibition of "Synchromist Paintings" by Morgan Russell and S. MacDonald-Wright, two young men who are proteges of Mrs. Harry Payne Whitney. The paintings, which crystallize the new movement that Morgan and MacDonald-Wright called "Synchromism"—a term coined from the Greek and meaning "with color," are on exhibition in the Carroll Galleries, No. 9 East Forty-fourth street, where they will remain until March 16.

There are about forty pictures, a few of which—as a sop to doubters—are canvases painted in the conventional manner, and are badly drawn and painted, by the way. The rest of the pictures resemble the sort of thing we have grown to call Cubist or Futurist art, and, with the best intentions in the world, are no easier to understand.

Fig. 27. Review of Synchromist exhibition at Carroll Galleries in *New York Press,* March 7, 1914. (excerpt).

sell, he enjoyed the local distractions of women and opium; he later noted that he believed his *Oriental Synchromy in Blue-Green* of 1918 was based—in its formal arrangement and subject matter—on a group of opium smokers (Pl. 20).⁸ Macdonald-Wright finally arranged to obtain money enough (by less than honest means, as he boasted to Russell) to return to Paris in April 1914 and to take his brother along.

From Paris, where Russell remained, Macdonald-Wright and his brother moved to London at the outbreak of war in August.

They stayed there through the spring of 1915 and, according to Macdonald-Wright, collaborated on three books.[9] Returning then to New York, they were instrumental in organizing "The Forum Exhibition of Modern American Painters" which opened on March 13, 1916, at the Anderson Galleries at 15 East 45th Street.

Willard Wright was one of the Forum Committee along with Dr. Christian Brinton (a critic), Robert Henri, Alfred Stieglitz, W. H. de B. Nelson (editor of *International Studio*), and Dr. John Weichsel (President of the People's Art Guild and a writer on art). Each member of the committee contributed a short foreword to the catalogue, but only Wright included a sizable essay entitled "What is Modern Painting?" which extolled the progress of Synchromism beyond that made by Cézanne. The catalogue also featured an explanatory note and a reproduction for each of the seventeen artists included with the exception of the only woman, Marguerite Zorach, who was evidently considered sufficiently accounted for by her husband William Zorach's essay and the reproduction of his painting.[10]

Macdonald-Wright's expectations for the Forum Exhibition were inflated. He wrote to Russell that he expected to earn at least $1,500 out of it and that it would travel to all the big cities on its way to the West Coast. He was to be disappointed in this, although his prophecy that the Forum would be "the most talked of exhibition" after the Armory Show was not inaccurate.

Russell traveled to New York for about a month at the time of the Forum Exhibition. This was his first trip there since he had moved to Paris in 1909; he would not return to the United States again until 1931. Very few of his fourteen works in the show were sold. Willard wrote to him and blamed this on the "knockers" of modern art. Stieglitz purchased Russell's *Archaic Composition No. 1* of 1915 for $41.35 rather than the price of $110 listed in the catalogue (Pl. 94).[11] Russell was so pleased that he presented *Archaic Composition No. 2* of 1915 to Stieglitz as a gift (Pl. 95). He wrote to Stieglitz from Paris that he had visited Mrs. Whitney (who had stopped his allowance as of January 1, 1916) just before leaving New York and found her "extremely sympathetic."[12] He added that if he had not previously purchased his ticket he felt certain he could have "made a lot come off." Stieglitz responded with sympathy that New York had not been fair to the Forum Exhibition and that Mrs. Whitney had not visited it. Willard Wright purchased one of Russell's drawings of a reclining nude for thirty dollars and accepted both the *Cosmic Synchromy* (Pl. 13) and *Au Café* as gifts from the artist. Russell's other three drawings in the exhibition went to Leo Stein.

When Macdonald-Wright had first written to Russell suggesting that he send paintings to the Forum Exhibition, he had requested four hundred words for a manifesto. Mindful of the hostilities they had provoked with their previous catalogue essays, he cautioned his colleague not to criticize other schools but simply to state his own point of view. He also encouraged Russell to send the *Cosmic Synchromy* because he felt that the

publicity the painting had received would assure its sale. He must have been alluding to the reproduction of this work in Willard's *Modern Painting*.

In his statement in the Forum catalogue Russell summarized his development leading to the *Cosmic Synchromy*:

My first synchromies represented a personal manner of visualizing the color rhythms; hence my treatment of light by multiple rainbow-like color-waves which, expanding into larger undulations, form the general composition.

In my next step I was concerned with the elimination of the natural object and with the retention of color rhythms. An example of this period is the Cosmic Synchromy. *The principal idea in this canvas is a spiral plunge into space, excited and quickened by appropriate color contrasts.*

Ironically, just as Russell stated his previous Synchromist philosophy in this explanatory note, he was temporarily moving away from both abstraction and his emphasis on color:

While there will probably always be illustrative pictures, it cannot be denied that this century may see the flowering of a new art of forms and colors alone. Personally, I believe that non-illustrative painting is the purest manner of aesthetic expression, and that, provided the basic demands of great composition are adhered to, the emotional effect will be even more intense than if there was present the obstacle of representation. Color is form; and in my attainment of abstract form I use those colors which optically correspond to the spatial extension of the forms desired.

Russell's declining interest in color is already apparent in his *Archaic Composition No. 1* and *Archaic Composition No. 2* (Pls. 94, 95). He also referred to these works in his essay: "In my latest development I have sought a 'form' which, though necessarily archaic, would be fundamental and permit of steady evolution, in order to build something at once Dionysian and architectural in shape and color." Actually, Russell based these two somber and puzzling paintings on self-portraits which include some recognizable features. The face depicted is more easily apparent in his studies (Pls. 96, 97).

Russell had continued to paint abstract Synchromies through the spring of 1915. By September 13, 1915, however, as Russell wrote to Mrs. Whitney, he had, at the advice of a specialist, found it necessary to give up his "vivid color work" of the previous winter due to eye strain and headaches. Over the summer, he had turned once again to sculpture, with himself as model through the use of three big mirrors. He also found "drawings and modestly colored still-life after nature" restful. Yet, in a letter to Mrs. Whitney dated November 7, 1915, Russell affirmed that he planned "to continue unflinchingly . . . to work out the art that I have given birth to, come what may." Although fully intending to return to his abstract Synchromist painting, Russell again considered Cézannesque forms during this period, as is evident in such paintings of 1915 as *Tree Bench* (Pl. 93). Here, as in the *Archaic Compositions*, Russell

has moved toward a darker palette that is closer to that of Cubism.

Writing to Macdonald-Wright on September 7, 1920, Russell recalled that he had already ceased to paint Synchromies when he came to New York in 1916, and this is borne out by Andrew Dasburg's recollection that over lunch at the time of the Forum Exhibition Russell told him: "I am through with Synchromism."[13] In another letter to Macdonald-Wright, on April 15, 1924, Russell also referred to an "impasse in my abstract synchromies" which he had experienced in 1916. Russell's work had evolved far beyond his first and best abstract Synchromies of 1913–14, characterized by what he had described, in his essay in the catalogue of the Forum Exhibition, as "color rhythms" and "a spiralic plunge into space." Ironically, while Russell was experiencing this crisis, Macdonald-Wright was painting some of his best abstract Synchromies, in the period just before the Forum Exhibition and during the next two years.

One wonders how much the war may have affected Russell, then isolated in Paris after most of his American colleagues had gone home or elsewhere. Most of his friends eventually departed and as early as January 20, 1915, he remarked in a letter to Dasburg:

You should be here now—since yesterday all the lights have to be out everywhere. The Parisians have been struck with the Zeppelin scare like the Londoners and now Paris streets look lugubrious and tragique. In front of the Gare Montparnasse is like a lonely dark country road at night.

This must have seemed especially dramatic in Paris, the "City of Light." Many of the avant-garde artists remained away from Paris for the duration of the war. Notably, Robert and Sonia Delaunay spent these years in Spain and Portugal. The rivalry of Synchromism and Orphism at the Salon des Indépendants of the spring of 1914 was effectively quelled by the war.

Macdonald-Wright exhibited twelve works in the Forum Exhibition and featured his first purely abstract work. At least one version of his *Abstraction on Spectrum (Organization No. 5)* of 1914 was included and reproduced in the catalogue (Pl. 10). A still extant watercolor study for *Conception Synchromy,* which is related to this oil, was probably in the Forum Exhibition as it was formerly owned by Dr. John Weichsel of the selection committee (Pl. 107). The painter George F. Of recalled that Macdonald-Wright's *Conception Synchromy* of 1915 was in the Forum Exhibition (Pl. 14).[14] If so, and it seems reasonable to suppose that this major work would have been included, then it must have been listed in the catalogue by another title. H. L. Mencken, who knew Willard Wright through their work on *The Smart Set* magazine, once owned Macdonald-Wright's *Arm Organization in Blue-Green* as well as the Synchromist abstraction *Bubbles* by Thomas Hart Benton (Pl. 22); either or both of these works may have been purchased at this time.

John Weichsel, in an article in *The International Studio* praising the Forum Exhibition, described the "New Art" ideals presented there as "an embodiment of the modern spirit."[15] His enthusiasm characterizes the response of American artists to this landmark exhibition and presages the important immediate influence that the art presented there, particularly Synchromism, would have in America.

5 · Impact of Synchromism in America

Thomas Hart Benton, more than any other American painter, was directly influenced by Synchromism. Benton had been living in Paris for more than a year when, in the late autumn of 1909, he met Stanton Macdonald-Wright, whom he later referred to as "the most gifted all-round fellow I ever knew."[1] By this time Benton had become acquainted with George Carlock and John Thompson, both pupils of Ernest Percyval Tudor-Hart; Carlock, as we have seen, was a friend of Morgan Russell. During the early winter of 1908–09, Thompson taught Impressionist techniques to Benton and encouraged him to adopt a full-color palette. Carlock, "a disciple of Cézanne," first guided Benton in his study of Classical and Renaissance art in the Louvre, which he continued with Macdonald-Wright.[2] Benton went on to experiment with Neo-Impressionism, notably Signac's Pointillism, and then with Cézanne's style, which he found more problematic.

When his father cut off his support, Benton returned in July 1911 to his family home in Missouri, where he struggled to find himself aesthetically. By early June 1912, he had arrived in New York. There he studied Cézanne's work again and developed a limited interest in the artist's design. His friends at this time included Samuel Halpert, who had become friendly with Robert Delaunay in Paris, and Macdonald-Wright when the latter came to New York from Paris in late 1913.

Benton attended the Synchromism exhibition at the Carroll Galleries "nearly every day." Years later he described his first impression as "like an explosion of rainbows," explaining:

The Synchromists had extended and intensified Cézanne's color-form theories, in which form was seen as a derivative of the organization of color planes. They had intensified these planes by abandoning completely the usual colors of nature, replacing

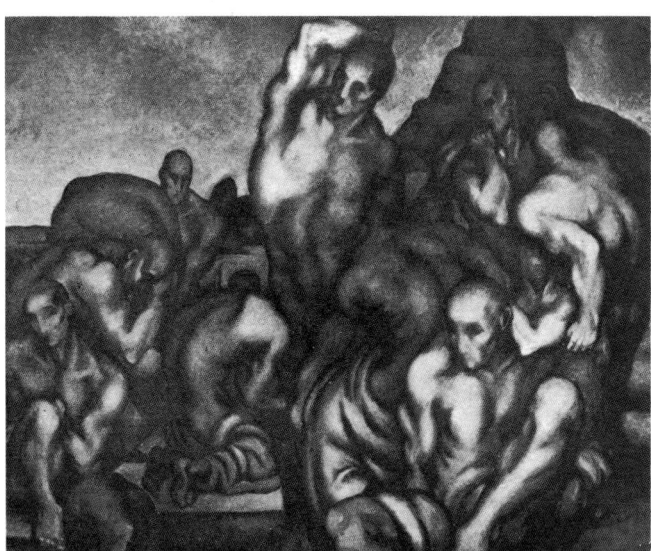

Fig. 28. Thomas Hart Benton,
Figure Organization No. 3, c.1915–16, now lost.
Reproduced from the Forum Exhibition catalogue, 1916.

them with highly saturated spectral colors and had extended them into an area of purely "abstract" form.[3]

Importantly, Benton recognized the underlying forms of even the seemingly abstract Synchromist paintings:

What most captured my interest, however, was the Synchromists' use of Baroque rhythms, derived not from Cézanne's work, as was the case with most of the Parisian painters who had experimented with such rhythms, but from the more basic source of Michelangelo's sculptures. Through its use of these rhythms, Synchromism seemed to offer a more logical connection between the orderly form of the past and the coloristic tendencies of the present than any other of the Parisian schools. . . . I could look more sympathetically at the Synchromist effort than most of the New York artists who came to see it. I could not accept the repudiation of all representational art, which was the core of Synchromist dogma, but its procedures were interesting enough to induce experimentation.

Bubbles, with its colorful abstract forms and light effects, is certainly worthy of being called a Synchromist painting, and may perhaps be dated as early as 1914 to this period of experimentation (Pl. 22). Benton, however, who felt himself wavering in "the winds and isms of the time," actually belittled his adaptation of the "enticing formulas" of Macdonald-Wright's Synchromism:

If one admitted, and we all then did, that the procedures of art were sufficient unto and for themselves and that the progress of art toward "purification" led away from representation toward

the more abstract forms of music, then synchromism was a persuasive conception. Arguing rebelliously because I still loved represented things, I set out to experiment with it. But I had neither the talent for good imitation nor the conviction to turn my friend's procedure to any ends of my own, and I got poor results.[4]

Benton admitted that, although he "neglected to inquire about the particular color system on which Synchromist painting was based," he first began, as a result of his experiments with Synchromism, to be included in exhibitions and to receive attention in the press.[5]

During 1914–15, Benton had also become friendly with John Weichsel, the Socialist-oriented member of the Forum Exhibition Committee, who encouraged him in quite a different direction—the use of representational form to express social content. Yet when Macdonald-Wright and his brother returned to New York in 1915, he and Benton once again became close associates. According to Benton:

Willard and Stanton were hatching plans for another Synchromist exhibit, but they had concluded that this time it would be politic to have it in conjunction with a few other artists. Stanton, who was, as in our Paris days, disposed to forward my interests, indicated that if I could produce the pictures, I would be included in the exhibition.[6]

Benton was finally able to learn from Macdonald-Wright about "the Synchromist color system." Although he believed the system to be "invented by Tudor-Hart," what he actually described as "a spectral wheel so divided that triads of harmoniously related colors could be automatically determined" undoubtedly owes to the theories of Ogden Rood.

Benton did "produce the pictures" necessary to be included in the Forum Exhibition. Illustrated in the catalogue, his now lost *Figure Organization No. 3* demonstrates his use of Michelangelo's figures as suggested to him by the Synchromists (Fig. 28). Benton later recalled his preparation for this exhibition:

In the autumn and winter of 1915–16, I produced a batch of pictures using Hart's color system, though in a somewhat arbitrary way. Following the Synchromist practice of the time, I based the compositions of these pictures on Michelangelo's sculpture. However, as the multiple-figure composition was again occupying my thoughts, I selected Michelangelo's early relief the "Battle of the Centaurs," rather than a single figure, to serve as a model for my creations.[7]

Benton also made paintings of heroic single figures based, like those of the Synchromists, on Michelangelo's *Dying Slave* (Fig. 7). Evidence of at least one such adaptation still exists though it has suffered an inadvertently harsh scrubbing by the owner (Fig. 29). In concluding his rather vague statement in the Forum Exhibition catalogue, Benton paid a tribute to the Synchromists when he wrote, "I believe that the representation of objective forms and the presentation of abstract ideas of

form to be of equal artistic value."[8] Although Benton's respect for abstraction did not endure much beyond his opportunity to join the Forum Exhibition, his friendship with Macdonald-Wright continued even after the latter left New York to live in California in 1919.

In his review of the Forum Exhibition, Willard Wright stated: "Benton is now working with the methods of the Synchromists of two years ago, softened and rounded to his own temperamental needs." According to Wright, however, none of the "many abstract canvases" Benton had done in the past year showed "the requisite progress for significant achievement. He has come a long way, but he still has far to go."[9]

Following his figural compositions shown in the Forum Exhibition, Benton also experimented, from late 1917 through the winter of 1919, with what he termed "constructivism," producing colorful, more geometric abstractions not unrelated to some of Morgan Russell's Synchromist paintings. As Russell had represented sculptured planes with color, Benton constructed three-dimensional forms which he then depicted in his paintings. One such work is *Constructivist Still Life: Synchromist Color* of 1917 (Pl. 120).

Even Benton's later, more characteristic paintings owe a debt to his early discovery of Michelangelo's rhythms in Synchromist painting. In *People of Chilmark (Figure Composition)* of 1920, such rhythms are combined with passages of near Synchromist color (Pl. 121). These colors were used with nearly abstract forms as late as 1925–26 when Benton designed and completely decorated the interior of a den for a home in Garden City, Long Island. A *Screen with an Abstract Sea Motif* (Pl. 122) recalls the transparent colors as well as the Baroque rhythms of Synchromist abstractions and even passages of his own *Bubbles*.

In the end, though, as Benton wrote, he ran into "impossible contradictions," and "quit Synchromism because I just couldn't paint George Washington as a rainbow."[10]

Another artist who responded directly to the impact of Synchromism was Andrew Dasburg, who was well acquainted with its development through his friendship with Morgan Russell. He first encountered modernism when he joined Russell in Paris during 1909–10. Matisse had stopped teaching soon after Dasburg's arrival, but through Russell he was able to visit Matisse's studio and years later he recalled the experience of seeing the artist at work "on the large panels of dancers." He was struck by the pains Matisse took to achieve the "limpidity and casualness" of his line. Dasburg also remembered Leo Stein and the soirées where he met Picasso and many of the other French artists:

Stein talked endlessly on aesthetics. . . . [He] allowed Morgan and me to take a painting by Cézanne to my studio. It was a long horizontal panel of apples. I studied this painting and copied it many times while it was in my possession.[11]

Morgan Russell's *Three Apples* still exists, but the works that

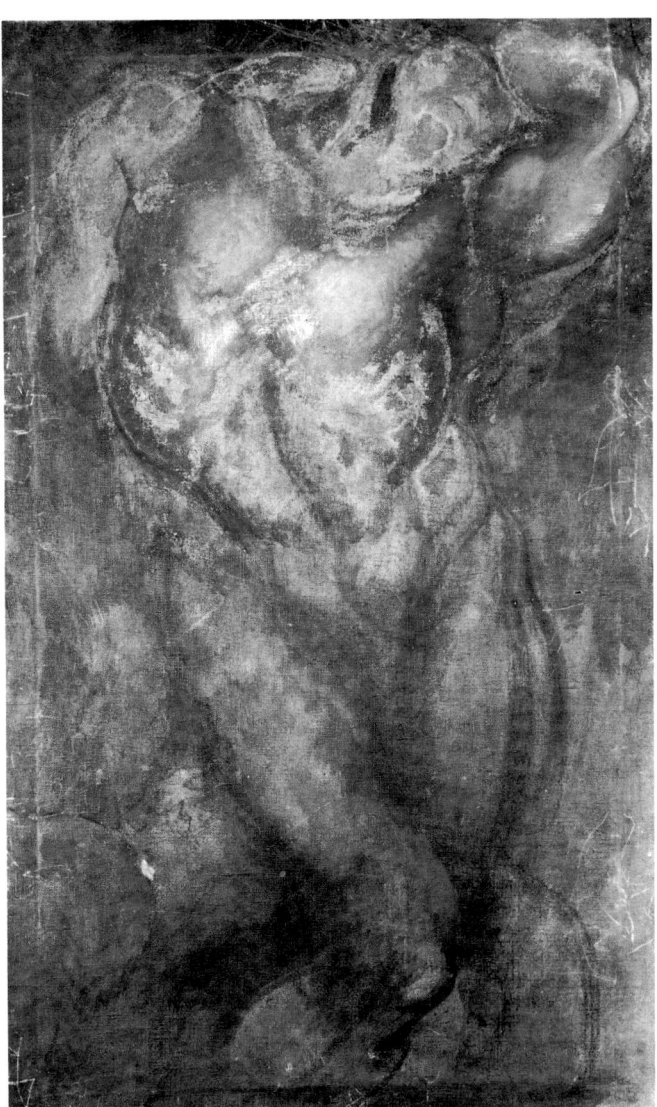

Fig. 29. Painting by Thomas Hart Benton inspired by Michelangelo's *Dying Slave*, c.1915–16. The work is extant, but little of the paint remains after cleaning.

Dasburg produced in response to this Cézanne are lost (Pls. 55, 56). "I came back from Europe inflamed like a newly converted evangelist and I talked endlessly about what I had seen in experimental art," wrote Dasburg. He returned to Paris in 1914 where he again worked closely with Russell; he now became increasingly interested in color theory and practice.

Like Russell, Dasburg first plunged into abstraction in the fall of 1913. He discussed color charts and chromatic scales with his friend Konrad Cramer (Fig. 30).[12] Both painted abstractions and showed them in a group exhibition at the Macdowell Club of New York in November 1913.[13] The *Improvisations* Cramer exhibited at this time demonstrate

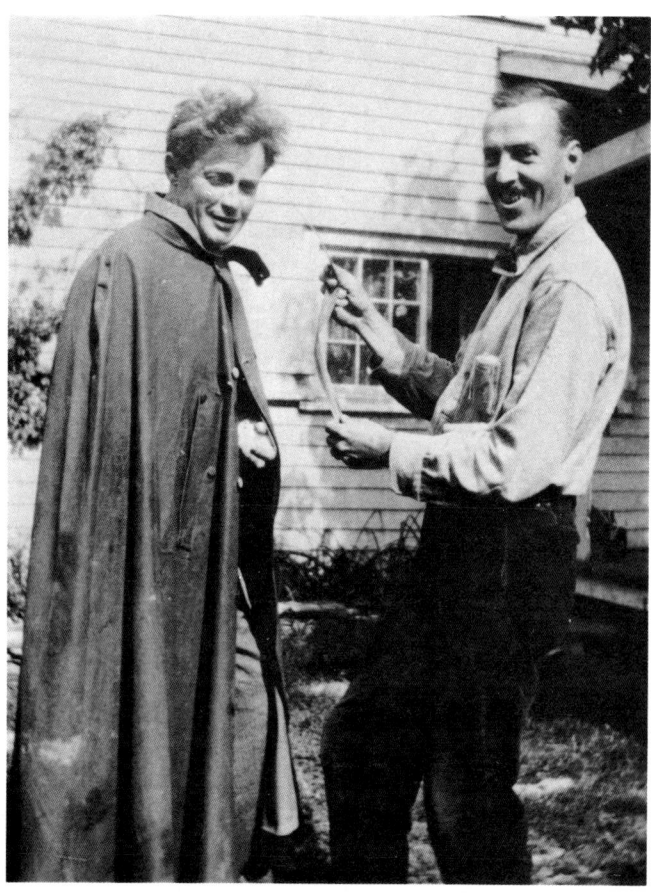

Fig. 30. Andrew Dasburg and Konrad Cramer in Woodstock, N.Y. Photo, collection of Andrew Dasburg.

Fig. 31. Andrew Dasburg, *To Mabel Dodge No. 2,* 1913, now lost.

Fig. 32. Andrew Dasburg, *Improvisation,* c.1915, now lost. Reproduced from the Forum Exhibition catalogue, 1916.

a bold, experimental approach to color, which he would have brought with him from his contacts with the avant-garde in Germany, and shared with his new American friends in Woodstock (Pls. 25, 26).

At this time Dasburg was an intimate friend of Mabel Dodge, whose townhouse at 23 Fifth Avenue was an avant-garde salon somewhat similar to that of Gertrude Stein in Paris; others in this circle included the sculptor Arthur Lee and his wife Freddie.[14] Dasburg produced two abstractions (now lost) which were later called the *Absence of Mabel Dodge* and *To Mabel Dodge No. 2* (Fig. 31).[15]

Extant examples of Dasburg's work of this period are few. His experiments with abstraction during 1915–16, such as his remarkable *Improvisations,* were shown in the Forum Exhibi-

tion. The single *Improvisation* that exists today, similar to the lost *Improvisation* reproduced in the catalogue, demonstrates that Dasburg had developed an impressive facility with abstract shapes and colors (Pl. 24; Fig. 32). Yet Willard Wright considered Dasburg a "man who gives the ideas of others a trial so that he may learn by their mistakes."[16] Because Dasburg also exhibited non-abstract work (two still lifes) in the Forum Exhibition, Wright pronounced a certain "tentativeness" in Dasburg's work, although he admitted that "his later paintings have undergone somewhat the Synchromist vision" and that he showed "a marked degree of originality and a sensitivity to a rhythmic order of forms."[17]

In his statement in the Forum Exhibition catalogue, Dasburg indicated his knowledge of color theory and his involvement with concerns of the avant-garde such as "pure aesthetic emotion, based alone on rhythm and form." He stressed Synchromist ideas:

In my use of color I aim to reinforce the sensation of light and dark, that is, to develop the rhythm to and from the eye by placing on the canvas the colors which, by their depressive or stimulating qualities, approach or recede in accordance with the forms I wish to approach or recede in the rhythmic scheme of the pictures. Thus the movement of the preconceived rhythm is intensified. This is what I mean by co-ordinating color and contour.[18]

At this time, Dasburg had read both Chevreul's *De la Loi du contraste simultané des couleurs* and Rood's *Modern Chromatics.*[19] Like Benton, Dasburg's interest in Synchromist abstraction shifted after the Forum Exhibition. He turned to Cubism and to more traditional work which, like his earlier experiments in Paris, owed a debt to Cézanne.

None of the other artists in the Forum Exhibition was directly inspired by Synchromism as were Benton and Dasburg, but many of them were involved with variations of Cubism and color experimentation. The Forum Exhibition, with its emphasis on Synchromism, did, however, have an enormous impact; it undoubtedly prompted many artists to experiment with pure abstraction and pure color for the first time. Some of the reverberations can perhaps be seen in the work of artists such as Jan Matulka, Stuart Davis, Arnold Friedman, Alfred H. Maurer, and Ben Benn.

Jan Matulka had studied at the conservative National Academy of Design in New York before he won the Joseph Pulitzer Prize in 1916 and spent a year traveling through Florida, the Bahamas, Mexico, Canada, and the American Southwest. His *Indian Dancers* was probably painted in response to both the experience of the Southwest and the color experimentation he had seen in the Forum Exhibition just before leaving for his extensive journey (Pl. 37). In this work and his *Cubist Nudes,* Matulka moved toward abstraction by breaking down the forms of the figure into dynamic geometric shapes of color (Pl. 141).

Stuart Davis, one of Robert Henri's students, also tried abstraction just at this time. The forms in his *Breakfast Table,* painted about 1917, appear almost to dissolve into areas of pure brilliant color (Pl. 44). Davis seems to have understood the emphasis on light which Russell expressed in the first abstract Synchromist painting. He later recorded some thoughts on the subject:

1. *The visual sensation is the result of light on three-dimensional form.*
2. *Sculpture is the form.*
3. *Painting is the light.*
4. *A painting at its best is an emotional chart of light.*
5. *It can be colored or black, grey and white.*
6. *Macdonald-Wright made some pure color progressions but they were used to describe complicated planal relations and as a result there was a lack of actual proportion in them. It was the old story of "a picture of something" instead of being a complete visual unit in itself.*[20]

Arnold Friedman's paintings suggest that he knew the work of either Morgan Russell or the Delaunays.[21] Friedman was a pupil of Robert Henri from 1905 until 1908, when he left to spend six months in Paris. There he discovered Seurat and began to experiment with the structural use of color. He saw the Armory Show and was friendly with his former classmate Walter Pach, one of the organizers of the exhibition. Exactly how he arrived at such powerful, brilliantly colored abstractions as his *Untitled* of 1918 (Pl. 30) remains a mystery, but his earlier watercolor *Hillside* hints that, like the Synchromists, he had admired Cézanne's use of structure and light (Pl. 142).

Alfred Maurer exhibited thirteen landscapes and three still lifes in the Forum Exhibition. He had lived in Paris for many years prior to his return to New York in 1914. There he had responded to the impact of Matisse and Fauvism. This inspiration is still evident in Maurer's *Landscape* of about 1916–17 which begins, however, to move toward a greater degree of abstraction (Pl. 148). When Maurer did reach pure abstraction, he usually held to a rather monochromatic Cubist palette. He eventually experimented with abstract colored shapes, perhaps as a result of the paintings he saw in the Forum Exhibition. His *Abstraction* of about 1916–19 is one such example (Pl. 149). The brighter colored shapes float in a rather unresolved space not entirely unlike some of Macdonald-Wright's abstractions in the Forum Exhibition.

Ben Benn was a more conservative artist who participated in the Forum Exhibition at the invitation of John Weichsel. Afterward, he was also tempted by the possibility of painting purely abstract works. One such effort, his *Sunset* of 1916, which is outstanding for its bright colors and fluid abstract shapes (Pl. 152), demonstrates Benn's response to Synchromism and to the abstract work of artists such as Marsden Hartley and Arthur Dove, also included in the Forum Exhibition.

While Russell remained in New York only a month at the time of the Forum Exhibition, Macdonald-Wright continued to live

and exhibit in New York until he settled in California in 1919. From November 22 to December 20, 1916, Stieglitz showed Macdonald-Wright's work in a group show at "291" which included Georgia O'Keeffe, Marsden Hartley, John Marin, and Abraham Walkowitz.[22] In March 1917, Stieglitz gave Macdonald-Wright his first one-artist exhibition in New York at "291," with eighteen works including several pre-Synchromist examples. This was very successful: it raised more than the $500 Macdonald-Wright had hoped for and resulted in three purchases by the leading art collector John Quinn.[23] Even after Macdonald-Wright stopped making Synchromies in 1920, he continued to correspond with Stieglitz, who gave him another one-artist exhibition in 1932 at An American Place.[24]

In 1920, Macdonald-Wright reminded Stieglitz of his remark that Macdonald-Wright's work and O'Keeffe's represented the masculine and feminine sides of a new art.[25] It was in fact after becoming acquainted with Macdonald-Wright at the time of the Forum Exhibition that Stieglitz met O'Keeffe, in May 1916. He scheduled her first one-artist exhibition at "291" in April 1917, immediately following that of Macdonald-Wright, whose brief catalogue statement had declared his intent to "create an art which stands half way between music and architecture."[26] O'Keeffe's work of this period included powerful abstractions which have an emphatic color sense, but she, like Arthur Dove, always maintained a closeness with the forms and colors she found in nature that sets her apart from Synchromism and its more theoretical use of color (Pl. 151).

A year later Macdonald-Wright had a second one-artist exhibition, at the Daniel Gallery. The catalogue lists fifteen works, including several which had been shown at "291," but contains no statement by the artist.[27] Macdonald-Wright later recalled that he also showed at the Montross Gallery before he left for California; this was probably a group exhibition.

Even though Morgan Russell resumed his Synchromies in France during the 1920s, Macdonald-Wright exerted a much greater influence on American art because he lived in the United States. This was particularly apparent at a major show of modern art, "Exhibition of Paintings and Drawings Showing the Later Tendencies in Art," presented by the Pennsylvania Academy of the Fine Arts in Philadelphia from April 16 to May 15, 1921. The catalogue of this exhibition has no text. It lists the "Committee on Selection" as including Thomas Benton, Paul Burlin, Arthur B. Carles, Bernard Gussow, Joseph Stella, Alfred Stieglitz, and William Yarrow, and the "Hanging Committee" as including Burlin, Benton, Carles, Stieglitz and Yarrow.[28]

Reviewing this exhibition for *The New Republic*, Paul Rosenfeld considered it more important than the Forum Exhibition in one respect: "For it proclaims the recognition extended by officialdom to the work of the younger generation of painters. . . . Museum-people have . . . invited them into the sacrosanct

spaces."[29] He went on to praise particularly the "fugues of icy color by Macdonald-Wright" and "ecstatic climaxes by Georgia O'Keeffe." He recognized the importance of Macdonald-Wright:

Here, at least, there is evidence that research in aesthetics is being made. The experiments conducted with color by Macdonald-Wright, the use to which he is putting the formal power of the spectrum, may be of first importance. Certainly, it has already been affecting the workers; the canvases of two other of the exhibitors, Benton and Yarrow, reveals its influence. . . . The committee scattered the work of various contributors a little too thoroughly. One would have much enjoyed seeing together the three examples of the art of Macdonald-Wright; one would have been further eclaircised at seeing the paintings of Benton and Yarrow, which owe so much to his experiments, in close proximity to his.

Macdonald-Wright's impact on Benton has already been discussed, but who is William Yarrow? Here is a perfect example of an American modernist whose art later became more traditional and who has been completely forgotten today.[30] His paintings are difficult to locate, particularly modernist examples, such as those mentioned in a review of his memorial exhibition in 1941: "Later around 1920, came the striking patterns and simplifications, almost abstractions of the modernists (*New York*, 1920 illustrates this phase)."[31] Yet a work such as his *Flowers* shown in the exhibition at the Pennsylvania Academy appears fresh and vibrant more than fifty years later (Pl. 23). Judging from *Flowers*, Rosenfield was correct in crediting Macdonald-Wright with having an important influence on Yarrow. His work, with its strong sense of color, undoubtedly deserves further investigation.

Macdonald-Wright's influence can again be seen in the work of Arthur B. Carles, who was on both the selection and hanging committees for the Pennsylvania Academy exhibition. Carles's work is also little known and the dating is often problematic. Yet in his *Nude* of 1921 Carles imposed prismatic planes of color on the surface of a figure in a manner which clearly indicates that he has absorbed ideas from Macdonald-Wright's Synchromies (Pl. 164).

Although Macdonald-Wright exhibited three works, including his *Aeroplane: Synchromy in Yellow-Orange* of 1920 (Pl. 21), at the Pennsylvania Academy in 1921, Morgan Russell was not invited to participate in the exhibition. He learned of it by reading Rosenfield's review in *The New Republic*, and wrote to Stieglitz that he was upset over this, enclosing a letter to be forwarded to Macdonald-Wright with whom he had lost contact.[32] Macdonald-Wright wrote Stieglitz that he had assumed Russell had been invited when Yarrow had asked him to exhibit.[33] Russell continued to exhibit in France and, by 1922, he was painting the Synchromies of his important *Eidos* series.

6 · Color Abstraction in American Painting

The Delaunays were interested in the rival Synchromists and were close friends with several other American artists. One was Samuel Halpert, who visited them in Spain and Portugal during 1914 and early 1915, and wrote them on July 28, 1915 about Willard Wright's book *Modern Painting*.[1] Sonia Delaunay translated long excerpts from it into French for Robert, and still has the manuscript. Another close friend was the American painter Leon Kroll. He wrote to Stieglitz in August 1914 from Spain, where he was staying with the Delaunays, that Robert wanted to visit New York to paint his impressions of the city.[2] But unlike other French artists of the avant-garde, the Delaunays were never to visit America.

The two American artists most directly inspired by the Delaunays were Arthur Burdett Frost, Jr., and Patrick Henry Bruce, who themselves became close friends in Paris. Both had studied in New York with William Merritt Chase and Robert Henri. Bruce arrived in Paris in 1904, two years before Frost. Introduced to each other by Walter Pach in 1907, they had joined the Académie Matisse by 1908,[3] a move on his son's part that Frost's father, the illustrator A. B. Frost, deplored.[4] Frost and Bruce were soon frequent visitors to the home of Leo and Gertrude Stein where, by early spring of 1912, they became acquainted with Robert Delaunay.

Frost was excited by the talk about Cubism which he heard at the Steins'.[5] In December 1912, he wrote to his mother:

Leo Stein is not interested except in one man, Delaunay. We are all interested in Delaunay. He seems to be the strong man who has come out of cubisme as Matisse was the strong man who came out of the Fauves.[6]

Another letter to his mother, of June 20, 1913, declares that Delaunay "has discovered painting." From his correspondence, it is clear that Frost spent a great deal of time with the Delaunays, often staying with them for weekends in the country at Louveciennes, and he was probably closer to them than was Bruce. In December 1913, Frost reported that he, the Bruces, and the Delaunays had all gone to the Bal Bullier, a popular dance hall in Montparnasse where Sonia Delaunay attracted much attention in her Simultaneous dress (Fig. 33). In her painting *Le Bal Bullier*, she recorded her impressions of the abstract geometric shapes of color seen in the crowds of whirling dancers (Pl. 29).

Very little of Frost's work survives: much of it was probably destroyed by his anguished father after the sudden death of his son, who had suffered from tuberculosis, in 1917. The earliest extant works are closer to Renoir than to Frost's teacher Matisse. While living with the Bruces at Belle-Ile in Brittany, Frost sent his parents, on October 22, 1914, a drawing which he explained was a study for his oil painting *Harlequin* of 1914

(Pls. 32, 128). He described the painting as "a figure with his back turned, in tights made like a patch-work quilt of all colors."[7] This small canvas evidently represents one of Frost's first attempts at using Delaunay's simultaneous colors with his own kind of figurative composition rather than the more abstract conventions of Delaunay. On August 1, 1914, he wrote to his father:

I have at last got something in painting. . . . Pure Renoir as to convention. It is not composed in relation to the carré of the canvas as my simultané things were. It looks like a sunny day in the country whereas my simultané things look like "la vie moderne," autos grands boulevards, lights, etc.

Frost painted his first non-representational works under the direct inspiration of Delaunay. He exhibited three lost still lifes in the Salon des Indépendants in the spring of 1914. That

Fig. 33. Sonia Delaunay in her Simultaneous dress, 1913, standing in front of Robert Delaunay's *The First Disc* (Pl. 124). Photo, collection of Sonia Delaunay.

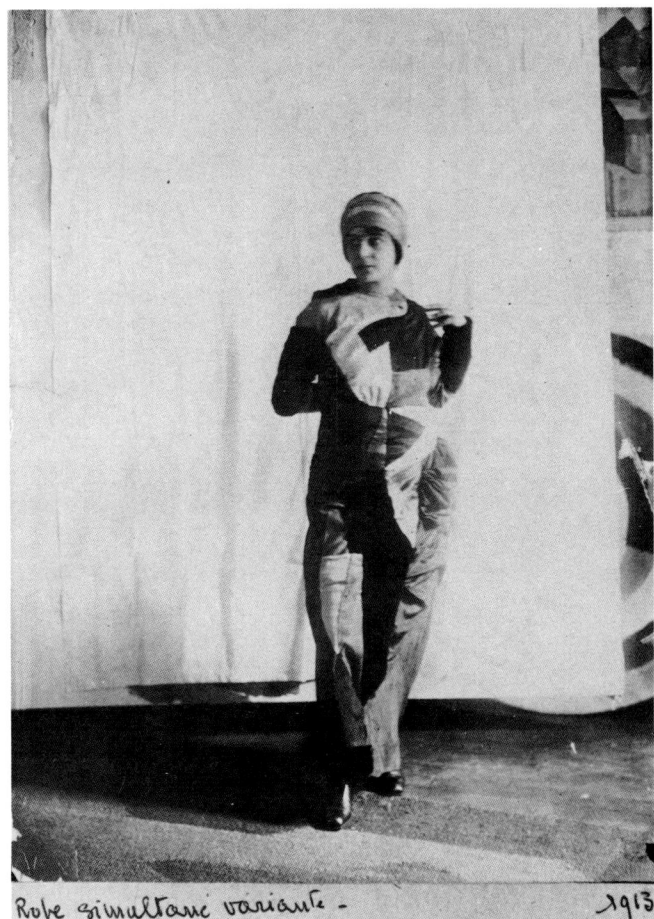

Fig. 34. Arthur Burdett Frost, Jr.,
Suns, 1913–14, now lost.
Reproduced from *Montjoie!,* March 1914.

Fig. 35. Arthur Burdett Frost, Jr.,
Descent from the Cross, 1913–14, now lost.
Photo, collection of Sonia Delaunay.

year his *Suns* [*Soleils*] and *Descent from the Cross* [*Descente du croix*] (Figs. 34, 35) were published in Paris; one French critic praised *Suns* as an "infinitely sensitive small oil."[8] The figural basis of *Descent from the Cross* can be seen underlying its seemingly abstract shapes.

Frost returned to America late in 1914 and settled in New York in early 1915. There he became friendly with James Daugherty, an artist with a neighboring studio. He proceeded to teach Daugherty what he described as the color principles of both Matisse and Delaunay. In an unpublished memoir, Daugherty recalled details of Frost's studio.

It was monastic. On the wall was a small painting of a prismatic harlequin. . . . There was also a harlequin suit on the wall organized according to his color machine which turned with a hand crank and the colors danced in actual motion.[9]

Daugherty also recalled that, according to Frost, both he and Bruce loathed Morgan Russell and Stanton Macdonald-Wright and Synchromist claims of innovation. This was clearly linked to their alliance with Delaunay.

In his unfinished *Abstraction* of 1917 and in his lost *Colored Forms* of the same year, Frost appears to have been influenced by Sonia Delaunay's depictions of the Bal Bullier in Paris four years earlier (Pl. 129; Fig. 36). Frost worked out his shapes from studying a photograph of a ballroom scene, a method he had learned from Bruce who had used photographs before 1914.[10] According to Daugherty, a third of Frost's "ball room picture" was finished when Bruce's six *Compositions* reached him from Paris (Pls. 27, 28, 132, 133), probably for the exhi-

Fig. 36. Arthur Burdett Frost, Jr.,
Colored Forms, 1917, now lost.

bition that was to take place in New York. Frost was so impressed with Bruce's use of black-and-white elements to enforce his color planes that he completely repainted his own canvas to incorporate black and white. Frost showed his own *Colored Forms* and entered one of Bruce's *Compositions* in the exhibition of the Society of Independent Artists in 1917.

Bruce's *Compositions* of about 1916 and the abstract still lifes which followed (Pls. 134, 135) are among the strongest and most original paintings by an American artist of this period. In his development as an artist Bruce had progressed from traditional portraits in the manner taught by Henri to a series of still lifes inspired by Impressionism, his study with Matisse, and Cézanne whose work he admired most.[11] Some of these early works were exhibited in New York in November 1916 at Bruce's exhibition at the Montross Gallery. Charles Caffin wrote enthusiastically in the *New York American*:

They are built up into a structure of color relations that is comparable to the composition of sound relations. And they create in one's imagination the sensation of music. . . . For my own part I feel the expression to be quite extraordinarily big and just as surprisingly abstract.[12]

Particularly remarkable is Bruce's rich sense of texture in his thickly painted Cézannesque *Still Life* of about 1911 (Pl. 130). Bruce is closer to Matisse in his use of the decorative pattern of floral tapestry in his *Still Life with Tapestry* of 1911–12 (Pl. 131). Most of the objects depicted and the very setting for this painting can be seen in a photograph of the Bruces' apartment in Paris (Fig. 37). The dynamic colors he used to energize this

work and the shallow spatial depth create a composition which begins to approach pure abstraction.

By mid-1912, Bruce, like Frost, had begun to feel the influence of Robert Delaunay. Unfortunately all his paintings of late 1912–14 are lost, but surviving photographs indicate the changed nature of his work. In the fall of 1913, Bruce was one of only four Americans to be included with the Delaunays in the First German Autumn Salon (Erster Deutscher Herbstsalon) in Berlin. Bruce exhibited his *Landscape* which, even in a photograph, reminds us of Delaunay's series of *Windows* of 1912 (Fig. 38; Pl. 123); Bruce also seems to refer to a city view seen through a window. In Paris at the Salon d'Automne of 1913, Bruce exhibited two *Compositions*, now lost; one of them we know from a photograph published in *Soirées de Paris* on December 15, 1913 (Fig. 39). Guillaume Apollinaire singled out Bruce's works for praise along with Francis Picabia's as striking "one's eye first in the Salon—*they are what we see best,*" and noted that Bruce's paintings "speak well for that sensitive artist."[13]

By 1913, Bruce and Frost were considered adherents of Delaunay's *école orphique*. In March, Bruce demonstrated his solidarity by insisting that his works be removed from the Armory Show in New York, following Delaunay's attempted withdrawal to protest the organizers' refusal to hang his monumental canvas *City of Paris*.[14] The organizers rejected these demands, and Samuel Halpert told the press that Bruce was the "only American painter at all considered by French artists."[15] The same article quoted Delaunay as asserting that the incident was "unfortunate" because his Orphism was "already successful

Fig. 37. Patrick Henry Bruce's apartment in Paris. Visible on the left are the tapestry, table, and bowl he depicted in *Still Life with Tapestry* (Pl. 131). Photo, collection of Mr. and Mrs. Henry M. Reed.

Fig. 38. Patrick Henry Bruce, *Landscape,* c.1913, now lost. Reproduced from *Der Sturm,* Berlin, fall 1913.

Fig. 39. Patrick Henry Bruce, *Composition,* c.1913, now lost. Reproduced from *Soirées de Paris,* December 15, 1913.

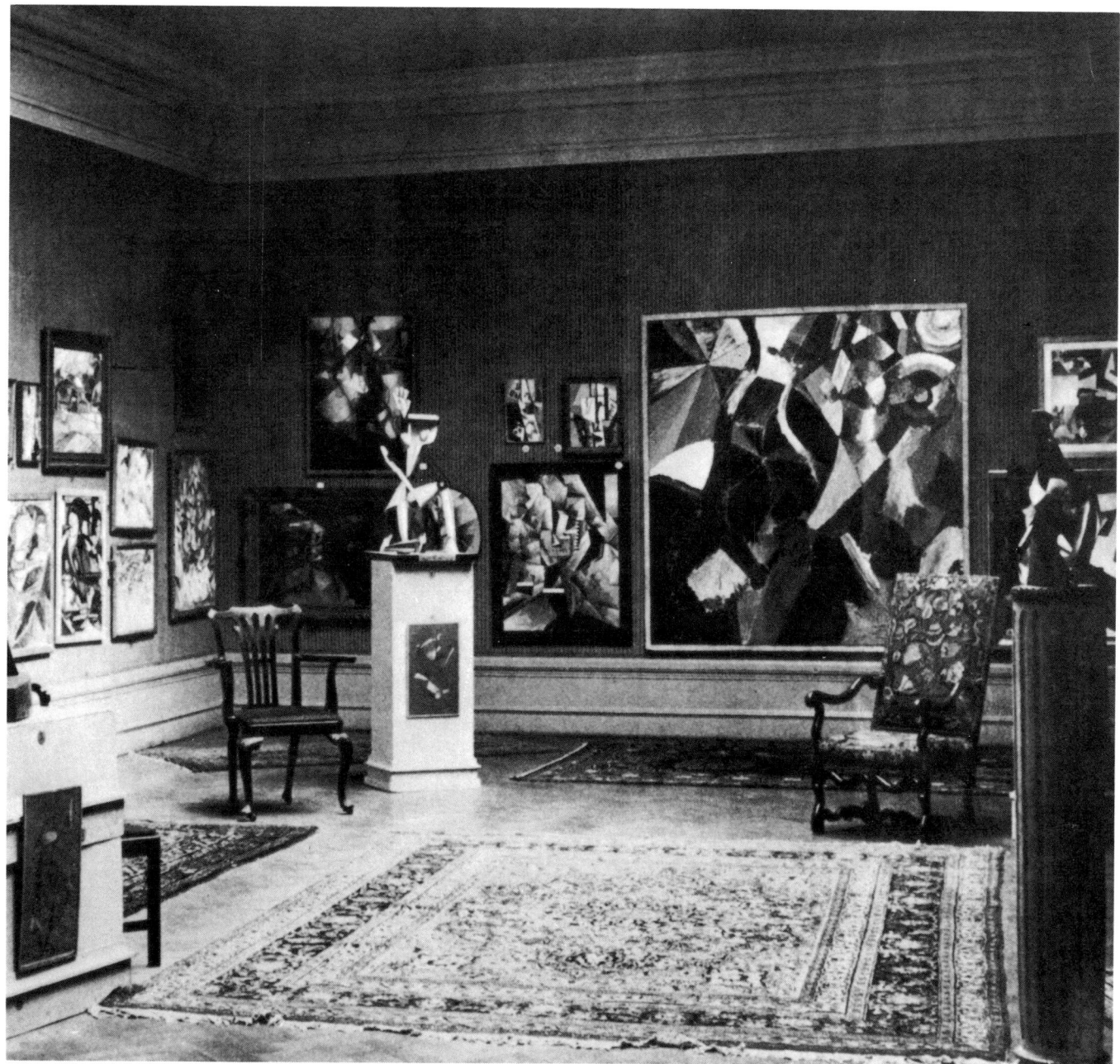

Fig. 40. Patrick Henry Bruce, *Movement, Color, Space: Simultaneous*, 1913–14, now lost.
It is the largest canvas in this view of selected works from the Salon des Indépendants
of 1914 exhibited at the Galerie Georges Giroux, Brussels, May 16–June 7, 1914.
Photo, collection of Donald Karshan.

and celebrated in Europe, and has influenced American painters here more than any other modern movements."

Bruce's large canvas *Movement, Color, Space: Simultaneous* [*Mouvement, couleur, l'espace: simultané*], exhibited at the Salon des Indépendants of 1914 (Fig. 40), is clearly related both to the color theories promoted by Delaunay and to the circular shapes of such works as *The First Disc* of 1912 (Pl. 124). It attracted the attention of Apollinaire, who

initially criticized the canvas as a subject too vast for the artist to encompass.[16] Little more than a week later Apollinaire wrote that Bruce involved the spectator in "the colorful domain of realistic abstraction" and that this work was "more personal" if "less pleasing" than the one in the Salon d'Automne.[17]

Bruce's six large *Compositions* of 1916 were shown in New York at the Modern Gallery in March 1917. According to

Fig. 41. Patrick Henry Bruce, *Le Bal Bullier,* 1914, now lost. Reproduced from *Comœdia,* June 2, 1914. Bruce and Frost had accompanied the Delaunays to the popular Paris dance hall, which also inspired a painting by Sonia Delaunay (Pl. 29).

Katherine Dreier, who purchased five of them for the Société Anonyme, Bruce was inspired by the "fancy-dress ball."[18] This is probable, especially when we consider his *Bal Bullier,* another lost work of 1914 which was obviously inspired by the Delaunays (Fig. 41).

In his *Compositions,* however, Bruce was able to move beyond the Delaunays' forms to a more original style with an individualistic use of extremely thick bright paint applied with a palette knife (Pls. 27, 28, 132, 133). Bruce was apparently still closely involved with the simultaneous color theories of Chevreul as espoused by Delaunay, but he freely improvised beyond any set of rules.[19] A letter of September 6, 1914, written by Frost's father to his friend the artist Gus Daggy, indicates that Bruce may have begun his *Compositions* by this date: "I learned lately what an 'Orphist' was, or is, for I believe Bruce is the only 'Orphist,' a friend told us what he does, it is like this [sketch resembling Bruce's *Compositions* drawn here] patches of crude color getting smaller toward the center, no 'form' whatever and generally straight lines, no curves. . . ."[20]

The numbers of the *Compositions* were not assigned by Bruce, but reflect the order in which they entered the collection of the Société Anonyme. *Composition III* (Pl. 28) may represent the first of the series because of the crudeness of the organization

of color planes in comparison to the more compact *Composition I* (Pl. 27) and *Composition II* (Pl. 133),[21] with their greater spatial illusion anticipating the works of Bruce's last period.

In the series of abstracted, often spare still lifes Bruce painted after the *Compositions,* he began to use colors effectively to create an architectonic sense of space (Pls. 134, 135). Each object is firmly delineated, unlike Morgan Russell's subtler attempts to render volumes in space through the use of smaller areas of different colors. Bruce simply called these canvases *Painting* [*Peinture*] or *Still Life* [*Nature morte*] when he exhibited them in the various Salons in Paris, but many have come to be called *Forms* after the descriptions written on the back by the artist's closest friend, Henri-Pierre Roché.[22] Bruce probably commenced this series with a simpler arrangement of forms and moved on to greater complexity, but none of these works can be dated accurately.

Although Bruce was able to create paintings which are noteworthy for their originality, he became discouraged and isolated in Paris. The Delaunays and many Americans left at the outbreak of the war, but Bruce remained. His close friendship with the Delaunays did not resume when they returned from Portugal and Spain in 1920.

An interest in color abstraction was not, of course, the monopoly of the Synchromists or the Simultaneists or those directly affected by them. Many artists subscribed to the color theories of Chevreul, Rood, or others such as Hardesty Maratta.[23] Some followed their own theoretical inventions. Others, such as Georgia O'Keeffe and Arthur Dove, were more intuitive and worked either from nature or their imagination (Pls. 150, 151).

O'Keeffe, like Max Weber, had been taught by Arthur Wesley Dow (1857–1922), who was somewhat more open to abstract principles than most art teachers of his day because of his training with the American Orientalist Ernest Fenollosa. Dow, who reportedly claimed that "seeing visual relations was like hearing music," encouraged his students to concern themselves with the spiritual quality in art.[24]

Maratta, like the Synchromists' teacher Tudor-Hart, theorized that the twelve notes of the musical scale corresponded to twelve color equivalents. In 1914, his diagram, "A Chart for Finding 'Triads and chords' in Sounds and Colors," was copyrighted. Maratta offered Robert Henri some ideas related to the later Synchromist developments when he first met him in March 1909; that was just before Morgan Russell left to settle in France.[25]

Henry Fitch Taylor, another color theorist, was a painter of Impressionist landscapes when, in 1911, he became a founding member of the Association of American Painters and Sculptors, the group that organized the Armory Show. After the impact of the exhibition of 1913, he began to paint abstractly (Pls. 158, 159). He invented "The Taylor System of Color Harmony" including a "ready reference chart of Color Harmony" which purported to be superior to the color wheel.[26] Taylor, too, attempted to link a chromatic scale in music to one in color and stressed major and minor triads or chords.

Wassily Kandinsky's *Art of Spiritual Harmony*, with its emphasis on the link between art and music, and between colors and emotions, was read and highly regarded by many American artists, particularly those of the Stieglitz circle,[27] among them Arthur Dove, Marsden Hartley, Georgia O'Keeffe, Konrad Cramer, and Abraham Walkowitz.[28] The effect of Kandinsky's ideas is perhaps best seen in Hartley's more mystical paintings of 1912–13 like *Portrait Arrangement No. 2* and *Painting No. 6* (Pls. 144, 145). This influence is also evident in Walkowitz's *Creation* (Pl. 48). Walkowitz would have known Kandinsky's *Improvisation No. 27* of 1912, purchased by Stieglitz from the Armory Show. Max Weber's fluid abstractions of 1912 may also owe to his reading of Kandinsky (Pls. 49, 50).

When Hartley arrived in Paris in the spring of 1912, he brought with him a letter of introduction to Delaunay from Samuel Halpert.[29] Hartley also saw the Delaunays when he visited with Gertrude Stein. Writing to Stieglitz on June 20, 1912, Hartley mentioned his visit to Robert Delaunay's studio but lamented that the artist's latest work was "like a demonstration for chemistry on the technical relations of color and sound."[30] In a letter to Stieglitz that July, Hartley wrote of Sonia Delaunay's "Orphistic" dress, which he later referred to as her Simultaneous costume at the occasion of the banquet for the First German Autumn Salon in Berlin in September 1913.[31]

Delaunay's influence on Hartley is revealed in his *Abstraction* of 1913, one of the most abstract pictures he ever painted (Pl. 33). The colorful hard-edged discs and stripes may refer to Delaunay's *The First Disc* of 1912, which Hartley could have seen when he visited Delaunay's studio that year (Pl. 124). Hartley's *Abstraction Blue, Yellow and Green* (Pl. 146) can only reflect his knowledge of Kandinsky's *Improvisations*, with which he became acquainted on his visit to Germany in 1913. *Abstraction Blue, Yellow and Green* is unsigned and has previously been shown upside down, but surely it represents a blue path leading to a yellow house with a gabled roof. Hartley returned to a flat emblematic design closer to Delaunay in his *Composition* (Pl. 34) and his military pictures of 1914–15.

When Arthur Burdett Frost, Jr. taught James Daugherty the color principles he had learned from Matisse and Delaunay, he found a receptive and eager artist open to modern ideas. Daugherty had embraced modernism in the year following the Armory Show, which he had seen. At the time Daugherty, an illustrator, managed to adapt Cubist and Futurist developments for popular consumption on color pages in the *New York Herald* during 1914–15. He reworked his design for *Futurist Picture of the Opening Game* of April 12, 1914, when it was returned to him, and the result is the painting *Three Base Hit (Opening Game)* (Pls. 136, 38). Full of dynamic movement, this is a notable Futurist painting by an American in 1914. The background crowd depicted by triangular shapes even creates a pattern reminiscent of Italian Futurist Giacomo Balla's work, such as *Iridescent Interpenetration* of 1912.[32]

Daugherty's paintings, after he received instructions on color from Frost, demonstrate his ability to construct monumental compositions by building volumes with harmonious colors. His *Moses* of about 1922 and the earlier untitled work on the reverse side of the canvas are powerful pictures even by contemporary standards (Pls. 40, 39). Daugherty, in turn, taught theories of simultaneous colors learned from Frost to Jay Van Everen in 1917. Van Everen then began to create his brightly colored and intricately constructed paintings (Pl. 140). However, his mosaics from the turn of the century which still decorate many New York subway stations seem to predict his later organization of shapes. Significantly, Daugherty, Van Everen, Bruce, and Jan Matulka all showed together as Simultaneists in exhibitions organized by the Société Anonyme in New York, June 17–August 1, 1920, and at the Worcester (Massachusetts) Art Museum, November 3–December 5, 1921.

Like Daugherty, Joseph Stella was inspired by Futurism. He actually saw the Futurist exhibition in Paris in 1912, and in the years that followed he became involved with volumes of pure color, as demonstrated by *Der Rosenkavalier* of 1913–14 and *Spring* of 1914 (Pls. 47, 154). Oscar Bluemner was also in Paris in 1912, and may have come into contact then with Robert Delaunay's work and the color theories he espoused. Bluemner's *Morning Light (Dover Hills, October)* of 1916 shows his understanding of the possibilities of combining color with Cubist abstraction (Pl. 46). He participated in the Forum Exhibition in 1916 with the Synchromists and was well acquainted with their work. He did not share their interest in the human figure, but color remained for him a lifelong preoccupation.

Arthur B. Davies turned to modernism as a result of his participation in organizing the Armory Show in 1913. He probably saw the Synchromists' exhibition at the Carroll Galleries in 1914. Later that year he produced a composition of dancers which has come to be called *Day of Good Fortune* (Pl. 45).[33] This canvas is an example of Davies's simplistic shift to Cubistic forms: he applied fragmented areas of bright color to human figures based on his limited understanding of color principles. This is not comparable to the Synchromists' sophisticated rendering of figures in space through the use of color properties.

Evidently it was Arthur B. Davies who encouraged Manierre Dawson to paint figural abstractions when they met late in 1910. Earlier in 1910, in Paris, Dawson met Gertrude Stein to whom he made his first sale. He was included by Walter Pach in the Chicago version of the Armory Show in 1913;[34] he had begun painting purely abstract works as early as 1910 and was one of the few Americans to include an abstraction in that show. Some of his most colorful abstractions, such as *Ariel* of 1912, are, like many Synchromist works, based on figurative motifs (Pl. 156).

In Philadelphia, the artists Lyman Saÿen, Carl Newman, Morton Schamberg, and Charles Sheeler were all involved with color abstraction. Saÿen was one of the first Americans to study with Matisse in Paris, along with Bruce, Frost, and Weber.[35] In 1910, Thomas Anshutz, who had been Saÿen's teacher at the

Pennsylvania Academy of the Fine Arts beginning in 1899, came to visit him in Paris. Anshutz (1851–1912) had also taught Robert Henri, the man to whom Morgan Russell felt he owed so much, and he influenced artists like Lyman Saÿen, Sheeler, Arthur B. Carles, and John Marin, who later became modernists. In Paris he and Saÿen experimented, trying to develop more brilliant colors and using a paint mill to mix them.

Saÿen's colors were especially bright as in his vivid *171 Blvd. St. Germain No. 1* of 1912 and his prismatic *Still Life* of 1914 (Pls. 162, 163). They so impressed Frost that he wrote home in 1914 that his own *Nude* was "the most horrible picture in color. It had Saÿen skinned a mile as to horrible color which is going some."[36] When Saÿen returned to Philadelphia with his family after the war broke out in 1914, he continued to paint with bold color and developed an increasingly abstract sense of design (Pl. 36). His work exhibited in Philadelphia in November 1914 and in subsequent years must have been a revelation for many local artists.

Carl Newman had visited his close friend Saÿen in Paris during the summer of 1910. After Saÿen returned to Philadelphia, he painted a chromatic spectrum on the ceiling of Newman's studio in Bethayres, where the two spent much time together. In Paris Saÿen had become familiar with the color theories of Chevreul and had undoubtedly known the work of the Synchromists and Robert Delaunay. The effect of the knowledge he communicated to Newman is striking. New-

man first produced vivid figures in landscapes (Pl. 165) and then progressed to pure abstraction. The shapes in Newman's painted decorative screen entitled *Spirit of Christmas* of about 1915–20 are reminiscent of both Delaunay and Hartley (Pl. 166). A small untitled watercolor of 1921 is a remarkable example of his experimentation with color abstraction (Pl. 35).

Morton Schamberg shared a studio with Charles Sheeler in Philadelphia before he left on his trip to Paris in 1908. Sheeler joined him there for January and February 1909, and they became acquainted with the work of Cézanne, Matisse, and Picasso. When Schamberg returned to Philadelphia in 1910, he began to develop his own style initially inspired by his knowledge of Fauvist color. In 1913 and 1914, Schamberg created color abstractions such as his *Still Life, Canephoros,* and *Untitled* (*Landscape*) (Pls. 160, 161, 42). His use of a figural motif expressed through abstract shapes of color, as in *Geometric Patterns* (Pl. 41), is similar to the Synchromists' art, but there is no evidence that he could have known their work before their New York exhibition in 1914. His first-hand knowledge of Fauvism and Cubism in Paris, undoubtedly reinforced by the Armory Show in which he exhibited in 1913, must be credited with leading him to develop independently his own color abstraction. Schamberg's development and the Synchromists' Carroll Galleries exhibition in 1914 may have prompted Charles Sheeler, still a close friend, to paint his jewel-like *Abstraction: Tree Form* of 1914 (Pl. 43).

7 · Synchromism Continued

Synchromism continued to have an important influence on contemporary American painting as late as 1921.[1] But as a cohesive movement and as a close partnership between Morgan Russell and Stanton Macdonald-Wright, it did not endure much beyond 1914, and certainly not beyond the Forum Exhibition of 1916. During the 1920s, though, and until their last meeting in Los Angeles in 1931, the two artists corresponded frequently, discussing their plans for the construction of a kinetic light machine.

The idea itself dates back at least to 1912, when Russell first mentioned it in a notebook. In the spring of 1914, he turned from his Synchromist canvases to explore further the possibility of a machine that would combine music with moving color and light. Russell adored music, particularly Beethoven's, and often studied a Beethoven score while working out color harmonies.[2] He composed music himself and used musical theory in arranging chords of color, as Tudor-Hart had suggested.

Russell may have had his idea for a light machine before he knew of similar projects.[3] Though, for example, *Colour-*

Music: The Art of Mobile Colour, by A. Wallace Rimington, was published in London in 1912, Russell could first have learned of this book in 1913, from an article published by a Paris newspaper, which he saved among clippings referring to his own works.[4] Whatever the sequence of events, he obviously considered Rimington's theories important and was interested in his attempt to define exact ratios between colors and musical notes.

Russell's main problem in developing the light machine was lack of financial support. In the fall of 1913, he wrote optimistically of inviting financial collaboration and of exhibiting the machine in the principal cities of Europe and America. Intending to seek backing in Paris, London, St. Petersburg, and Moscow, he noted the necessity to "explain clearly about the aim which will give birth to a new art but at the same time renew and deepen an enjoyment of the old."

Unfortunately, Russell's project for the light machine never progressed much beyond his extensive notes and related paintings. He conceived of "an apparatus that by reducing the luminosity of the screen, or of the lamps . . . will reduce that

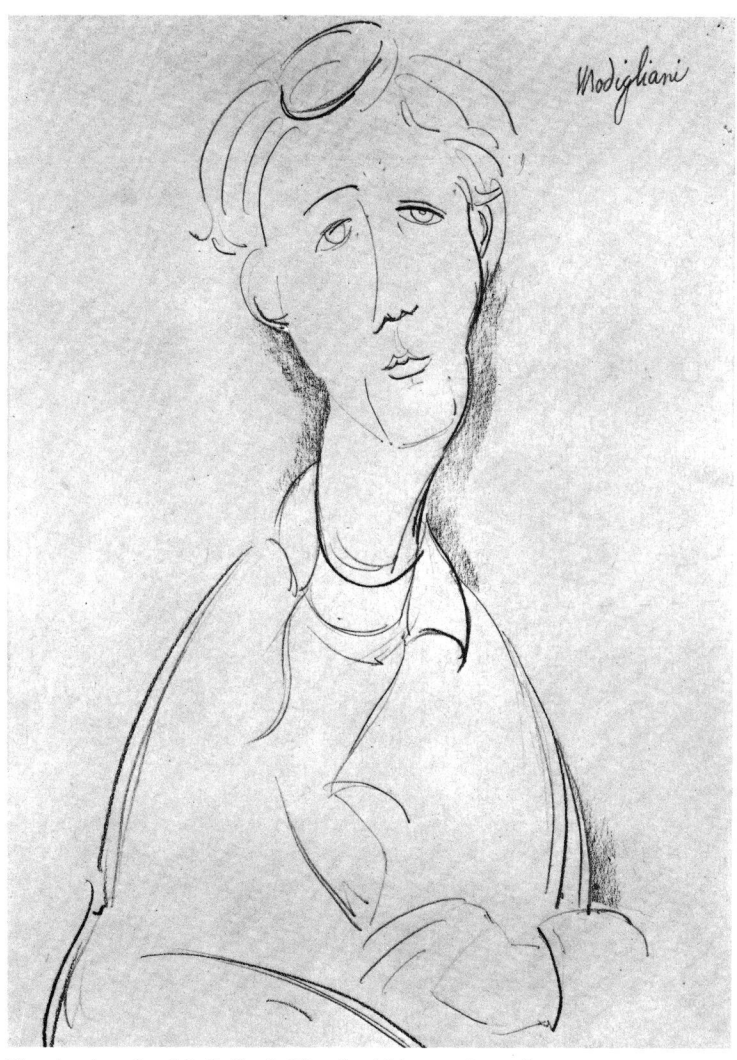

Fig. 42. Blaise Cendrars, poet
of the Simultaneous, c.1920. Russell
left a sketch of his friend Cendrars (Pl. 98).

Fig. 43 Amedeo Modigliani, *Sketch of Morgan Russell*, c.1917.
Brook Street Gallery, London.

of the colors. . . ." (Pl. 99). He also made a number of studies with oil paint on tissue paper (Pls. 17, 18, 100–102). These abstract images are meant to be viewed with a light shining from behind as if projected on an illuminated screen. The effect, in a properly darkened room, is dramatic. Some of the small colored squares may have been designed to be seen in a series resembling motion pictures.[5]

Having stopped painting Synchromies by the time of the Forum Exhibition in 1916, Russell went to live at Le Cannet, not far from Cannes, in the south of France in 1917. Letters to Mrs. Whitney of November 1, 1916, and August 12, 1917, mention his desire to travel about France in order to freshen his imagination, and speak of the landscapes and nudes he was then painting.

While in Le Cannet, Russell became friends with the French poet of the Simultaneous, Blaise Cendrars (Pl. 98; Fig. 42), and his friend the Italian painter Amedeo Modigliani, who

both painted and sketched Russell in 1917 (Fig. 43). Four years earlier, it will be recalled, Cendrars had collaborated with Sonia Delaunay on *La Prose du Transsibérien et de la petite Jehanne de France,*[6] but his friendship with the Delaunays had not lasted through the war, in which he fought as a member of the Foreign Legion. Cendrars' acquaintance with Russell's work goes back at least as far as the special issue of Ricciotto Canudo's review *Montjoie!* devoted to modern dance in 1914, in which Cendrars' poem "Ma Danse" appeared on the same page as one of Russell's drawings (Fig. 44).[7] In a generous spirit of friendship, Cendrars encouraged Russell to continue making Synchromies and tried over the next several years to find projects which would help the impoverished and depressed American artist, whose work he admired. His proposals included being the designer for Abel Gance's film *La Roue* (in which Cendrars both collaborated with Gance and played a role), collaborating on a Synchromist ballet for the Ballet

Fig. 44. Morgan Russell's lost drawing of a dancer, reproduced from *Montjoie!*, January–February 1914.

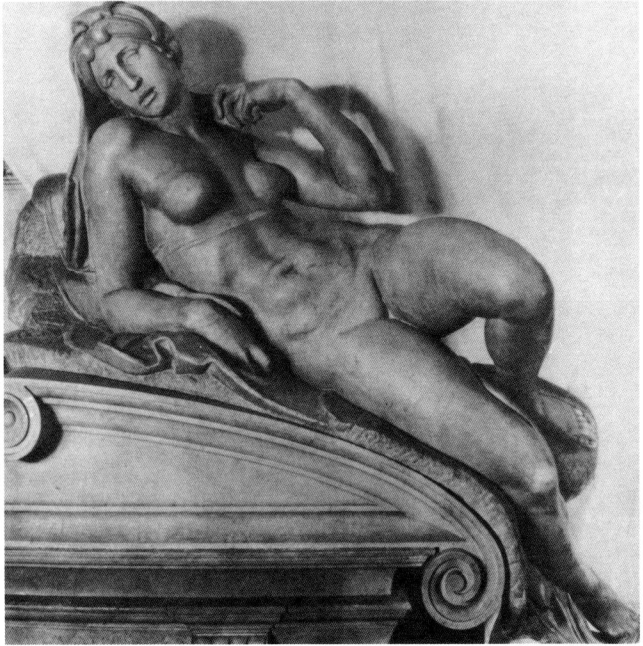

Fig. 45. Michelangelo, *Dawn* or *Aurora*. Medici Chapel, Florence.

Suédois, and illustrating an edition of his novel *L'Or*. Unfortunately, none of these schemes, which would have brought Russell once again into the orbit of the French avant-garde, was ever realized. By 1921, along with his landscapes and nudes, he was painting themes from classical mythology.

Russell's last series of abstract Synchromies, painted during 1922 and known as *Eidos* after the Greek for "form" or "shape," marked his return to abstract canvases for the first time since 1915 (Pls. 103–106). These were, however, only a substitute for the light machine that he envisioned but could not afford to produce. He actually imagined the *Eidos* pictures projected with a musical accompaniment. In the catalogue of his exhibition of 1923 at the Galerie La Licorne, five *Eidos*

(thèmes-synchromatiques) pour une Synchromie à la Vue are listed.[8] In a catalogue note, Russell attempted to explain them:

Each Eidos represents the general effect of the impressions that remain with us after having seen their details unfold on a luminous screen or in the air itself after a display of fireworks. . . . arts of an unprecedented power . . . illuminating reason by the divine intoxication of the senses. . . .[9]

Here Russell seems to be referring to his plans for a light machine. Writing to Macdonald-Wright on October 19, 1922, he expressed the hope that this machine would serve as "a basis for future Synchromies in light," and he asserted, "even if I'm to be obliged to do them only on canvas I'm going along at it, for I'm passionately interested in it and have confidence in its future."

The colors of these later Synchromies, which Russell painted on occasion until 1930, are more muted than in the earlier ones, when he had often used the basic bright hues of the spectrum. Another noticeable development in the *Eidos* paintings and in many other works after the spring of 1914 is the illusion of a vast blue or empty space receding behind the predominant floating shapes of color. In the early abstract Synchromies such as *Synchromie en bleu violacé,* Russell extended the shapes of color to the edges of the frame, letting the color properties alone give the illusion of recession and projection.

Macdonald-Wright painted his best Synchromies only after the Carroll Galleries exhibition in 1914. After experimenting briefly with pure abstraction he returned to paintings based on a figurative motif. Originally this motif was more or less submerged, but eventually his pictures became more figurative than abstract. In the years 1916–21, Macdonald-Wright also painted Synchromies based on both still life and landscape (Pls. 114, 118, 119), but the most characteristic works are those with a figurative theme. From a barely recognizable head peeking out from behind the whirls of Synchromist color in his *Conception Synchromy* of 1915 (Pl. 11), he proceeded to base his Synchromies on full heroic figures.[10] An example is his *Sunrise Synchromy in Violet* of 1918 (Pl. 116), which undoubtedly borrows its pose and theme from Michelangelo's figure of *Dawn* or *Aurora* (Fig. 45) in the Medici Chapel. After this last attempt at exploring Renaissance form, Macdonald-Wright moved from New York to the West Coast, where he pursued representational painting and developed a life-long interest in Oriental art and culture. In 1953, the year of Russell's death, however, Macdonald-Wright resumed painting abstract Synchromies which he had given up decades earlier. In 1959–62, he created his *Synchrome Kineidoscope,* which projects kinetic color though without musical accompaniment.

In 1923 Willard Wright's book *The Future of Painting* promoted the idea that painting would in the future yield to "the art of color." This color art would, according to Wright, be

more closely associated with music and drama than with painting. Although the book received considerable attention in the press, Wright's prophesy of the death of painting was premature.[11] On March 8, 1920, Macdonald-Wright wrote to Stieglitz that he believed painting had died and that he envisioned an even greater art—that of colored light.[12] He considered color to be a musical element and described the direct relationship between the sound of certain instruments and a deep ultramarine blue. Macdonald-Wright pointed out to Stieglitz that he had studied music and its construction as extensively as he had studied painting.

In 1924, Macdonald-Wright wrote *A Treatise on Color* for his students at the Art Students League in Los Angeles.[13] His discussion of the "analogy between color and sound" and of the relationship of colors to emotions recalls his own studies with Tudor-Hart. Macdonald-Wright explained Morgan Russell's color as using yellow for "the highest light" and violet for "the deepest shadow" with the intermediate colors to express amounts of light between the two. His own use of color was based on the fact "that as nature recedes from the eye it becomes blue-violet or violet, while as it advances it becomes warmer, or in other words, more yellow or more orange." He placed in the middle distance "all the intermediate steps of the spectrum."

Although Macdonald-Wright admitted that he had found Chevreul and Rood "interesting," he strongly objected to a description of Synchromism as based on these nineteenth-century color principles, and dismissed Chevreul as merely a mender of tapestries.[14] Yet both Macdonald-Wright and Russell appear to have frequently chosen a dominant color key for their Synchromies in accordance with Rood's principles. Rood's point was that triads of color can produce balanced and harmonious color when the three colors are chosen from a region of 120 degrees on the color circle.[15] This, as has been demonstrated, was Russell's basis of color in his *Synchromy in Orange: To Form* (Pl. 12).

In his mature Synchromies dating from 1916, Macdonald-Wright more frequently used Rood's suggested variation—that of changing one color to the left or right of the primary color to achieve a different harmony. This seems to be the basis of his color in *Synchromy in Green and Orange*, *Synchromy in Blue-Green*, and *Oriental Synchromy in Blue-Green* (Pls. 110, 108, 20).[16] It is possible that Macdonald-Wright

later objected to assertions that Synchromism, like Orphism, was directly based on the theories of Chevreul and Rood, since he and Russell had absorbed much of this information through Tudor-Hart rather than from copying Delaunay or studying these theorists' writings. However, even Willard Wright admitted that his brother was helped in his color experiments by Chevreul, Helmholtz, and Rood.[17]

In the years 1910–1925, many American artists created paintings that can be called color abstractions. Various sources of inspiration were called upon, from color theories then in vogue to the artist's own intuition and nature itself. Many American artists traveled to Europe where they met and were influenced by Matisse, Picasso, Delaunay, and others. Ideas could be shared in a network of teachers, friends, and acquaintances that existed on both sides of the Atlantic.

The Synchromists, therefore, were not unique in their sources or goals. Theories of color such as those published by Chevreul and Rood were accessible either directly from the books themselves or through secondary sources. The idea of linking colors to music or states of emotion was of interest to many artists at the time, and the attempt to express light through rhythmic color was also made by others.

Yet of the American artists only the founders of Synchromism, Morgan Russell and Stanton Macdonald-Wright, worked within a defined movement with declared objectives, thereby gaining wider recognition and influence among their contemporaries. In this sense, it is fair perhaps to speak of a Synchromist period, keeping in mind that there were many other artists at the time working toward color abstraction, such as Patrick Henry Bruce, Marsden Hartley, or James Daugherty, who developed outside of the Synchromist movement itself.

It was an age of great experimentation, with artists responding to the sense of modernity in the air. Many sought to create a new art and the Synchromists believed that they had done so. In its concern with abstract color, Synchromism may well have been a more important current in the development of American art after the Armory Show than has been commonly recognized. In spite of Willard Wright's conclusion, of course, it was not the final step in painting. The struggle for an art of pure color had only just begun. Yet the Synchromists have left us with a body of work and ideas of significant historical importance, as well as a rich visual legacy.

Plates

1. Morgan Russell, *Synchromist Poster*, June 1913

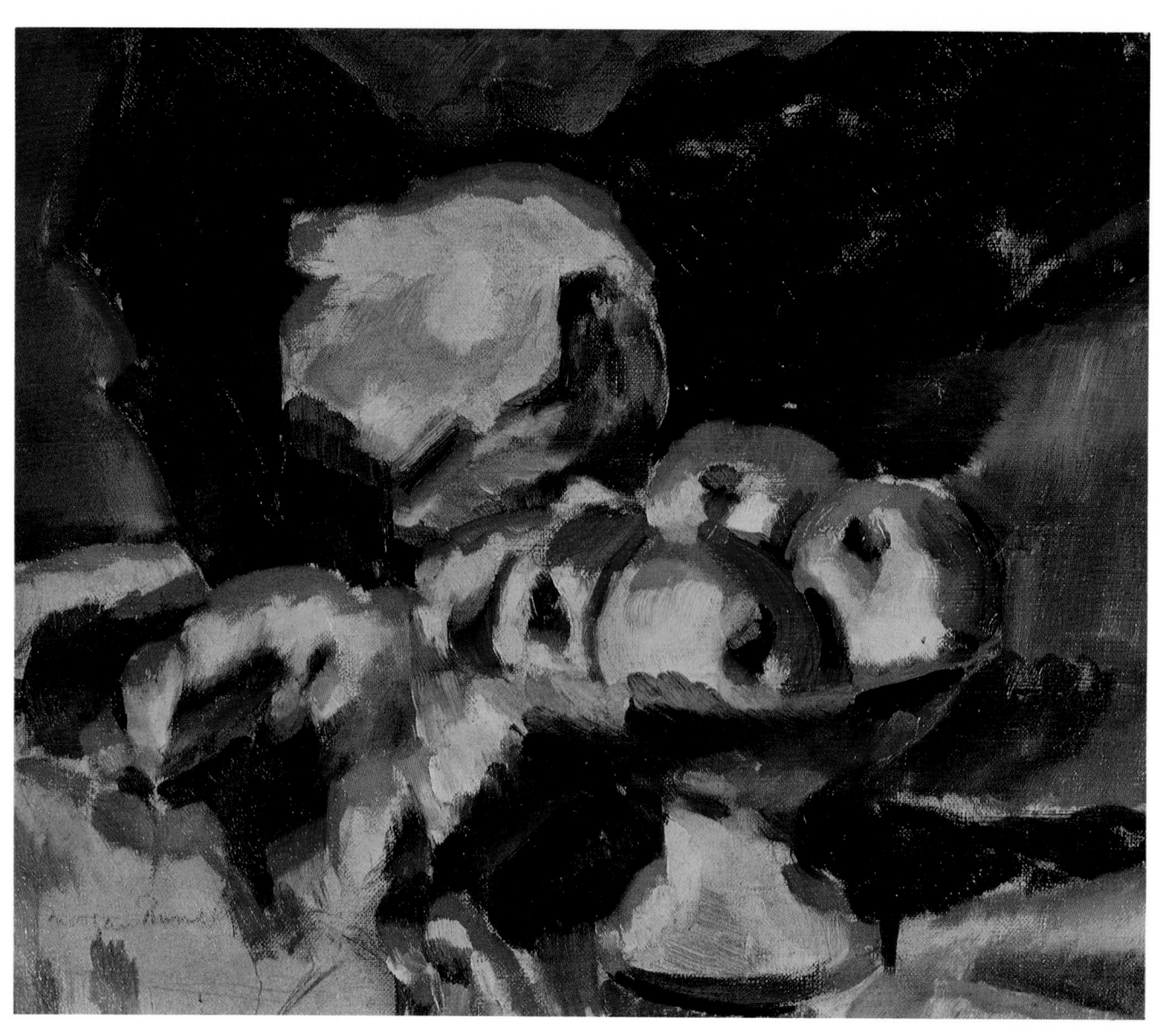

2. Morgan Russell, *Still Life Synchromy,* 1912–13.

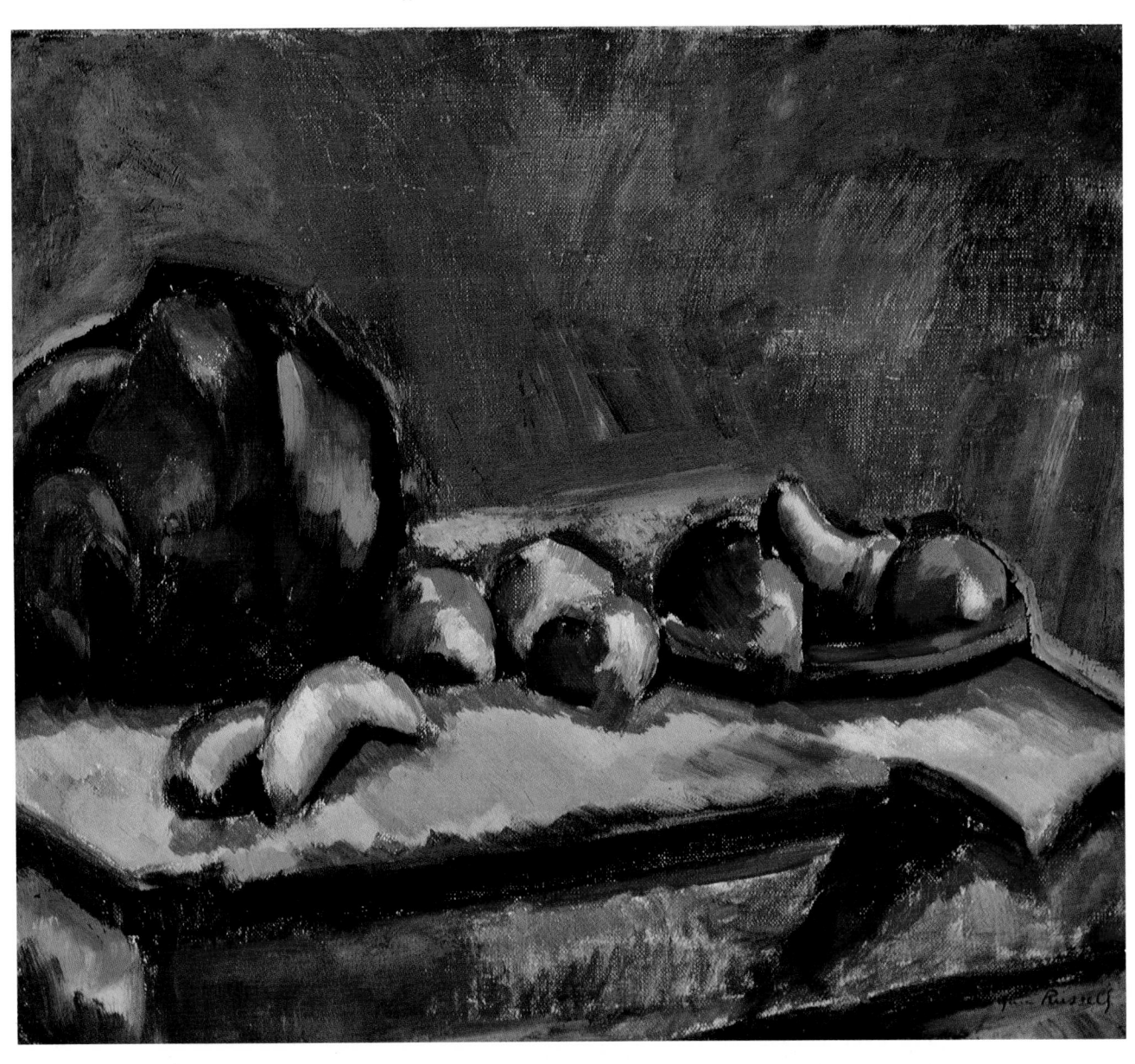

3. Morgan Russell, *Still Life with Bananas,* 1912–13.

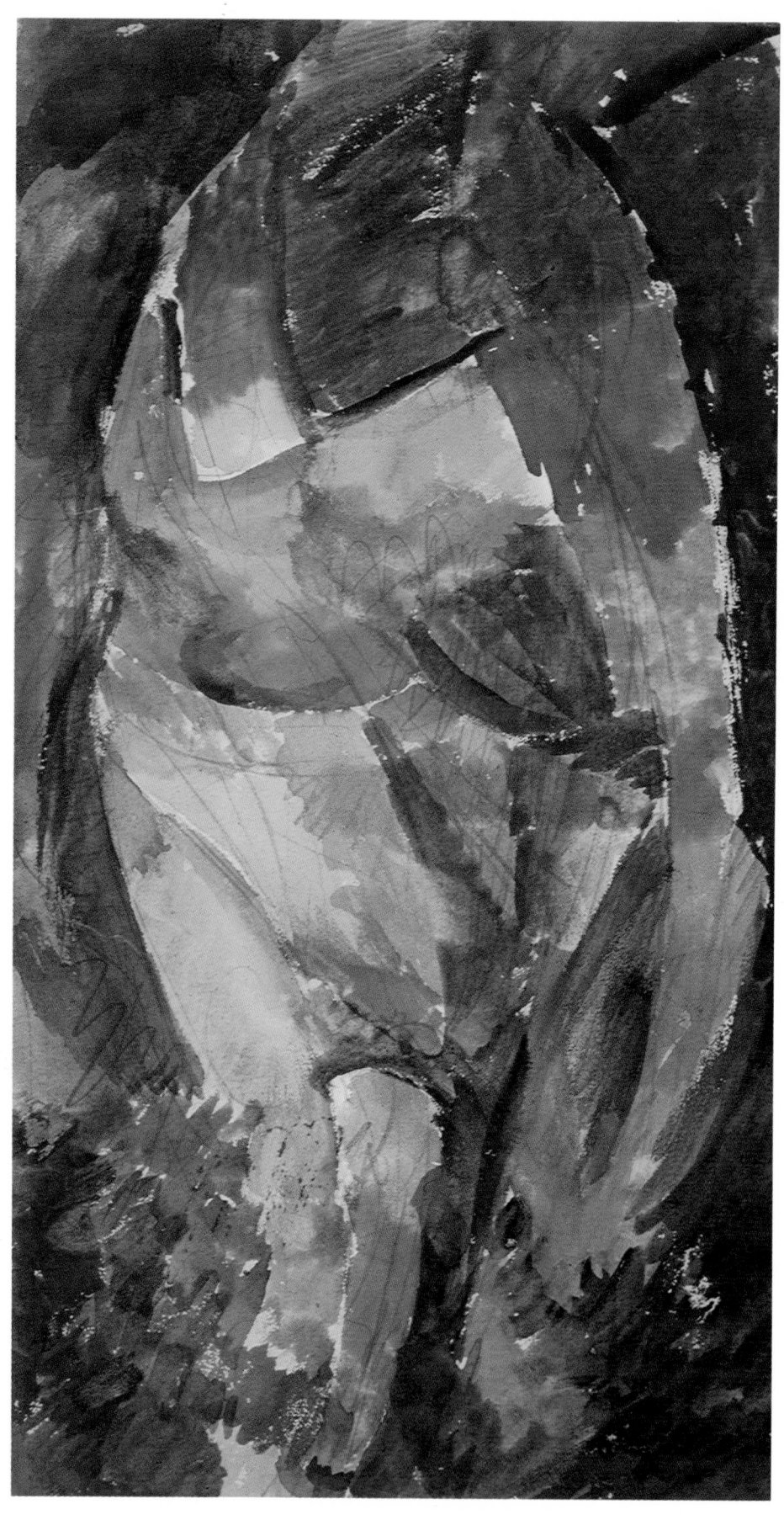

4. Morgan Russell, *Sketch after Michelangelo's "Pietà,"* 1912.

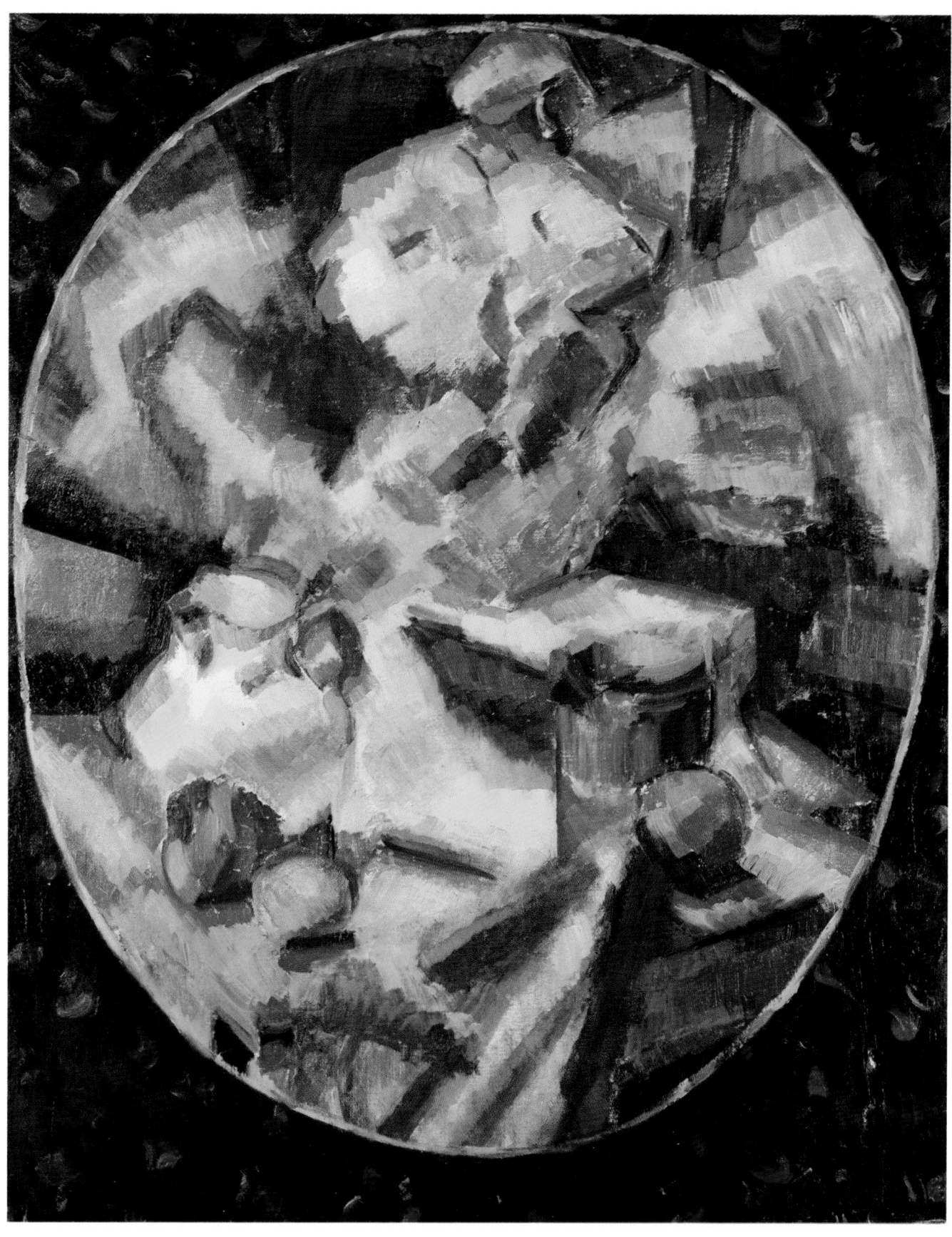

5. Morgan Russell, *Synchromy in Yellow* [*Synchromie en jaune*], 1913.

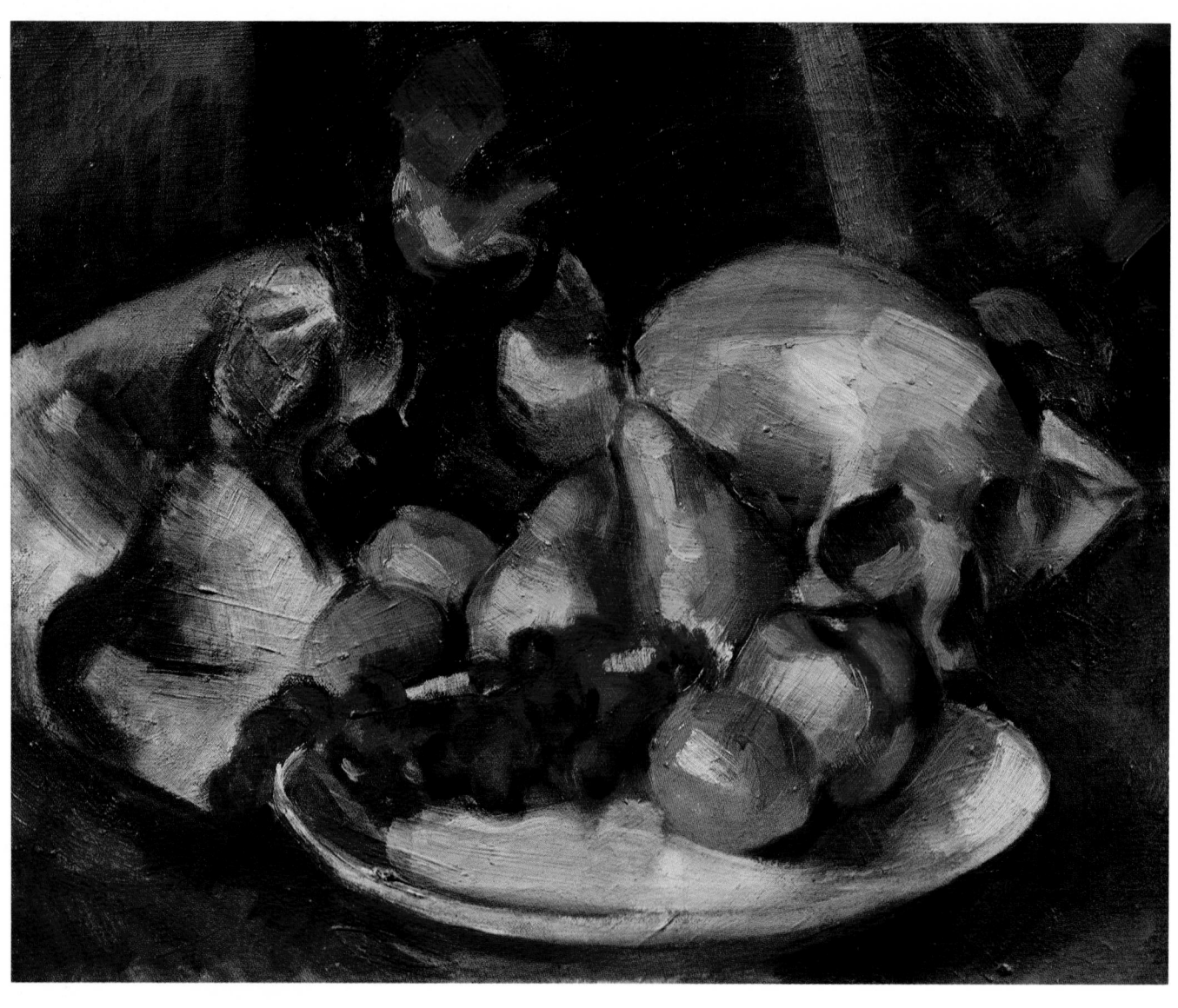

6. Stanton Macdonald-Wright, *Still Life with Skull*, 1912.

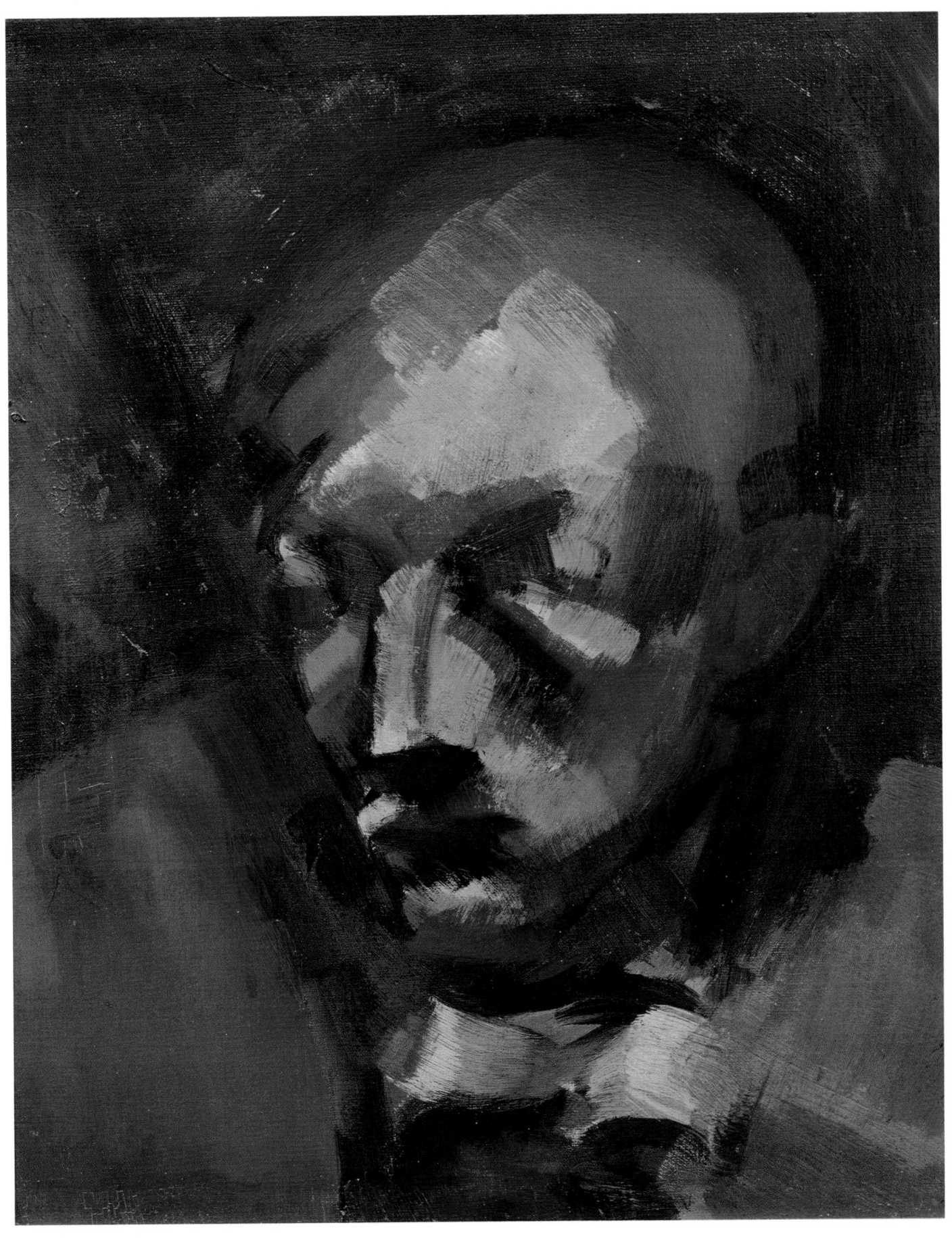

7. Stanton Macdonald-Wright, *Portrait of Jean Dracopoli*, 1912.

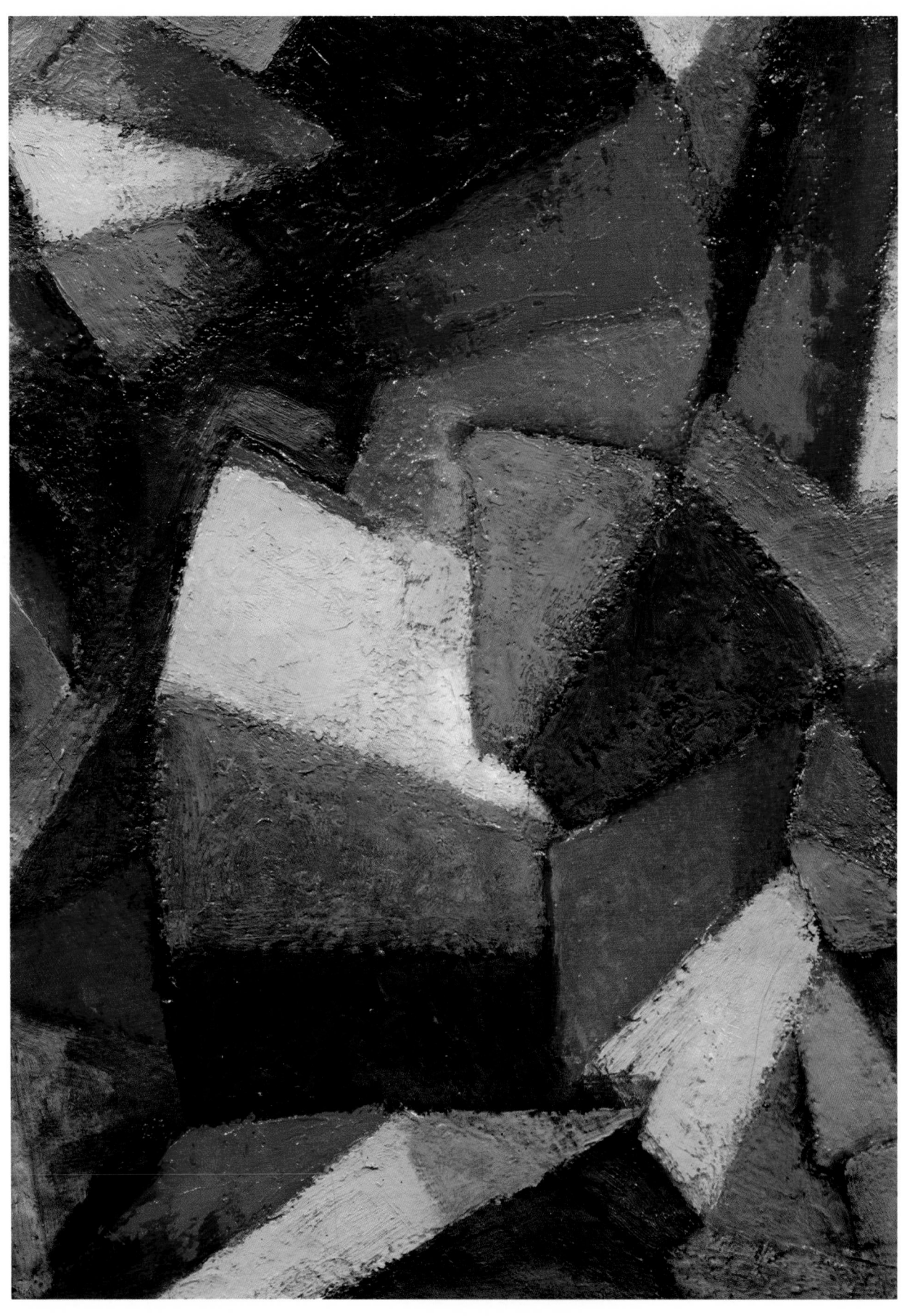

8. Morgan Russell, *Synchromy in Deep Blue-Violet* [*Synchromie en bleu violacé*] (*Synchromy to Light, No. 2*), 1913.

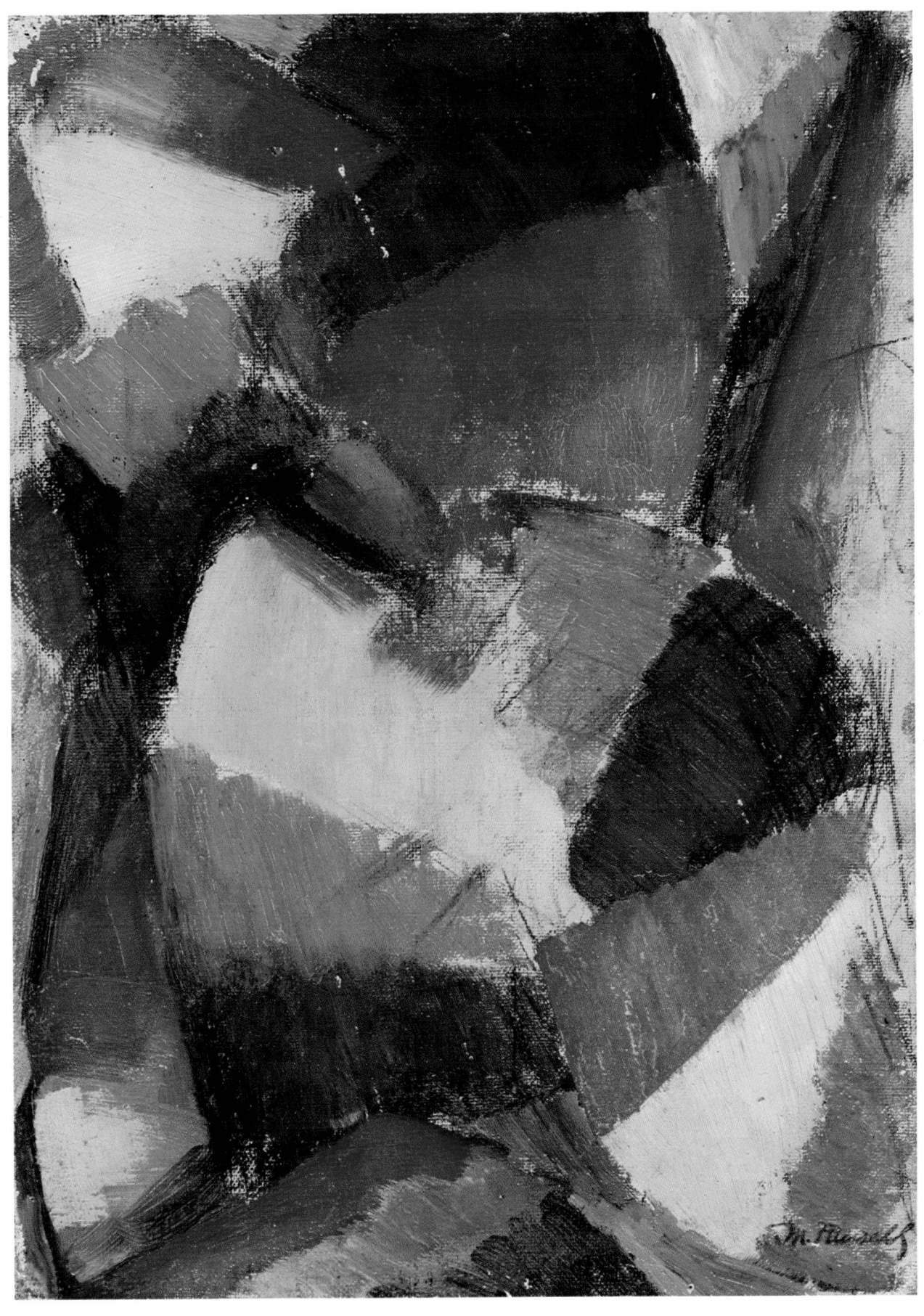

9. Morgan Russell, *Study for Synchromie en bleu violacé (Synchromy to Light)*, 1913.

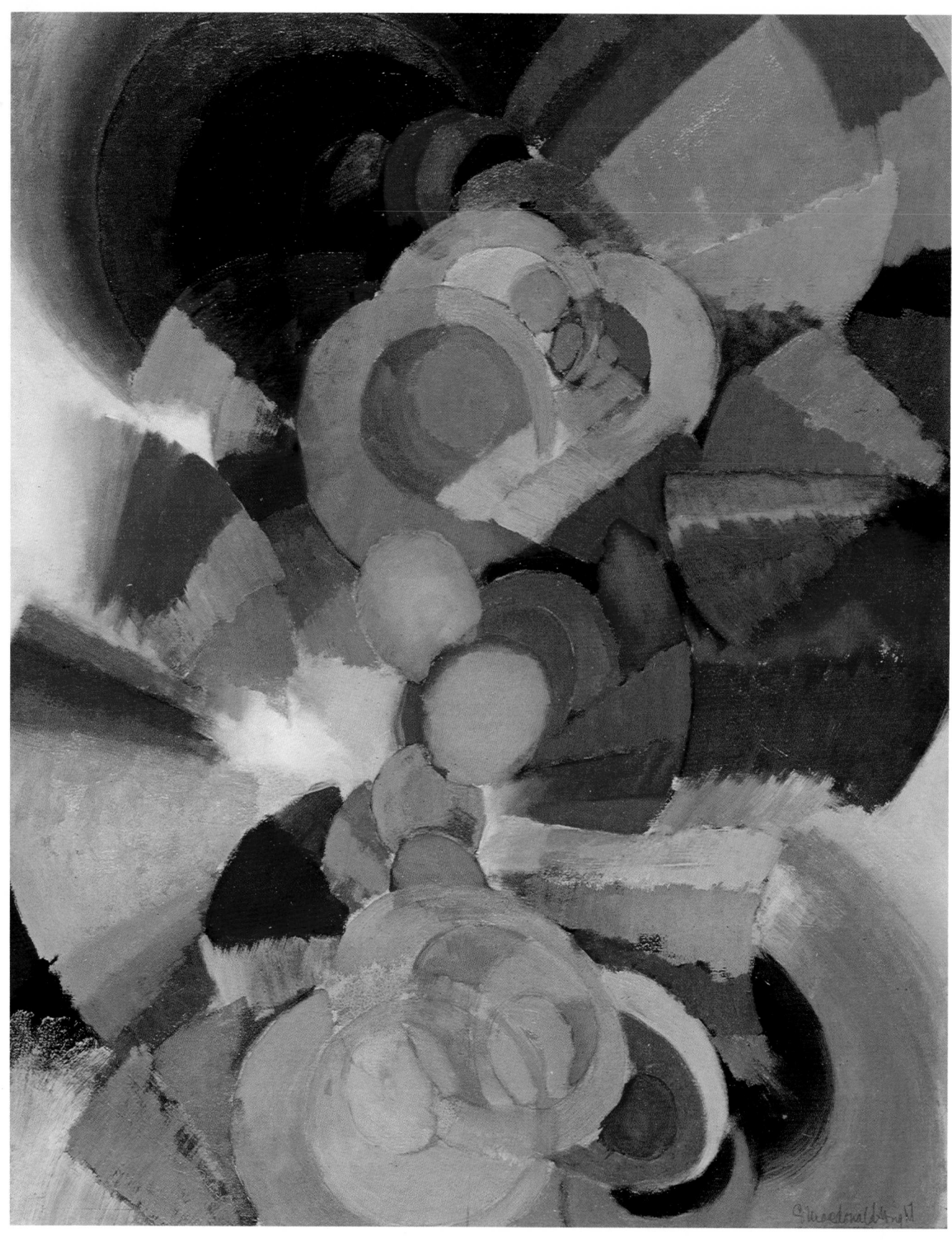

10. Stanton Macdonald-Wright, *Abstraction on Spectrum (Organization No. 5)*, 1914.

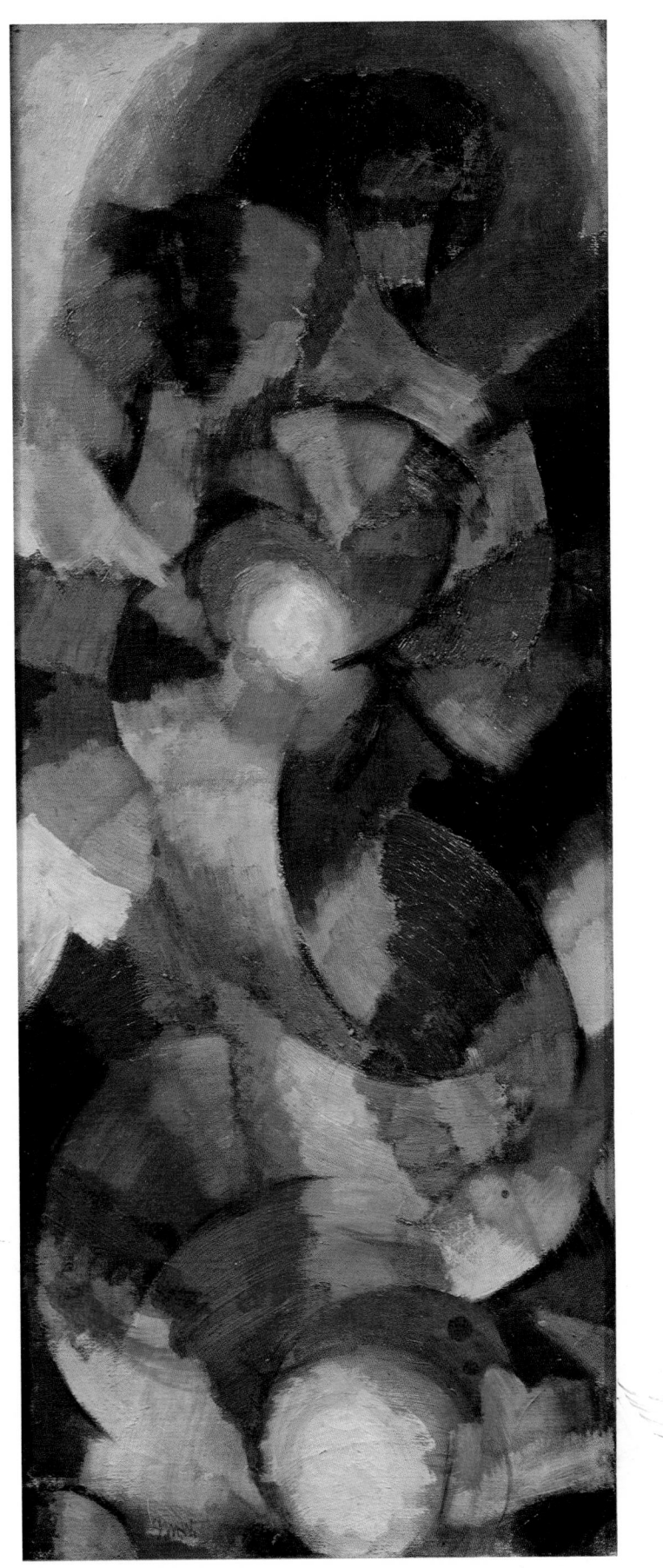

11. Stanton Macdonald-Wright, *Conception Synchromy*, 1914.

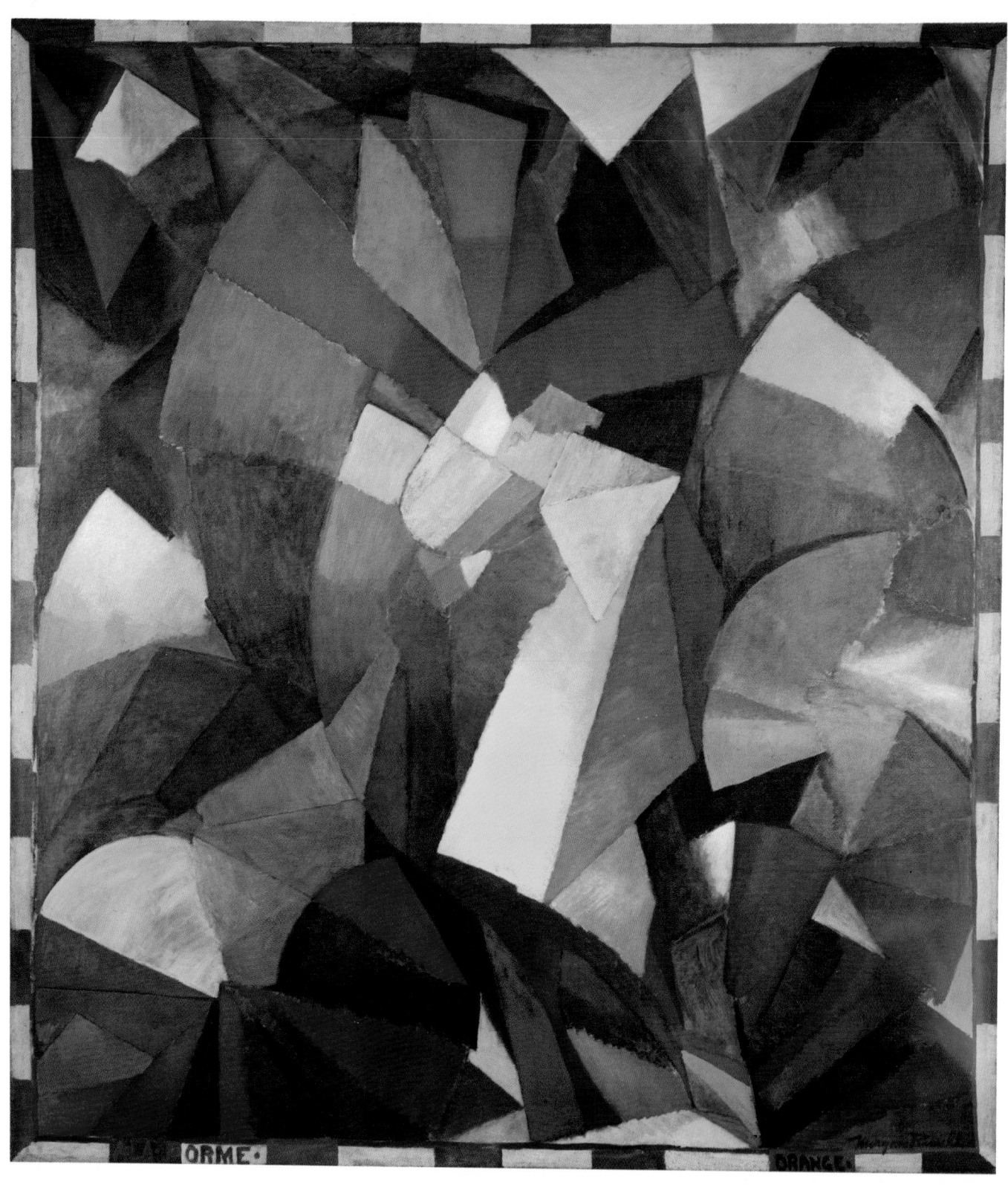

12. Morgan Russell, *Synchromy in Orange: To Form*, 1913–14.

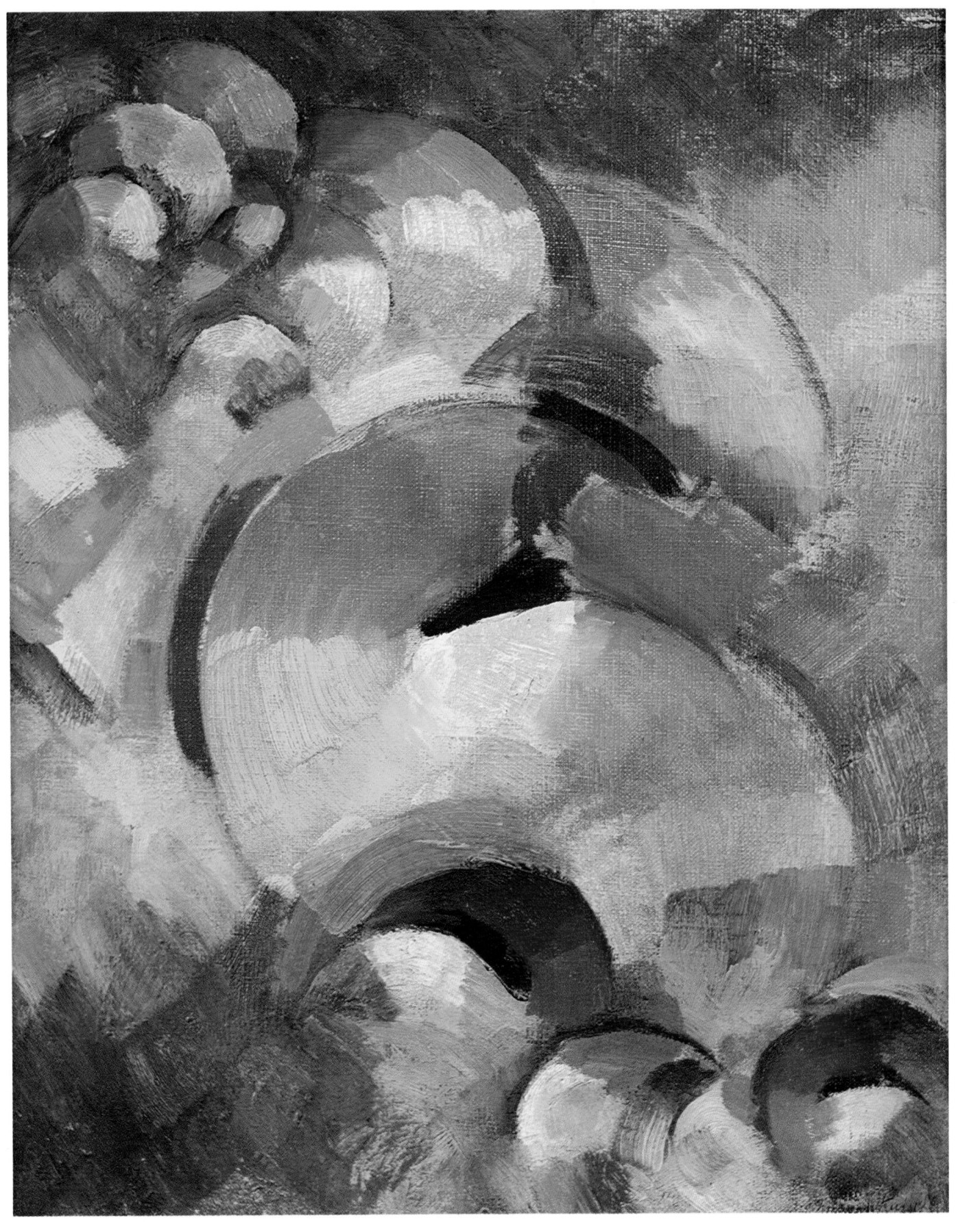

13. Morgan Russell, *Cosmic Synchromy* [*Synchromie cosmique*], 1913–14.

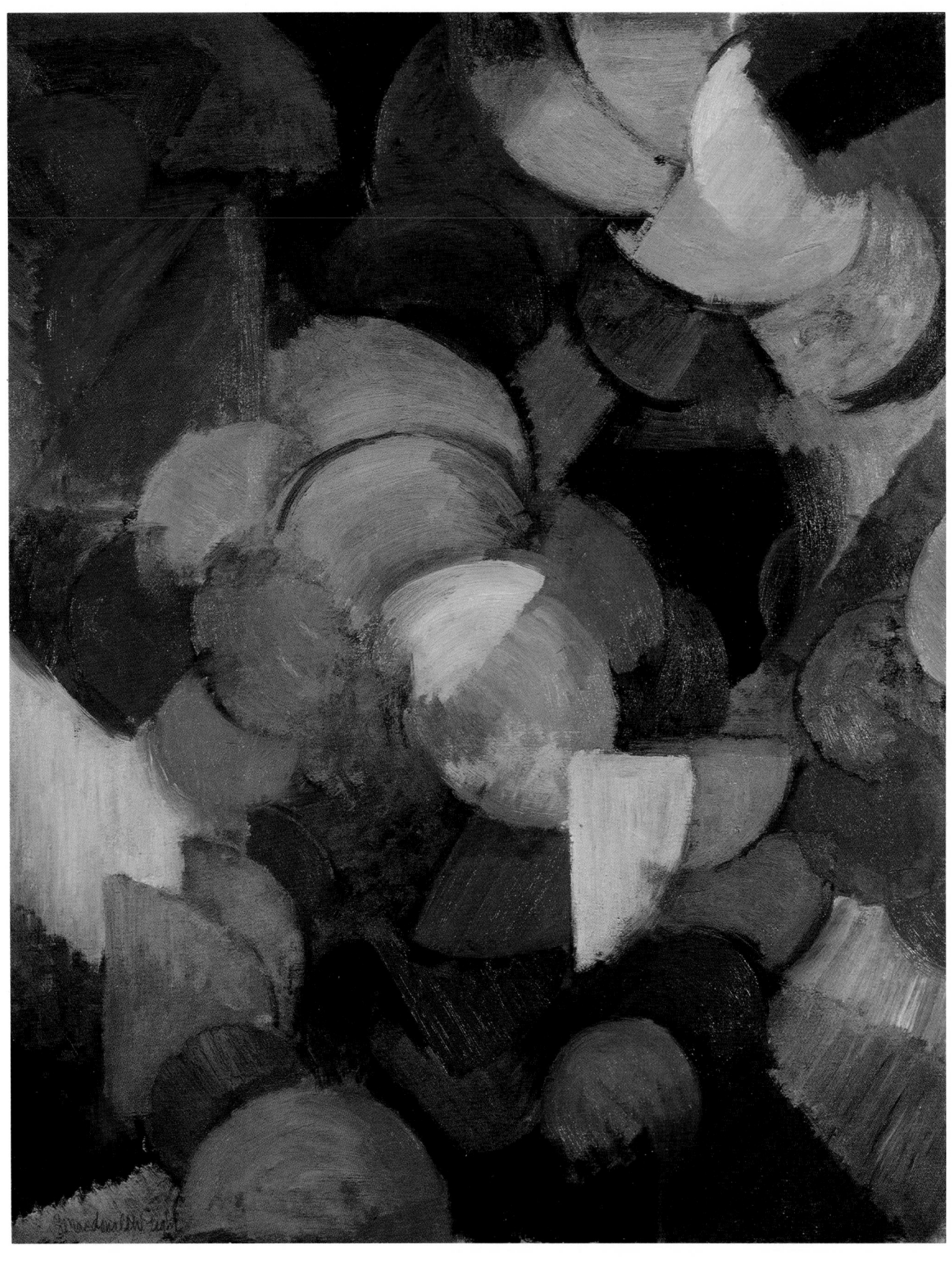

14. Stanton Macdonald-Wright, *Conception Synchromy,* 1915.

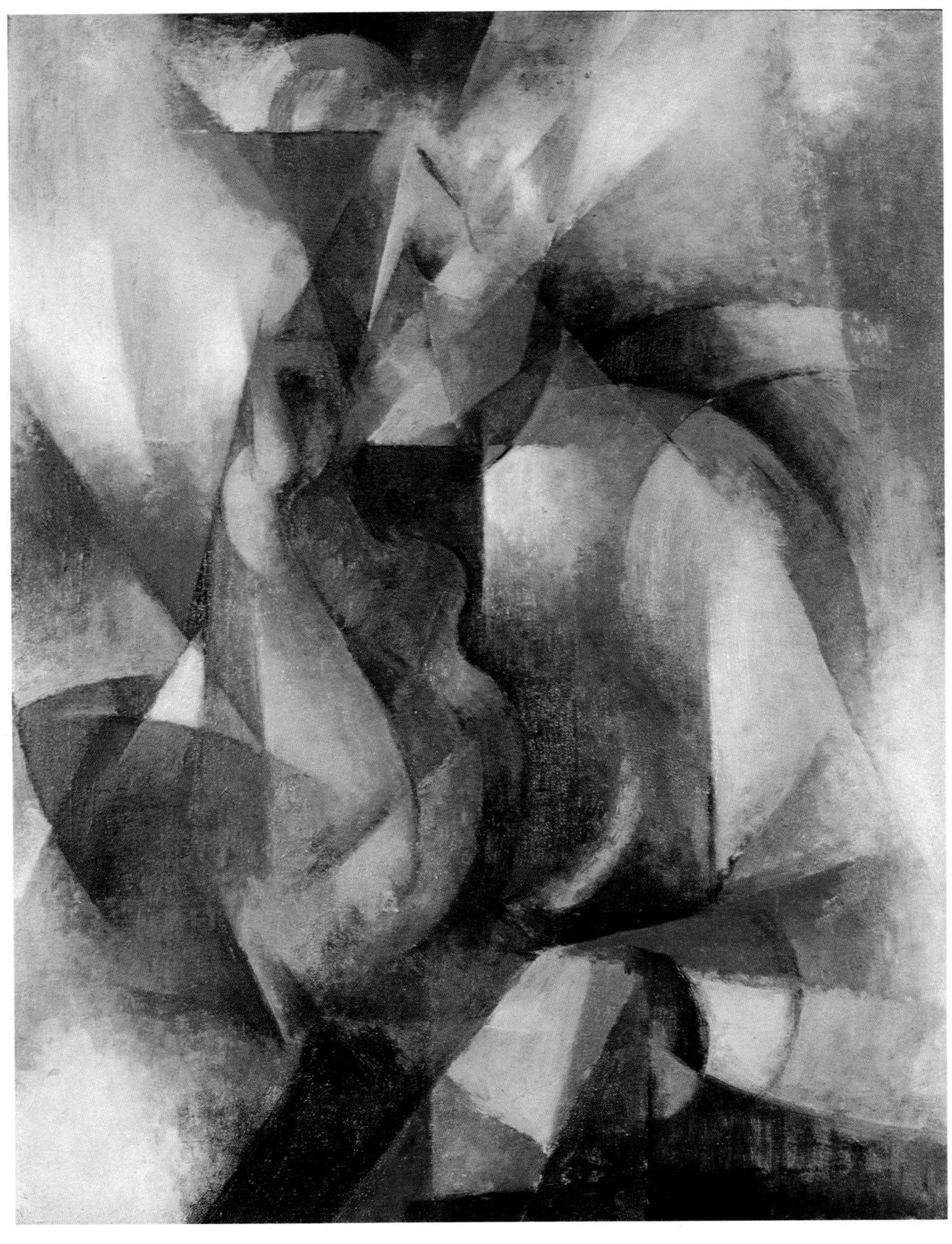

15. Stanton Macdonald-Wright, *Self-Portrait,* 1915.

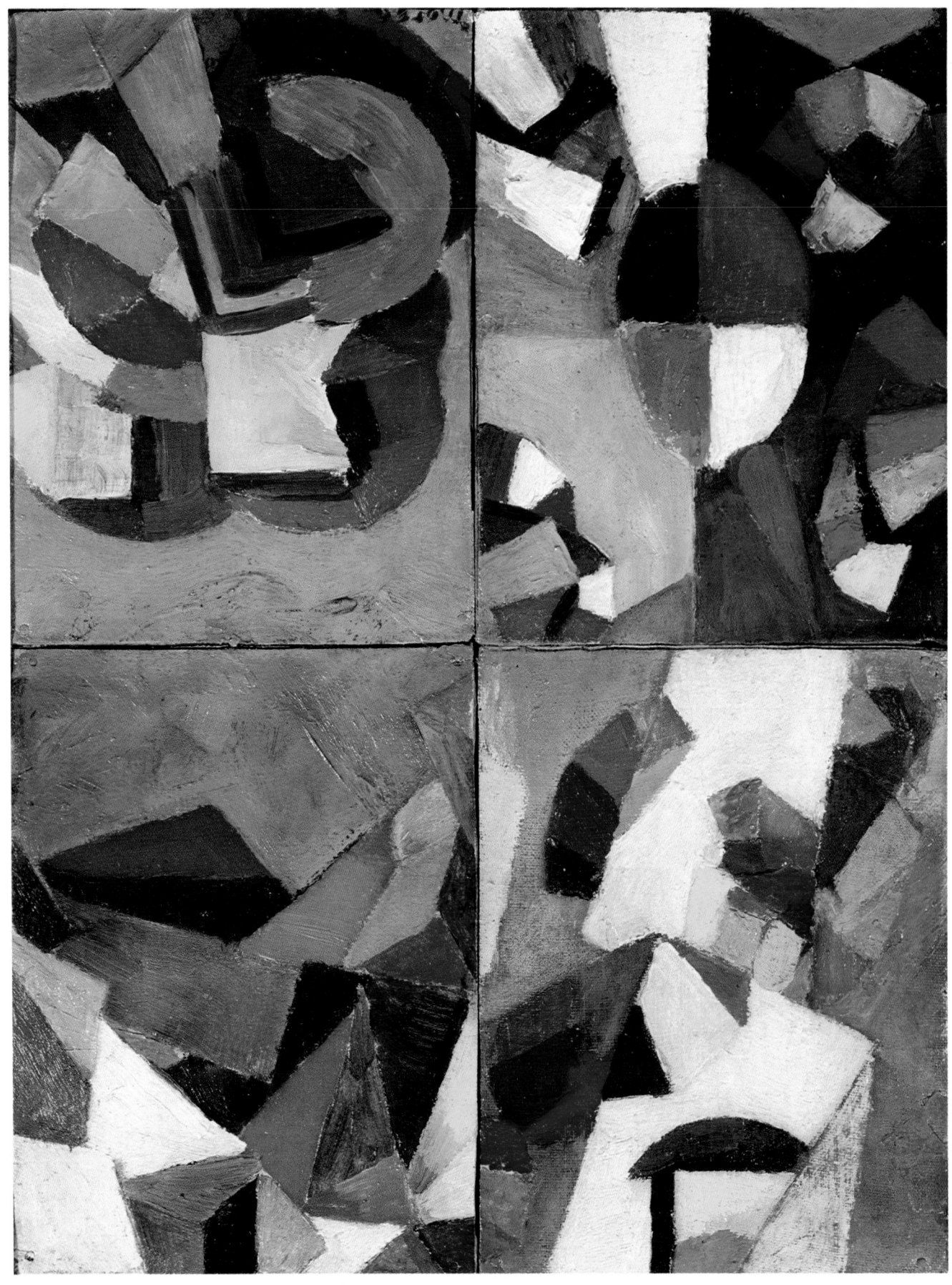

16. Morgan Russell, *Four-Part Synchromy, No. 7*, 1914–15.

17. Morgan Russell, *Untitled Study in Transparency,* c.1913–23.

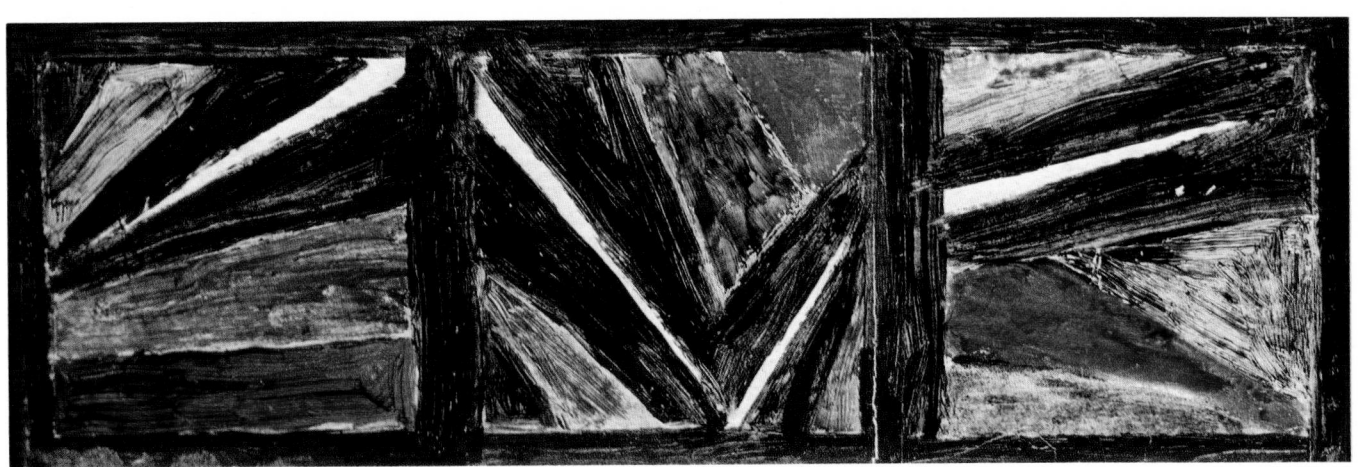

18. Morgan Russell, *Untitled Study in Transparency,* c.1913–23.

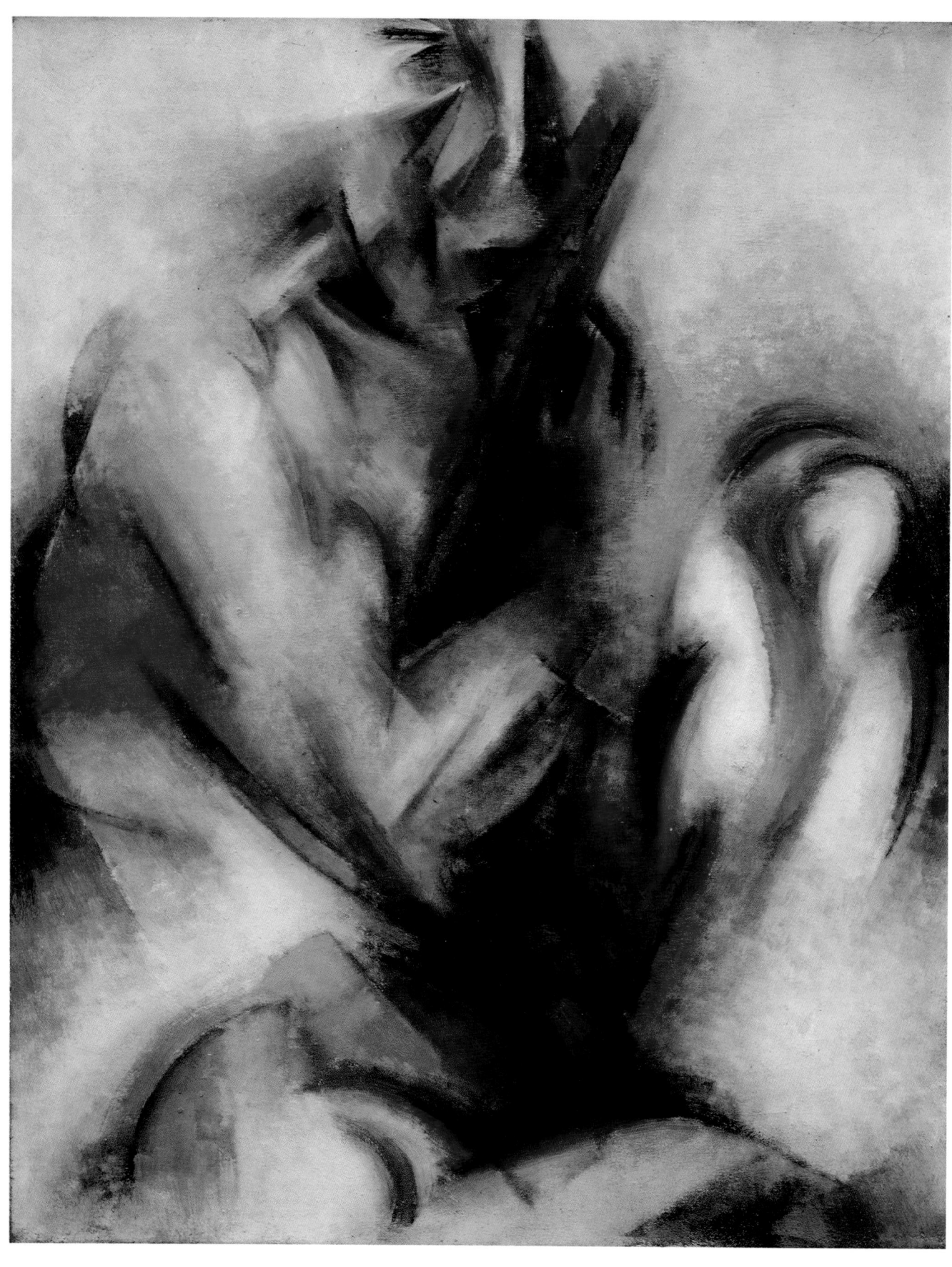

19. Stanton Macdonald-Wright, *Synchromy in Blue*, 1916.

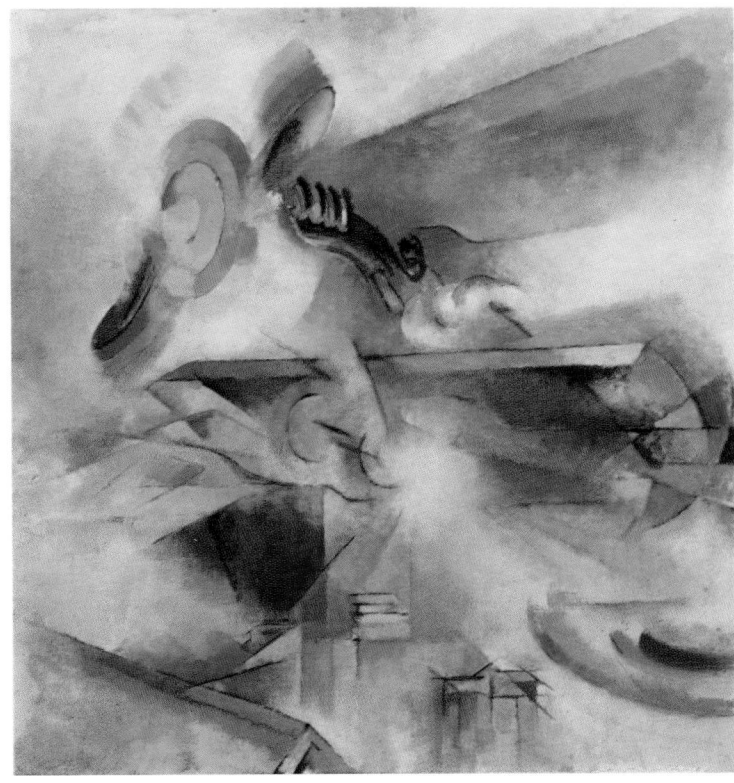

20. Stanton Macdonald-Wright,
Oriental Synchromy in Blue-Green, 1918.

21. Stanton Macdonald-Wright,
Aeroplane: Synchromy in Yellow-Orange, 1920.

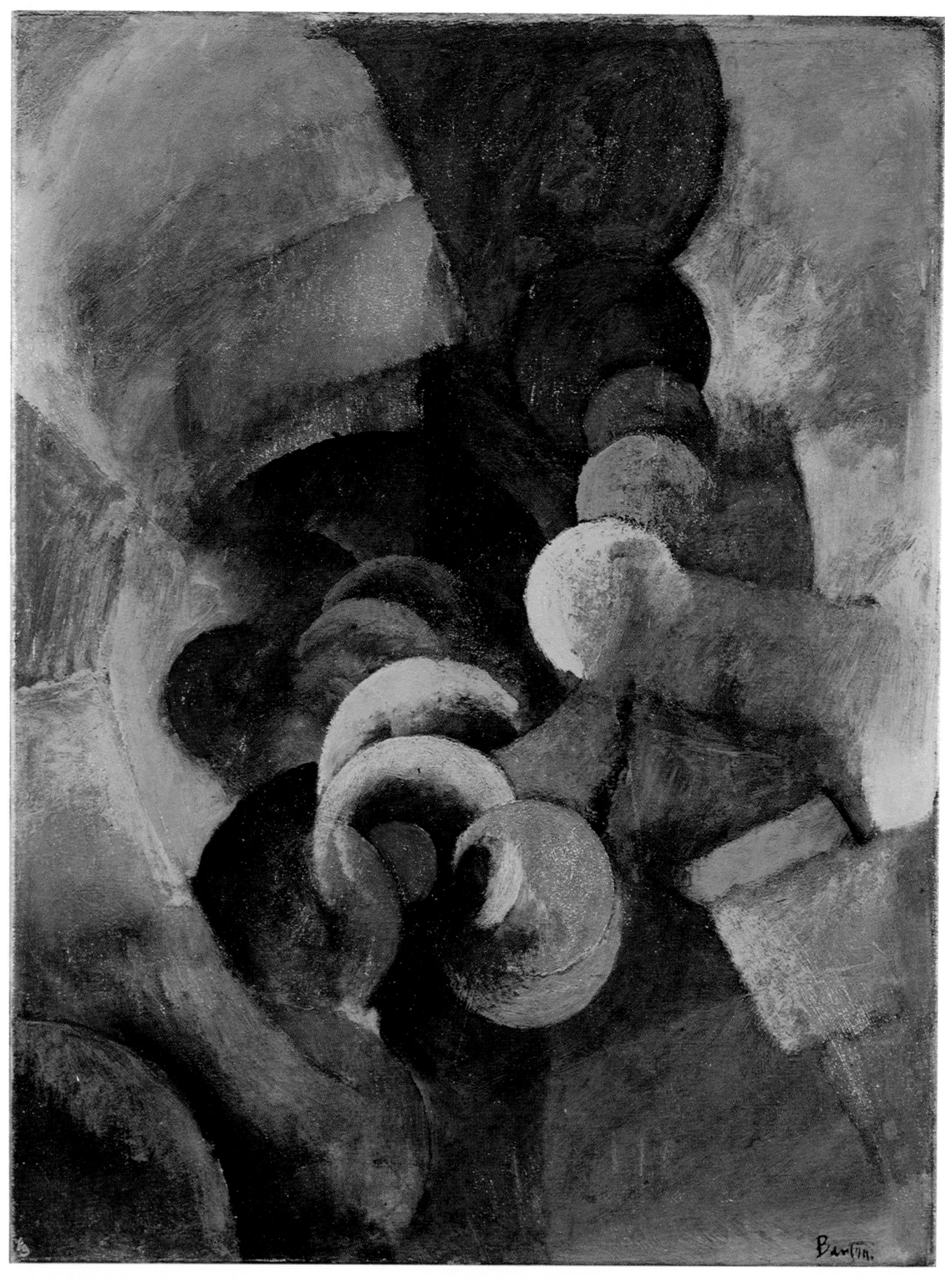

22. Thomas Hart Benton, *Bubbles,* c.1914–17.

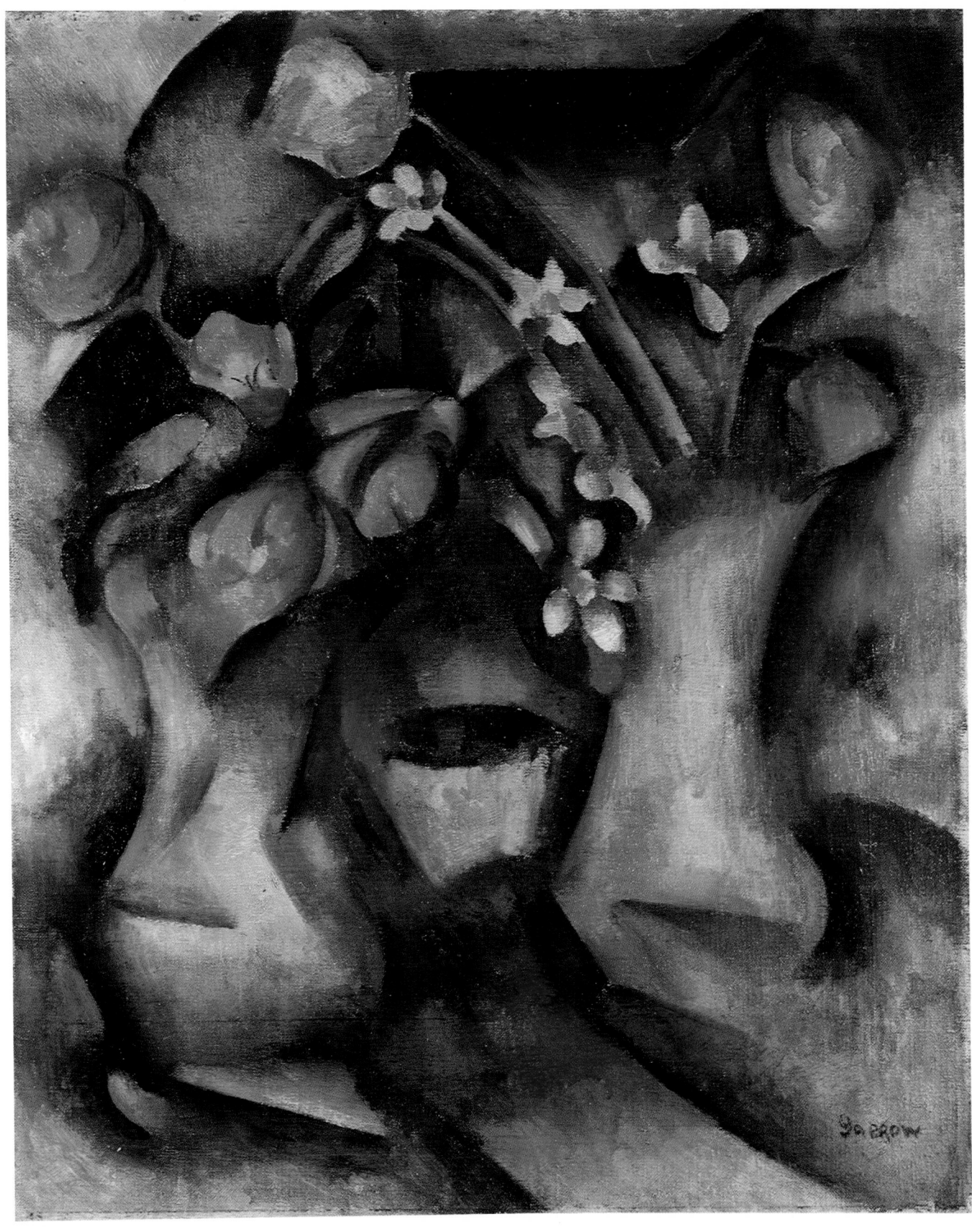

23. William Henry Kemble Yarrow, *Flowers,* c.1920.

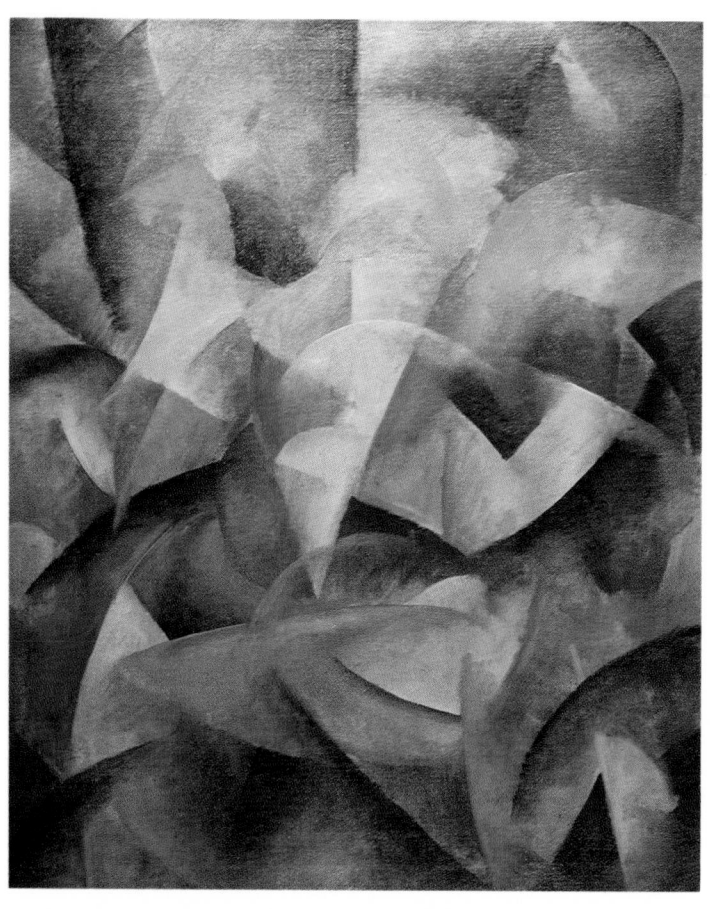

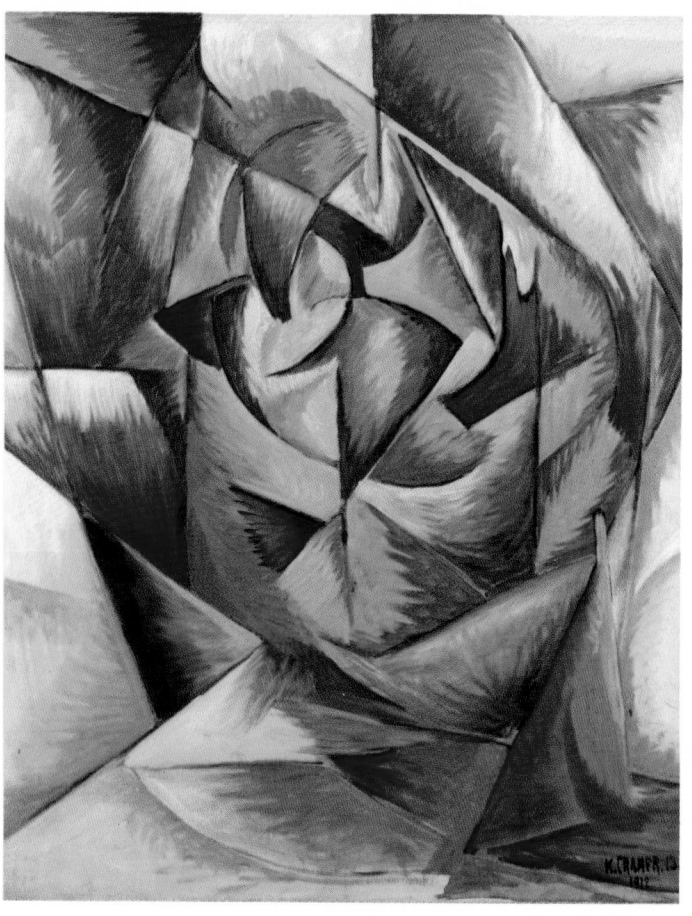

24. Andrew Dasburg, *Improvisation*, c.1915–16.

25. Konrad Cramer, *Improvisation No. 1*, 1912/13.

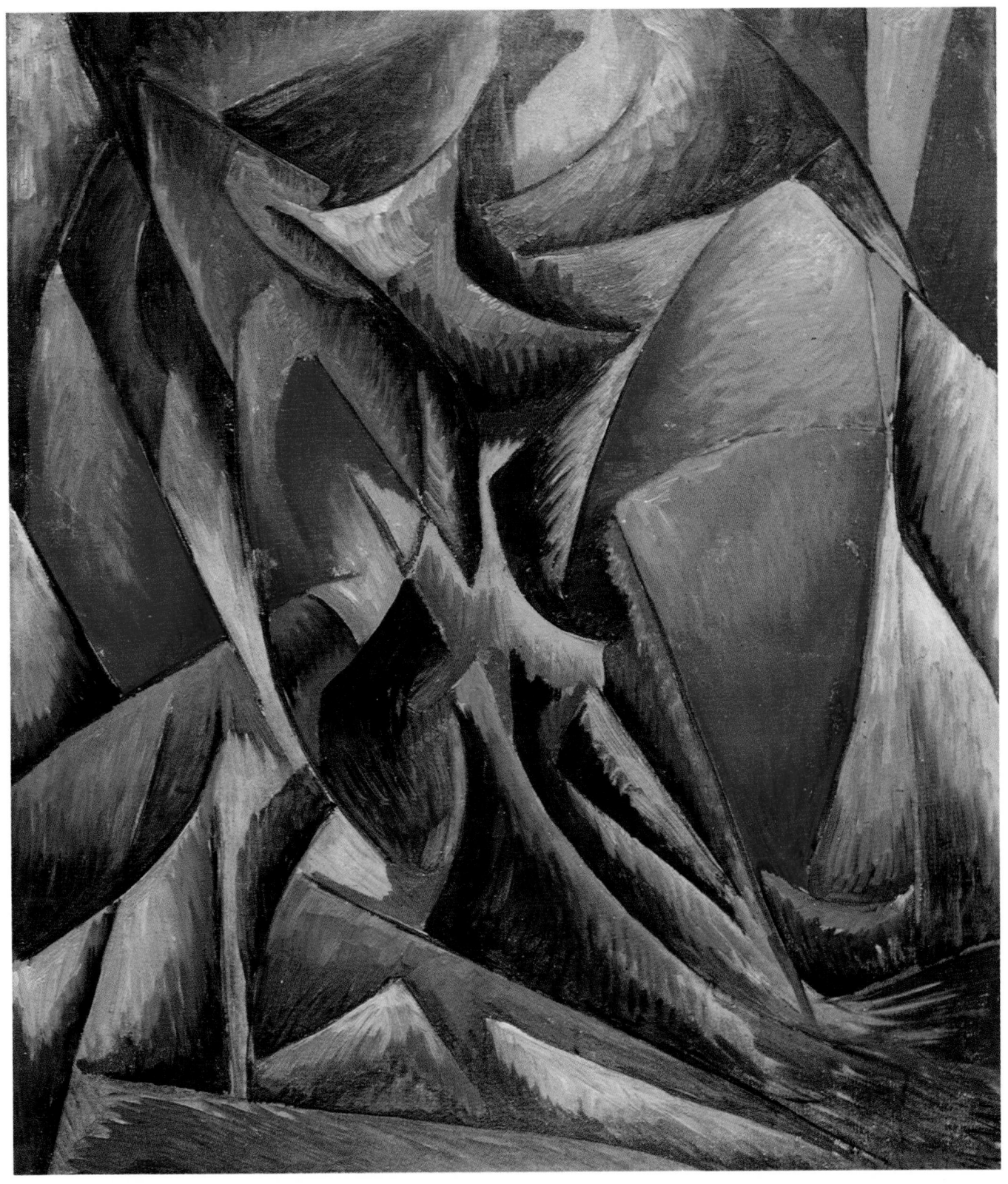

26. Konrad Cramer, *Improvisation,* 1912.

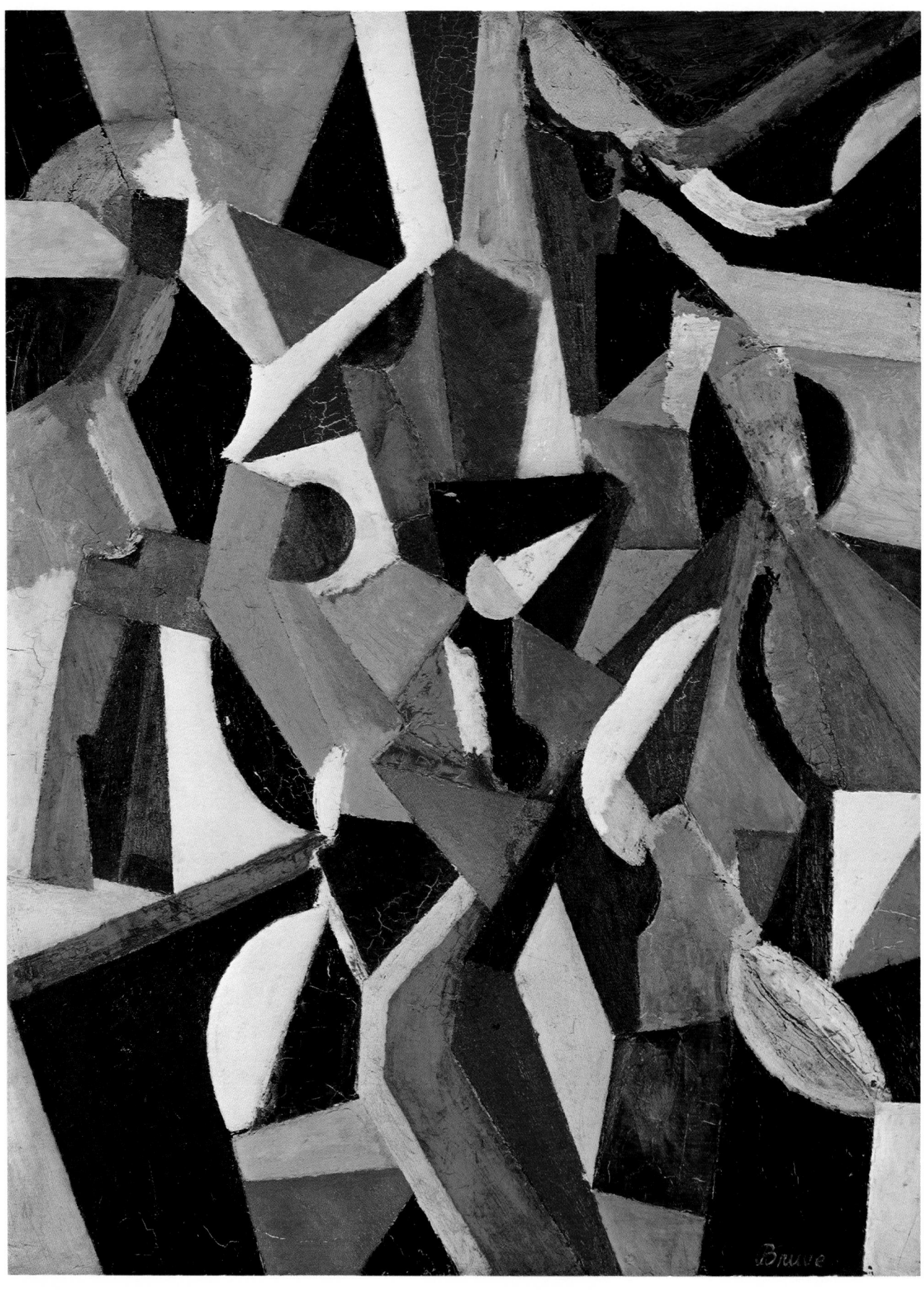

27. Patrick Henry Bruce, *Composition I,* 1916.

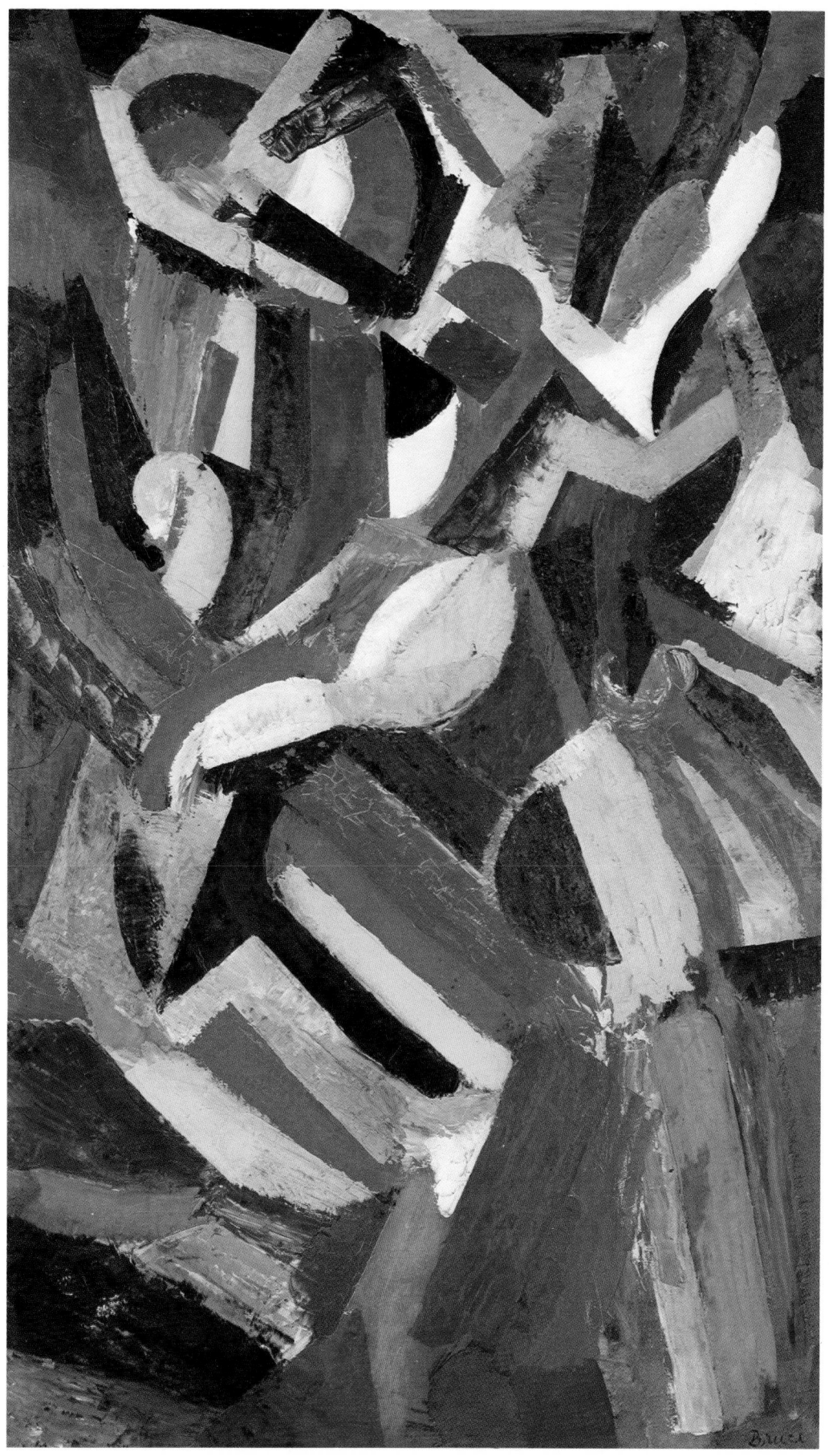

28. Patrick Henry Bruce, *Composition III,* 1916.

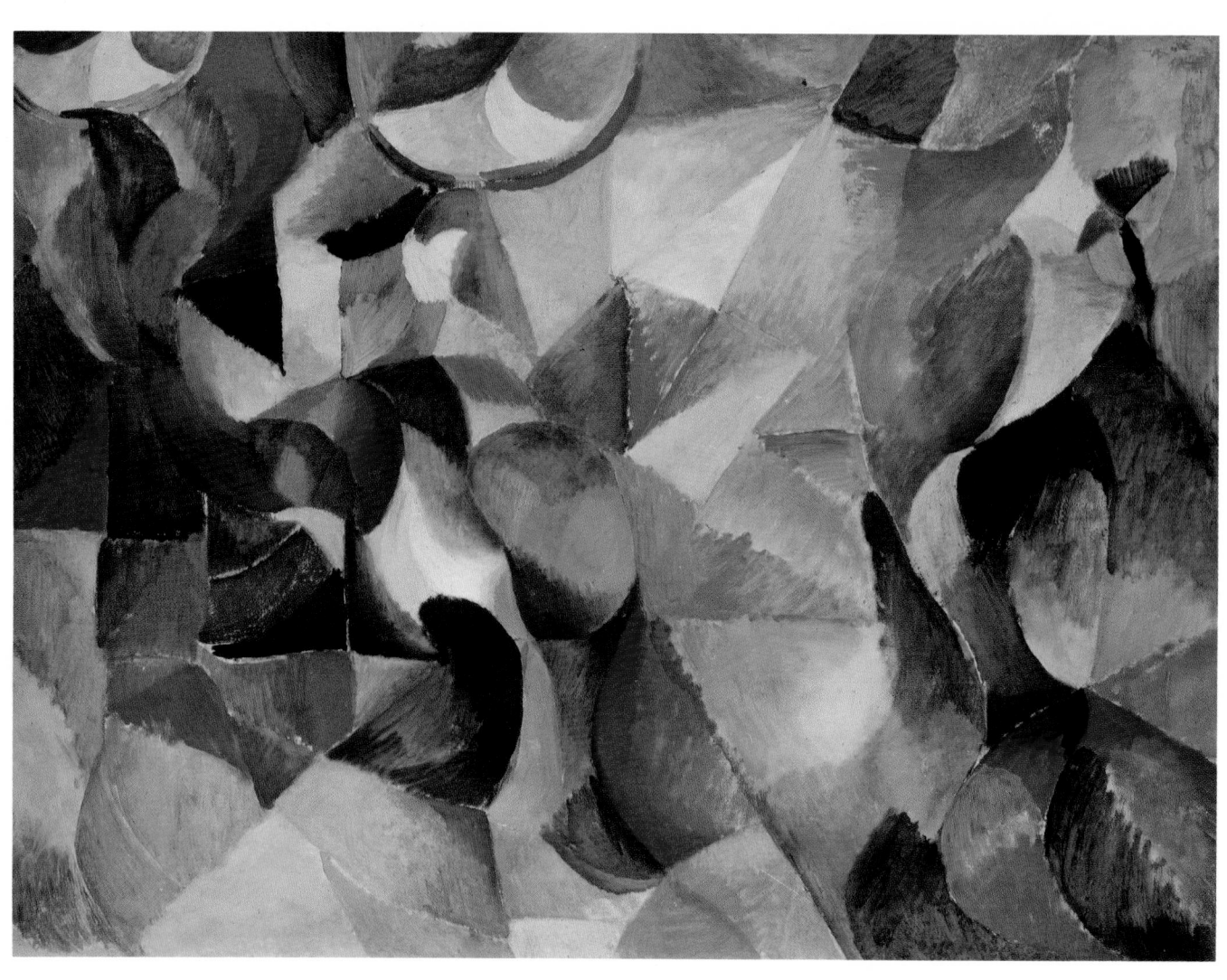

29. Sonia Delaunay, *Le Bal Bullier,* 1913.

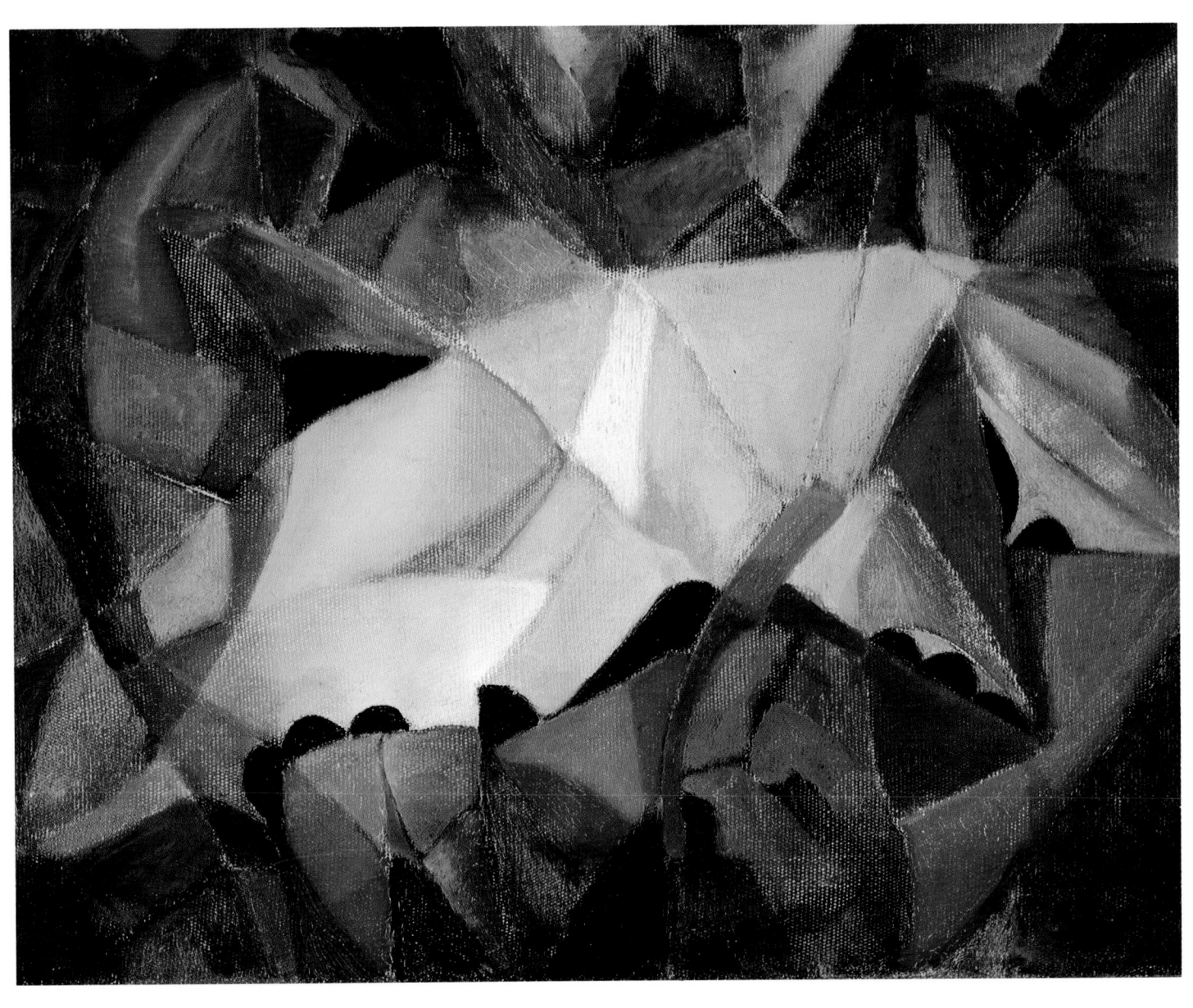

30. Arnold Friedman, *Untitled,* c.1918.

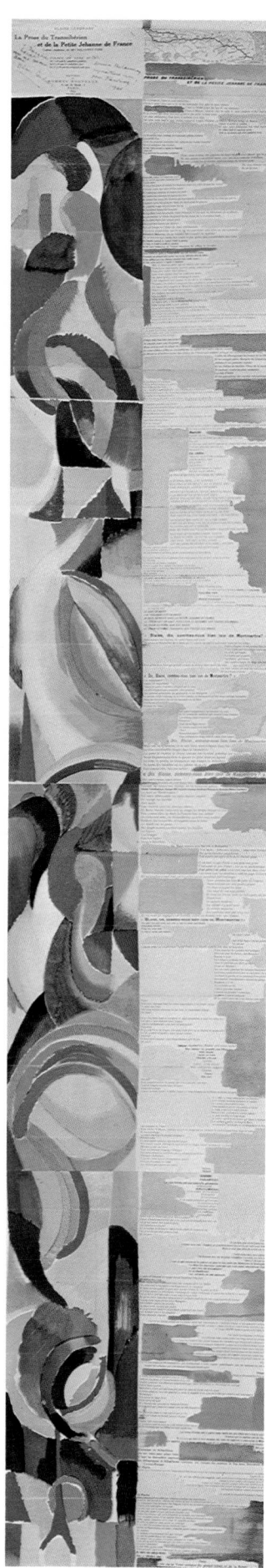

31. Sonia Delaunay and Blaise Cendrars, *La Prose du Transsibérien et de la petite Jehanne de France*, 1913.

32. Arthur Burdett Frost, Jr., *Harlequin*, 1914.

33. Marsden Hartley, *Abstraction*, c.1913.

34. Marsden Hartley, *Composition*, 1913.

35. Carl Newman, *Untitled*, 1921.

36. H. Lyman Saÿen, *Scheherazade*, 1915.

37. Jan Matulka, *Indian Dancers,* c.1916–17.

38. James Henry Daugherty,
Three Base Hit (Opening Game), 1914.

39, 40. James Henry Daugherty,
Untitled (recto), 1920;
Moses (verso), c.1922.

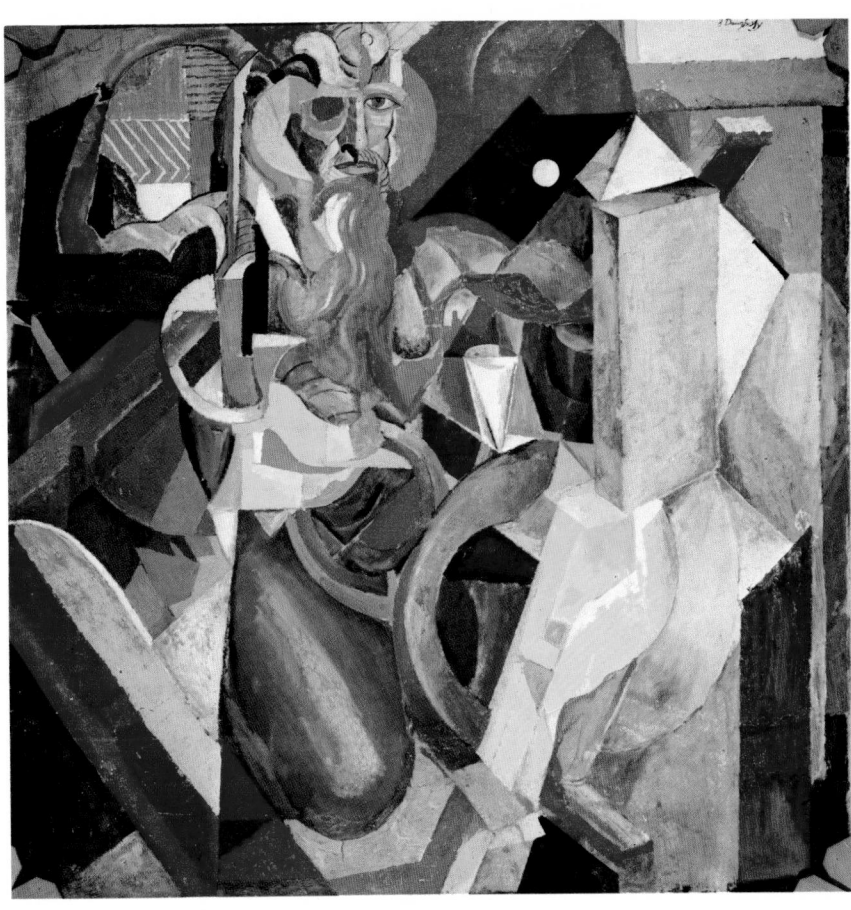

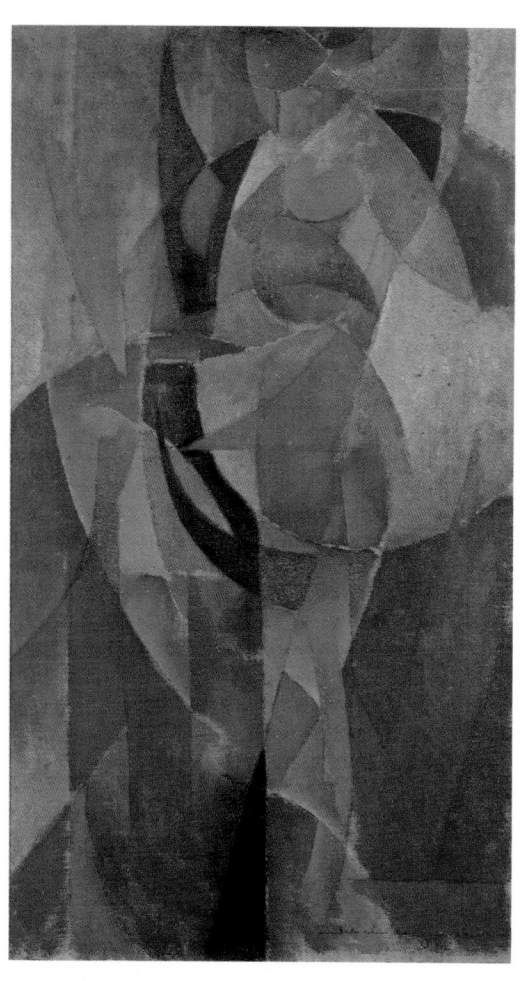

41. Morton L. Schamberg, *Geometric Patterns*, 1914.

42. Morton L. Schamberg, *Untitled (Landscape)*, 1914.

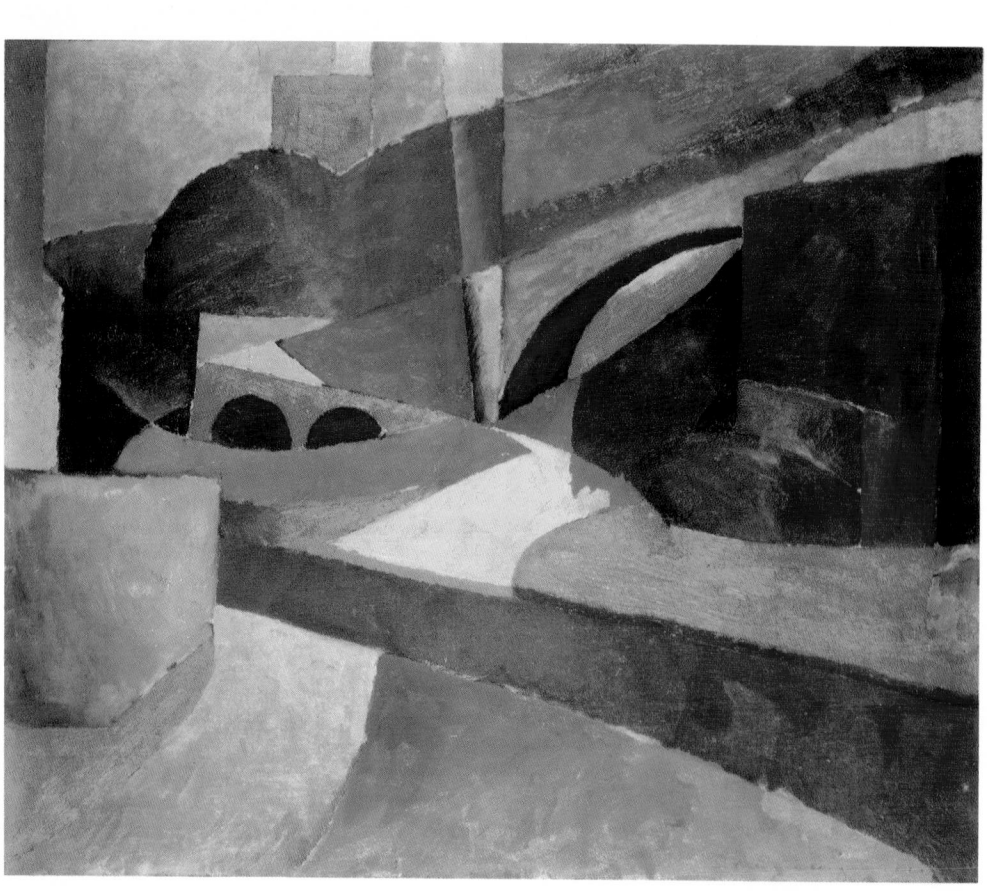

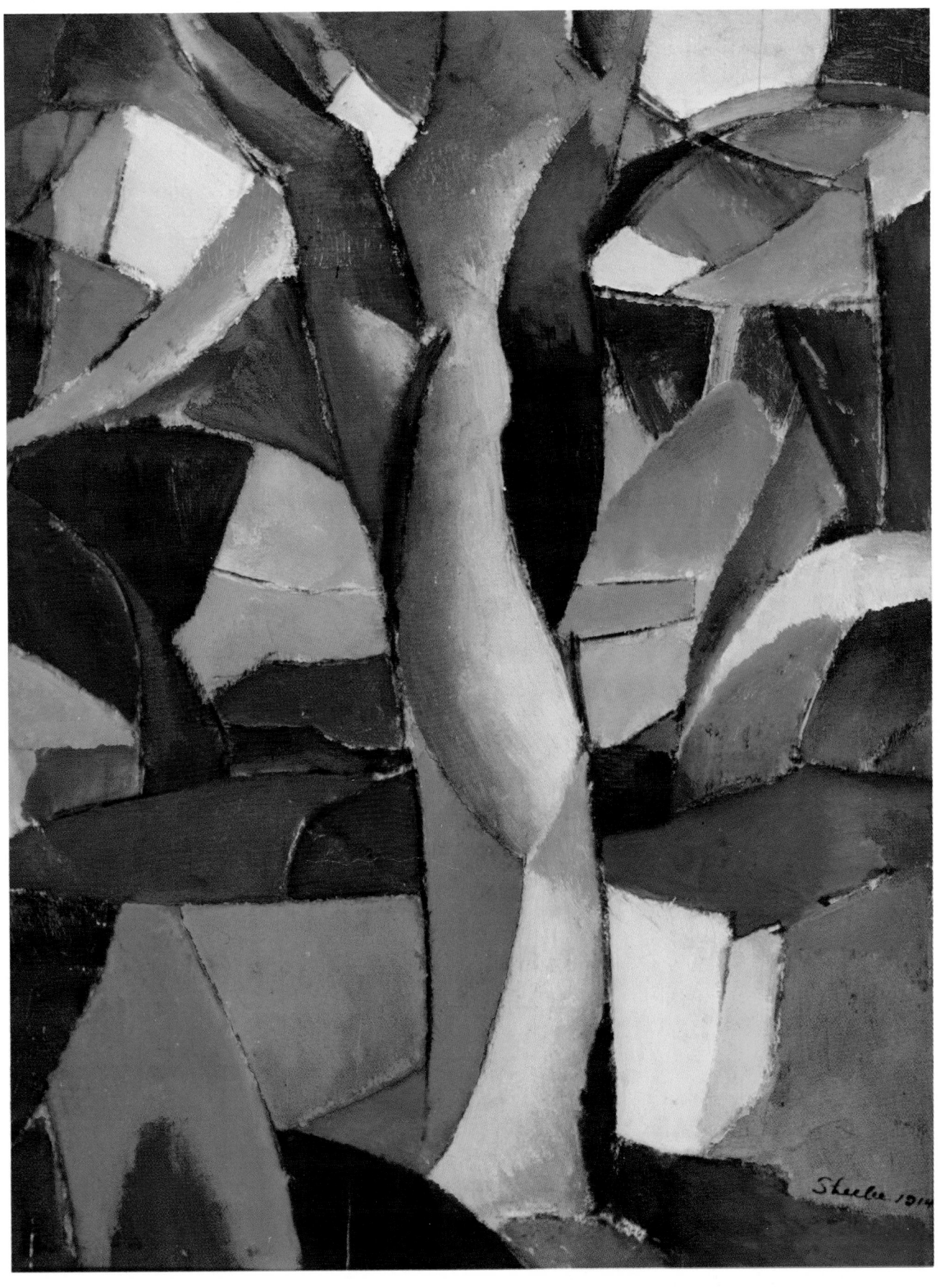

43. Charles Sheeler, *Abstraction: Tree Form*, 1914.

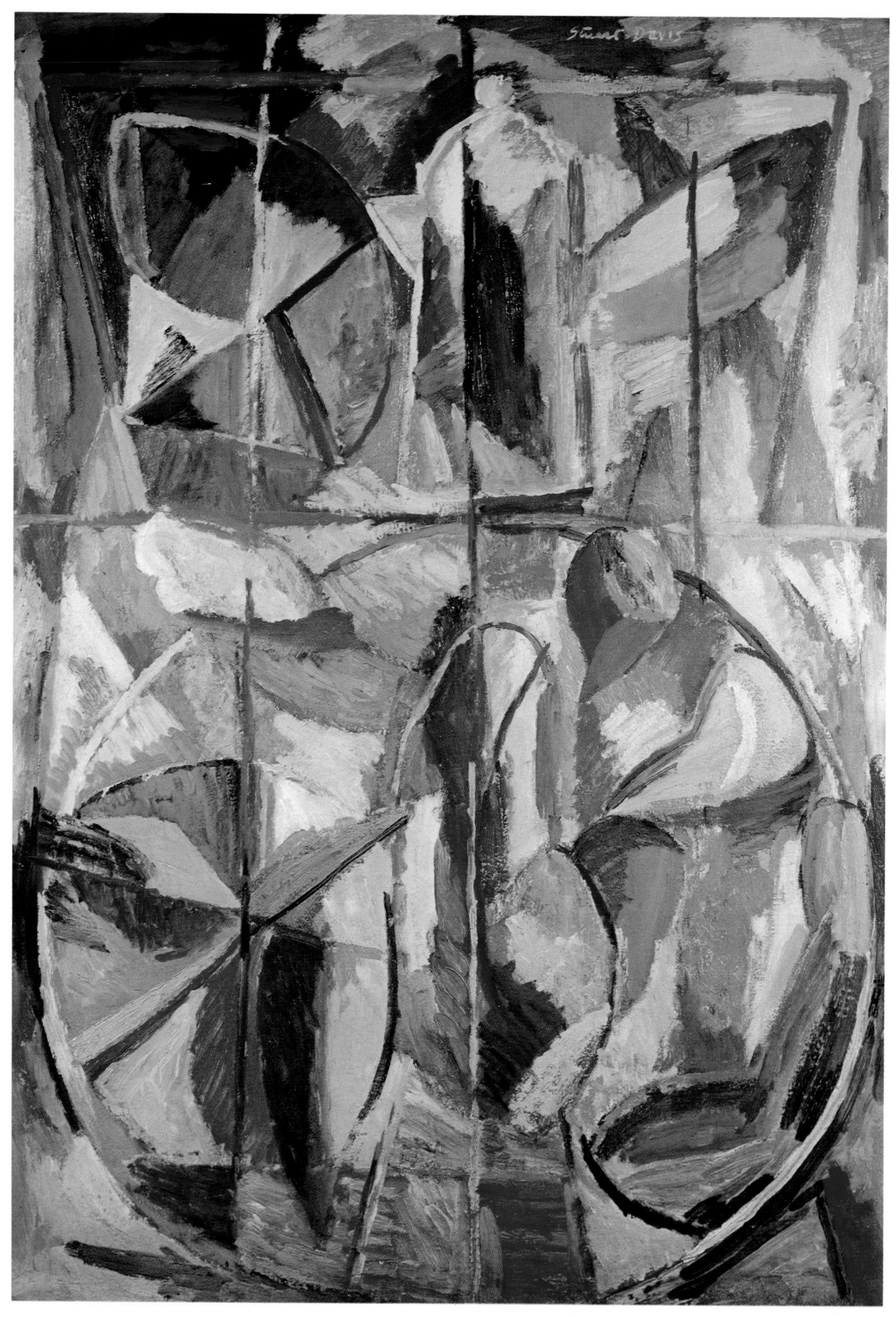

44. Stuart Davis, *The Breakfast Table*, c.1917.

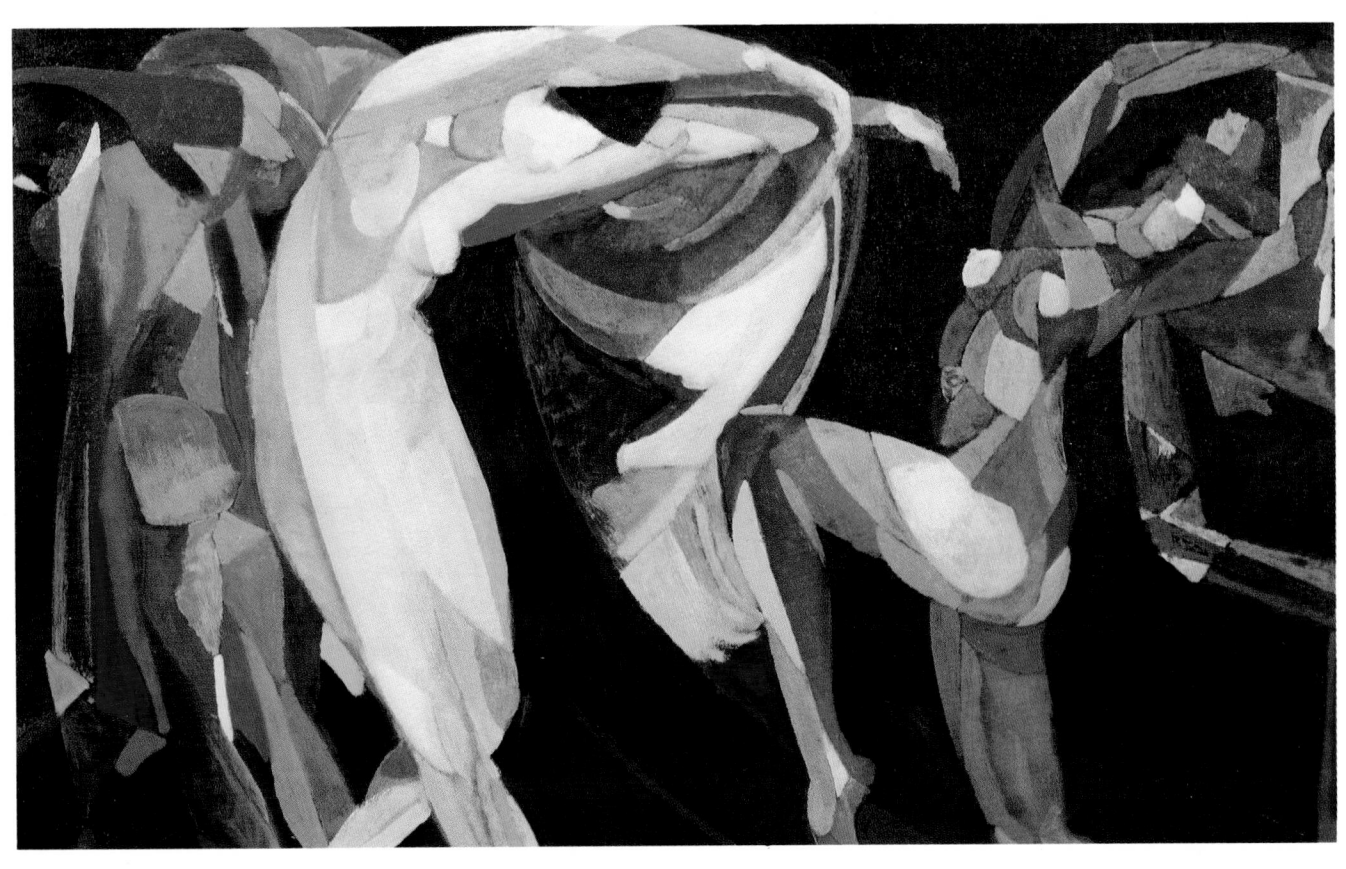

45. Arthur B. Davies, *Day of Good Fortune,* 1914.

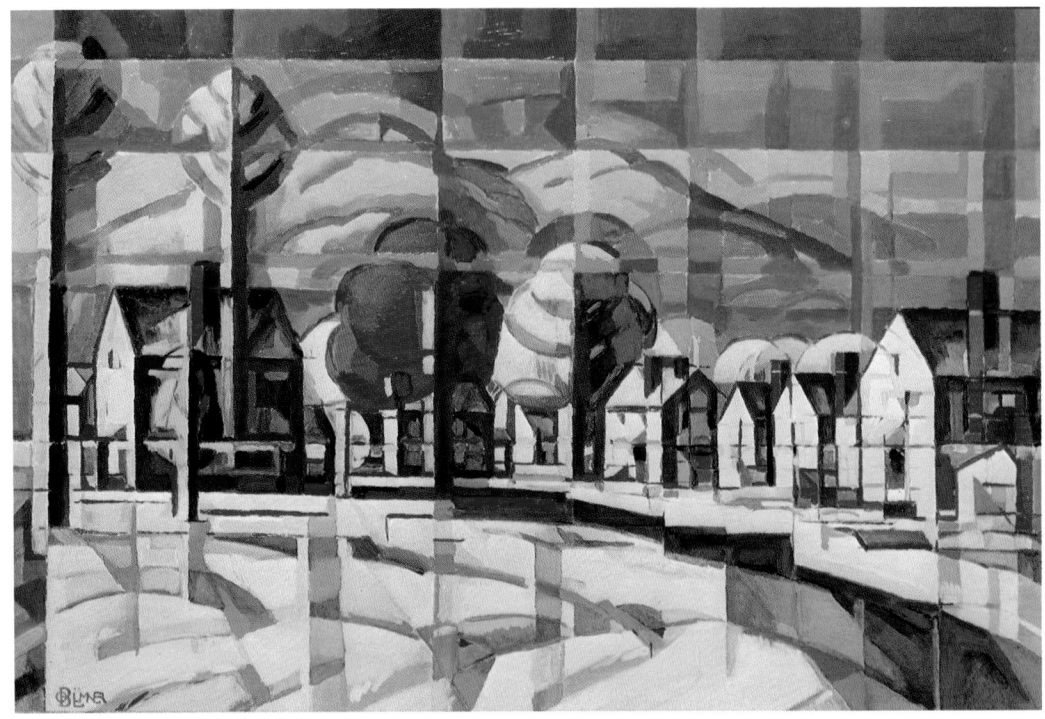

46. Oscar Bluemner, *Morning Light (Dover Hills, October)*, 1916.

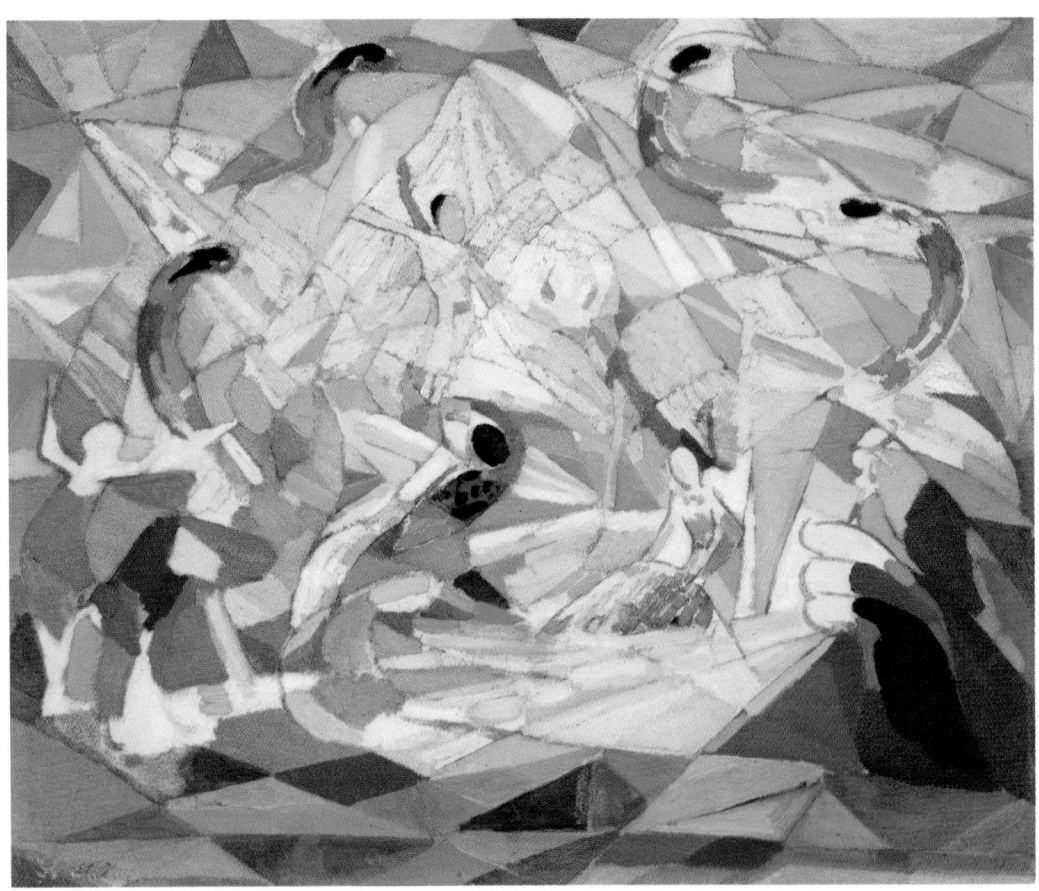

47. Joseph Stella, *Der Rosenkavalier*, 1913–14.

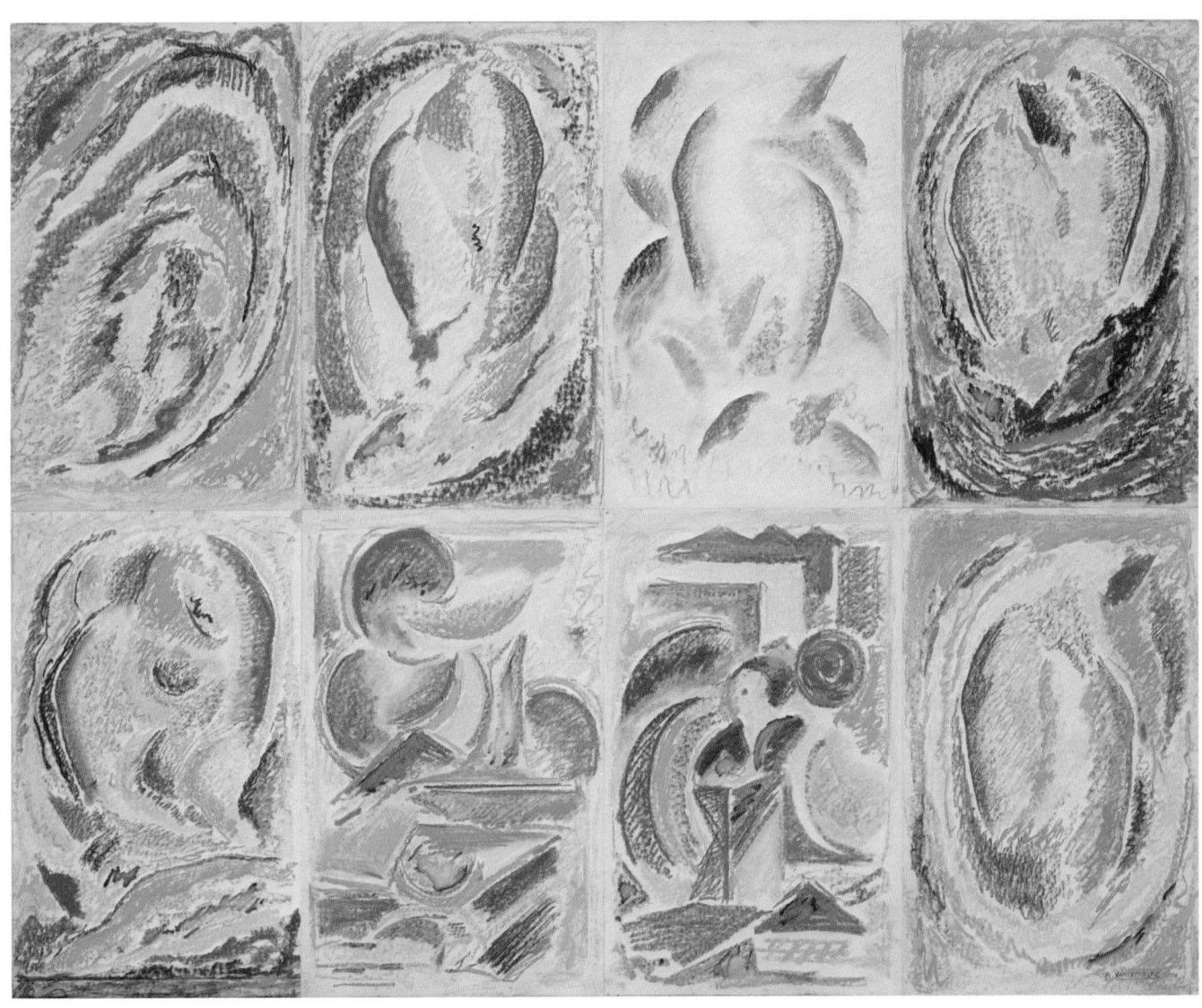

48. Abraham Walkowitz, *Creation,* 1914.

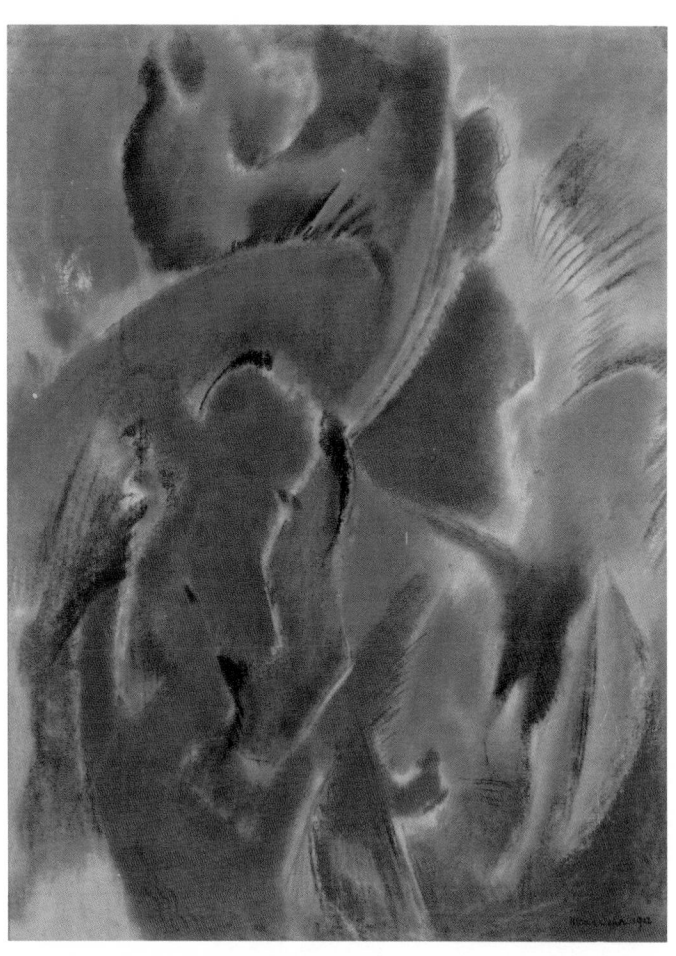

49. Max Weber, *Music,* 1912.

50. Max Weber, *Untitled Abstraction,* 1912.

51

51. Morgan Russell, *My First Painting, Old Westbury, Long Island,* 1907.

52. Morgan Russell, *The Bridge,* 1908.

53. Morgan Russell, *Nude Men on the Beach* [*Hommes nus sur la plage*], 1910.

54. Morgan Russell, *Isadora,* 1910.

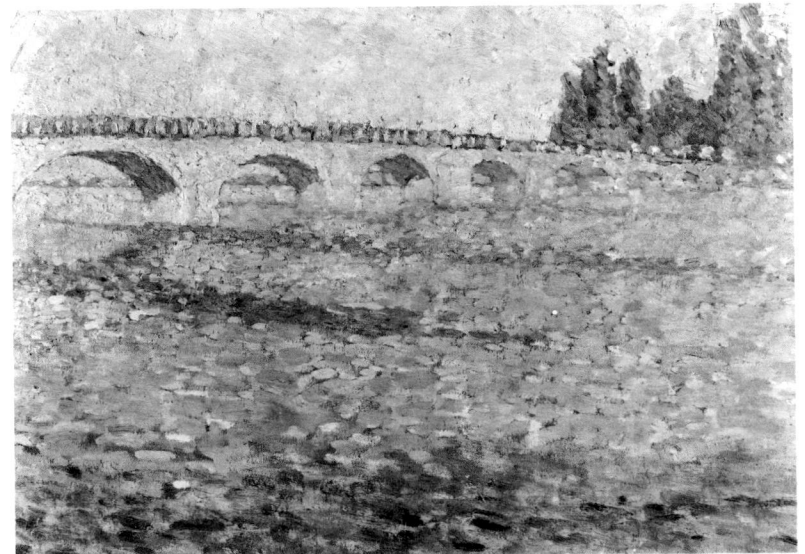

52

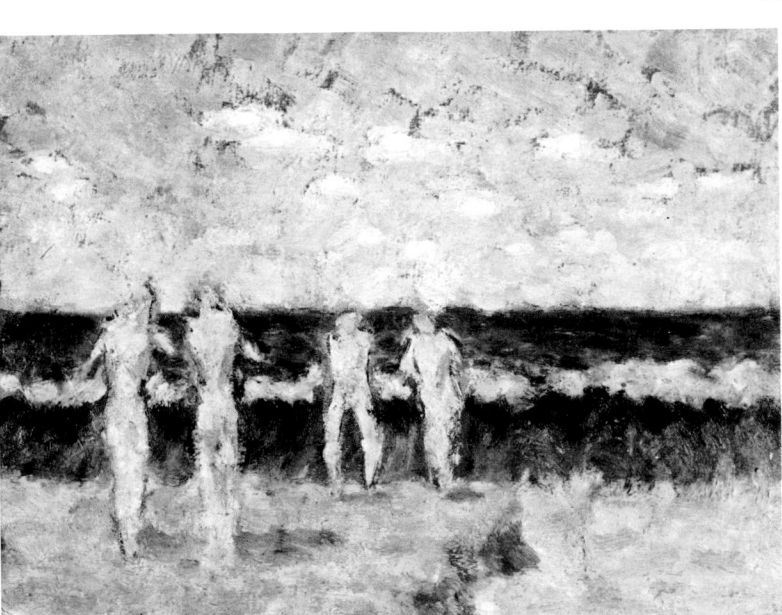

53

54

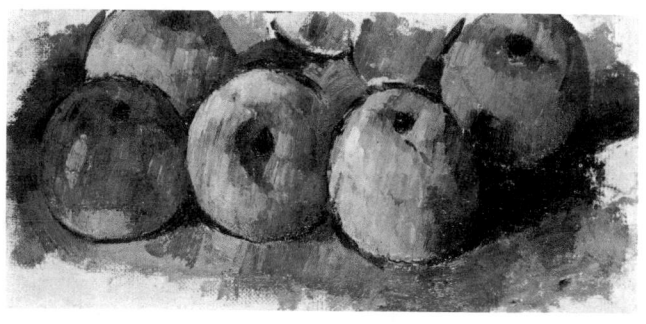

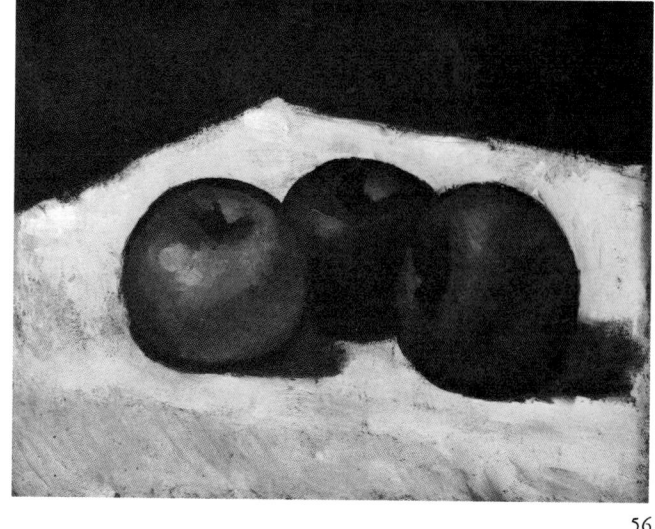

55

56

55. Paul Cézanne, *Apples* [*Pommes*], c.1873–77.
56. Morgan Russell, *Three Apples* [*Trois Pommes*], 1910.
57. Morgan Russell, *Still Life with Fruit and Glass,* c.1911–12.
58. Morgan Russell, *Still Life with Purple Plate,* 1912–13.

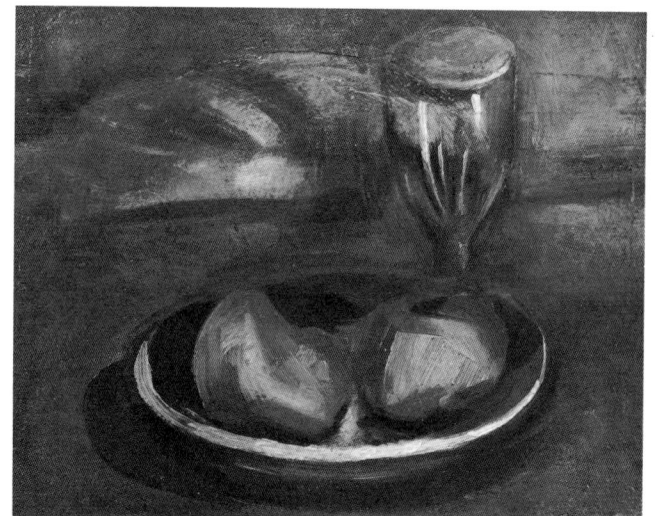

57

58

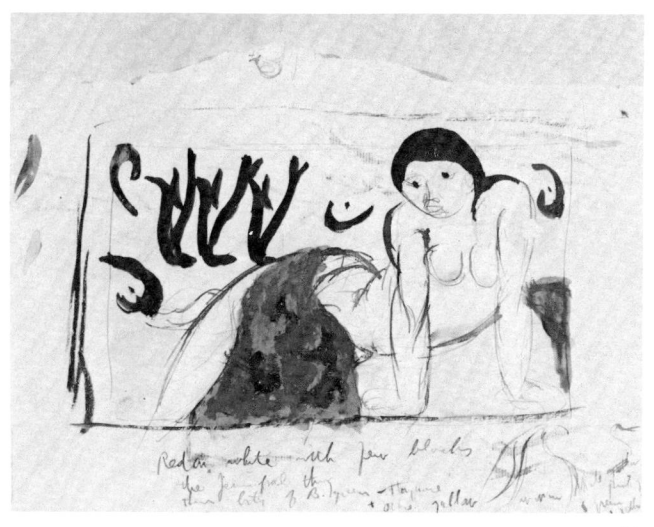

59

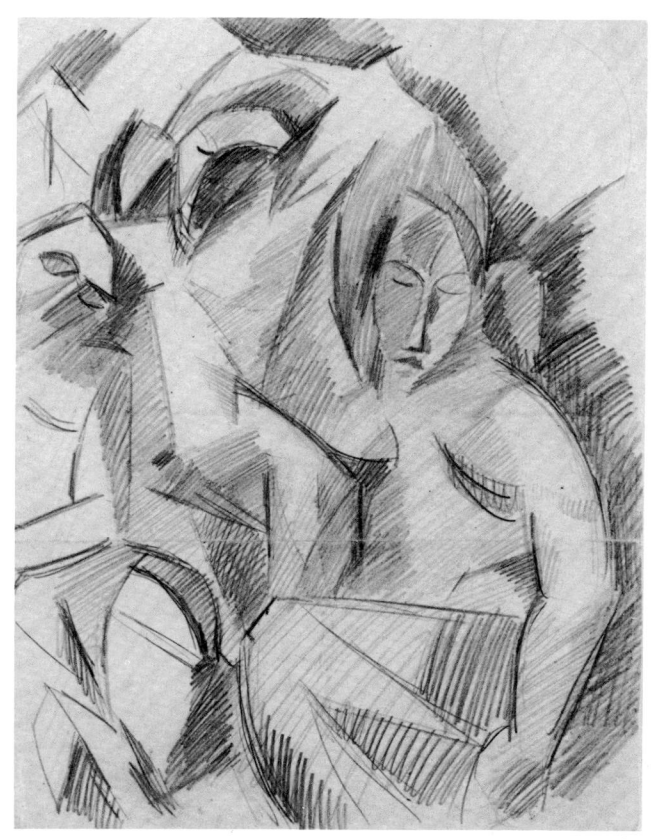

60

59. Morgan Russell, *Study for Reclining Nude Figure,* c.1909.

60. Morgan Russell, *Study after Picasso's "Three Women,"* c.1911.

61. Morgan Russell, *Self-Portrait Sketch with Sculpture,* c.1910.

62. Morgan Russell, *Sketch of a Male Nude,* 1912.

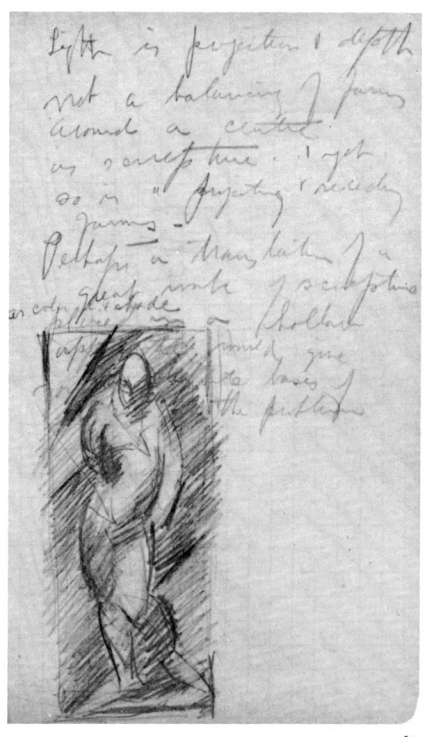

62

61

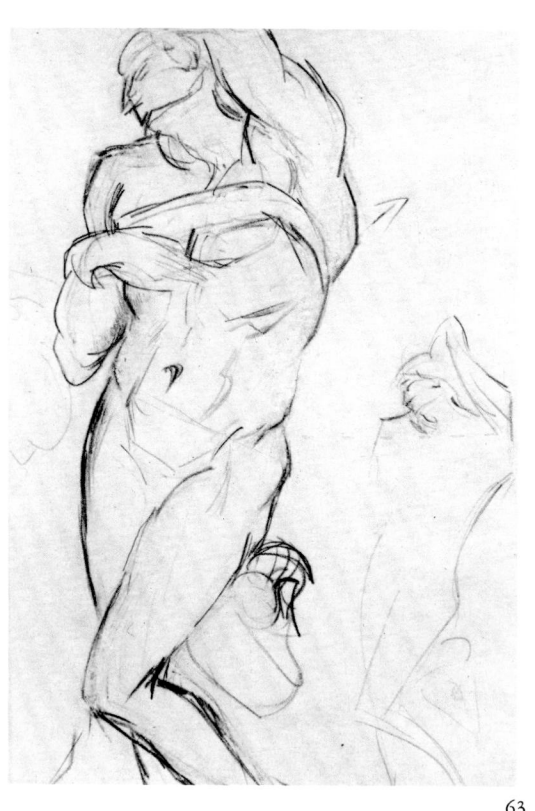

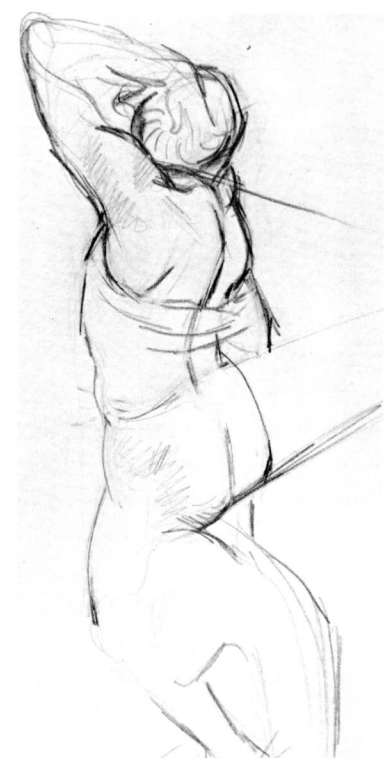

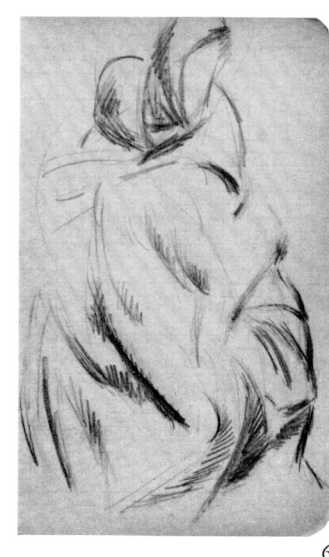

65

63

64

63. Morgan Russell, *Sketch after Michelangelo's "Dying Slave,"* c.1910–12.
64. Morgan Russell, *Study after Michelangelo's "Dying Slave,"* c.1910–12.
65. Morgan Russell, *Sketch after Michelangelo's "Pietà,"* 1912.
66. Morgan Russell, *Sketch for Synchromie en bleu violacé,* 1912.

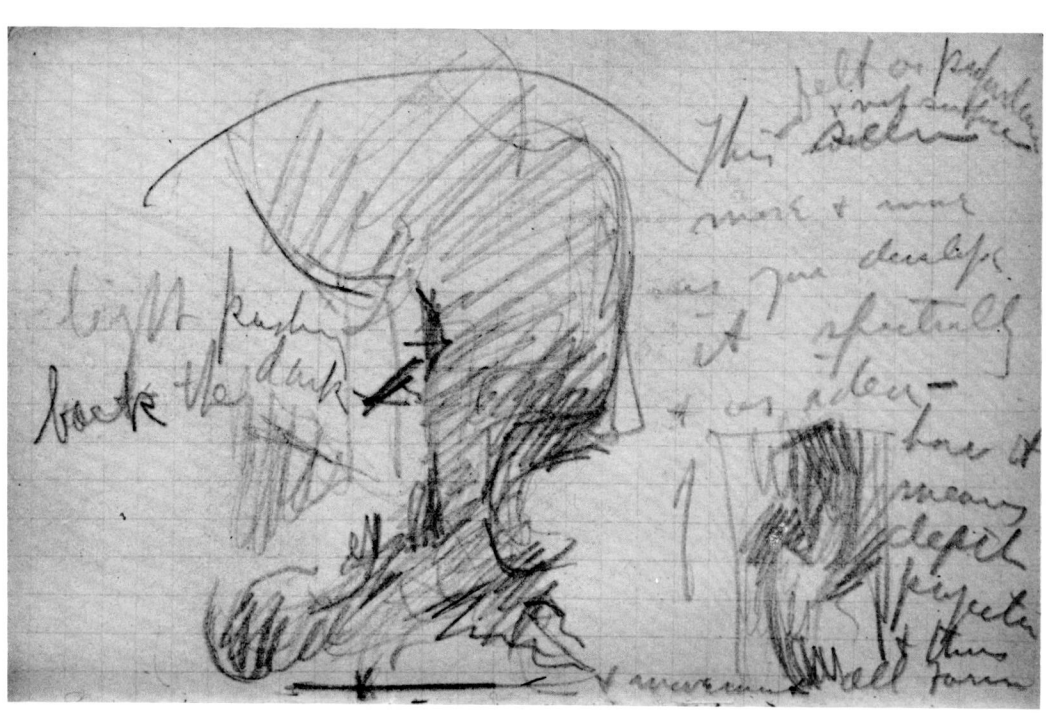

66

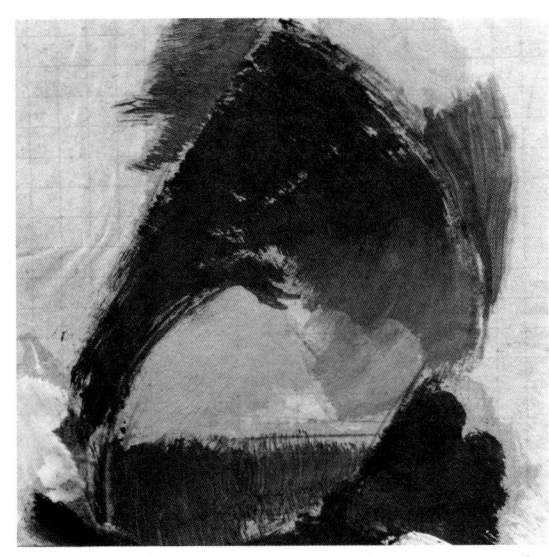

69

67. Morgan Russell, *Sketch for Synchromie en bleu violacé,* 1912.

68. Morgan Russell, *Sketch for Synchromie en bleu violacé,* 1912.

69. Morgan Russell, *Study for Synchromie en bleu violacé,* 1913.

70. Morgan Russell, *Study for Synchromie en bleu violacé,* 1913.

67

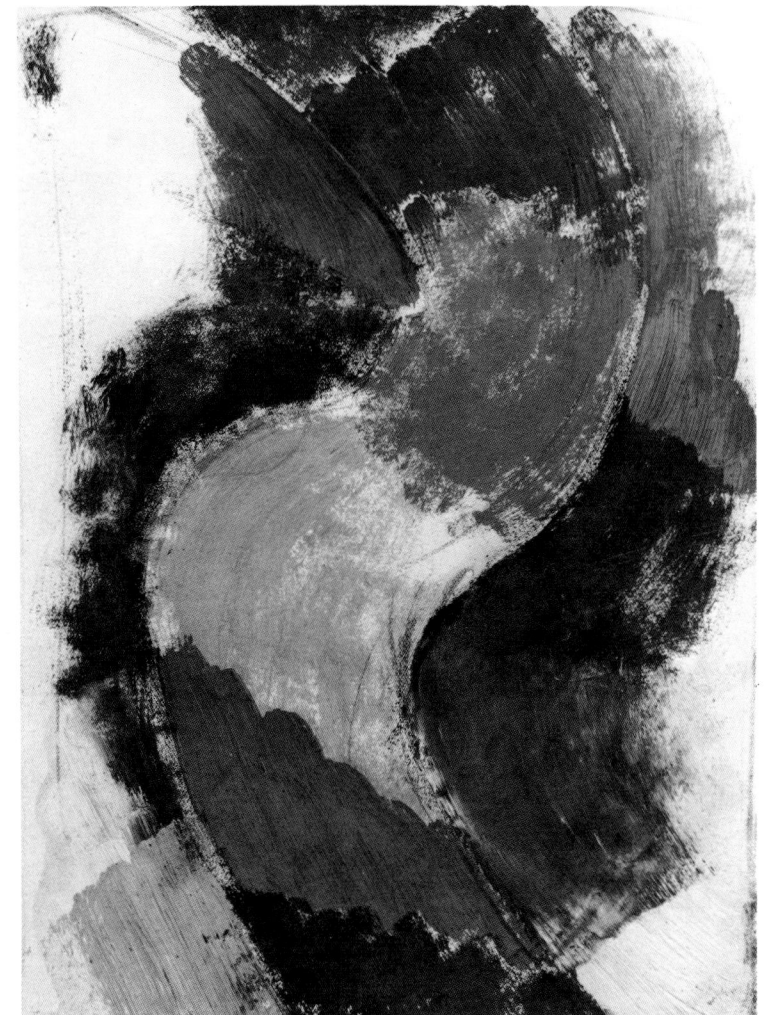

68

70

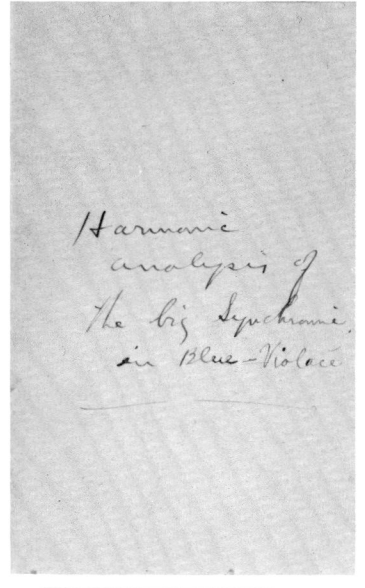

*Harmonic
analysis of
the big Synchromie
in Blue-Violace*

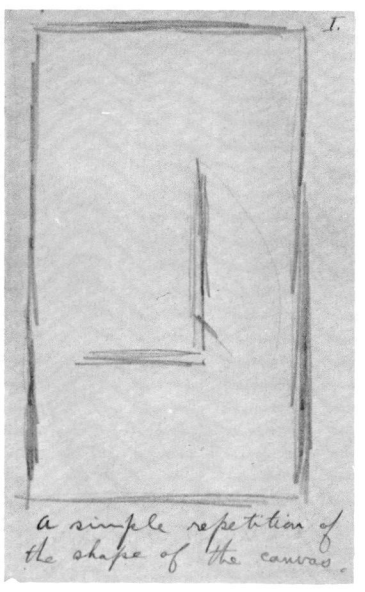

*a simple repetition of
the shape of the canvas.*

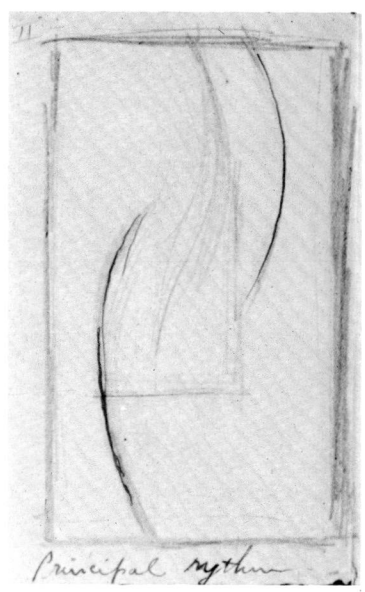

Principal rythm

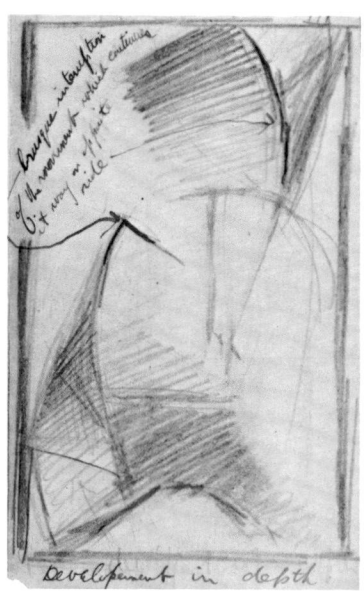

Development in depth

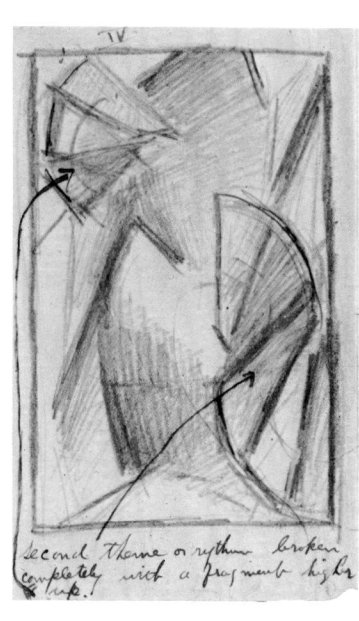

*Second theme or rythm broken
completely into a fragment higher
up.*

71. Morgan Russell,
*Harmonic Analysis of the big
Synchromie in Blue-Violacé*, 1913.

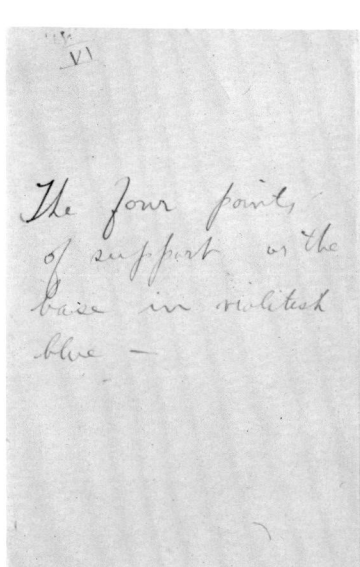

*The four points
of support or the
base in violetish
blue —*

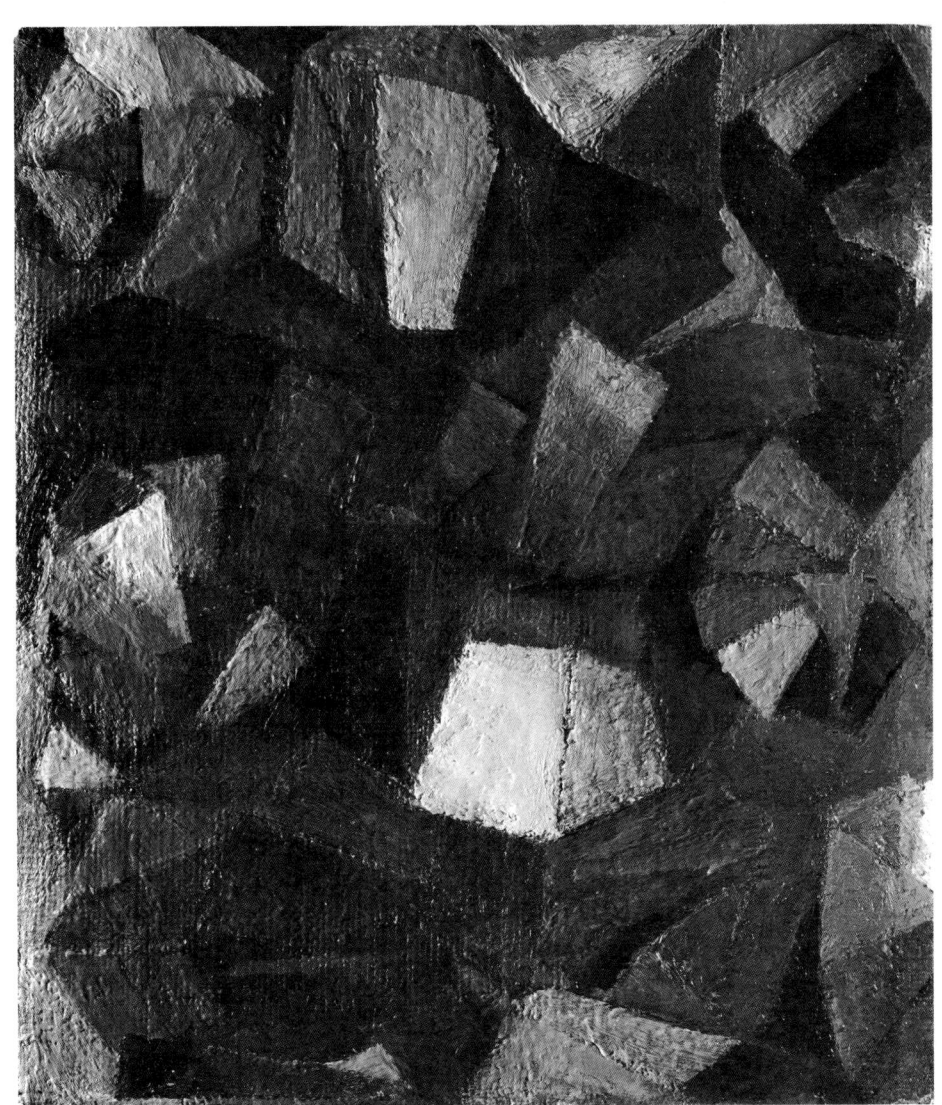

72

72. Morgan Russell,
*Creavit Deus Hominem (Synchromy
No. 3: Color Counterpoint)*, 1914.

73. Morgan Russell,
Studies after Michelangelo
(recto Pl. 74), 1913–14.

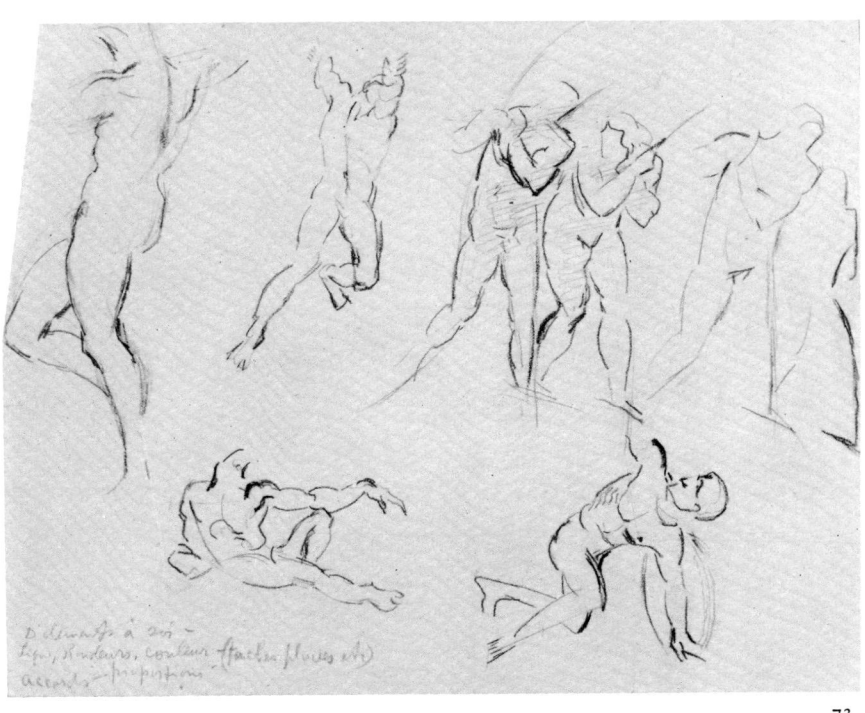

73

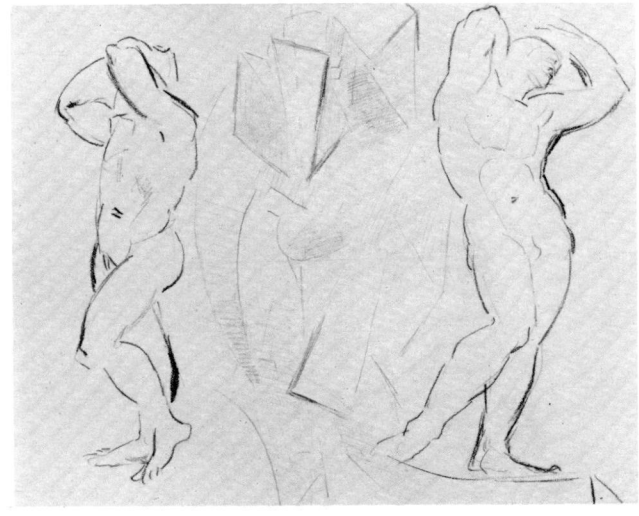

74

75

77

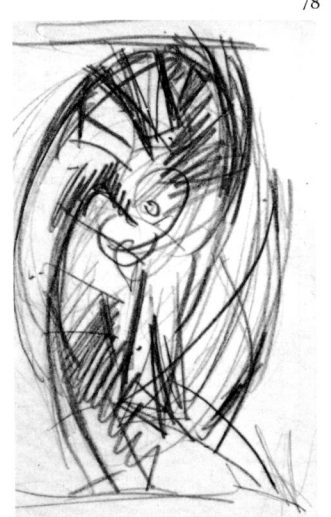

78

79

77. Morgan Russell,
Sketch of a Male Nude, 1913–14.

78. Morgan Russell,
*Study for Synchromy in Orange:
To Form,* 1914.

79. Morgan Russell,
*Study for Synchromy in Orange:
To Form,* 1914.

76

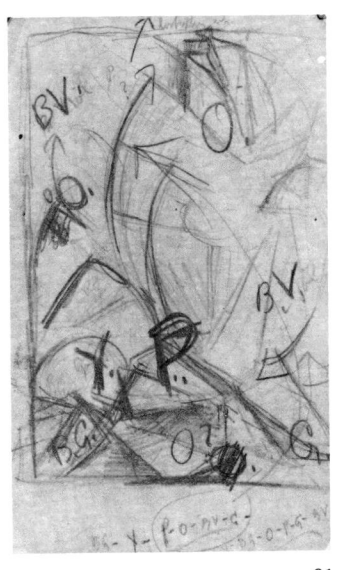

80

81

80. Morgan Russell, *Study for Synchromy in Orange: To Form*, 1914.

81. Morgan Russell, *Study for Synchromy in Orange: To Form*, 1913–14.

82. Morgan Russell, *Two Studies for Synchromy in Orange: To Form*, 1913–14.

83. Morgan Russell, *Study for Synchromy in Orange: To Form*, 1913–14.

84. Morgan Russell, *Study for Synchromy in Orange: To Form*, 1913–14.

85. Morgan Russell, *Study for Synchromy in Orange: To Form*, 1914.

82

83

84

85

86

89

86, 87. Morgan Russell, *Color Studies,* 1912.

88. Morgan Russell, *Color Study,* 1913.

89. Morgan Russell, *Sketch after Delaunay's "Homage to Blériot,"* 1914.

90. Morgan Russell, *Studies after Delaunay's "Homage to Blériot,"* 1914.

90

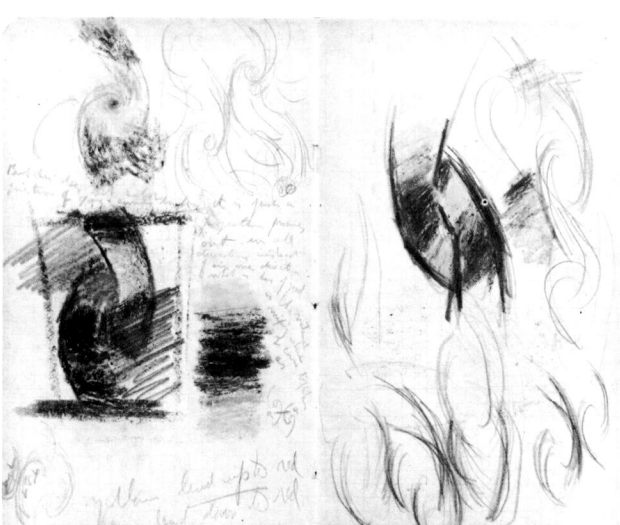

87

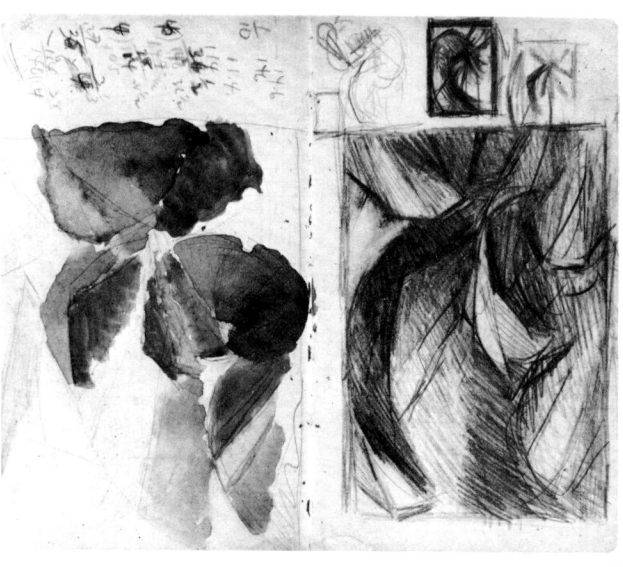

88

91. Morgan Russell, *Synchromy,* c.1914.
92. Morgan Russell, *Synchromy,* 1915.
93. Morgan Russell, *Tree Bench,* 1915.

91

92

93

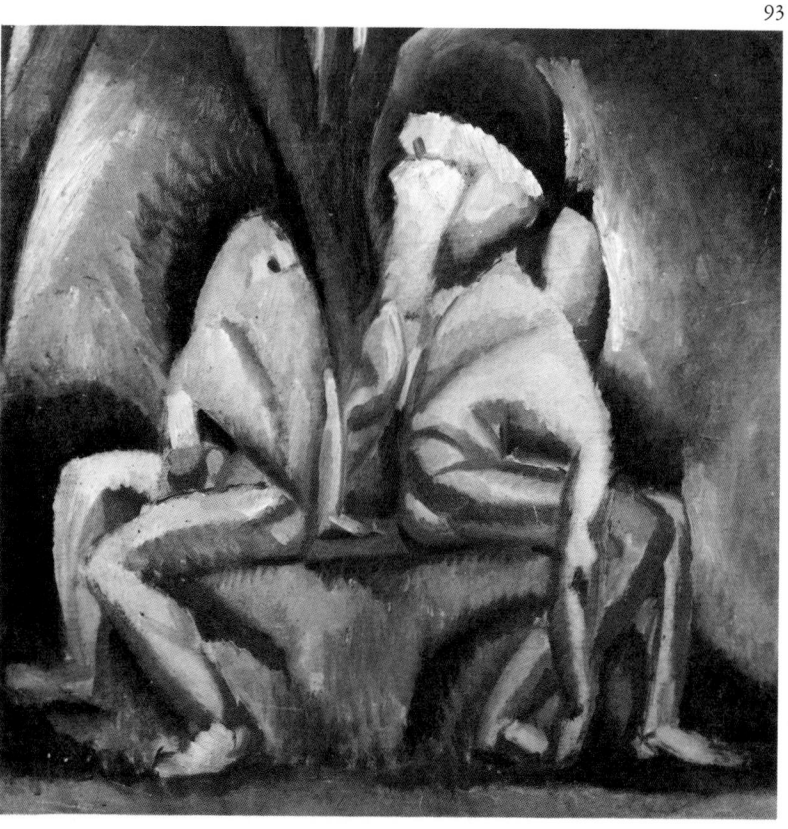

94

94. Morgan Russell, *Archaic Composition No. 1,* 1915–16.
95. Morgan Russell, *Archaic Composition No. 2,* 1915–16.
96. Morgan Russell, *Studies for Archaic Composition,* 1915.

96

97

97. Morgan Russell, *Studies for Archaic Composition,* 1915.
98. Morgan Russell, *Sketch of Blaise Cendrars,* 1921.
99. Morgan Russell, *Study for Kinetic Light Machine,* c.1916–23.

99

98

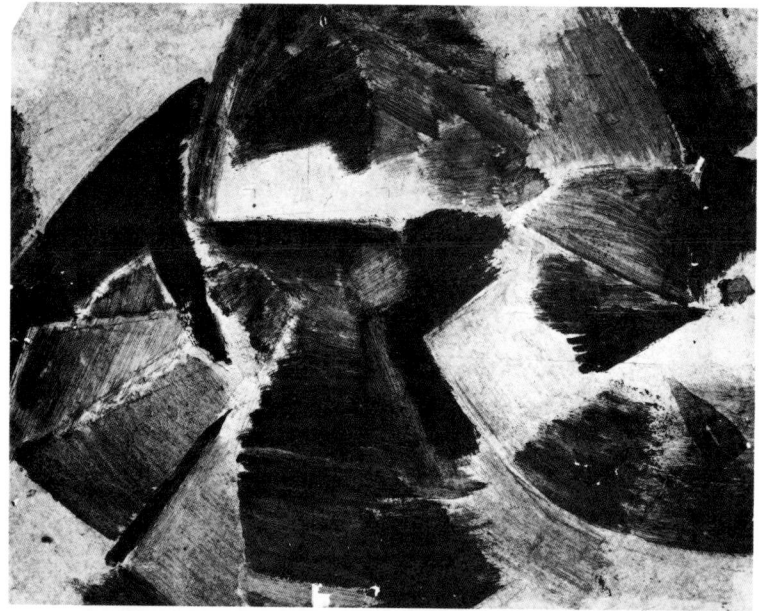

100

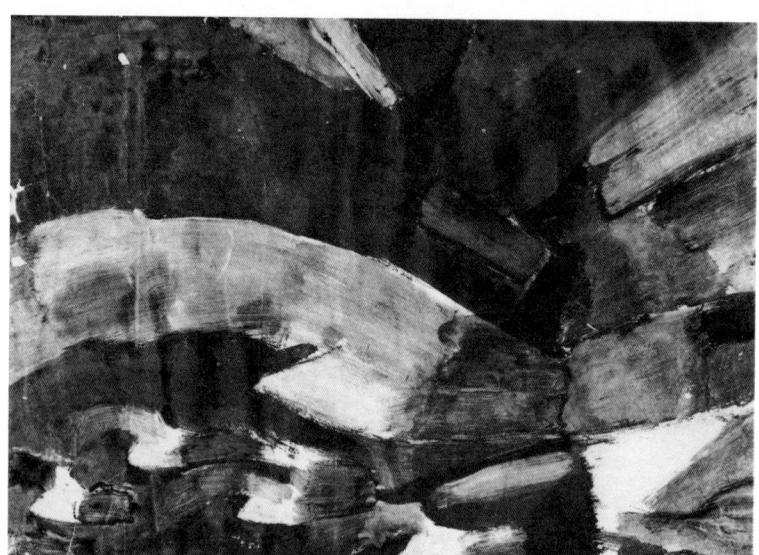

101

100. Morgan Russell, *Untitled Study in Transparency,* c.1913–23.

101. Morgan Russell, *Untitled Study in Transparency,* c.1913–23.

102. Morgan Russell, *Untitled Study in Transparency,* c.1913–23.

103. Morgan Russell, *Eidos 23,* 1922–23.

104. Morgan Russell, *Synchromy,* 1922–23.

105. Morgan Russell, *Synchromy No. 6 (One Part of Three-Part Synchromy),* c.1922–23.

106. Morgan Russell, *Color Form Synchromy (Eidos),* 1922–23.

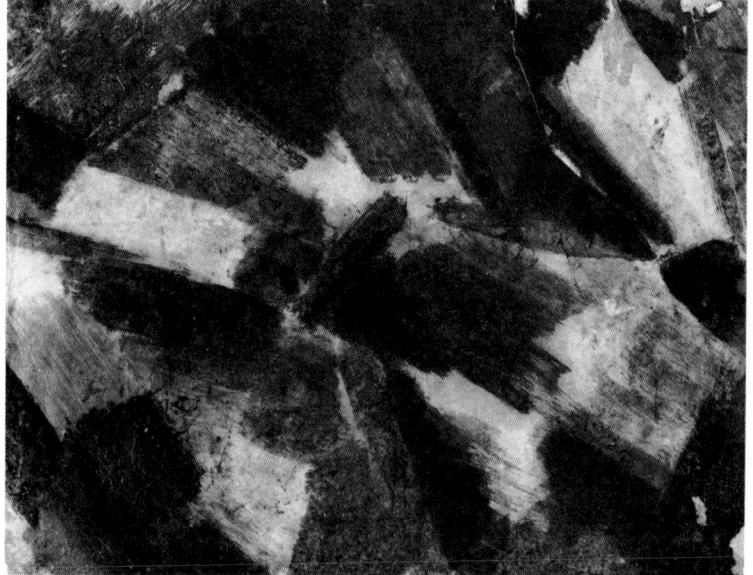

102

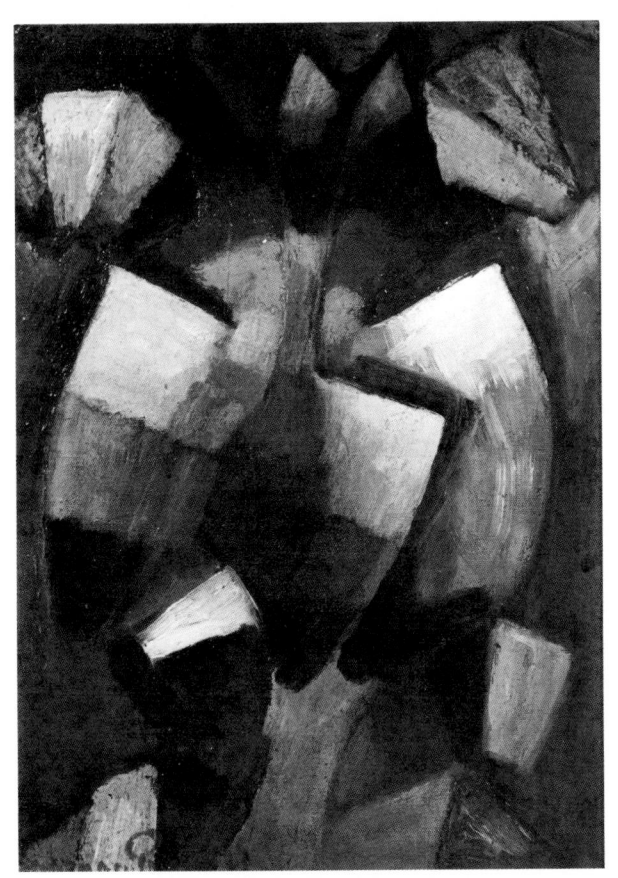

103

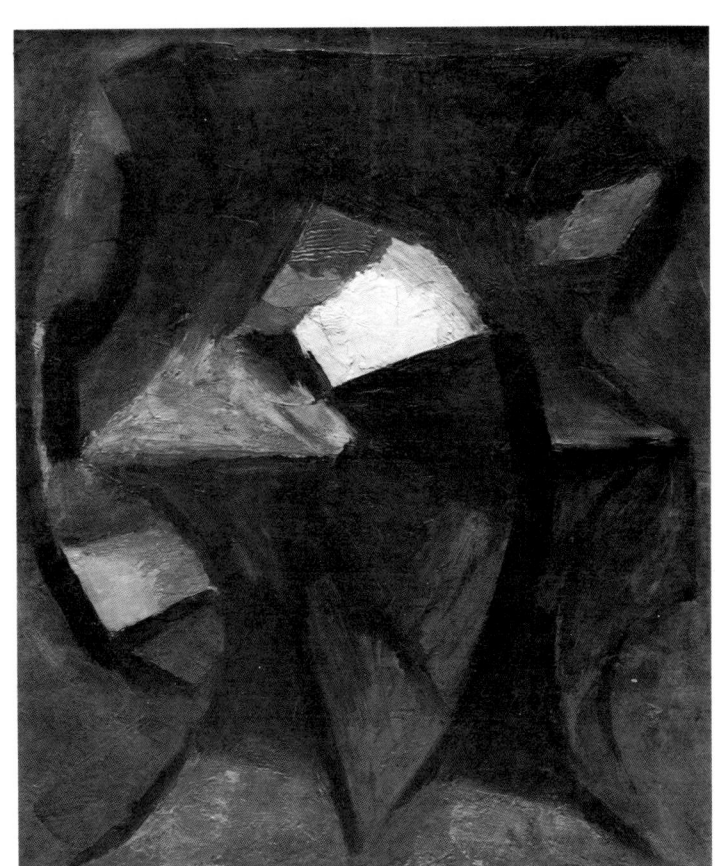

104

105

106

"Conception" Life-cycle serie no. II -
Tinted sketch for Synchromie in Blue-violet

107. Stanton Macdonald-Wright,
Study for Conception Synchromy, 1914.

108. Stanton Macdonald-Wright,
Synchromy in Blue-Green, 1916.

109. Stanton Macdonald-Wright,
Synchromy 3, c.1916.

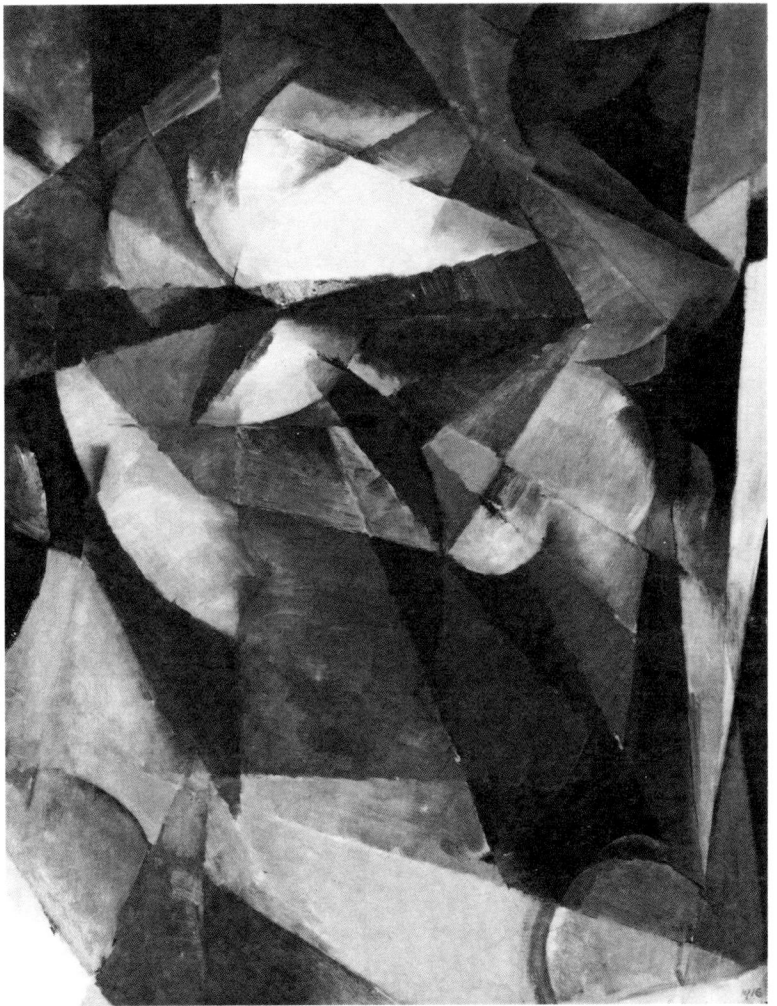

108

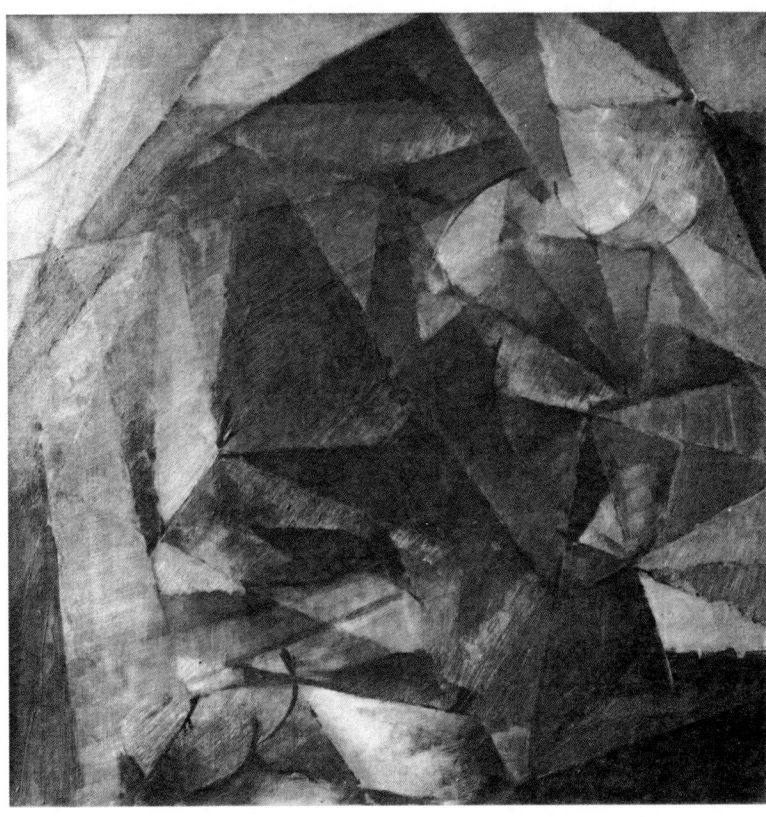

109

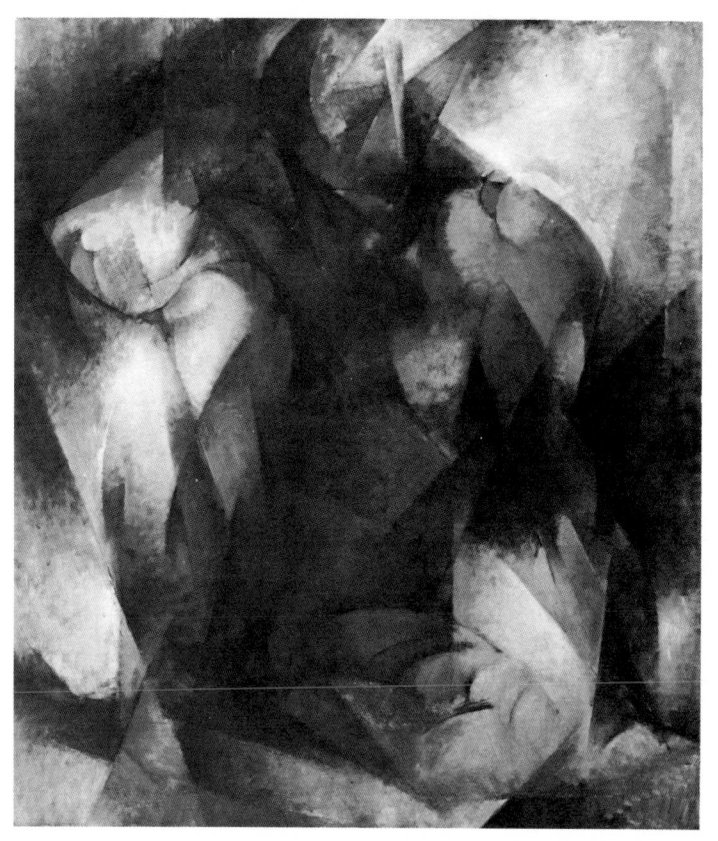

110

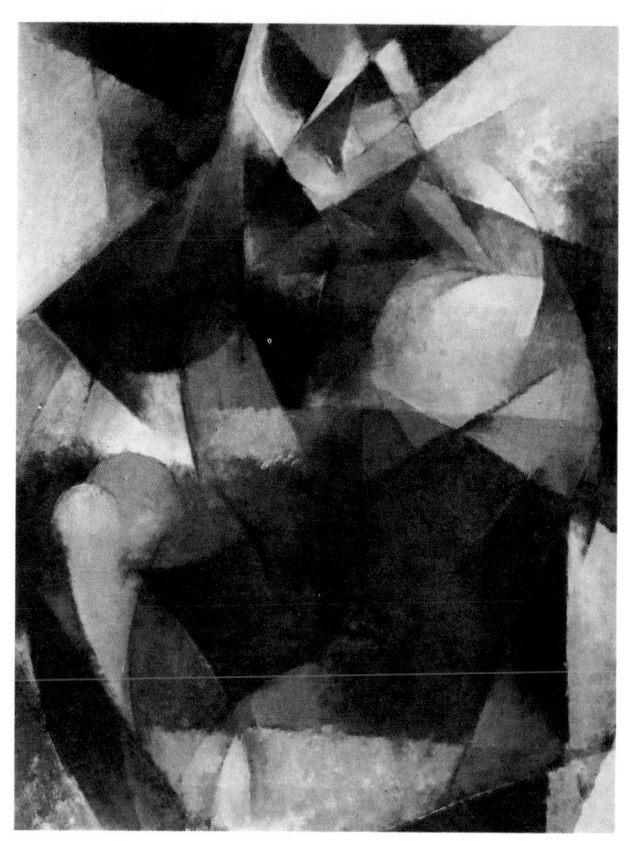

111

112

113

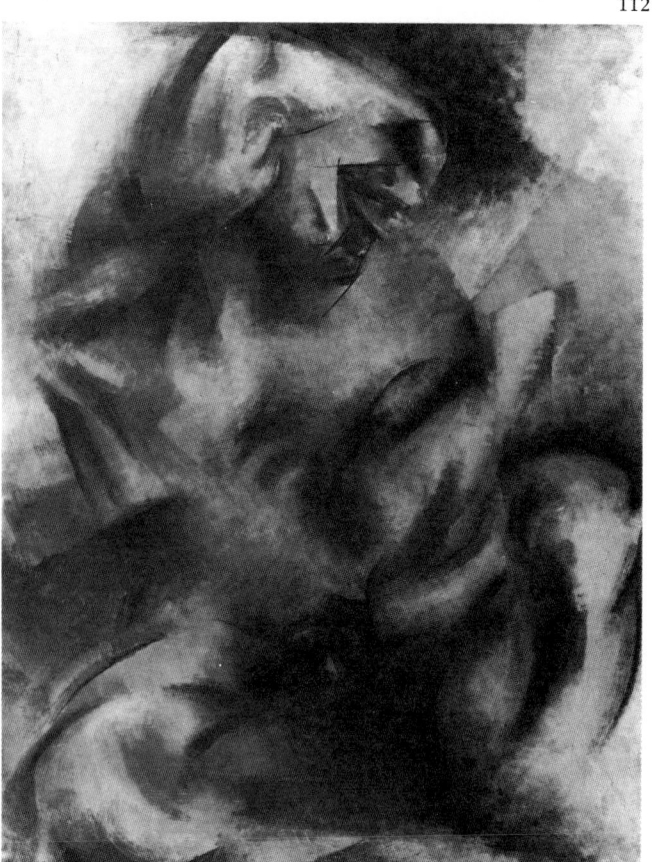

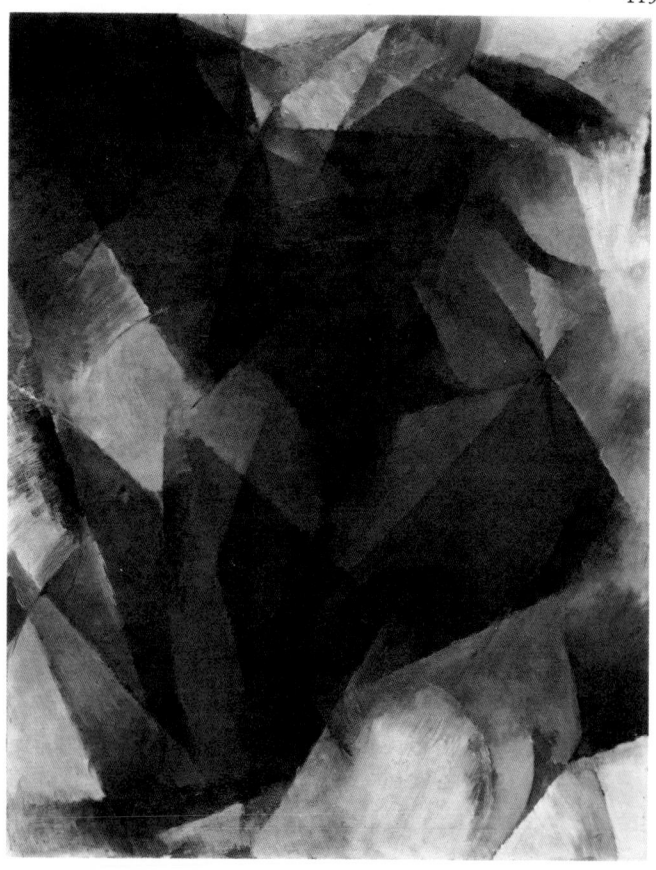

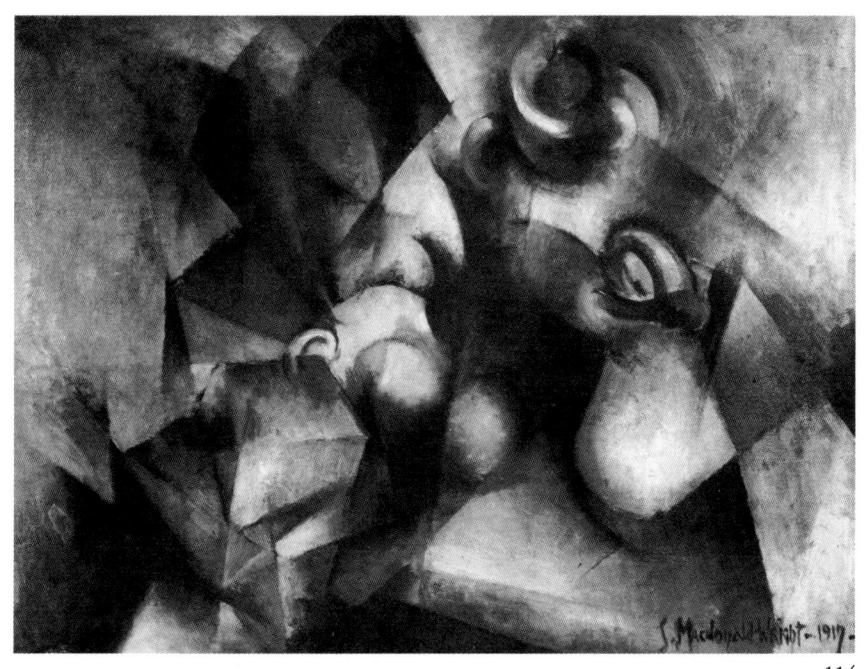

114

115

110. Stanton Macdonald-Wright, *Synchromy in Green and Orange*, 1916.
111. Stanton Macdonald-Wright, *Synchromy in Blue*, c.1917.
112. Stanton Macdonald-Wright, *Synchromy in Purple*, 1917.
113. Stanton Macdonald-Wright, *Synchromy*, 1917.
114. Stanton Macdonald-Wright, *Still Life Synchromy*, 1917.
115. Stanton Macdonald-Wright, *Trumpet Flowers*, 1919.
116. Stanton Macdonald-Wright, *Sunrise Synchromy in Violet*, 1918.
117. Stanton Macdonald-Wright, *Abstraction: Nude in Orange*, 1919.

116

117

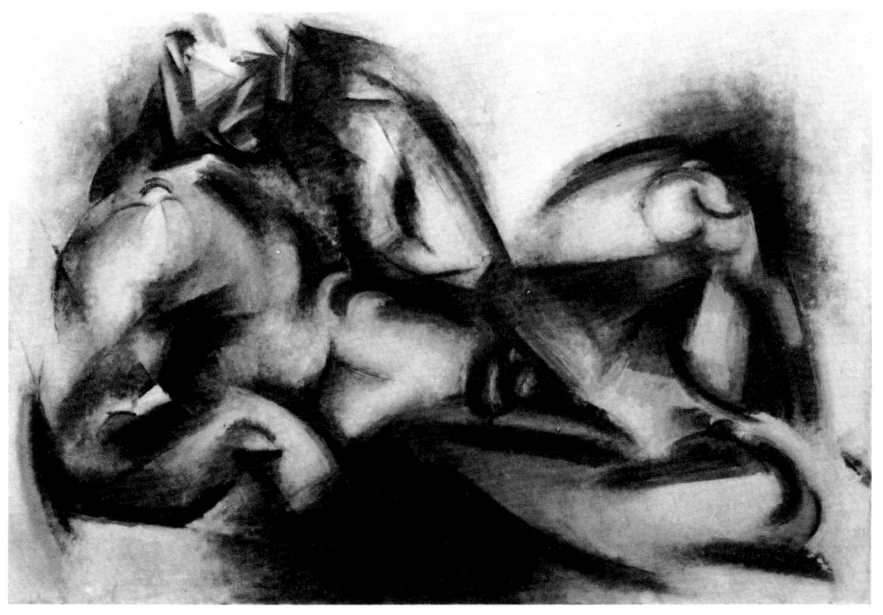

118

118. Stanton Macdonald-Wright,
California Landscape, c.1916.

119. Stanton Macdonald-Wright,
Canyon Synchromy (Orange), c.1919.

120. Thomas Hart Benton, *Constructivist Still Life:
Synchromist Color,* 1917.

121. Thomas Hart Benton, *People of Chilmark
(Figure Composition),* 1920.

122. Thomas Hart Benton, *Screen with an
Abstract Sea Motif,* c.1925.

119

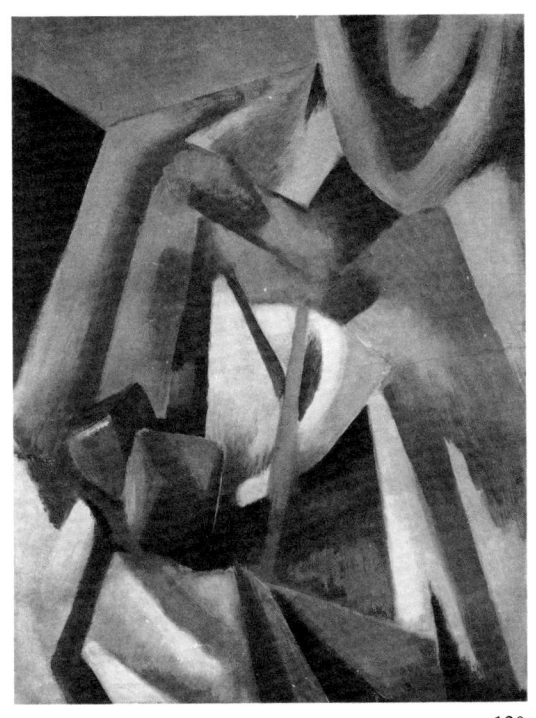

120

121

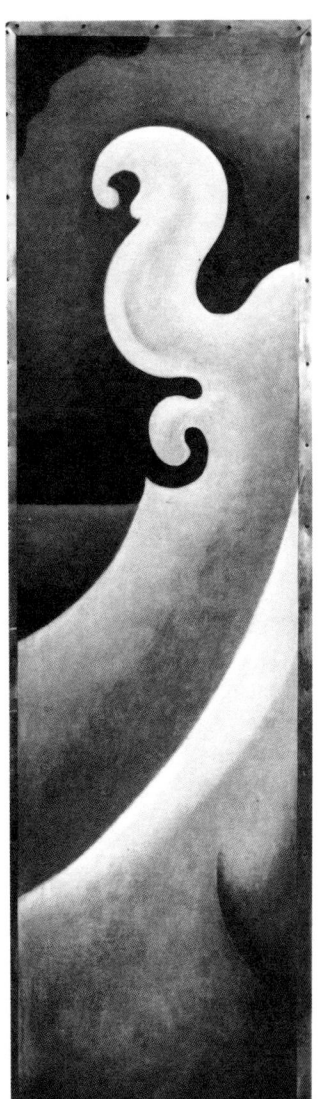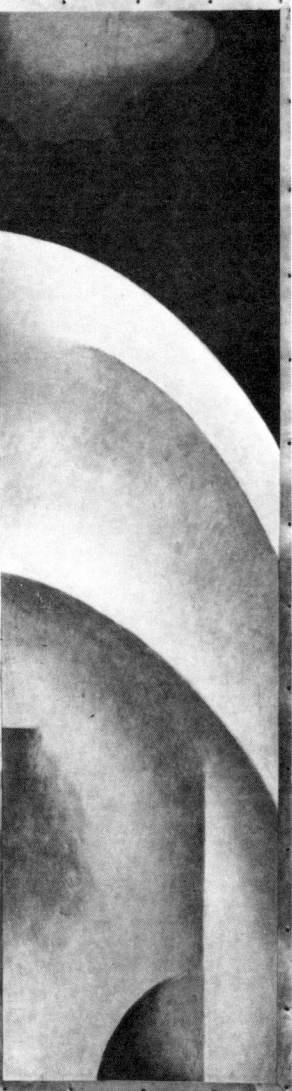

122

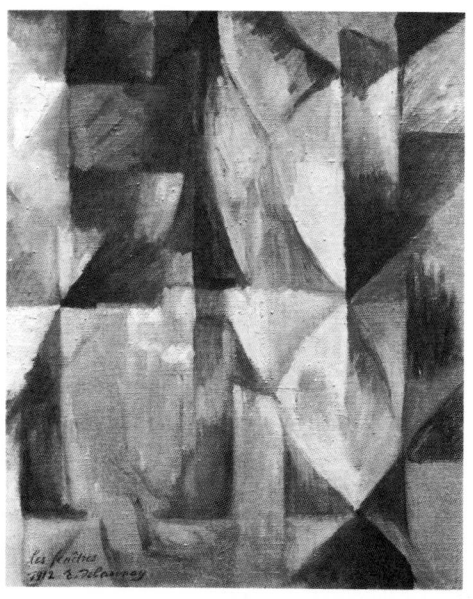

123

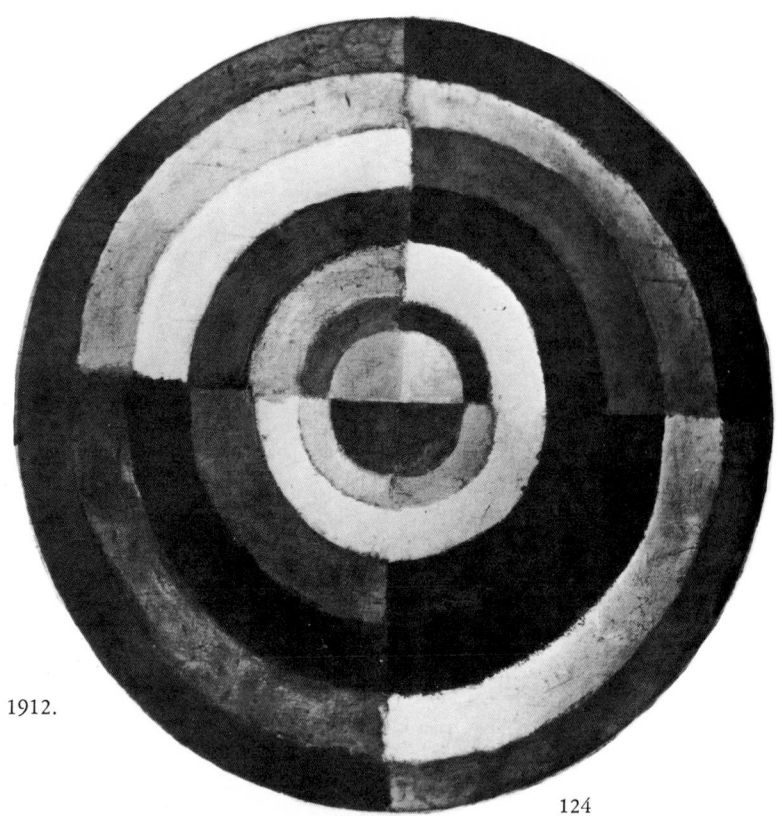

123. Robert Delaunay, *The Windows* [*Les Fenêtres*], 1912.

124. Robert Delaunay,
The First Disc [*Le premier Disque*], 1912.

124

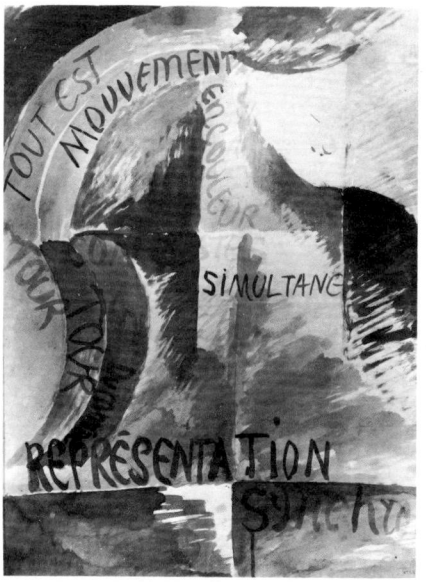

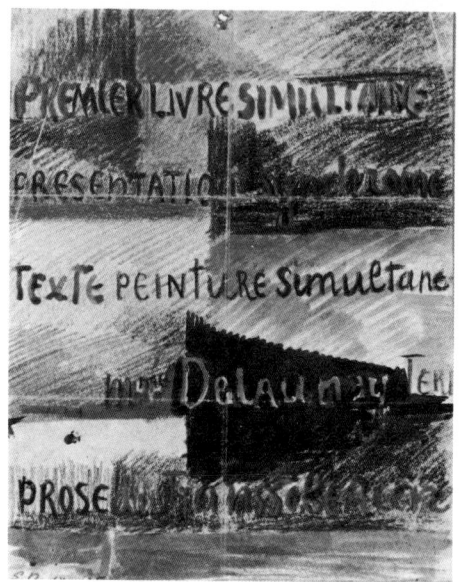

125. Sonia Delaunay,
*Simultaneous Poster
for Smirnoff's Lecture
"The Simultaneous,"* 1913.

126. Sonia Delaunay, *Project
for Poster for "La Prose du
Transsibérien et de la petite
Jehanne de France,"* 1913.

127. Sonia Delaunay,
*Advertisement for "La Prose du
Transsibérien et de la petite
Jeanne* [sic] *de France,"* 1913.

125

126

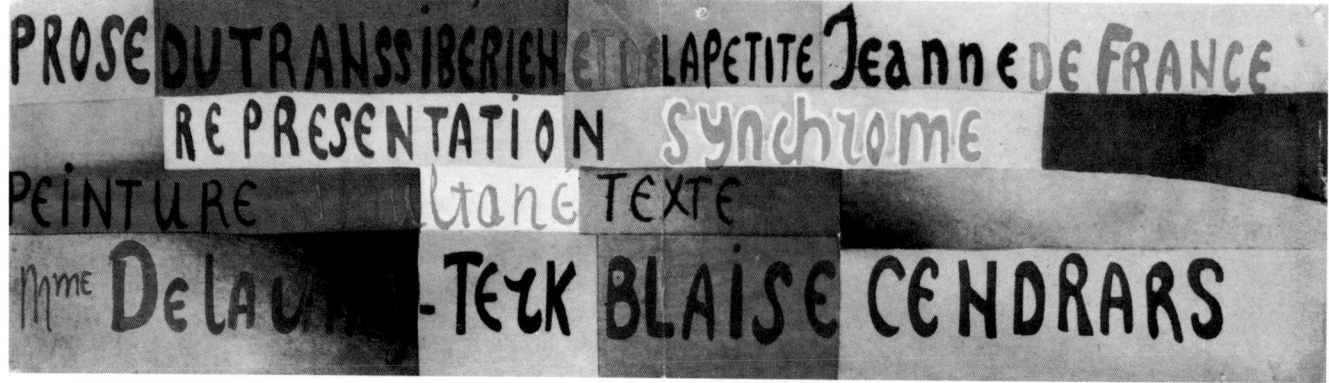

127

128

129

128. Arthur Burdett Frost, Jr., *Drawing for Harlequin,* 1914.

129. Arthur Burdett Frost, Jr., *Abstraction* (unfinished), 1917.

130. Patrick Henry Bruce, *Still Life,* c.1911.

131. Patrick Henry Bruce, *Still Life with Tapestry,* 1911–12.

130

131

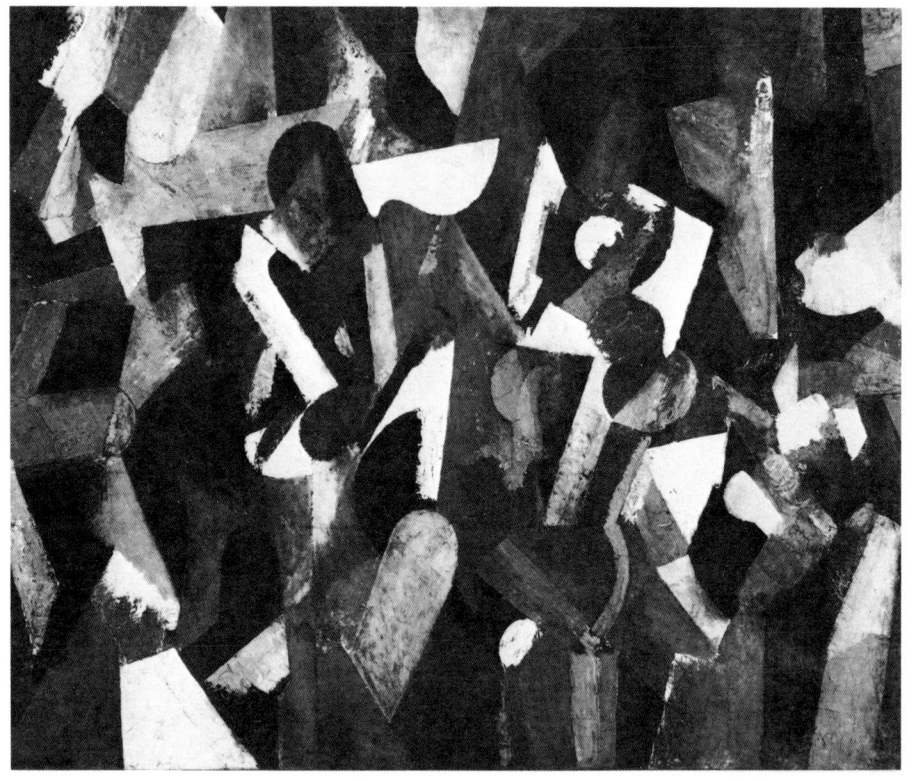

132

133

134

132. Patrick Henry Bruce, *Composition V*, 1916.
133. Patrick Henry Bruce, *Composition II*, 1916.
134. Patrick Henry Bruce, *Forms*, 1920–21.
135. Patrick Henry Bruce, *Untitled (Forms)*, 1920–21.

135

136

137

136. James Henry Daugherty, *Futurist Picture of the Opening Game,*
from *New York Sunday Herald,* April 12, 1914.

137. James Henry Daugherty, *Broadway Nights,*
from *New York Sunday Herald,* January 31, 1915.

138. James Henry Daugherty, *Mural Decoration,* 1918.

139. James Henry Daugherty, *Simultaneous Contrasts,* 1918.

139

138

140

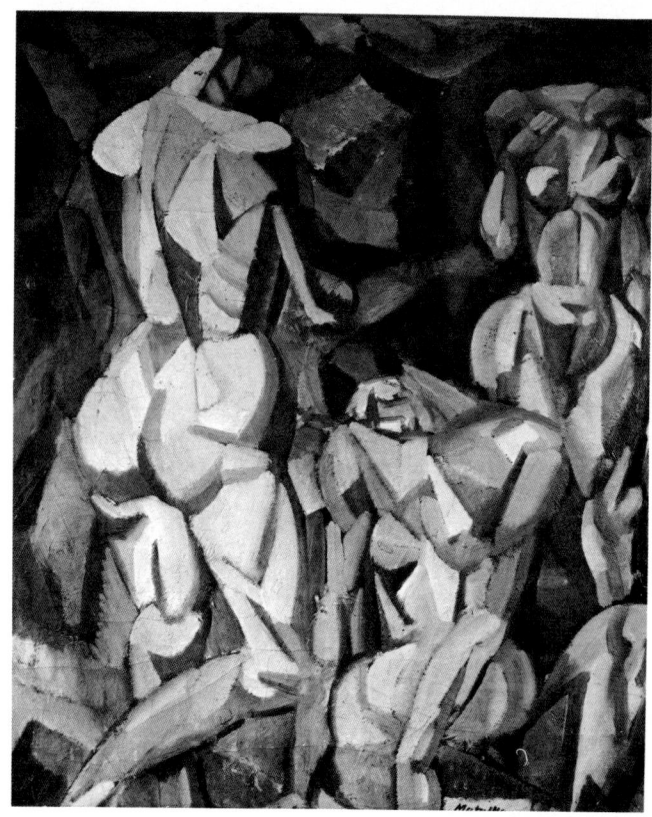

141

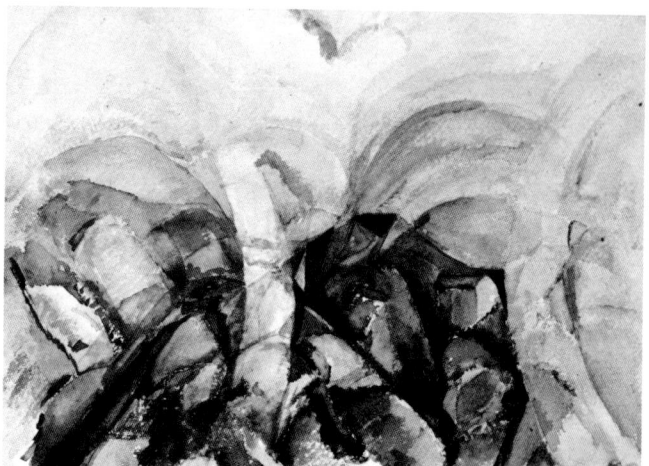

142

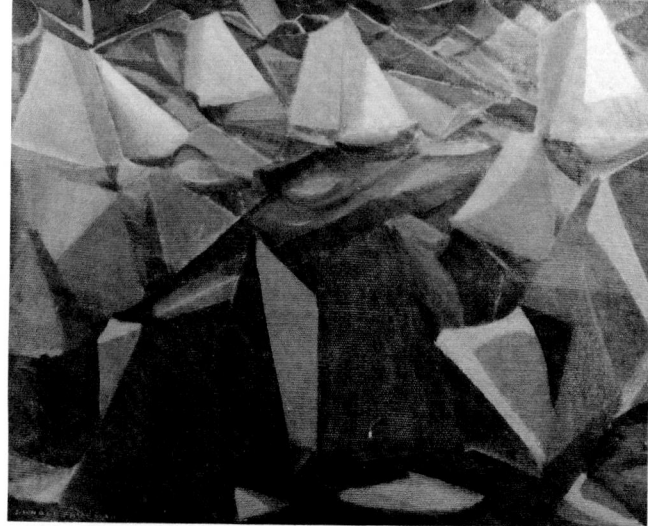

143

140. Jay Van Everen, *Abstraction,* 1920.
141. Jan Matulka, *Cubist Nudes,* c.1915–16.
142. Arnold Friedman, *Hillside,* c.1917.
143. Arnold Friedman, *Untitled,* 1919.

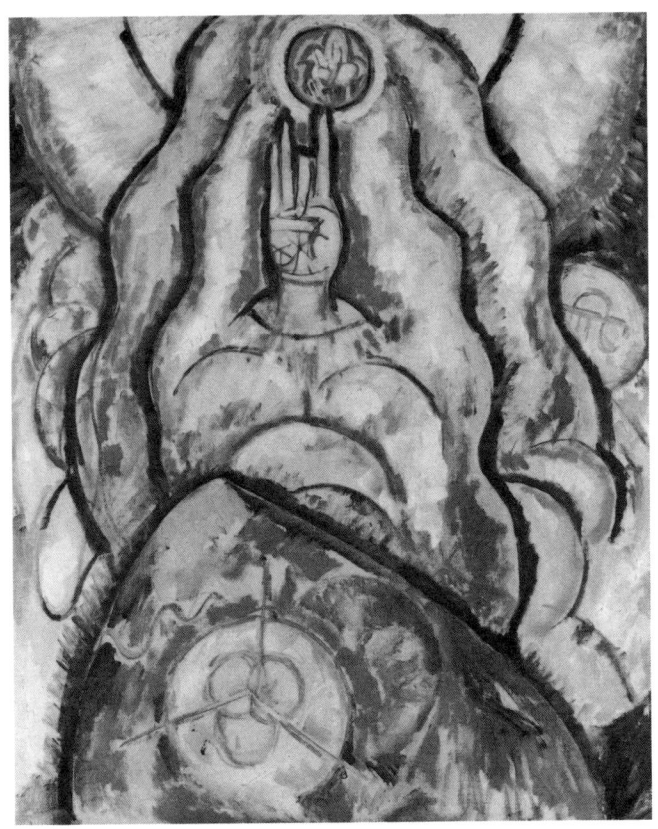

144

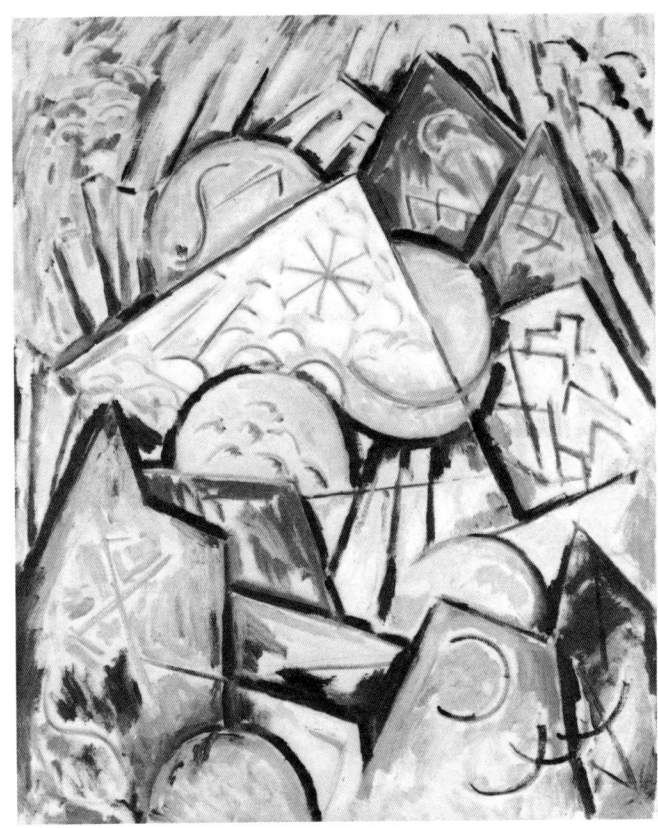

145

144. Marsden Hartley, *Portrait Arrangement No. 2*, 1912–13.

145. Marsden Hartley, *Painting No. 6*, 1913.

146. Marsden Hartley, *Abstraction Blue, Yellow and Green*, c.1913.

147. Marsden Hartley, *Composition*, 1914.

146

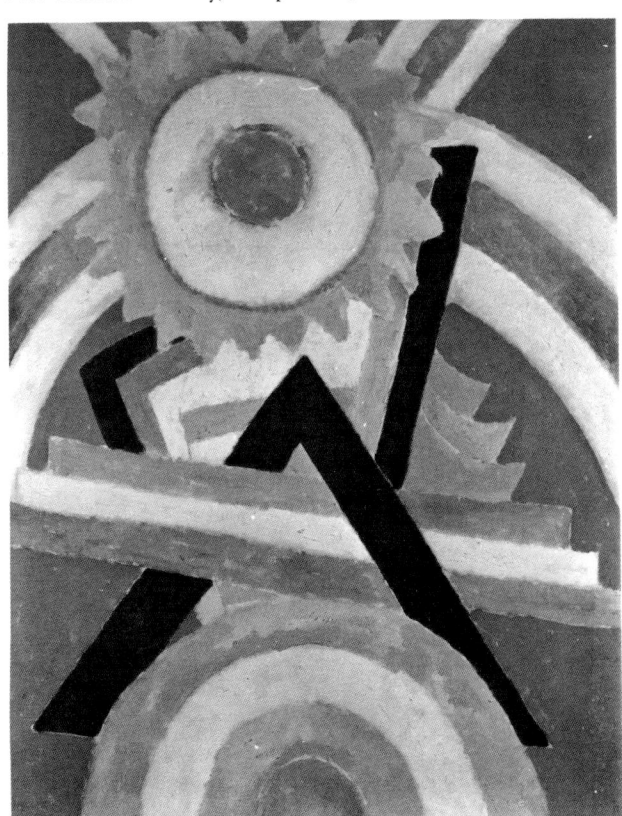

147

148

149

148. Alfred H. Maurer, *Landscape,* c.1916–17.
149. Alfred H. Maurer, *Abstraction,* c.1916–19.
150. Arthur Dove, *Abstraction,* 1914.
151. Georgia O'Keeffe, *From the Plains I,* 1919.

150

151

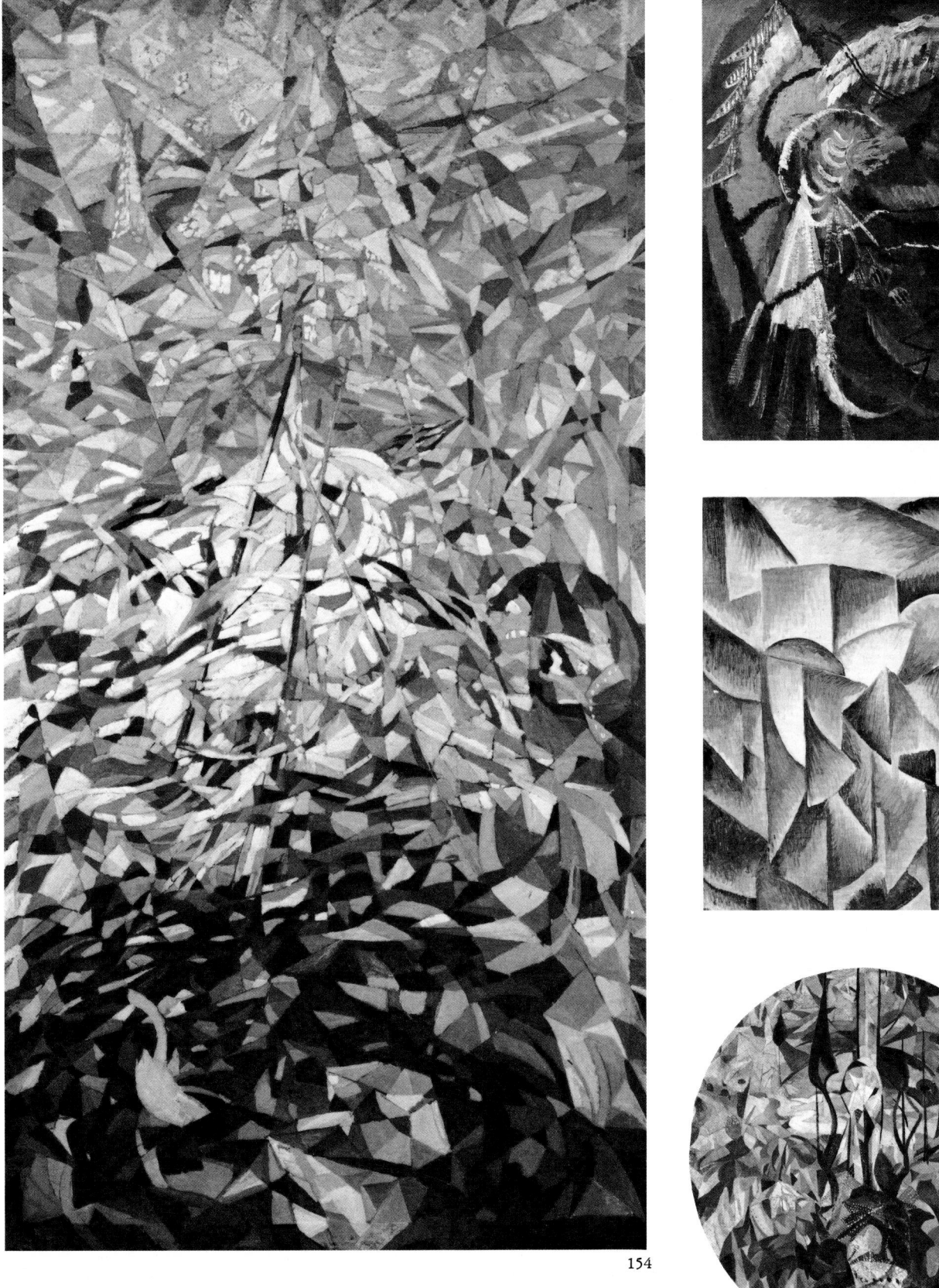

152

153

154

155

152. Ben Benn, *Sunset,* 1916.
153. Konrad Cramer, *Blocks,* 1912.
154. Joseph Stella, *Spring,* 1914.
155. Joseph Stella, *Coney Island,* c.1915.

157

156. Manierre Dawson, *Ariel,* 1912.

157. Arthur B. Davies, *Figures,* 1916.

158. Henry Fitch Taylor, *The Parade—Abstracted Figures,* c.1913.

159. Henry Fitch Taylor, *Untitled (Abstraction),* 1915.

156

158

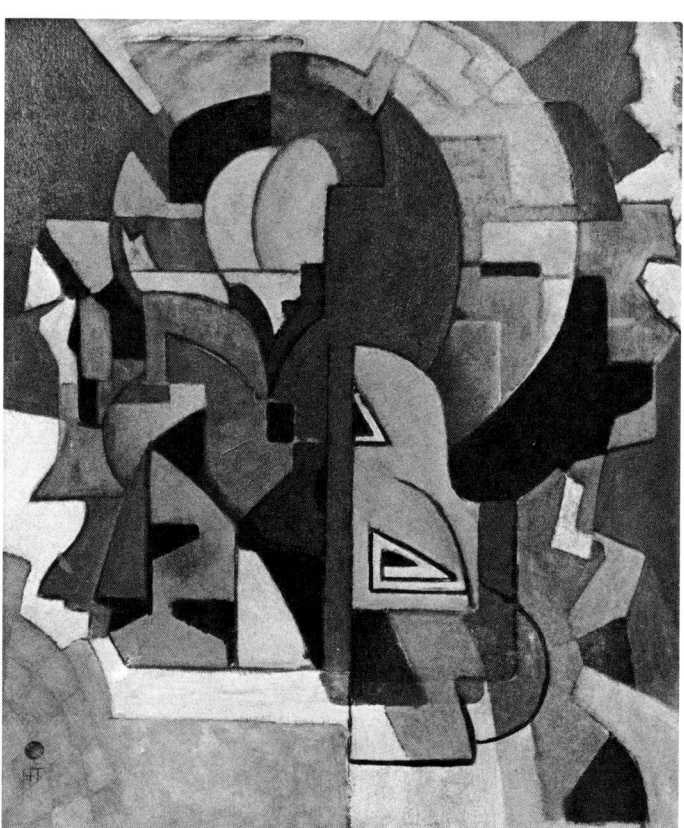

159

160

161

160. Morton L. Schamberg, *Still Life*, 1913.

161. Morton L. Schamberg, *Canephoros*, 1913.

162. H. Lyman Saÿen, *171 Blvd. St. Germain No. 1*, 1912.

163. H. Lyman Saÿen, *Still Life*, 1914.

162

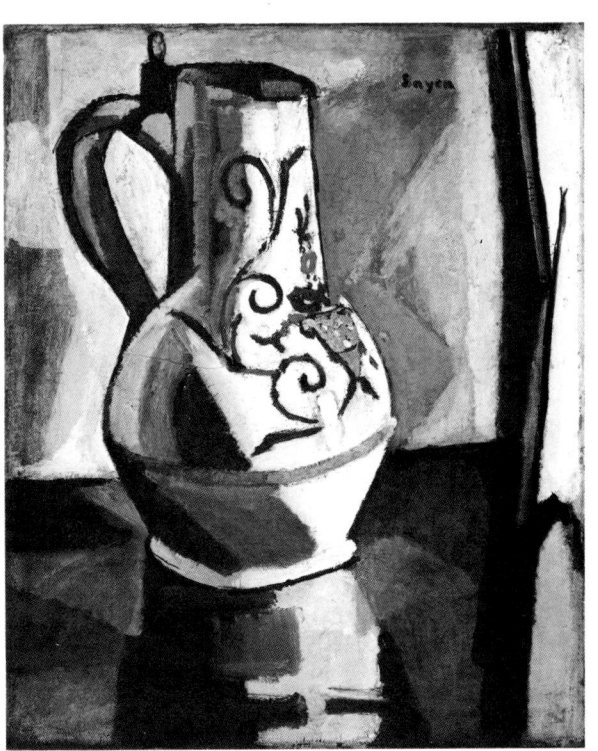

163

164

165

164. Arthur B. Carles, *Nude,* 1921.

165. Carl Newman, *Untitled (Bathers),* c.1917.

166. Carl Newman, *Spirit of Christmas,* c.1915–20.

166

Notes

Appendix

Selected Bibliography

Checklist / Artists' Biographies

Notes

1. PRELUDE TO SYNCHROMISM

1. Dates pertaining to Morgan Russell have been taken from several chronologies that exist among the artist's unpublished papers as well as from his notebooks and letters. Many of the artist's voluminous writings appear on scraps of paper and are nearly illegible. Various sources occasionally list conflicting dates. Unless otherwise indicated, Russell's unpublished notebooks, papers, and all letters to him are in the extensive collection of Mr. and Mrs. Henry M. Reed, Caldwell, New Jersey, and are quoted with the kind permission of the owners and Mme Morgan Russell, Dallas, Texas. The correspondence between Russell and Stanton Macdonald-Wright is now in the Archives of American Art, Washington, D.C. For a more complete chronology of Russell, see Gail Levin, "Morgan Russell: The Avant-Garde Dilemma," in *California: 5 Footnotes to Modern Art History,* Los Angeles County Museum of Art, 1977, pp. 19–20. Since this chronology was published, I have found further documents which have led me to revise certain dates as indicated in the text.

2. Mme Suzanne Binon Russell, Morgan Russell's widow, recalled that the artist said he painted this tiny canvas at Mrs. Whitney's home in Old Westbury, Long Island.

3. Karal Ann Marling, Introduction to *Woodstock: An American Art Colony 1902–1977,* Vassar College Art Gallery, 1977. Marling identifies Russell as "a fellow veteran of the Harrison class" which in 1907 included Dasburg. Dasburg (letter to the author written for him by his son Alfred V. Dasburg, June 27, 1977) stated that although Russell visited Woodstock during the summer of 1907, he did not attend classes. In his "Notes," in *Andrew Dasburg,* Dallas Museum of Fine Arts, 1957, the artist stated that he, Russell, and Walter Dorwin Teague all rented a house together in Woodstock for two dollars a month. None of the chronologies Russell kept lists Harrison as his teacher, nor is there a reference to him in his letters as there is to Bridgman.

4. For the impact of the work of Matisse and others of the European avant-garde in the Armory Show of 1913, see Milton W. Brown, *The Story of the Armory Show,* New York, 1963.

5. In filling in a biographical data form for the Whitney Museum of American Art on July 11, 1951, Russell stated that he studied with Matisse in Paris from 1908–09. Cf. Dasburg, who was with Russell in Paris in 1909–10: "Russell had joined a class Matisse was teaching" ("Notes," *Andrew Dasburg*); Macdonald-Wright, who did not know Russell until 1911, has denied that he studied with Matisse (Macdonald-Wright to Waldo Rasmussen, November 4, 1966; copy letter, Collection of Mrs. Stanton Macdonald-Wright, Los Angeles). Russell on the same form listed 1906 as the year he began to study with Robert Henri, but the most likely date is 1907. The Whitney questionnaire is routinely sent to a living artist when the Museum acquires a work by him.

6. Dasburg recalls that about this time he, Grace Johnson (whom he later married), and Russell walked from Boston to New York, stopping at farmhouses along the way. Letter to the author,

written for Andrew Dasburg by Alfred V. Dasburg, June 27, 1977.

7. Russell later (c. 1923) wrote the French art critic Jean-Gabriel Lemoine that he had inherited his passion for the strength and suppleness of the male body from his father, once an amateur acrobat. Archives of American Art, Washington, D.C.

8. On the shelf in the background is a cast or model after Puget's *Ecorché.* This sculpture also appears in Patrick Henry Bruce's *Still Life with Statuette,* c.1912 (oil on canvas, 21 x 7¾", Collection of Mr. and Mrs. Malcolm Chase, Jr.); Bruce was then also working in Paris. The *Ecorché* was long erroneously attributed to Michelangelo, which probably accounts for its occurrence in Russell's studio. Casts of the *Ecorché* were typical studio props in this epoch. It was copied in bronze by Matisse and included both in his paintings and those of Cézanne. See Tom M. Wolf, "Patrick Henry Bruce," *Marsyas,* xv, 1970–72, pp. 77–78, for a detailed comparison of the varied treatments of Puget's *Ecorché* in Bruce, Cézanne, and Matisse.

9. Morgan Russell to Andrew Dasburg, letter from Paris, late August 1908, Andrew Dasburg Collection, George Arents Research Library for Special Collections at Syracuse University, Syracuse, N.Y. A series of letters from Russell in Paris to Dasburg in New York, 1908–1915, in the references that follow are also from this source unless otherwise indicated.

10. F. R., "France. Le Salon d'Automne," *The Art News,* October 15, 1910, p. 5. "Mr. Russell is obviously influenced by Cézanne, but he is a draughtsman with a strong personal sense of form and color."

11. For Picasso's *Still Life with Fruit and Glass,* see Pl. 45 in *Four Americans in Paris: The Collections of Gertrude Stein and Her Family,* The Museum of Modern Art, New York, 1970.

12. Stanton Macdonald-Wright to Michel Seuphor, December 27, 1956. Macdonald-Wright referred to Simonson as a mutual friend and identified him as the director of the New York Theatre Guild.

13. Willard Huntington Wright, *Modern Painting: Its Tendency and Meaning,* New York, 1915, p. 283. Wright stated that the artist's (and therefore his own) family name was Van Vranken. Macdonald-Wright occasionally used this surname in signing work (see Pl. 107).

14. Lee Simonson, *Part of a Lifetime,* New York, 1943, p. 20.

15. Herschel B. Chipp, "Orphism and Color Theory," *Art Bulletin,* x, March 1958, p. 63.

16. Simonson, *Lifetime,* pp. 14–22. Donald Gallup, ed., *The Flowers of Friendship: Letters Written to Gertrude Stein,* New York, 1953, pp. 64–65. In an undated letter he wrote during the fall of 1912, Hartley asked to visit Gertrude Stein to see her albums of Picasso sketches. In a postscript he mentioned that she would remember him as a friend of Lee Simonson's who had come with Carlock to visit her the previous spring.

17. Percyval Tudor-Hart, "A New View of Colour," *Cam-*

bridge Magazine, February 23, 1918, pp. 452–56; and "The Analogy of Sound and Colour," *Cambridge Magazine*, March 2, 1918, p. 480.

18. Alasdair Alpin MacGregor, *Percyval Tudor-Hart 1873–1954: Portrait of an Artist*, London, 1961, p. 114. In Ch. 15, "Tudor-Hart and His Pupils," MacGregor omits both Morgan Russell and Stanton Macdonald-Wright.

19. Author's translation of: "Je lui demandais . . . si on ne pouvait pas logiquement peindre en traduisant la lumière par jaune, l'ombre par bleu et les graduations moins forte entre ces deux par les verts, bleus, oranges, et rouges." "Je rends tout hommage à M. T.H. et . . . l'aide que j'ai trouvé chez lui."

Russell wrote in his notebooks in English, French, and Franglais, and his handwriting is difficult, sometimes impossible, to decipher. I have chosen to reprint his numerous apparent misspellings, and the excerpts are transcribed here as faithfully as possible.

20. Adrian Bernard Klein, *Colour Music: The Art of Light*, London, 1930, pp. 102–03.

21. *Ibid.*, p. 103.

22. The Futurist documents collected by Morgan Russell are now in the Lydia and Harry L. Winston Collection (Dr. and Mrs. Barnett Malbin).

2. GENESIS

1. Morgan Russell to Stanton Macdonald-Wright, August 4, 1921, Archives of American Art.

2. Meda Mladek and Margit Rowell, *František Kupka 1871–1957: A Retrospective*, The Solomon R. Guggenheim Museum, New York, 1975. Orphism, or Orphic Cubism, is the term invented by the poet-critic Guillaume Apollinaire in 1912 to label the work of Robert Delaunay, Fernand Léger, Francis Picabia, Marcel Duchamp, and Kupka. W. Warshawsky emphasized Kupka's importance as an Orphist in "Orpheism latest of Painting Cults: Paris School led by François Kupka holds that color affects sense like Music," *New York Times*, October 19, 1913, p. 4. For a detailed treatment of the figure in Synchromism, see Gail Levin, "The Tradition of the Heroic Figure in Synchromist Abstractions," *Arts Magazine*, 51, June 1977, pp. 138–42.

3. Margit Rowell, "František Kupka; a Metaphysics of Abstraction," in *Kupka Retrospective*, p. 69. The following reference cited is also from this page.

4. Wassily Kandinsky, *Uber das Geistige in der Kunst: Insbesondere in der Malerei*, Munich, 1912 (actually available from mid-December 1911). Translated by M.T.H. Sadler as *The Art of Spiritual Harmony*, London and Boston, 1914.

5. Wright, *Modern Painting*, p. 288. Wright's importance as both a critic of literature and art has not been sufficiently studied. He also wrote mysteries under the name S. S. Van Dine.

6. Stanton Macdonald-Wright, "The Artist Speaks," *Art in America*, 55, May–June 1967, p. 73.

7. Wright, *Modern Painting*, p. 289.

8. *Ibid.*

9. *Ibid.*

10. James R. Mellow, *Charmed Circle: Gertrude Stein & Company*, New York, 1974, p. 98. There is correspondence from Apollinaire to Russell, whose acquaintance he may have made at the Steins.

11. *Ibid.*, p. 188.

12. Sonia Delaunay, interviews with the author, June 1975 and May–June 1977.

13. Notes of October 1913, in *Du Cubisme à l'art abstrait*, Pierre Francastel, ed., Paris, 1957, p. 111.

14. The text of the poem evokes the journey by train from Moscow to Nikolskoye on the Sea of Japan, recalling the places seen on route and the lost land of France. At the top, on the left, is a panel containing the printed title and other such information, while on the right is a Michelin railway map of the Trans-Siberian expanse. Twelve different type faces were employed, some only for one word. Beyond the importance of the poem itself, this presentation represents a significant new direction in graphic design.

15. Arthur A. Cohen, *Sonia Delaunay*, New York, 1975, p. 34.

16. Delaunay, *Du Cubisme*, pp. 146–47.

17. Morgan Russell to Andrew Dasburg, letter postmarked March 12, 1914, Private collection, New York.

18. Michel Hoog, *Robert Delaunay*, Staatliche Kunsthalle, Baden-Baden, 1976, p. 137.

19. Wright, *Modern Painting*, p. 300, discusses this quality of duration in Morgan Russell's *Synchromy in Orange: To Form*.

20. Wright, *Modern Painting*, p. 277.

3. DEBUT: MUNICH AND PARIS, 1913–1914

1. John Alan Walker, "Interview: Stanton Macdonald-Wright," *American Art Review*, I, January–February 1974, p. 59; reprinted from *Southwest Art Gallery Magazine*, May 1973.

2. Macdonald-Wright, "Artist Speaks," p. 73.

3. Wright, *Modern Painting*, p. 297.

4. For a color reproduction of *Synchromie en bleu violacé*, see Gail Levin, "Morgan Russell's Notebooks: An American Avantgarde Painter in Paris," *RACAR [Canadian Art Review]*, III, no. 2, 1976, p. 75. This painting, now in the collection of Mrs. Stanton Macdonald-Wright, was lost (literally buried) for many years. Russell, probably in 1932, had sent his paintings, rolled up, to his friend Frank Stevens to be kept until he sent for them. After the death of both Stevens and Russell, the crate of paintings was dug up by the new owners of the Stevens home. Through litigation, Macdonald-Wright obtained possession of *Synchromie en bleu violacé*, which he repainted in attempting to restore it, since it had suffered much paint loss.

5. Morgan Russell to Gertrude Vanderbilt Whitney, December 1913, Whitney Family Collection.

6. *Ibid.*

7. Wright, *Modern Painting*, p. 299.

8. Michel-Eugène Chevreul, *De la Loi du contraste simultané des couleurs et de l'assortiment des objets colorés,* Paris, 1839; revised 1889; translated by Charles Martel as *The Principles of Harmony and Contrast of Colours,* London, 1854 (Faber Birren, ed., New York, 1967); and by John Spanton as *The Laws of Contrast of Colour and Their Application to the Arts,* London, 1857. Ogden N. Rood, *Modern Chromatics, with Applications to Art and Industry,* New York, 1879; Faber Birren, ed., New York, 1973.

9. *Les Synchromistes S. Macdonald-Wright et Morgan Russell,* Bernheim-Jeune & Cie., Paris, 1913 (see Appendix).

10. Chevreul, *Contraste simultané,* 1839, p. 135.

11. Macdonald-Wright, "Artist Speaks," p. 73.

12. Stanton Macdonald-Wright, "Chronology of Stanton Macdonald-Wright's Life and Work," in *The Art of Stanton Macdonald-Wright,* National Collection of Fine Arts, Washington, D.C., 1967, p. 21.

13. See for example: Riciotto Canudo, "L'Art cérébriste," *Le Figaro,* February 9, 1914; André Salmon, "Le Salon," *Montjoie!* March 1914, pp. 21–28; Marc Vromant, "A propos du Salon des Indépendants. Du Cubisme et autres synthèses," *Comœdia,* April 15, 1915, pp. 1–2; Louis Vauxcelles, "Les Arts," *Gil Blas,* May 7, 1914, p. 4; Maurice-Verne, in *L'Arc d'Argent,* June 28, 1914.

14. "Synchromy in Orange: The Creation of Man conceived as the result of a natural generating force"; Donald E. Gordon, ed., *Modern Art Exhibitions 1900–1906: Selected Catalogue Documentation,* Munich, 1974, II, p. 807. The Russell painting is listed as number 2970. Russell used the theme of the creation of man in at least one other painting of this time, *Creavit Deus Hominem,* basing his forms on Michelangelo's *Adam* on the Sistine Ceiling (Pls. 72, 73).

15. Arthur Cravan, "L'Exposition des Indépendants," *Maintenant,* March–April 1914, pp. 1–17, author's translation.

16. Roger Allard, "La 30ᵉ Exposition des artistes indépendants," *Les Écrits Français,* March 1914, p. 12, author's translation.

17. Douglas MacAgy, *American Genius in Review No. 1,* Dallas Museum for Contemporary Arts, 1960, n.p., wrote: "It is also said that Russell encountering the Orphist leader Delaunay on the street, would shake his fist and use it when [Delaunay] claimed the stake."

18. Russell to Dasburg, letter postmarked March 12, 1914.

19. For example, Marc Vromant, in *Comœdia,* April 15, 1914.

4. NEW YORK, 1914–1916

1. Stanton Macdonald-Wright to Lloyd Goodrich, then Director of the Whitney Museum of American Art, July 16, 1963.

2. Willard Huntington Wright, "Impressionism to Synchromism," *The Forum,* 50, December 1913, pp. 757–70. The references that follow are also from this article.

3. Russell to Dasburg, letter postmarked March 12, 1914, Private collection, New York.

4. Macdonald-Wright to Goodrich, July 16, 1963. In the same letter Macdonald-Wright mentioned having inadvertently insulted the Chicago art collector Arthur Jerome Eddy, who visited the exhibition. Benton was evidently masquerading as an underworld character called "Ki Ki la Souris," according to a *New York Sun* article, "Artist Advertises for Paris Apache," which purported to tell a story of intrigue about Jean Dracopoli's threats and illegal attempts to recover a painting by Macdonald-Wright; from vol. 48 of Willard Huntington Wright's scrapbooks, Gift of Mrs. Willard Huntington Wright to the Rare Book and Manuscript Division of Firestone Library, Princeton University. This is an example of Willard Wright's attempts to publicize and provoke interest in the first Synchromism exhibition in America through jests and tall tales.

5. Thomas Hart Benton, *An American in Art: A Professional and Technical Autobiography,* Lawrence, Kans., 1969, p. 34.

6. "In the Art Galleries, Synchronists [*sic*] still at Carroll's," *New York Times,* March 14, 1914, p. 10.

7. "'Synchromist' Art Now Assails Eye. . .," *New York Press,* March 7, 1914, p. 12. This review presented Synchromism as sensational and puzzling.

8. Macdonald-Wright to Russell, undated letters of 1914, c. March, Archives of American Art; Macdonald-Wright, reply on Whitney Museum of American Art form requesting information about the painting, [April 26], 1953.

9. Macdonald-Wright, "Chronology," in which he stated that he collaborated with Willard on the following books: *Modern Painting: Its Tendency and Meaning,* 1915; *The Creative Will: Studies in the Philosophy and Syntax of Aesthetics,* 1916; and *The Future of Painting,* 1923.

10. *The Forum Exhibition of Modern American Painters,* Anderson Galleries, New York, 1916; reprinted 1968.

11. Willard Huntington Wright to Russell, April 6, 1916.

12. Morgan Russell to Alfred Stieglitz, letter from Paris, April 6, 1916, Alfred Stieglitz Archives, Collection of American Literature, Beinecke Rare Book and Manuscript Library, Yale University, New Haven, Conn.

13. Andrew Dasburg, in response to a list of questions sent him by the author, May 31, 1977.

14. This information was recorded at the time the work was given to the Whitney Museum of American Art by George F. Of, who was one of the seventeen artists included in the Forum Exhibition.

15. John Weichsel, "Another New Art Venture: The Forum Exhibition," *The International Studio,* 58, June 1916, p. cxvi.

5. IMPACT OF SYNCHROMISM IN AMERICA

1. Thomas Hart Benton, *An Artist in America,* New York, 1937, p. 36.

2. Benton, *American in Art,* pp. 16–19.

3. Ibid., p. 33. The following quotation is also from this source.

4. Benton, *Artist in America,* p. 39.

5. Benton, *American in Art,* p. 34; *Artist in America,* p. 39.

6. Benton, *American in Art,* p. 36.

7. Ibid., p. 37.

8. Benton, "Explanatory Note," *Forum Exhibition.*

9. Willard Huntington Wright, "Forum Exhibition at the Anderson Galleries," *Forum,* 55, April 1916, pp. 458–59. Except for *Bubbles,* all Benton's abstract Synchromist works have been lost.

10. Thomas Hart Benton to William Agee, December 21, 1965, Collection of William Agee.

11. Andrew Dasburg, "Notes," in *Andrew Dasburg.* The other quotations in this paragraph are also from this source.

12. Dasburg in answering the author's questionnaire, spring 1977.

13. *Exhibition of Paintings and Sculpture by: Oliver Chaffee, Konrad Cramer, Andrew Dasburg, Grace Johnson, Arthur Lee, Henry Lee McFee, Paul Rohland, William Zorach,* The Macdowell Club of New York, November 13–23, 1913, included seven works by Dasburg and six *Improvisations* by Cramer.

14. Mabel Dodge Luhan, *Intimate Memories,* New York, 1936, III, pp. 249–54.

15. The two paintings Dasburg dedicated to Mabel Dodge were included in the Exhibition of Contemporary Art held at the National Arts Club, New York, February 5–March 7, 1914. See Judith Zilczer, "The World's New Art Center: Modern Art Exhibitions in New York City, 1913–1918," *Archives of American Art Journal,* 14, no. 3, 1974, p. 3.

16. Wright, "Forum Exhibition," p. 461.

17. Ibid., pp. 460–61.

18. Dasburg, "Explanatory Note," *Forum Exhibition.*

19. Dasburg's response on a list of questions sent him by the author, May 31, 1977.

20. Stuart Davis, March 5, 1923, in "Excerpts from the Notebooks of Stuart Davis, with Diagrams and Sketches," *Stuart Davis,* Diane Kelder, ed., New York, 1971, p. 42. It is interesting to note that Davis's studio in New York around 1915–17 was near those of the French moderns Albert Gleizes, Jacques Villon, Marcel Duchamp, and Francis Picabia.

21. As this book goes to press, Arnold Friedman's papers have recently come to light and may contain the answers to some of the unknown factors in his development.

22. For further information on Stieglitz, see William Innes Homer, *Alfred Stieglitz and the American Avant-Garde,* Boston, 1977.

23. On April 2, 1917, Quinn bought from Stieglitz *Synchromy in Blue,* 1914, *Synchromy in Red,* 1917, and *Synchromy in Orange,* 1917. Correspondence between Stanton Macdonald-Wright and John Quinn, John Quinn Memorial Collection, Manuscripts and Archives Division, The New York Public Library, Astor, Lenox and Tilden Foundations. He later exchanged with Macdonald-Wright some of the artist's paintings for others that he preferred. Quinn could have known Macdonald-Wright's work from the first Synchromist exhibition in New York at the Carroll Galleries in 1914; he was in close contact with the gallery, then operated by Harriet Bryant, and was soon to become its most important client. For additional information on Quinn, see Judith K. Zilczer, *The Noble Buyer: John Quinn, Patron of the Avant-Garde,* Hirshhorn Museum and Sculpture Garden, Washington, D.C., June 15–September 4, 1978, catalogue in preparation.

24. See Macdonald-Wright to Stieglitz, Stieglitz Archives, Yale.

25. Macdonald-Wright to Stieglitz, March 8, 1920, Stieglitz Archives, Yale.

26. Stanton Macdonald-Wright in *Exhibition of Paintings and Sculpture by Stanton Macdonald-Wright,* Photo-Secession Gallery ("291"), New York, 1917.

27. *Recent Paintings by Stanton Macdonald-Wright,* Daniel Gallery, New York, exhibition closed March 18, 1918.

28. *Exhibition of Paintings and Drawings Showing the Later Tendencies in Art,* The Pennsylvania Academy of the Fine Arts, Philadelphia, 1921.

29. Paul Rosenfield, "The Academy Opens Its Doors," *The New Republic,* May 4, 1921, p. 290. The quotations following are from the same source.

30. "William Henry Kemble Yarrow (1891–1941)," *New York Times,* April 22, 1941, obituary, states that Yarrow won a silver medal in 1915 at the Panama Pacific Exposition and showed in 1916 at the Art Club of Philadelphia. He painted murals in the Princeton Gym in 1935.

31. "Yarrow Memorial Exhibition," *World Telegraph,* December 13, 1941.

32. Russell to Stieglitz, June 4, 1921, Stieglitz Archives, Yale.

33. Macdonald-Wright to Stieglitz, July 23, 1921, Stieglitz Archives, Yale.

6. COLOR ABSTRACTION IN AMERICAN PAINTING

1. Samuel Halpert to Robert Delaunay, July 28, 1915, Collection of Sonia Delaunay, Paris.

2. The Delaunays evidently planned to sell some of their own work, or part of their collection of African sculpture and paintings by Henri Rousseau, in order to finance their voyage. Leon Kroll's letters to the Delaunays, Mme Delaunay collection, and letters from Kroll and Halpert to Alfred Stieglitz, Stieglitz Archives, Yale, give further information on the friendship of the Delaunays and American artists.

3. Alfred H. Barr, Jr., *Matisse, His Art and His Public,* New York, 1951, pp. 116–17.

4. For additional information on A.B. Frost's attitude toward his son's modernism, see Henry M. Reed, *The A.B. Frost Book,* Rutland, Vt., 1967, pp. 114–16.

5. Arthur B. Frost, Jr., to his mother, November 24, 1912, Collection of Mr. and Mrs. Henry M. Reed. For an excerpt, see Reed, *Frost Book,* pp. 117–18.

6. Arthur B. Frost, Jr., to his mother, December 1912, Reed collection. The following references are to Frost's unpublished letters in the Reed collection. There is also correspondence from Frost to the Delaunays in the collection of Mme Delaunay, who told the author, in an interview of May 1977, that Robert was very touched when he received a card of a Ferris wheel (a subject he had painted) from Frost in Vienna.

7. Frost letter in the Reed collection; for a longer excerpt see Reed, *Frost Book,* p. 118.

8. Vromant in *Comœdia*, April 15, 1914.

9. James Henry Daugherty, unpublished memoir of Arthur Burdett Frost, Jr., n.d., Reed collection.

10. Ibid. Arthur B. Frost, Jr., wrote his father on September 18, 1914 (Reed collection): "I want photographs to paint from. . . . Bruce wants dance halls, like Bullier . . . lots of women in modern clothes . . . crowds, cafe scenes are all interesting."

11. For a more detailed analysis of Bruce's development, see William C. Agee, "Patrick Henry Bruce: A Major American Artist of Early Modernism," *Arts in Virginia,* XVII, Spring 1977, pp. 12–32.

12. Charles H. Caffin, "Important Things in Art, Significant Still-Lifes by Bruce," *New York American,* November 27, 1916, p. 6.

13. Guillaume Apollinaire, in *L'Intransigeant,* November 19, 1913; *Apollinaire on Art,* New York, 1972, p. 329.

14. For details of this incident, see Brown, *Armory Show,* pp. 120–22. Correspondence from the Bruces to the Delaunays indicates their friendship. These and Halpert's lengthy letters to Delaunay are in the collection of Mme Delaunay.

15. "French Artist at Odds with N.Y. Exhibitors: Robert de Launay . Asks That His Pictures Be Withdrawn, but Gets No Satisfaction," *New York Tribune,* March 2, 1913, p. 4.

16. Guillaume Apollinaire, "Exposant de l'Epatant," *L'Intransigeant,* March 5, 1914; *Apollinaire on Art,* p. 359.

17. Guillaume Apollinaire, in *Soirées de Paris,* March 15, 1914; *Apollinaire on Art,* p. 366. Although this work has not survived, it was reproduced in *Montjoie!* in March 1914, p. 22.

18. Katherine S. Dreier, *Western Art and the New Era,* New York, 1923, p. 95.

19. Agee, "Bruce," p. 20, also discusses Bruce's use of Rood's triads of colors similar to Russell and Macdonald-Wright.

20. He was also extremely critical of Bruce's work and claimed to have an old palette in his studio that was superior to this sort of painting. A.B. Frost to Gus Daggy, September 6, 1914, Reed collection.

21. Agee, in "Bruce," treats this issue in detail. I concur with his order.

22. Bruce gave Roché twenty-one of these canvases. For Roché's important statement on Bruce written in 1938, see Katherine S. Dreier et al., *Collection of the Société Anonyme,* Yale University Art Gallery, New Haven, Conn., 1950, pp. 143–44.

23. "The Maratta System of Color," *Scientific American Supplement,* LXVIII, November 13, 1909, p. 311.

24. Lawrence W. Chisholm, *Fenollosa: The Far East and American Culture,* New Haven, Conn., 1963, p. 231.

25. For Robert Henri's interest in Maratta, see William Innes Homer with the assistance of Violet Organ, *Robert Henri and His Circle,* Ithaca, N.Y., 1969, pp. 184–89. It is possible that Maratta gave a studio demonstration of his theories of color relationships and that Russell was present.

26. "The Taylor System of Color Harmony," *Color Trade Journal,* XII, February 1923, pp. 56–58.

27. See Ch. 2, n. 4. Stieglitz published translated excerpts as "Extracts from 'The Spiritual in Art,'" *Camera Work,* no. 39, July 1912, p. 34.

28. For further information on the impact of Kandinsky see Sandra Gail Levin, "Wassily Kandinsky and the American Avant-Garde, 1912–1950," Ph.D. dissertation, Rutgers University, New Brunswick, N.J., 1976.

29. Halpert also wrote directly to Delaunay about Hartley, March 29, 1912, Mme Delaunay collection.

30. Marsden Hartley to Alfred Stieglitz, postcard of June 20, 1912, Stieglitz Archives, Yale.

31. Hartley to Stieglitz, letters of July 1912 and September 28, 1913, Stieglitz Archives, Yale.

32. Daugherty, according to his son Charles in an interview with the author in spring 1977, had an Italian friend who may have told him about Futurism. For further detail on Daugherty, see Gail Levin, "James Daugherty: Early Modernist and Simultaneist," *Whitney Review 1976–77* [Whitney Museum of American Art annual report], 1977.

33. *Day of Good Fortune* is an oil sketch for the monumental (84 x 150″) decorative mural, now in the Detroit Institute of the Arts, called *The Dances,* painted in 1914–15 and exhibited at the Montross Gallery in New York, March 2–April 24, 1915, where it was purchased by John Quinn. (Walt Kuhn to John D. Morse, April 8, 1939, Walt Kuhn papers, Archives of American Art.)

34. Karl Nickel, Introduction, *Manierre Dawson: Paintings 1909–1913,* Ringling Museum of Art, Sarasota, Fla., 1967, p. 6.

35. Adelyn D. Breeskin, *H. Lyman Saÿen,* National Collection of Fine Arts, Washington, D.C., 1970, p. 34. Barr, in *Matisse,* does not list Saÿen as a Matisse pupil. Prior to the exhibition at the National Collection of Fine Arts, Saÿen was little known. He was a close friend of Leo Stein.

36. Arthur B. Frost, Jr., to his mother, September 21, 1914, Reed collection.

7. SYNCHROMISM CONTINUED

1. This was especially evident at the "Exhibition of Paintings and Drawings Showing the Later Tendencies in Art" held at the Pennsylvania Academy in 1921, discussed in Ch. 5.

2. Walker, "Interview: Stanton Macdonald-Wright," 65. Wright remarked: ". . . we [he and Russell] used to sit on the floor with a score of Beethoven and work out certain color harmonies according to the Beethovenian format."

3. Russell's plans to combine light, color, and music were preempted in New York in 1915, with the performance of Alexander Nicolayevich Scriabin's *Prometheus: Poem of Fire.* Colored lights were projected on a screen to the sound of Scriabin's music. For reviews on this event, see Klein, *Colour Music,* pp. 247–48. By 1919, Thomas Wilfred had invented the Clavilux which projected color and light (without music) on a translucent screen by the use of a keyboard controlling projectors behind the screen. See Donna M. Stein, *Thomas Wilfred: Lumia—A Retrospective Exhibition,* Corcoran Gallery of Art, Washington, D.C., 1971.

4. Lucien Chassaigne, "Feuilleton de Journal," *Le Journal,* no. 77, August 22, 1913. For further information on Rimington, see Klein, *Colour Music.*

5. Stanton Macdonald-Wright actually experimented with color film and motion pictures in California in 1919 and the following few years.

6. For further information on Cendrars, see Jacqueline Chadourne, *Blaise Cendrars: poète du cosmos,* Paris, 1973. Russell's friendship with Cendrars is revealed in the poet's letters in the Reed collection, and in Russell's letters to Macdonald-Wright, Archives of American Art. For excerpts of these see Levin, "Morgan Russell: The Avant-Garde Dilemma," p. 18. Cendrars was also a close friend of Fernand Léger during these years.

7. P. 7 of *Montjoie!* "Numéro consacré à la Danse Contemporaine," January–February 1914; the Russell drawing accompanies an article by Valentine de Saint-Point, "La Métachorie." Russell's drawings—there is another, rather Cubist sketch on p. 13—were published here along with those of Rodin, Dufy, Lhote, Archipenko, Matisse, Bakst, and others. Canudo is listed among Russell's papers as owning several of his paintings, all of which have since disappeared.

8. The *Eidos* paintings were themes or studies for a larger, never executed *Synchromy to Vision* [*Synchromie à la vue*]. This is perhaps linked to Russell's concern with the eyestrain he suffered during 1915, which he thought was caused by his previous emphasis on "vivid color work."

9. *Exposition de Tableaux et Synchromies par Morgan Russell,* Galerie La Licorne, Paris, May 4–17, 1923, author's translation. Russell's analogy of his *Eidos* paintings to fireworks recalls a passage he may have read from *Music and Morals,* 1875, by Rev. H. R. Howeis, M.A., reprinted in Klein, *Colour Music,* p. 5. "The reader whose eye is passionately responsive to colour may gain some faint anticipation of the colour-art of the future, if he will try to recall the kind of impression made upon him by the exquisite tints painted upon the dark curtain of the night at a display of fireworks. I select fireworks as an illustration in preference to the most gorgeous sunset, because I am not speaking of Nature but of Art."

10. For further amplification of this idea, see Levin, "Tradition of the Heroic Figure in Synchromist Abstractions."

11. Willard Huntington Wright, *The Future of Painting,* New York, 1923. Reviews of the book included: "Painter vs. Draughtsman The Future of Painting—What Ingres Said," *Time,* October 1, 1923; "Nature of Painting," *New York World,* August 5, 1923; "Painting and the New Art of Color," *Evening Post* (Chicago), August 17, 1923; Thomas Craven, "An Aesthetic Prophecy," *Dial,* July 1923; Alan Burroughs, "The New Books," *The Arts,* May 1923.

12. Macdonald-Wright to Stieglitz, March 8, 1920, Stieglitz Archives, Yale. The following references are also from this letter.

13. Stanton Macdonald-Wright, *A Treatise on Color,* 1924; reprinted in *The Art of Stanton Macdonald-Wright,* National Collection of Fine Arts, Washington, D.C., 1967, pp. 65–100.

14. Stanton Macdonald-Wright to Alfred Barr, April 22, 1967, copy letter, Collection of Mrs. Stanton Macdonald-Wright. Macdonald-Wright protested at length the traveling exhibition organized by William C. Agee for the Museum of Modern Art and the brief catalogue statement. He insisted that he never heard Russell or Delaunay mention either Chevreul or Rood and pointed out Russell's and his own study with Tudor-Hart.

15. Rood, *Modern Chromatics,* 1973, pp. 236–45.

16. Agee, in *Synchromism and Related Color Principles,* p. 32, first pointed out this application of Rood.

17. Wright, *Modern Painting,* p. 285.

Appendix: Documents of Synchromism

AUSSTELLUNG DER SYNCHROMISTEN MORGAN RUSSELL, S. MACDONALD-WRIGHT
Der Neue Kunstsalon, Munich, June 1–30, 1913

IN EXPLANATION OF SYNCHROMISM[1]

A certain kind of picture in the field of modern painting has recently become popular. Although quite intriguing, these paintings only fleetingly engage our attention. Observed closely, they are merely pretty and are appealing only through the varied play of light and an excess of pleasant details. As a whole, however, the works lack that genuine inner strength which is the mark of artists whose innate sense for certain fundamental elements of painting, such as form and movement and the visionary comprehension of the painterly whole, imparts vitality to a work of art.

A new and fruitful innovation of light seen as color was introduced forty years ago by the Impressionists. All that remained, though, was the captivation and appeal of the paintings. With few exceptions, the Impressionists produced only mediocre works that nonetheless were considered appealingly effective by the masses. The error of these painters was simply their sole preoccupation with the problem of light. They contented themselves with the strongest possible portrayal of air playing over objects and with the intense luminousness of their paintings, disregarding the previously mentioned qualities.

Only Renoir and Cézanne were able to impart an enduring quality to their works. Admittedly, though, the great charm emanating from the wealth of light gradation in Cézanne's paintings and his exceptional skill in drawing exerted a disastrous influence. The fate of all great artists whose works express their powerful vision with such seeming effortlessness is that mediocre talents have ceaselessly been tempted to imitate the quality of effortlessness.

This is particularly true of the Cubists, who attempted to substitute appealing and skillful use of technical means to make up for their deficient genius.

Recently some painters have realized that the brown and white of the Cubists does not represent the culmination of all painting and have turned to studying color and to painting colorfully again. By no means more successful in their attempts than the Impressionists, they too only achieve a momentarily engaging quality. Their paintings otherwise at best manifest profundity, even though only vaguely and uncertainly.

Certain successful innovations recognizable in the paintings exhibited here constitute the only enrichment of means since the Impressionists that are capable of having a productive effect.

One thing may be promptly stated—only as a decorative element is color unable to affect us more deeply (used as such, it can at best be of utility in applied art). Similarly, to restrict ourselves to a literal portrayal of the coloration of objects in changing illumination is at best a stupid undertaking. All that matters is to treat color as a purely functional instance.

The Impressionists showed us that strong light produces the impression of yellow, and weak, cool light that of violet-blue. They neglected, however, to instruct us concerning the cause of the sensations of green, orange, red, etc. We are consequently compelled to treat extremes of light as colors and simply to copy the coloration of objects in order to complete our color scale. With a little more exertion on their part, they would have realized that medium intensities of light also produce in us impressions of corresponding color nuance. This provides us finally with the theory of light sought in vain by the Impressionists. Even Cézanne's attempts were in vain, as is revealed by his last letters (written before his death).

The Futurists naively believed they had taken a big step forward by subordinating the static element in favor of movement. But static and dynamic qualities in art are two forces that supplement each other, and their concurrence permits us to feel one or the other strongly. The static element without its dynamic counterpart or vice versa is negative and incapable of affecting us.

Is it not extremely curious that painters never realized that a single color, without being brought into relation with other colors, has the capacity of producing the impression of the weight, massiveness and spatial depth of objects! Here is a color that produces the impression of solidity or of impenetrability, while another seems to us empty or transparent. One seems distant, another as if it were quite close and approaching us. After all, the depth of space is expressed through gradations of color, to some extent through color zones. To lighten a color by mixing it with white does not suffice to impart the effect of being in the foreground. Similarly, a color cannot be made to recede by merely adding black. The color itself must be modified in different spatial zones.

Although the first part of what has thus far been stated applies mainly to pictures by the painter Russell and the last part mainly to pictures by the painter Wright, no one for an instant will have the impression that Russell's paintings lack substantiality or that Wright's lack light. Rather do all these factors concatenate to a fortunate whole to form an utterly complete painterly vision, finally solving the great problem of form and color. In other words, we blend both of these elements so that all that remains is one, actually the only possible

vision of reality capable of expressing the totality of different qualities applicable exclusively to painting.

Mankind has until now always tried to satisfy its need for the highest spiritual exaltation only in music. Only tones have been able to grip us and transport us to the highest realms. Whenever man had a desire for heavenly intoxication, he turned to music. Yet color is just as capable as music of providing us with the highest ecstasies and delights.

By having liberated ourselves from certain impediments and ties and plunged boldly into the unknown, we have wrested from nature the secrets necessary for bringing painting to this highest degree of intensity. Moreover, painting has the advantage over music of being closer to reality, for the visual sense connects us with nature to a higher degree than does the sense of sound. There is nothing higher to be striven for in art once this is finally achieved.

In the belief that we ourselves are most capable of explaining our own work, we have, despite the widespread custom of false modesty, written our own foreword. We nonetheless are certain that intelligent people will not condemn our position toward our work. If a famous precedent for our action is required, a certain letter directed by Leonardo da Vinci to the Duke of Milan may serve.
 MORGAN RUSSELL
 S. MACDONALD-WRIGHT

LES SYNCHROMISTES S. MACDONALD-WRIGHT ET MORGAN RUSSELL
Bernheim-Jeune & Cie., Paris, October 27–November 8, 1913

GENERAL INTRODUCTION[2]

Given the radically new character of our work, we believe it necessary to preface the catalogue of paintings exhibited with brief explanations.

By the word "Synchromism," we certainly do not mean to designate a school. But we were anxious to adopt a name that would be our own. In this way, we shall perhaps escape the vexation of seeing ourselves enrolled by maniacs for classification under a label that corresponds badly with our aims.

The Impressionists, as is known, brought about a decisive change in the pictorial methods practiced up to their day. Their art consisted of expressing color relationships, not of coloring a drawing according to the decorative or dramatic needs of the subject. Their point of departure was the study of light.

This movement has unleashed a host of efforts aimed either at revolutionizing painting still further, or of making it regress toward the aesthetic not of a Rubens or a Michelangelo, but of some distant Cambodian or Congolese. We wish neither to criticize the audacities of these last twenty or thirty years, nor to present ourselves as unscathed by their influence. We simply think it appropriate to show how we differ from our predecessors and what our personal contribution is.

We consider that orientation toward color is the only direction that painters can engage in for the moment. We shall speak neither of Cubists nor Futurists, finding their efforts superficial and of secondary interest, without indeed debating their legitimacy. In order to focus attention and to make clear by contrast the particular nature of our activity, let us first consider that young school of painting, Orphism. A superficial resemblance between the works of this school and a Synchromist canvas exhibited at the last Salon des Indépendants has led certain critics to confuse them: this was to take a tiger for a zebra, on the pretext that both have a striped skin.

Despite the great importance conferred by their talent, the Impressionists barely dwelt on any but elementary problems.

They had, for instance, noted that sunlight turning yellow creates a complementary sensation of violet in the shadows; they had observed certain reactions of colors on one another, and the search for a harmonious whole based on these factors constituted the essence of their method.

In Orphism, we see the manifestation of analogous processes, more broadly applied, it is true, and complicated by the distortions and linear, rhythmic effects to which Cézanne initiated us, and of which Picasso and his disciples made themselves the vulgarizers. The results, moreover, corresponded ill with the ambitions of the program. Reduced to the humble task of enumerating and cataloguing objects, color was spread thin over compositions that were powerless to evoke volume; far from realizing its function, which is to arouse a qualitative emotion, it seems to have had no suspicion of its essential role. No doubt these Orphists excel at making a shade recede or stand out in relation to neighboring shades. But the technical observations they have been able to make on the subject do not amount to a treasure, and this sort of color perspective was already familiar to the Impressionists, who themselves had not invented it.

Instead of forcing colors to serve no matter where, we assign them a place that conforms with their intimate nature, their natural propensity. By covering a large surface with black or violet, does anyone imagine that he has expressed a powerful and solid mass on the pretext that a person is wearing a costume of that color or that a wall is coated with this one? It would be too naive; as musicians, we would not play a funeral march on the flute on the pretext that this instrument was capable of sounding the seven notes of the musical scale.

Let us leave painters prone to illusions of this kind the trouble of choosing and grouping colored objects, and rendering on canvas their drab and literal likeness—an idle exercise, good only for copyists. Our dream for color is of a nobler task. It is the very quality of form that we mean to express and reveal through it, and here for the first time color appears in this role.

It is incumbent on painters to fathom the mysterious relations between color and form, between the colors and the characters of form: its organic rhythm, spatiality, density, transparency, luminosity, etc. Having thus penetrated reality in a conscious and lucid fashion, they will know how to express the emotion of their discoveries through the language of color.

An art may be born that would surpass contemporary painting in emotional power as the modern orchestra outdoes the harpsichord's old solo. As precursors, we shall have contributed something tangible and concrete to vague foreshadowings and vaguer needs, and shown the way in which efforts should be directed.

<div style="text-align:right">S. MACDONALD-WRIGHT
MORGAN RUSSELL</div>

INDIVIDUAL INTRODUCTION[3]

Form is expressed in my mind as color: at the same time as a composition of form, my imagination conceives the organization of color that corresponds to it.

Since the juxtaposition of two or three colors on the canvas results in a luminous sensation, I find it useless to occupy myself with light more expressly—such a concern can lead only to an impasse.

Each color has a position of its own in emotional space and possesses a well-defined character. I conceive space itself as endowed with a plastic significance that is expressed by color. Since form is not the volume of each object seen separately, I organize my canvas as a block, as much in depth as in surface.

The intimate relationship of color with form and space has never been thoroughly examined. In contemporary painting as in ancient, the coupling of the colors with the forms[4] presents perpetual contradictions, which become all the more painful as our senses are the more acute. Indeed, certain painters have noted this antipathy between forms and colors; but the fact of having observed these contradictions has so intoxicated them that they have been rendered incapable of broaching a solution to the difficulty. They have remained complacently agog before their mere observation.

Space[5] is expressed by a spectrum that somehow unfolds in the sense of depth. Think of the phenomenon brought about when the artists' imagination, weary of the colored calligraphy of the Middle Ages and its childish panorama, began to deploy itself in depth, bringing us into the heart of reality itself. There is, however, a great difference between those painters' space and ours: with them we "recognize" space by the diminution of sizes, with us the quality, depth,[6] evokes a subjective emotion.

We are incapable of imagining a form that is not the result of some contact of our senses with nature. Or at least the forms that issue from this contact are infinitely more expressive and varied than those born of the inventive labor of the intellect. So far as form is concerned, one must maintain a relationship with nature. In opposition to purely logical theories, we mean to stay true to reality. In it is the foundation of every pictorial work. But I condemn the illustrative subject-matter

affected by the Orphists and care no more to make "painted tales" than to suggest musical effusions. It would not displease me if my art were down to earth; the essential is that it should not be abstract.[7]

<div style="text-align:right">S. MACDONALD-WRIGHT</div>

INDIVIDUAL INTRODUCTION[8]

My way of conceiving light differs from the vision of the Impressionists in the following respects:

(1) I am not concerned, so to speak, with the local color of objects;

(2) I do not consider the sun to be yellow. I note that the great amount of light it sends us creates in us a sensation of yellow, which is as much of a subjective illusion as the violet in shadows.

All the values of light create in us color sensations. The extreme degrees, with their equivalents of yellow and violet, are accompanied by half-tones, and they too have their equivalents in sensations of color.

In paintings today,[9] yellow and violet do indeed exist as the rendering of a degree of light, but red, orange or green are present only if a fortunate chance has placed an object in that color in the painter's field of vision.

I have thus arrived at what I shall call, for want of a better term, orchestration from black to white—these being admitted to the dignity of colors.

A phenomenon similar to the one I am emphasizing here is the impression of "color" that we feel in the different parts of the orchestra, from base to treble.

For a long time now I have had the intuition of a vision of color that differs from the vision today, as the vision of form in movement in sculpture at the time of Phidias differs from the stiff and inert form of archaic Greek statuary.

One would look in vain, in the great works of the hallowed masters, for a color rhythm that generates the whole. Certainly, a splendid linear order animates and governs the work, that is to say, the directions motivated by the forms are poised around a center. But what we as moderns consider the real structural matter of a painting has remained in the primitive state of a juxtaposition of hues and lacks any kind of continuity.

In order to resolve the problem of a new pictorial structure, we have considered light as intimately related chromatic waves, and have submitted the harmonic connections between colors to a closer study. These "color rhythms" somehow infuse a painting with the notion of time: they create the illusion that the picture develops, like a piece of music, within a span of time, while the old painting existed strictly in space, its every expression grasped by the spectator simultaneously and at a glance. In this there is an innovation that I have systematically explored, believing it to be of a kind to elevate and intensify the expressive power of painting.

A word about my last Synchromy in dark blue and I shall have ended this account of my technical preoccupations.

One often hears painters say that they work on the form first, in the hope of arriving at the color afterwards. It seems

to me that the opposite procedure should be adopted. In the painting in question, I have worked solely with color, its rhythms, its contrasts, and certain directions motivated by the color masses. There is no subject to be found there in the ordinary sense of the word: its subject is "dark blue," evolving in accordance with the particular form of my canvas. But one should beware of seeing in this a kind of musical painting. If, in the foregoing, we happen to have alluded to music, it was by way of comparison and in order to make ourselves better understood in a field of ideas still unfamiliar to the public.

Obviously, I renounce the rich heritage of fine habits of drawing. In return, I run the happy risk of falling on some of the correspondences that exist between reality and our sensations of color.

It is from an ensemble of colors poised around a generative color that form must spring. From this point of view, the processes of my art are related to the very mechanism of natural vision.

MORGAN RUSSELL

EXHIBITION OF SYNCHROMIST PAINTINGS BY MORGAN RUSSELL AND S. MACDONALD-WRIGHT[10]
Carroll Galleries, New York, March 2–16, 1914

FOREWORD

Because of the radically new character of Synchromism, perhaps it is well to give a short explanation of its aims, so that it will not be confounded with the schools of painting which have cropped up in such rapid succession since the birth of Impressionism. To begin with, the word Synchromism is not meant to stand for a school, but is employed by Mr. Macdonald-Wright and Mr. Russell merely that they may escape classification under labels which do not express their tendencies. The name is purely a technical one, meaning simply "with color." In its very nature it is more universal than such restricted and technically meaningless appellations as "Fauveism," "Futurism" and "Cubism." Synchromism is an artistic principle rather than a method, and as such can never become a "school."

As we know, Impressionism brought to the art of painting a decisive and momentous change in pictorial methods. It did away with the mere coloring of drawings in accordance with the decorative and dramatic needs of the subject. It confined itself to a close and realistic study of color relations. The study of light was the Impressionists' real point of departure.

Their discoveries were a tremendous stimulus to painting, and gave birth to many new efforts whose ambition it was either to revolutionize painting to even a greater degree, or to turn it backward to a Congo or Cambodian *esthétique*. But in their very enthusiasm for revolution these new painters forgot the very principle which had inspired them to action, namely, the juxtaposition of color. And since color is the only quality which should engage painters of to-day, such schools as "Futurism" and "Cubism" resolved themselves in superficial manifestations, for their use of color had long since been superannuated. The Cubists unsuccessfully attempted to hide their antiquated inspiration beneath a quasi-novel lineal aspect, and the Futurists merely reverted to juvenile literary illustration. Therefore these schools added nothing to the development of painting.

The Impressionists, to the contrary, had actually assisted in the solution of the more elementary color problems. For instance, they noted that the yellow in sunlight called up in us a complementary sensation of violet in the shadows. On the foundation of this discovery they were able to construct more or less harmonious ensembles, which were more truthful transcriptions of nature than any paintings that had gone before. But in their striving for accuracy they lost sight of the fundamental consideration of all great art—composition in the rhythmic sense of the word.

Although since Cézanne and Renoir the actual achievements in painting have been almost infinitesimal, the numerous schools which have followed these two men have done much in establishing the conviction that art has to be divorced from mere imitation before it can reach the highest point of intensity of which it is capable.

The Synchromists have made certain artistic discoveries which have enabled them to plunge directly into the pure rhythmic composition of canvases, not by the use of line, like the ancients, but by the organization of color-forms. Before them, the essential role of color (which is to excite in us a qualitative emotion of form) has not been even remotely suspected. Instead of placing colors at random on the canvas, they assign to them a place which conforms to their natural propensity in depth. The solidity of some colors will not permit them to express space. On the other hand, the transparency or fluidity of other colors could never express a solid mass. These are attributes of color-form, which, when disregarded, result in chaos to the trained eye.

Color, when properly applied, can reveal the quality itself of form, and this is what the Synchromists have succeeded in doing for the first time. With them an art is born whose power to create emotion surpasses other contemporary painting, just as the modern orchestra surpasses the harpsichord. They have brought into modern painting something tangible and concrete to take the place of vague speculations. They have shown in what direction the efforts of painting should turn.

WILLARD HUNTINGTON WRIGHT

INTRODUCTION

Each color has a position which is definitely its own in emotional space, and possesses a character which is clearly and pre-

cisely defined. We conceive space itself as having a distinct plastic significance which is expressed by color.

Form being something more than the volume of each object seen separately, our compositions are organized as block-manifestations, as much in depth as in surface.

In modern as well as ancient painting, the coupling of certain colors with certain forms offers perpetual contradictions which will be the more unbearable as our senses become more sharpened. True, certain painters have noticed this antipathy between form and color, but so great was their enthusiasm over the mere observation that it prevented them from approaching the solution to the problem.

Space is expressed by a spectrum which extends itself, receding, as it were, in the sense of depth.

Note the phenomenon which was produced when the artist's imagination, tired of the tinted calligraphy of the middle ages, began to unroll itself into depth. Thus we were taken into the very bosom of reality itself; but this was done by line and required an intellectual process for realization. However, between these artists' space and ours there lies a great gulf: with them we "recognize" space by the diminution of sizes and the gradation of tone, while with us the depth-quality is produced by a subjective emotion.

For a long time we have been conscious of a color vision different from that of contemporary painters. This conception is as different from the common conception as the Phidian age of sculpture with its rhythmic form is from the stiff and inert statuary of the archaic Greeks.

In vain one searches for a color rhythm which generates the ensemble in the great works of the consecrated masters. Of course, a distinct vision of unity of line animates the composition as a whole—that is to say: the directions engendered by the forms are equilibrated about a center. But that which we as moderns consider the constructive matter of a painting (color) has remained in the primitive state of tint juxtaposition, and its treatment totally lacks all character of continuity.

Besides solving the problem of the inherent nature of colors in their relation to form, we have applied ourselves to a close study of the harmonious relation of these colors to one another. And, as a result of the incorporation of these colors into gamut-form, they convey the notion of "time" in painting. They give the illusion that the canvas *develops* like music, in time, while both the old and modern paintings exist strictly in space. With one glance they can be felt in their entirety.

This is an innovation which we deem of tremendous importance in exalting and intensifying the power of expression in our art. Form should grow out of an ensemble of key-colors equilibrating about one generative color. Viewed in this light, our art is closely allied to the mechanism of human vision.

The relation of space emotions and the emotions of density and transparency, which we wish to express, dictates to us the colors most capable of transmitting these sensations to the spectator.

In our painting, color becomes the *generating function*. For instance, we do not permit ourselves to paint an object that advances with violet, for by its nature this color expresses not a form but a quality of space.

Likewise we can no longer conceive of the stupid juxtapositions of colors devoid of any rhythmic interlinking as art organizations. An art whose ambition it is to be pure should express itself only with means inherent in this art.

Painting being the art of color, any quality of a picture not expressed by color is not painting.

In thus creating the subjective emotions of depth and rhythm we achieve the dreams of painters who talk of drawing the spectator into the center of the picture, but instead of his being drawn there by intellectual processes he is enveloped in the picture by *tactile sensations*.

We limit ourselves to the expressions of plastic emotions; for in painting it is ridiculous to search for the fourth dimension and philosophic ideas, or musical abstractions.

We do not pretend to have invented new qualities for art, but to have brought to it a new vision which permits us to express the old qualities with a potency unknown until our day.

S. Macdonald-Wright
Morgan Russell

NOTES

1. Translation from the German by Martha Humphreys.

2. Translation from the French of this and the two individual statements by Mary Laing.

3. Macdonald-Wright included an English version of this statement in the exhibition catalogue *The Art of Stanton Macdonald-Wright* in 1967. The translation here follows the 1913 text. Significant variations in the later version are noted below.

4. ". . . the coupling of some colors with certain forms"; Macdonald-Wright, 1967.

5. Macdonald-Wright added the words "in my work" in the 1967 version.

6. *la qualité profondeur*: the whole passage in the 1967 version has been amplified to read: "with them we recognize space by size diminutions (perspective), with us the quality of depth created by color calls forth a subjective emotion."

7. The last two sentences are omitted in the 1967 version.

8. Macdonald-Wright contributed a translation of this to the exhibition catalogue *Morgan Russell Memorial Exhibition* in 1953. The translation here follows the 1913 text.

9. *Dans les tableaux actuels*: rendered by Macdonald-Wright in 1953 as "In the Impressionist canvasses."

10. The Foreword and Introduction are reprinted here without change, except for the correction of certain obvious misprints.

Selected Bibliography

UNPUBLISHED SOURCES

Bruce, Patrick Henry, and Bruce, Helen. Correspondence to Robert and Sonia Delaunay. Collection of Sonia Delaunay, Paris.

Daugherty, James Henry. Memoir of Arthur Burdett Frost, Jr., n.d. Collection of Mr. and Mrs. Henry M. Reed, Caldwell, N.J.

Frost, Arthur B., Jr. Correspondence to his family. Collection of Mr. and Mrs. Henry M. Reed, Caldwell, N.J.

Halpert, Samuel. Letters to Robert Delaunay. Collection of Sonia Delaunay, Paris.

———— Letters to Alfred Stieglitz. Alfred Stieglitz Archives, Collection of American Literature, Beinecke Rare Book and Manuscript Library, Yale University, New Haven, Conn.

Hartley, Marsden. Correspondence to Alfred Stieglitz. Alfred Stieglitz Archives, Collection of American Literature, Beinecke Rare Book and Manuscript Library, Yale University, New Haven, Conn.

Kroll, Leon. Letters to Robert Delaunay. Collection of Sonia Delaunay, Paris.

———— Letters to Alfred Stieglitz. Alfred Stieglitz Archives, Collection of American Literature, Beinecke Rare Book and Manuscript Library, Yale University, New Haven, Conn.

Macdonald-Wright, Stanton. Letters to Lloyd Goodrich. Whitney Museum of American Art, New York.

———— Correspondence between Stanton Macdonald-Wright and John Quinn. John Quinn Memorial Collection, Manuscripts and Archives Division, The New York Public Library, Astor, Lenox, and Tilden Foundations.

———— Letters to Morgan Russell. Archives of American Art, Smithsonian Institution, Washington, D.C.

———— Letters to Alfred Stieglitz. Alfred Stieglitz Archives, Collection of American Literature, Beinecke Rare Book and Manuscript Library, Yale University, New Haven, Conn.

Russell, Morgan. Notebooks and papers. Collection of Mr. and Mrs. Henry M. Reed, Caldwell, N.J.

———— Letters to Andrew Dasburg. Andrew Dasburg Collection, George Arents Research Library for Special Collections at Syracuse University, Syracuse, N.Y.

———— Letters to Gertrude Vanderbilt Whitney. Collection of the Whitney Family, New York.

———— Letters to Stanton Macdonald-Wright. Archives of American Art, Smithsonian Institution, Washington, D.C.

Wright, Willard Huntington. Scrapbooks, 58 vols. Rare Book and Manuscript Division, Firestone Library, Princeton University, Princeton, N.J.

EXHIBITION CATALOGUES

Les Peintres futuristes italiens. Bernheim-Jeune & Cie., Paris, February 5–24, 1912.

International Exhibition of Modern Art. Armory of the Sixty-Ninth Infantry, New York, February 15–March 15, 1913.

Ausstellung Der Synchromisten Morgan Russell, S. Macdonald-Wright. Introduction by Morgan Russell and Stanton Macdonald-Wright. Der Neue Kunstsalon, Munich, June 1–30, 1913.

Erster Deutscher Herbstsalon. Der Sturm, Berlin, September 20–December 1, 1913.

Les Synchromistes S. Macdonald-Wright et Morgan Russell. Introductions by Morgan Russell and Stanton Macdonald-Wright. Bernheim-Jeune & Cie., Paris, October 27–November 8, 1913.

Exhibition of Synchromist Paintings by Morgan Russell and S. Macdonald-Wright. Foreword by Willard Huntington Wright, Introduction by Morgan Russell and S. Macdonald-Wright. Carroll Galleries, New York, March 2–16, 1914.

The Forum Exhibition of Modern American Painters. Essay by Willard Huntington Wright; Forewords by Christian Brinton, Robert Henri, W. H. de B. Nelson, Alfred Stieglitz, John Weichsel, Willard Huntington Wright; Explanatory Notes by Ben Benn, Thomas H. Benton, Oscar Bluemner, Andrew Dasburg, Arthur G. Dove, Marsden Hartley, S. Macdonald-Wright, John Marin, Alfred Maurer, Henry L. McFee, George F. Of, Man Ray, Morgan Russell, Charles Sheeler, A. Walkowitz, William Zorach. Anderson Galleries, New York, March 13–25, 1916. Reprint, New York, 1968.

Exhibition of Paintings and Sculpture by Stanton Macdonald-Wright. Photo-Secession Gallery ("291"), New York, March 20–31, 1917.

Recent Paintings by Stanton Macdonald-Wright. Daniel Gallery, New York, closed March 18, 1918.

Exhibition of Paintings and Drawings Showing the Later Tendencies in Art. The Pennsylvania Academy of the Fine Arts, Philadelphia, April 16–May 15, 1921.

Exposition de Tableaux et Synchromies par Morgan-Russell. Introduction by Elie-Faure. Galerie La Licorne, Paris, May 4–17, 1923.

Exhibition by Stanton Macdonald-Wright and Morgan Russell. Stendahl Art Galleries, Los Angeles, January 4–23, 1932.

Paintings by Stanton Macdonald-Wright and Morgan Russell. Los Angeles Museum, February 1932.

Pioneers of Modern Art in America. Introduction by Lloyd Goodrich. Whitney Museum of American Art, New York, April 9–May 19, 1946.

Three American Pioneers: Morgan Russell, Macdonald-Wright, and Patrick Henry Bruce. Rose Fried Gallery, New York, November 20–December, 1950.

Abstract Painting and Sculpture in America. Text by Andrew C. Ritchie. The Museum of Modern Art, New York, January 23–March 25, 1951. Reprint, New York, 1972.

Morgan Russell Memorial Exhibition. Rose Fried Gallery, New York, October–November, 1953.

A Retrospective Showing of the Work of Stanton Macdonald-Wright. Introduction by Richard F. Brown. Los Angeles County Museum, January 19–February 19, 1956.

Andrew Dasburg. Introduction by Jerry Bywaters, "Notes" by Andrew Dasburg. Dallas Museum of Fine Arts, March 3–April 21, 1957.

American Genius in Review No. 1. Introduction by Douglas MacAgy. Dallas Museum for Contemporary Arts, May 11–June 19, 1960.

The Decade of the Armory Show. Text by Lloyd Goodrich. Whitney Museum of American Art, New York, February 27–April 14, 1963.

1914: An Exhibition of Paintings, Drawings and Sculpture Created in 1914. Essays by George Boas, Henri Peyre, Lincoln Johnson, Jr., and Gertrude Rosenthal. The Baltimore Museum of Art, October 6–November 15, 1964.

Retrospective of Konrad Cramer. Bevier Gallery, Rochester Institute of Technology, Rochester, N.Y., January 10–24, 1964.

Synchromism and Color Principles in American Painting: 1910–1930. Catalogue and text by William C. Agee. M. Knoedler and Co., Inc., New York, October 12–November 6, 1965.

Synchromism and Related Color Principles in American Painting 1910–1930. The Museum of Modern Art, New York, Traveling Exhibitions, 1967.

Cubism: Its Impact in the USA 1910–1930. Introduction by Clinton Adams. University of New Mexico Art Museum, Albuquerque, February 10–March 19, 1967 (exhibition traveled).

The Art of Stanton Macdonald-Wright. Introduction by David W. Scott; includes reprint of *A Treatise on Color* by Stanton Macdonald-Wright. National Collection of Fine Arts, Smithsonian Institution, Washington, D.C., May 4–June 18, 1967.

Manierre Dawson: Paintings 1909–1913. Introduction by Karl Nickel. Ringling Museum of Art, Sarasota, Fla., November 6–26, 1967 (exhibition traveled).

Oscar Bluemner: American Colorist. Fogg Art Museum, Cambridge, Mass., October 11–November 15, 1967.

Oscar Bluemner, 1867–1938. Preface by Alfredo Valente, Foreword by John Davis Hatch. New York Cultural Center, December 16, 1969–March 8, 1970.

Four Americans in Paris: The Collections of Gertrude Stein and Her Family. Introduction by Margaret Potter, essays by June Gordon et al. The Museum of Modern Art, New York, December 19, 1970–March 1, 1971.

Max Weber: The Years 1906–1916. Bernard Danenberg Galleries, New York, May 12–30, 1970.

H. Lyman Saÿen. Essay by Adelyn D. Breeskin. National Collection of Fine Arts, Smithsonian Institution, Washington, D.C., September 25–November 1, 1970.

Georgia O'Keeffe. Text by Lloyd Goodrich. Whitney Museum of American Art, New York, October 8–November 29, 1970 (exhibition traveled).

Stanton Macdonald-Wright: A Retrospective Exhibition 1911–1970. Interview by Frederick Wight. UCLA Art Galleries, Grunwald Graphic Arts Foundation, Los Angeles, November 16–December 20, 1970.

Thomas Wilfred: Lumia—A Retrospective Exhibition. Text by Donna M. Stein. Corcoran Gallery of Art, Washington, D.C., April 16–May 30, 1971.

James H. Daugherty. Essay by William C. Agee. Robert Schoelkopf Gallery, New York, December 4–31, 1971.

Color and Form 1909–1914. Essays by Joshua C. Taylor, Peter Selz, Lilli Lonngren, Herschel B. Chipp, William C. Agee, Henry G. Gardiner. Fine Arts Gallery of San Diego, November 20, 1971–January 2, 1972 (exhibition traveled).

Thomas Hart Benton: A Retrospective of His Early Years, 1907–1929. Rutgers University Art Gallery, New Brunswick, N.J., November 19–December 30, 1972.

Alfred H. Maurer, 1868–1932. Foreword by Joshua C. Taylor, essay by Sheldon Reich. National Collection of Fine Arts, Smithsonian Institution, Washington, D.C., February 23–May 13, 1973.

Abraham Walkowitz, 1878–1965. Essay by Martica Sawin. Utah Museum of Fine Arts, Salt Lake City, October 27–December 1, 1974 (exhibition traveled).

Arthur Dove. Text by Barbara Haskell. San Francisco Museum of Art, November 21, 1974–January 5, 1975 (exhibition traveled).

Frantisek Kupka 1871–1957: A Retrospective. Text by Mladek Meda and Margit Rowell. The Solomon R. Guggenheim Museum, New York, October 10–December 7, 1975.

Pennsylvania Academy Moderns 1910–1940. Essays by Joshua C. Taylor and Richard T. Boyle. National Collection of Fine Arts, Smithsonian Institution, Washington, D.C., 1975 (exhibition traveled to the Pennsylvania Academy of the Fine Arts).

Avant-Garde Painting and Sculpture in America 1910–1925. Essays by William Innes Homer et al. Delaware Art Museum, Wilmington, April 4–May 18, 1975.

Twentieth-Century American Drawing: Three Avant-Garde Generations. Essay by Diane Waldman. The Solomon R. Guggenheim Museum, New York, January 23–March 21, 1976 (exhibition traveled).

Robert Delaunay. Preface by Jean Cassou, Introduction by Michel Hoog. Orangerie des Tuileries, Paris, May 25–August 30, 1976 and Kunsthalle, Baden-Baden, September 25–November 14, 1976. Catalogue expanded and reissued in German with Foreword by Hans Albert Peters.

California: 5 Footnotes to Modern Art History. "Morgan Russell: The Avant-Garde Dilemma," essay and chronology by Gail Levin. Los Angeles County Museum of Art, January 18–April 24, 1977.

Woodstock: An American Art Colony 1902–1977. Introduction by Karal Ann Marling. Vassar College Art Gallery, Poughkeepsie, N.Y., January 23–March 4, 1977.

BOOKS

Apollinaire, Guillaume. *The Cubist Painters: Aesthetic Meditations, 1913.* Tr. by Lionel Abel. New York, 1944; revised 1949, 1962.

———— *Apollinaire on Art: Essays and Reviews 1902–1918.* Ed. by Leroy C. Breunig, tr. by Susan Suleiman. New York, 1972.

Baigell, Matthew. *Thomas Hart Benton.* New York, 1974.

Barr, Alfred H., Jr. *Cubism and Abstract Art.* New York, 1936. Reprint, 1974.

———— *Matisse, His Art and His Public.* New York, 1951. Reprint, 1966.

Baur, John I. H. *Revolution and Tradition in Modern Art.* Cambridge, Mass., 1951.

Benton, Thomas Hart. *An American in Art: A Professional and Technical Autobiography.* Lawrence, Kan., 1969.

———— *An Artist in America.* New York, 1937.

Birren, Faber. *History of Color in Painting.* New York, 1965.

Blesh, Rudi. *Modern Art U.S.A.: Men, Rebellion, Conquest, 1900–1956.* New York, 1956.

Brion-Guerry, L., ed. *L'Anneé 1913: Les formes esthétiques de l'oeuvre d'art à la veille de la première guerre mondiale.* Paris, 1971.

Brown, Milton. *American Painting from the Armory Show to the Depression.* Princeton, N.J., 1955.

———— *The Story of the Armory Show.* New York, 1963.

Chevreul, M.-E. *De la Loi du contraste simultané des couleurs, et de l'assortiment des objets colorés.* Paris, 1839. Republished, based on the first English translation by Charles Martel, London, 1854, as *The Principles of Harmony and Contrast of Colors and Their Applications to the Arts,* with introduction and notes by Faber Birren, New York, 1967.

Chadourne, Jacqueline. *Blaise Cendrars: poète du cosmos.* Paris, 1973.

Chisholm, Lawrence W. *Fenollosa: The Far East and American Culture.* New Haven, Conn., 1963.

Cohen, Arthur A. *Sonia Delaunay.* New York, 1975.

Coquoit, Gustave. *Cubistes, futuristes et passéistes.* Paris, 1914.

Damase, Jacques et al. *Sonia Delaunay: Rhythms and Colours.* New York, 1972.

Delaunay, Robert. *Du Cubisme à l'art abstrait.* Pierre Francastel, ed. Paris, 1957.

Dreier, Katherine S. *Western Art and the New Era.* New York, 1923.

Dreier, Katherine S., and Duchamp, Marcel; Hamilton, George Heard, ed. *Collection of the Société Anonyme: Museum of Modern Art 1920.* New Haven, Conn., 1950.

Eddy, Arthur Jerome. *Cubists and Post-Impressionism.* Chicago, 1914; rev. ed. 1919.

Gallup, Donald, ed. *The Flowers of Friendship: Letters Written to Gertrude Stein.* New York, 1953.

Golding, John. *Cubism: A History and an Analysis, 1907–1914.* New York, 1959. Reprint, 1968.

Gordon, Donald E., ed. *Modern Art Exhibitions 1900–1906: Selected Catalogue Documentation.* Munich, 1974.

Homer, William Innes. *Seurat and the Science of Painting.* Cambridge, Mass., 1964.

Homer, William Innes, with assistance of Violet Organ. *Robert Henri and His Circle.* Ithaca, N.Y., 1969.

Judson, William D., III. "Patrick Henry Bruce: 1881–1936." Master's thesis. Oberlin College, Ohio, 1968.

Kandinsky, Wassily. *Uber das Geistige in der Kunst: Insbesondere in der Malerei.* Munich, 1912. Tr. by M.T. H. Sadler as *The Art of Spiritual Harmony.* London and Boston, 1914. Republished in new rev. ed. as *Concerning the Spiritual in Art.* New York, 1947.

Kelder, Diane, ed. *Stuart Davis.* New York, 1971.

Klein, Adrian Bernard. *Colour Music: The Art of Light.* London, 1930.

Lawder, Standish D. *The Cubist Cinema.* New York, 1973.

La Tourette, F. Gilles de. *Robert Delaunay.* Paris, 1950.

Levin, Sandra Gail. "Wassily Kandinsky and the American Avant-Garde, 1912–1950." Ph.D. dissertation, Rutgers University, New Brunswick, N.J., 1976.

Luhan, Mabel Dodge. *Intimate Memories.* New York, 1936.

Macdonald-Wright, Stanton. *A Treatise on Color.* Los Angeles, 1924. Reprinted in *The Art of Stanton Macdonald-Wright.* National Collection of Fine Arts, Washington, D.C., 1967.

MacGregor, Alasdair Alpin. *Percyval Tudor-Hart 1873–1954: Portrait of an Artist.* London, 1961.

McCausland, Elizabeth. *Marsden Hartley.* Minneapolis, 1952.

Martin, Marianne W. *Futurist Art and Theory, 1909–1915.* London, 1968.

Mellow, James. *Charmed Circle: Gertrude Stein & Company,* New York, 1974.

Norman, Dorothy. *Alfred Stieglitz: An American Seer.* New York, 1973.

Perlman, Bennard B. *The Immortal Eight; American Painting from Eakins to the Armory Show (1870–1913).* New York, 1962.

Philadelphia Museum of Art. *Arthur B. Carles.* Monograph text by Henry G. Gardiner. Philadelphia, 1970.

Reed, Henry M. *The A.B. Frost Book.* Rutland, Vt., 1967.

———— "Synchromism and Related Tendencies in American Abstract Painting." Unpublished manuscript, Caldwell, N.J.

Rimington, A. Wallace. *Colour-Music: The Art of Mobile Colour.* London, 1912.

Rood, Ogden N. *Modern Chromatics, with Applications to Art and Industry.* New York, 1879. Republished with introduction and notes by Faber Birren. New York, 1973.

Rose, Barbara. *American Art Since 1900: A Critical History.* New York, 1967.

Rosenblum, Robert. *Cubism and Twentieth-Century Art.* New York, 1960.

Seuphor, Michel [Ferdinand Louis Berckelaers]. *Abstract Painting: Fifty Years of Accomplishment, from Kandinsky to the Present.* New York, 1961.

Simonson, Lee. *Part of a Lifetime.* New York, 1943.

Stein, Gertrude. *The Autobiography of Alice B. Toklas.* New York, 1933.

Vriesen, Gustav, and Imdahl, Max. *Robert Delaunay: Light and Color.* New York, 1969.

Werner, Alfred. *Max Weber.* New York, 1975.

Wolf, Ben. *Morton Livingston Schamberg.* Philadelphia, 1963.

Wright, Willard Huntington. *Modern Painting: Its Tendency and Meaning.* New York, 1915; 2nd ed., 1926.

———— *The Future of Painting.* New York, 1923.

Wright, Willard Huntington, and Macdonald-Wright, Stanton. *The Creative Will: Studies in the Philosophy and the Syntax of Aesthetics.* New York, 1916.

ARTICLES

Agee, William C. "Synchromism: The First American Movement." *Art News,* 64, October 1965, pp. 28–31 ff.

———— "Synchromism and Color Principles in American Painting 1910–1930." *Art in America,* 53, October-November 1965, pp. 75–77.

———— "Rediscovery: Henry Fitch Taylor," *Art in America,* November–December 1966, pp. 40–43.

——— "Patrick Henry Bruce: A Major American Artist of Early Modernism." *Arts in Virginia*, 17, Spring 1977, pp. 12–32.

Allard, Roger. "La 30ᵉ Exposition des artistes indépendants." *Les Ecrits Français*, March 1914, p. 12.

Brigante, Nick and Feitelson, Lorser. "Tribute to Stanton Macdonald-Wright." *American Art Review*, 1, January–February 1974, p. 54.

Caffin, Charles H. "Important Things in Art, Significant Still-Lives by Bruce." *New York American*, November 27, 1916, p. 6.

Canudo, Riciotto. "L'Art cérébriste." *Le Figaro*, February 9, 1914.

Chipp, Herschel B. "Orphism and Color Theory." *The Art Bulletin*, 40, March 1958, pp. 55–63.

Clausen, Henry. "Recollections of Stanton Macdonald-Wright." *American Art Review*, 1, January–February 1974, pp. 55–58.

Craven, Thomas. "An Aesthetic Prophecy." *Dial*, July 1923.

Dasburg, Andrew. "Cubism—Its Rise and Influence." *Arts*, 4, November 1923, pp. 278–83.

"French Artist at Odds with N.Y. Exhibitors." *New York Tribune*, March 2, 1913, p. 4.

Gallup, Donald. "The Weaving of a Pattern: Marsden Hartley and Gertrude Stein." *Magazine of Art*, 41, November 1948, pp. 256–61.

Hey, Kenneth R. "Manierre Dawson: A Fix on the Phantoms of the Imagination." *Archives of American Art Journal*, 14, no. 4, 1974, pp. 7–12.

Homer, William Innes. "Stuart Davis, 1894–1964: Last Interview." *Art News*, 63, pp. 43 and 56.

Levin, Gail. "Morgan Russell's Notebooks: An American Avant-Garde Painter in Paris." *RACAR (Canadian Art Review)*, 3, 1976, pp. 73–87.

——— "The Tradition of the Heroic Figure in Synchromist Abstractions." *Arts Magazine*, 51, June 1977, pp. 138–42.

——— "James Daugherty: Early Modernist and Simultaneist." *Whitney Review 1976–77* [Whitney Museum of American Art, New York, annual report], 1977.

Macdonald-Wright, Stanton. "The Influence of Aviation on Art: The Accentuation of Individuality." *The Ace: The Aviation Magazine of the West*, September 1919, pp. 11–12.

——— "The Artist Speaks," with a Note on Synchromism by Barbara Rose. *Art in America*, 55, May 1967, pp. 70–73.

"The Maratta System of Color." *Scientific American Supplement*, LXVIII, November 13, 1909, p. 311.

Miller, Arthur. "Synchromists Reunited." *Los Angeles Times*, July 19, 1931.

——— "Wright and Russell Give Season's Major Exhibit." *Los Angeles Times*, January 10, 1932, p. 16.

Reich, Sheldon. "Abraham Walkowitz: Pioneer of American Modernism." *American Art Journal*, 3, Spring 1971, pp. 72–83.

Rosenfield, Paul. "The Academy Opens Its Doors." *The New Republic*, May 4, 1921, p. 290.

Scott, David W. "Stanton Macdonald-Wright: A Retrospective." *American Art Review*, 1, January–February 1974, pp. 49–53.

Seuphor, Michel [Ferdinand Louis Berckelaers]. "L'Orphisme." *L'Art d'Aujourd' hui*, March 1950.

——— "Synchromies." *L'Oeil*, 37, January 1958, pp. 57–61.

"The Taylor System of Color Harmony." *Color Trade Journal*, XII, February 1923, pp. 56–58.

Tudor-Hart, Percyval. "A New View of Colour." *Cambridge Magazine*, February 23, 1918, pp. 452–56.

——— "The Analogy of Sound and Colour." *Cambridge Magazine*, March 2, 1918, p. 480.

Vaugironne, V. de. "Une nouvelle Ecole de peinture: le synchromisme." *La Revue Moderne*, November 25, 1913, pp. 12–14.

Vauxcelles, Louis. "Les Arts." *Gil Blas*, May 7, 1914, p. 4.

Vromant, Marc. "A propos du Salon des Indépendants. Du cubisme et autres synthèses." *Comœdia*, April 15, 1914, pp. 1–2.

——— "La Peinture simultaniste." *Comœdia*, June 2, 1914, pp. 1–2.

Walker, John Alan. "Interview: Stanton Macdonald-Wright." *American Art Review*, 1, January–February 1974, pp. 59–68.

Warshawsky, W. "Orpheisme, Latest of Painting Cults." *New York Times*, October 19, 1913, p. 4.

Weichsel, John. "Another New Art Venture: The Forum Exhibition." *International Studio*, 58, June 1916, p. cxvi.

"William Henry Kemble Yarrow: 1891–1941" (obituary). *New York Times*, April 22, 1941.

Wolf, Tom M. "Patrick Henry Bruce." *Marsyas*, XV, 1970–72, pp. 77–78.

Wright, Willard Huntington. "Impressionism to Synchromism." *Forum*, 50, December 1913, pp. 757–70.

——— "Synchromism." *International Studio*, 56, October 1915, pp. xcvii–c.

——— "Aesthetic Struggle in America." *Forum*, 55, February 1916, pp. 201–20.

——— "An Abundance of Modern Art." *Forum*, 105, March 1916, pp. 318–34.

——— "Forum Exhibition at the Anderson Galleries." *Forum*, 55, April 1916, pp. 457–71.

——— "Modern Art." *International Studio*, 41, April 1917, pp. lxii–lxiv.

Zilczer, Judith. "The World's New Art Center: Modern Art Exhibitions in New York City, 1913–1918." *Archives of American Art Journal*, 14, no. 3, 1974, pp. 2–7.

Checklist/Artists' Biographies

The following is a list of works in the exhibition, arranged alphabetically by artist.[1] A brief biography of each artist is included. Height precedes width in the dimensions. Where a work is reproduced in this book, the Plate reference is given in brackets following the title and date.

BEN BENN (1884–)
Born in Russia. Emigrated to United States in 1894. Studied at the National Academy of Design, New York, 1904–08. Exhibited in Forum Exhibition, 1916. Friend of Marsden Hartley. First one-artist exhibition, Neumann Gallery, 1925. Lives in New York.

Sunset, 1916 [Pl. 152]
Oil on canvas, 22 x 28″
Collection of Mr. and Mrs. Meredith J. Long

THOMAS HART BENTON (1889–1975)
Born in Neosho, Mo. Studied at the Art Institute of Chicago, 1907–08. Lived in Paris, 1908–11; met Stanton Macdonald-Wright, Leo Stein, Morgan Russell, John Thompson, and George Carlock. Settled in New York, 1912. Experimented with Synchromist abstraction after seeing the Synchromist exhibition in 1914. Exhibited in Forum Exhibition, 1916; Daniel Gallery, 1917. Associated with John Weichsel's People's Art Guild about 1917. Began historical murals in 1919; continued to depict American subjects in both genre scenes and history paintings.

Bubbles, c.1914–17 [Pl. 22]
Oil on canvas, 21¾ x 16½″
The Baltimore Museum of Art; Gift of H. L. Mencken

Constructivist Still Life: Synchromist Color, 1917 [Pl. 120]
Oil on paper, 17½ x 13⅝″
Columbus (Ohio) Gallery of Fine Arts; Gift of Carl A. Magnuson

People of Chilmark (Figure Composition), 1920 [Pl. 121]
Oil on canvas, 65½ x 77½″
Hirshhorn Museum and Sculpture Garden, Smithsonian Institution, Washington, D.C.

Screen with an Abstract Sea Motif, c.1925 [Pl. 122]
Oil on canvas; each panel 68 x 20″
Private collection

OSCAR BLUEMNER (1867–1938)
Born in Hanover, Germany. Studied painting and architecture at the Royal Academy of Design in Berlin. Emigrated to Chicago, Ill., in 1892. Moved from Chicago to New York, 1901. Left for Europe, 1912; had one-artist show at Gurlit Galleries, Berlin. Exhibited five landscapes at Armory Show, 1913. First one-artist show in U.S. at "291" in 1915. Exhibited Forum Exhibition, 1916. Moved to South Braintree, Mass., in 1926. Continued his interest in color and its emotional qualities. Committed suicide in 1938.

Morning Light (Dover Hills, October), c.1916 [Pl. 46]
Oil on canvas, 20 x 30⅛″
Hirshhorn Museum and Sculpture Garden, Smithsonian Institution, Washington, D.C.

PATRICK HENRY BRUCE (1881–1936)
Born in Long Island, Va. First studied under sculptor Edward Valentine, Richmond Art School. Came to New York, 1901, where he studied under William Merritt Chase and in 1903 with Robert Henri. To Paris, 1904, where he knew the Steins and studied with Matisse in 1908. Admired the art of Cézanne. Exhibited frequently in the Paris salons. Close friend of Arthur Burdett Frost, Jr., and Robert Delaunay. Influenced by Delaunay, with whom he exhibited in Berlin at Der Sturm in 1913. Exhibited in New York at the Montross Gallery in 1916 and at the Modern Gallery in 1917. Lived in France until 1936, when he returned to the United States; committed suicide the same year.

Still Life, c.1911 [Pl. 130]
Oil on canvas, 10⅝ x 13¾″
Collection of Mr. and Mrs. Henry M. Reed

Still Life with Tapestry, 1911–12
[Pl. 131]

Oil on canvas, 19¼ x 27″
Collection of Mr. and Mrs. Henry M. Reed

Composition I, 1916 [Pl. 27]
Oil on canvas, 45½ x 34¾″
Yale University Art Gallery, New Haven, Conn.; Gift of Collection Société Anonyme

Composition II, 1916 [Pl. 133]
Oil on canvas, 38¼ x 51″
Yale University Art Gallery, New Haven, Conn.; Gift of Collection Société Anonyme

Composition III, 1916 [Pl. 28]
Oil on canvas, 63¼ x 38″
Yale University Art Gallery, New Haven, Conn.; Gift of Collection Société Anonyme

Composition V, 1916 [Pl. 132]
Oil on canvas, 51⅜ x 63⅝″
Yale University Art Gallery, New Haven, Conn.; Gift of Collection Société Anonyme

Forms, 1920–21 [Pl. 134]
Oil on canvas, 23½ x 28¾″
Howard S. Wilson Memorial Collection, University of Nebraska–Lincoln Art Galleries

Untitled (Forms), 1920–21 [Pl. 135]
Oil on canvas, 23¾ x 36¼″
William H. Lane Foundation, Leominster, Mass.

Still Life, c.1922–25
Oil on canvas, 23½ x 28⅜″
Collection of Roy R. Neuberger

ARTHUR B. CARLES (1882–1952)
Born in Philadelphia, Pa. Studied with William Merritt Chase and Thomas Anshutz, 1902–07. Lived mostly in Paris, 1907–12, where he met the Steins, Alfred Maurer, and Edward Steichen. Claimed to have studied with Matisse. Included in "Younger American Painters" exhibition of March 1910 at "291," where he had a one-artist show in January 1912. Exhibited in Armory Show, 1913; and in "Later Tendencies in Art," Pennsylvania Academy of the Fine Arts, 1921.

Nude, 1921 [Pl. 164]
Oil on canvas, 30 x 25″
Collection of Mr. and Mrs. Malcolm C. Eisenberg

1. Not all the works will be included at every museum showing the exhibition.

PAUL CÉZANNE (1839–1906)
French, born in Aix-en-Provence. First
came to Paris in 1861. Initial one-artist
exhibition at Ambroise Vollard's gallery,
1895. Entire room of the Salon d'Automne
of 1904 devoted to his work, which be-
came increasingly respected at this time.
Memorial retrospective exhibition in the
Salon d'Automne of 1907, with fifty-six
examples. Americans knew his work in
the Steins' collection, from public exhibi-
tions, and from Vollard's gallery. Ameri-
can painters who particularly admired his
art included Bruce, Dasburg, Hartley,
Macdonald-Wright, Russell, and Weber.

Apples [*Pommes*], c.1873–77 [Pl. 55]
Oil on canvas, 4⅞ x 10¼"
Collection of Mr. and Mrs. Eugene Victor
Thaw

KONRAD CRAMER (1888–1963)
Born in Wurtzberg, Germany. Emigrated
to the United States, 1911. Lived in New
York City and Woodstock, N.Y. Studied
with Karl Schmidt-Rottluff and knew
Kandinsky's work in Germany. Painted
pure abstractions before 1913 and ex-
hibited them at the MacDowell Club in
New York, November 1913. Friend of
Andrew Dasburg and Alfred Stieglitz.
Later turned his attention to Cubist col-
lage and photography.

Blocks, 1912 [Pl. 153]
Oil on canvas, 18¾ x 16"
Collection of Mr. and Mrs. Henry M. Reed

Improvisation, 1912 [Pl. 26]
Oil on canvas, 30 x 26"
Fine Arts Gallery of San Diego

Improvisation No. 1, 1912/13 [Pl. 25]
Oil on canvas, 29¾ x 24"
Whitney Museum of American Art, New
York; Lawrence H. Bloedel Bequest,
1977

ANDREW DASBURG (1887–)
Born in Paris, emigrated to New York in
1892. Studied at the Art Students League
with Frank V. Du Mond, Kenyon Cox, and
George Bridgman; then with Robert Henri
in New York and with Birge Harrison in
Woodstock, where Morgan Russell joined
him during the summer of 1907. With
Russell in Paris, 1909–10, where he met
Matisse and Leo Stein. In New York,
friendly with Mabel Dodge and Konrad
Cramer. Exhibited pure abstract paint-
ings at the MacDowell Club, New York,
1913. Exhibited in the Armory Show, 1913;

Forum Exhibition, 1916. Has lived in Taos,
N.M., since 1930.

Improvisation, c.1915–16 [Pl. 24]
Oil on canvas, 35½ x 29½"
Collection of Mr. and Mrs. Henry M. Reed

JAMES HENRY DAUGHERTY (1887–1974)
Born in Asheville, N.C.; raised in Indi-
ana, Ohio, and Washington, D.C. Studied
painting at the Corcoran Art School,
Washington, 1903, then in Philadelphia at
the Pennsylvania Academy of the Fine
Arts under William Merritt Chase, 1904–
05. Traveled to Europe, 1905–07, and
studied with Frank Brangwyn in London.
Experimented with Futurism in New York
in 1914. In 1915 he had a studio adjoin-
ing that of Arthur Burdett Frost, Jr. In
1916–22 he painted in an abstract style
inspired by color theories learned from
Frost and through the work of Bruce.
After 1920, Daugherty painted murals in
a representational style and continued to
work as an illustrator, returning to ab-
straction in the mid-sixties. Exhibited in
1914 at the MacDowell Club, New York.
From 1917, exhibited at the Society of In-
dependent Artists in New York and from
1920 with the Société Anonyme, Inc.

Futurist Picture of the Opening Game
[Pl. 136]
Color reproduction from the *New York
Sunday Herald*, April 12, 1914; 9¼ x 12"
Whitney Museum of American Art, New
York, 1977

Three Base Hit (Opening Game), 1914
[Pl. 38]
Gouache and ink on paper, 12½ x 17½"
Whitney Museum of American Art, New
York, 1977

*Right This Way! Sensations of Color,
Movement and Noise at Coney Island*
Color reproduction from the *New York
Sunday Herald*, May 31, 1914; 25 x 18"
Whitney Museum of American Art, New
York; Gift of Mr. and Mrs. Charles
Daugherty, 1977

Vacation Days
Color reproduction from the *New York
Sunday Herald*, July 19, 1914;
22¾ x 16½"
Whitney Museum of American Art, New
York; Gift of Mr. and Mrs. Charles
Daugherty, 1977

Broadway Nights [Pl. 137]
Color reproduction from the *New York
Sunday Herald*, January 31, 1915;
23¾ x 16⅝"

Whitney Museum of American Art, New
York; Gift of Mr. and Mrs. Charles
Daugherty, 1977

Mural Decoration, 1918 [Pl. 138]
Oil on burlap, 76 x 74½"
Yale University Art Gallery, New Haven,
Conn.; Gift of Collection Société
Anonyme

Simultaneous Contrasts, 1918 [Pl. 139]
Oil on canvas, 35¾ x 40½"
The Museum of Modern Art, New York;
Gift of Mr. and Mrs. Henry M. Reed, 1969

Flight into Egypt, c.1920
Oil on canvas, 39½ x 29¾"
Robert Schoelkopf Gallery, New York

Untitled (recto), 1920 [Pl. 39]
Moses (verso), c.1922 [Pl. 40]
Oil on canvas, 75 x 75"
Collection of R. L. B. Tobin

ARTHUR B. DAVIES (1862–1928)
Born in Utica, N.Y. Moved to Chicago,
1878; studied at the Chicago Academy of
Design and, in 1882, at the Art Institute
of Chicago with Charles Corwin. Moved to
New York, 1887; studied at Gotham Art
School and Art Students League. Began
first of a series of one-artist shows at
Macbeth Gallery in 1896. Showed at the
exhibition of "The Eight" in 1908. Be-
came president of The Association of
American Painters and Sculptors, 1911.
Instrumental in organizing the Armory
Show, 1913, and thereafter experimented
with modernism.

Day of Good Fortune, 1914 [Pl. 45]
Oil on canvas, 18 x 30"
Whitney Museum of American Art, New
York; Gift of Mr. and Mrs. Arthur G.
Altschul, 1971

Figures, 1916 [Pl. 157]
Tempera on panel, 20¼ x 8¼"
Munson-Williams-Proctor Institute,
Utica, N.Y.

STUART DAVIS (1894–1964)
Born in Philadelphia, Pa. Friend of John
Sloan, George Luks, and Robert Henri in
East Orange, N.J. Studied with Henri,
1909. Included in exhibition of Inde-
pendent Artists, New York, 1910. Moved
to New York in 1913 and worked for
Sloan at *The Masses*. Exhibited in the
Armory Show that year, and in 1917 had
first one-artist show at Sheridan Square
Gallery, New York. Second one-artist
show at Ardsley Studios in Brooklyn,
1918. Exhibited People's Art Guild, 1915;

Society of Independent Artists, 1917 and 1918. Continued to develop abstraction influenced by Cubism.

The Breakfast Table, c.1917 [Pl. 44]
Oil on canvas, 48 x 34"
Kennedy Galleries, Inc., New York

MANIERRE DAWSON (1887–1969)
Born in Chicago, Ill. Worked as an architect, 1909–14. Traveled to Europe, 1910. In Paris, met Gertrude Stein and sold a painting to her. That fall in New York, met Arthur B. Davies, who introduced him to Albert Pinkham Ryder. Through Walter Pach, exhibited an abstract painting, *Wharf under Mountain,* in the Chicago version of the Armory Show, 1913. Exhibited with the "14" in Detroit in 1914 and showed at the Montross Gallery, New York. The same year he exhibited thirty-five works at the Milwaukee Art Society. After 1914 financial problems made it difficult for him to find time for his art.

Ariel, 1912 [Pl. 156]
Oil on wood, 32¼ x 23¾"
Robert Schoelkopf Gallery, New York

Twelve, 1913
Oil on wood, 27 x 20½"
Robert Schoelkopf Gallery, New York

ROBERT DELAUNAY (1885–1941)
French, born in Paris; married Sonia Terk in 1910. Friend of American artists Samuel Halpert, Leon Kroll, Arthur Burdett Frost, Jr., and Patrick Henry Bruce; also of the Steins. Friend of poet Guillaume Apollinaire, who described his work as Orphist. Exhibited in Salon des Indépendants, 1913, and in 1914 when Morgan Russell showed his Synchromies. Exhibited in Berlin at First German Autumn Salon, 1913. Included in exhibitions and almanac *Der Blaue Reiter.* In Spain and Portugal with his wife Sonia during 1914–20.

The First Disc [Le premier Disque], 1912 [Pl. 124]
Oil on canvas, 53" diameter
Collection of Mr. and Mrs. Burton Tremaine

The Windows [Les Fenêtres], 1912 [Pl. 123]
Oil on canvas, 18 x 15"
Collection of Arthur G. Altschul

SONIA DELAUNAY (1885–)
French, Russian-born. Studied at Academy in Karlsruhe, Germany. Came to

Paris, 1905; married Robert Delaunay, 1910. Sewed abstract blanket for their son Charles in 1911; made studies of light, 1912. During 1913, met the poet Blaise Cendrars and collaborated with him; created Simultaneous dresses and wore them to the Bal Bullier; exhibited at First German Autumn Salon in Berlin. Exhibited at the Salon des Indépendants, 1914. In Spain and Portugal with her husband Robert, 1914–20. Returned to Paris in 1920. Designed and sold Simultaneous fabrics in 1923 and designed costumes for Tristan Tzara's *Le Coeur à gaz.* Lives in Paris.

Le Bal Bullier, 1913 [Pl. 29]
Oil on canvas, 38⅛ x 51⅛"
Stadtisches Kunsthalle, Bielefeld, Germany

La Prose du Transsibérien et de la petite Jehanne de France, 1913 [Pl. 31]
Poem by Blaise Cendrars
Stencil and type on paper, 78¾ x 14"
Collection of Tamar Judith Cohen
Second copy: Collection of Mr. and Mrs. Henry M. Reed

Advertisement for "La Prose du Transsibérien et de la petite Jeanne [sic] de France," 1913 [Pl. 127]
Stencil on paper, 3¾ x 13½"
Collection of Mr. and Mrs. Henry M. Reed

Project for Poster for "La Prose du Transsibérien et de la petite Jehanne de France," 1913 [Pl. 126]
Crayon and watercolor on paper, 10 x 7⅞"
Musée National d'Art Moderne, Paris

Simultaneous Poster for Smirnoff's Lecture "The Simultaneous," 1913 [Pl. 125]
Watercolor on paper, 25¼ x 19¼"
Collection of the artist

ARTHUR G. DOVE (1880–1946)
Graduated from Cornell University and worked as an illustrator. Traveled to France, 1908–09. Lived in Cagnes with Alfred Maurer. Exhibited Salon d'Automne, 1909; then returned to New York, exhibited in the "Younger American Painters" show at "291." Close friend of Alfred Steiglitz, who gave him his first one-artist exhibition in 1912. Dove's collages were exhibited at the opening of Stieglitz's Intimate Gallery in 1925. Continued to work between abstraction and nature.

Abstraction, 1914 [Pl. 150]
Oil on canvas, 18 x 22"
Terry Dintenfass Gallery, New York

ARNOLD FRIEDMAN (1874–1946)
Born in New York. Studied at the Art Students League under Robert Henri, 1905–08. Visited Paris, 1908. Exhibited that year at the Old Harmonie Club on West 42nd Street in "The Exhibition of Paintings and Drawings of Contemporary Americans," with Edward Hopper, George Bellows, and other Henri students. Experimented with Pointillism and then abstraction. Charter member of Society of Independent Artists, 1917. Until 1933, worked in postal service, painting in his spare time.

Hillside, c.1917 [Pl. 142]
Watercolor on paper, 9⅞ x 14"
Collection of Arthur G. Altschul

Untitled, 1918
Oil on canvas, 20 x 24⅛"
Private collection

Untitled, c.1918 [Pl. 30]
Oil on canvas, 9 x 13½"
Collection of Mr. and Mrs. Henry M. Reed

Untitled Abstraction, c.1918
Oil on canvas mounted on board, 10⅜ x 12¾"
Private collection

Untitled, 1919 [Pl. 143]
Oil on canvas, 16⅞ x 22"
Private collection

ARTHUR BURDETT FROST, JR. (1887–1917)
Born in Philadelphia, Pa., son of the illustrator A. B. Frost. Studied at the Chase School in New York with Robert Henri, 1905; moved to Paris, 1906. Beginning of close friendship with Patrick Henry Bruce, 1907. Studied at the Académie Julian, then with Matisse; knew the Steins, Lyman Saÿen, and the Delaunays. Influenced by Delaunay, 1912–13. Treated for tuberculosis in Switzerland, mid-1911–12; then lived with Bruce and his wife in Paris and Brittany before returning to New York in late 1914. Influenced James Daugherty and Jay Van Everen toward chromatic painting.

Drawing for Harlequin, 1914 [Pl. 128]
Pencil on paper, 5 x 3½"
Collection of Mr. and Mrs. Henry M. Reed

Harlequin, 1914 [Pl. 32]
Oil on canvas, 13½ x 9½"
Collection of Mr. and Mrs. Henry M. Reed

Abstraction (unfinished), 1917 [Pl. 129]
Oil and charcoal on canvas, 50 x 56"
Collection of Mr. and Mrs. Henry M. Reed

MARSDEN HARTLEY (1877–1943)
Born in Lewiston, Me. Moved to Ohio, attended Cleveland School of Art. Studied in New York under William Merritt Chase, 1899. First one-artist show at "291" in 1909. Traveled to Europe in spring 1912. Met Wassily Kandinsky and Franz Marc. Exhibited at First German Autumn Salon in Berlin, organized by Der Sturm, 1913. Returned to United States, 1913; exhibited two paintings in the Armory Show. Exhibited at "291" in 1914 and was then in Germany until late 1915. Included in Forum Exhibition, 1916. Traveled to New Mexico, 1918, where he returned to representational painting.

Portrait Arrangement No. 2,
1912–13 [Pl. 144]
Oil on canvas, 39½ x 31¾"
Weyhe Gallery, New York

Composition, 1913 [Pl. 34]
Oil on panel, 19½ x 15½"
Collection of Mr. and Mrs. Henry M. Reed

Painting No. 6, 1913 [Pl. 145]
Oil on canvas, 39¾ x 32"
Weyhe Gallery, New York

Abstraction, c.1913 [Pl. 33]
Oil on paperboard mounted on panel,
24 x 20"
Collection of Mr. and Mrs. Meredith J. Long

Abstraction Blue, Yellow and Green,
c.1913 [Pl. 146]
Oil on canvas, 24⅜ x 18¾"
Los Angeles County Museum of Art;
Gift of Morton D. May

Composition, 1914 [Pl. 147]
Oil on canvas, 39½ x 31⅞"
Columbus (Ohio) Gallery of Fine Arts;
Gift of Ferdinand Howald

STANTON MACDONALD-WRIGHT
(1890–1973)
Born in Charlottesville, Va. Moved to Santa Monica, Calif., with his family in 1900. Studied with Warren T. Hedges at the Art Students League in Los Angeles, 1904–05. To Paris, 1907; studied at various schools. Joined Tudor-Hart's class in 1911 and met Morgan Russell through Lee Simonson. Exhibited in first Synchromist exhibitions in Munich, June 1913, and Paris, October 1913. Arranged Synchromist exhibition, New York, March 1914. Exhibited Forum Exhibition, 1916. One-artist show at "291" in March 1917.

Moved to California, 1919. Experimented with color film, 1920s. Director Art Students League, Los Angeles, 1922–30. Interested in Oriental art, painted murals, worked for W.P.A. Developed a kinetic light machine, the *Synchrome Kineidoscope,* 1959–62.

Portrait of Jean Dracopoli, 1912 [Pl. 7]
Oil on canvas mounted on board,
16¼ x 13⅛"
Collection of Roy R. Neuberger

Still Life with Skull, 1912 [Pl. 6]
Oil on canvas, 15⅜ x 19¼"
Private collection

Abstraction on Spectrum (Organization No. 5), 1914 [Pl. 10]
Oil on canvas, 30⅛ x 24³⁄₁₆"
Des Moines Art Center; Coffin Fine Arts Trust Fund, 1962

Study for Conception Synchromy,
1914 [Pl. 107]
Watercolor on paper, 23 x 17½"
Collection of Mr. and Mrs. Henry M. Reed

Conception Synchromy, 1914 [Pl. 11]
Oil on canvas mounted on cardboard,
29¾ x 11⅛"
Lydia and Harry L. Winston Collection
(Dr. and Mrs. Barnett Malbin)

Conception Synchromy, 1915 [Pl. 14]
Oil on canvas, 30 x 24"
Whitney Museum of American Art, New York; Gift of George F. Of, 1952

Self-Portrait, 1915 [Pl. 15]
Oil on canvas, 29½ x 23½"
Collection of Dr. Moritz Jagendorf

Synchromy in Blue, 1916 [Pl. 19]
Oil on canvas, 29⅞ x 23⅞"
Weyhe Gallery, New York

Synchromy in Blue-Green,
1916 [Pl. 108]
Oil on canvas, 28 x 36"
Private collection

Synchromy in Green and Orange,
1916 [Pl. 110]
Oil on canvas, 34½ x 30½"
Walker Art Center, Minneapolis;
T. B. Walker Acquisition Fund

California Landscape, c.1916 [Pl. 118]
Oil on canvas, 29⅞ x 22⅛"
Columbus (Ohio) Gallery of Fine Arts;
Gift of Ferdinand Howald

Synchromy 3, c.1916 [Pl. 109]
Oil on canvas, 28 x 28"
University Gallery, University of Minnesota, Minneapolis; Bequest of Hudson D. Walker

Still Life Synchromy, 1917 [Pl. 114]
Oil on canvas, 22 x 30"
Collection of Joseph H. Hazen

Synchromy, 1917 [Pl. 113]
Oil on canvas, 31 x 24"
The Museum of Modern Art, New York;
Given anonymously, 1949

Synchromy in Purple, 1917 [Pl. 112]
Oil on canvas, 36 x 28"
Los Angeles County Museum of Art;
Los Angeles County Funds

Synchromy in Blue, c.1917 [Pl. 111]
Oil on canvas, 26¼ x 20⅛"
The Museum of Modern Art, New York;
The Sidney and Harriet Janis
Collection, 1967

Oriental Synchromy in Blue-Green,
1918 [Pl. 20]
Oil on canvas, 36 x 50"
Whitney Museum of American Art,
New York, 1952

Sunrise Synchromy in Violet,
1918 [Pl. 116]
Oil on canvas, 35¾ x 54¼"
Museum of Art, Carnegie Institute,
Pittsburgh

Abstraction: Nude in Orange,
1919 [Pl. 117]
Oil on canvas, 19 x 13"
Collection of Mr. and Mrs. Henry M. Reed

Trumpet Flowers, 1919 [Pl. 115]
Oil on canvas, 18⅛ x 13⅛"
The Museum of Modern Art, New York;
The Sidney and Harriet Janis
Collection, 1967

Canyon Synchromy (Orange),
c.1919 [Pl. 119]
Oil on canvas, 24⅛ x 24⅛"
University Gallery, University of Minnesota, Minneapolis; Gift of Ione and Hudson Walker

Aeroplane: Synchromy in Yellow-Orange,
1920 [Pl. 21]
Oil on canvas, 24½ x 24"
The Metropolitan Museum of Art, New York; The Alfred Stieglitz Collection, 1949

JAN MATULKA (1890–1972)
Born in Vlachovo Brezi in Bohemia; emigrated to the United States, 1907. Began studying at the National Academy of Design in New York under George Willoughby Maynard in 1911. After winning the Joseph Pulitzer Prize in 1916, he traveled through Florida, Mexico, Canada, and the American Southwest. Developed a

modernist style. From 1920, exhibited with the Société Anonyme, Inc., in New York and at the Worcester Art Museum with Daugherty, Bruce, and Van Everen as the Simultaneists. Influential teacher at Art Students League, New York, 1929–32.

Cubist Nudes, c.1915–16 [Pl. 141]
Oil on canvas, 29 x 25″
University of Nebraska–Lincoln Art Galleries; Gift of Mary Riepma Ross

Indian Dancers, c.1916–17 [Pl. 37]
Oil on canvas, 26 x 16¼″
The Anschutz Collection, Denver

ALFRED H. MAURER (1868–1932)
Born in New York City, son of Louis Maurer, illustrator and artist. Left for Europe, 1897, and settled in Paris. Studied briefly at Académie Julian. Met Leo and Gertrude Stein in 1904, and came under the influence of Matisse. Included in exhibition "Younger American Painters" at "291" in 1910. Exhibited in the Armory Show, 1913; Forum Exhibition, 1916. Returned to New York, 1914. Close friend of Arthur Dove. Committed suicide in 1932.

Landscape, c.1916–17 [Pl. 148]
Oil on board, 21⅜ x 18⅛″
Weyhe Gallery, New York

Abstraction, c.1916–19 [Pl. 149]
Oil on board, 21½ x 17¾″
Weyhe Gallery, New York

CARL NEWMAN (1858–1932)
Lived in Bethayres, Pa., near Philadelphia. Taught at the Pennsylvania Academy of the Fine Arts, 1892–95. Knew Thomas Anshutz. Visited his friend Lyman Saÿen in Paris in the summer of 1910. Had Saÿen decorate the ceiling of his studio with a chromatic spectrum in 1915–16. Experimented with pure abstraction around 1920.

Untitled (Nude), c.1915–16
Oil on canvas mounted on fiberboard, 16⅛ x 22″
National Collection of Fine Arts, Washington, D.C.; Gift of Anna McCleery Newton

Spirit of Christmas, c.1915–20 [Pl. 166]
Oil and tempera on fiberboard; four-panel screen, each panel 67 x 23″
National Collection of Fine Arts, Washington, D.C.; Gift of Anna McCleery Newton

Untitled (Bathers), c.1917 [Pl. 165]
Oil on canvas, 32 x 28¼″

Whitney Museum of American Art, New York; Gift of Milton and Gertrude Luria, 1977

Untitled, 1921 [Pl. 35]
Watercolor on paper, 11 x 8½″
National Collection of Fine Arts, Washington, D.C.

GEORGIA O'KEEFFE (1887–)
Born near Sun Prairie, Wis. Studied at Art Institute of Chicago with John Vanderpoel, 1905–06; then at Art Students League in New York with William Merritt Chase. Summer course at the University of Virginia with Alon Bement in 1912. Taught in Virginia, Texas, and South Carolina. Studied with Arthur Wesley Dow at Columbia University. Alfred Stieglitz first showed her work at "291" in 1916. First one-artist exhibition at "291" in 1917. Married Stieglitz, 1924. From 1929, spent most summers in New Mexico. Has lived in Albiquiu, N.M., since 1949.

From the Plains I, 1919 [Pl. 151]
Oil on canvas, 27⅝ x 23⅝″
Collection of Andrew J. Crispo

MORGAN RUSSELL (1886–1953)
Born in New York City. To Europe in spring of 1906; studied sculpture at Art Students League in New York with James Earle Fraser in the fall. With Andrew Dasburg in Woodstock, summer 1907; joined Robert Henri's painting class that fall. Received allowance from Gertrude Vanderbilt Whitney, 1908–16. Second trip to Paris, 1908; met the Steins, Matisse, Picasso, and Rodin. Settled in Paris, 1909. Studied with Tudor-Hart and met Stanton Macdonald-Wright, 1911. Exhibited in Armory Show, New York, and in first Synchromist exhibitions in Munich and Paris, 1913. Exhibited in Salon des Indépendants, Paris, and Synchromist exhibition in New York, 1914. Visited New York in 1916 for Forum Exhibition, in which he was included. Moved to south of France, 1917; settled on farm in Burgundy, 1921. Exhibited recent Synchromies in Paris, 1923. Visited Macdonald-Wright in California, July 1931–June 1932. In Rome, 1932–36; painted religious themes. Returned to United States in 1946.

My First Painting, Old Westbury, Long Island, 1907 [Pl. 51]
Oil on cardboard, 5½ x 7½″
Collection of Mme Morgan Russell

The Bridge, 1908 [Pl. 52]
Oil on canvas, 18½ x 26¼″
Collection of Mr. and Mrs. Edwin L. Cox

Study of Reclining Nude Figure, c.1909 [Pl. 59]
Watercolor on paper, 5⅛ x 8″
Collection of Mr. and Mrs. Henry M. Reed

Isadora, 1910 [Pl. 54]
Pencil on paper, 5¾ x 3½″
Collection of Michel Seuphor

Nude Men on the Beach [Hommes nus sur la plage], 1910 [Pl. 53]
Oil on cardboard, 9⅜ x 13″
Collection of Dr. and Mrs. William Q. Sturner

Still Life (Apple), 1910
Oil on canvas, 7¼ x 11″
Collection of Mr. and Mrs. Henry M. Reed

Three Apples [Trois Pommes], 1910 [Pl. 56]
Oil on cardboard, 9¾ x 12⅞″
The Museum of Modern Art, New York; Given anonymously

Self-Portrait Sketch with Sculpture, c.1910 [Pl. 61]
Pencil on paper, 19 x 12″
Collection of Mr. and Mrs. Henry M. Reed

Sketch after Michelangelo's "Dying Slave," c.1910–12 [Pl. 63]
Pencil on paper, 12¼ x 8¼″
Collection of Mr. and Mrs. Henry M. Reed

Study after Michelangelo's "Dying Slave," c.1910–12 [Pl. 64]
Pencil on paper, 12 x 6⅛″
Collection of Mr. and Mrs. Henry M. Reed

Study after Picasso's "Three Women," c.1911 [Pl. 60]
Pencil on paper, 11⅝ x 9⅛″
Collection of Mr. and Mrs. Henry M. Reed

Still Life with Fruit and Glass, c.1911–12 [Pl. 57]
Oil on canvas, 10⅝ x 13¾″
Collection of Mr. and Mrs. Henry M. Reed

Sketch for Synchromie en bleu violacé [Pl. 66]
From artist's notebook dated May 1912
Pencil on paper, 3½ x 5⅝″
Collection of Mr. and Mrs. Henry M. Reed

Two Sketches for Synchromie en bleu violacé [Pls. 67, 68]
Sketch of a Male Nude [Pl. 62]
From artist's notebook dated July 1912
Pencil on paper, 5¾ x 3⅝″
Collection of Mr. and Mrs. Henry M. Reed

Sketch after Michelangelo's "Pietà" [Pl. 65]

Two Color Studies [Pls. 86, 87]
In artist's notebook dated August 1912
Crayon and pencil on paper, 6¼ x 3⅞"
Collection of Mr. and Mrs. Henry M. Reed

Sketch after Michelangelo's "Pietà," 1912
[Pl. 4]
Watercolor on paper, 12 x 6½"
Collection of Mr. and Mrs. Henry M. Reed

Still Life with Bananas, 1912–13 [Pl. 3]
Oil on canvas, 16 x 18¼"
Collection of Mr. and Mrs. Henry M. Reed

Still Life with Purple Plate, 1912–13
[Pl. 58]
Oil on canvas, 10 x 15½"
Collection of Patricia Wash Eaton

Still Life Synchromy, 1912–13 [Pl. 2]
Oil on canvas, 14½ x 17½"
Collection of Stephan Lion

Color Study [Pl. 88]
In artist's notebook dated August 1913
Watercolor and pencil on paper, 6¼ x 3⅞"
Collection of Mr. and Mrs. Henry M. Reed

*Harmonic Analysis of the big Synchromie
in Blue-Violacé,* 1913 [Pl. 71]
Watercolor, ink, and pencil on paper;
four sheets, each 4¹⁵⁄₁₆ x 6⅛"
Whitney Family Collection

*Study for Synchromie en bleu violacé
(Synchromy to Light),* 1913 [Pl. 9]
Oil on canvas, 13 x 9½"
Los Angeles County Museum of Art; Gift
of Mr. and Mrs. David E. Bright

Study for Synchromie en bleu violacé,
1913 [Pl. 70]
Oil on paper, 9¾ x 7"
Collection of Mr. and Mrs. Henry M. Reed

Study for Synchromie en bleu violacé,
1913 [Pl. 69]
Oil on graph paper, 3¾ x 3¾"
Collection of Mr. and Mrs. Henry M. Reed

Synchromist Poster, June 1913 [Pl. 1]
Gouache on paper, 41½ x 26½"
Collection of Eric Silver and Gail Evra

*Synchromy in Deep Blue-Violet
[Synchromie en bleu violacé], (Synchromy
to Light, No. 2),* 1913 [Pl. 8]
Oil on canvas mounted on cardboard,
13 x 9⅝"
Lydia and Harry L. Winston Collection
(Dr. and Mrs. Barnett Malbin)

*Synchromy in Yellow [Synchromie en
jaune],* 1913 [Pl. 5]
Oil on canvas, 39¼ x 31½"
Fine Arts Gallery of San Diego

*Cosmic Synchromy [Synchromie
cosmique],* 1913–14 [Pl. 13]

Oil on canvas, 16½ x 13¼"
Munson-Williams-Proctor Institute,
Utica, N.Y.

Sketch of Male Nude, 1913–14 [Pl. 77]
Pencil on paper, 5⅞ x 3¹¹⁄₁₆"
Collection of Mr. and Mrs. Henry M. Reed

Studies after Michelangelo (recto),
1913–14 [Pl. 73]
*Study for Synchromy in Orange: To
Form* (verso), 1913–14 [Pl. 74]
Pencil on paper, 6¼ x 8"
Private collection

*Study for Synchromy in Orange: To
Form,* 1913–14 [Pl. 83]
Pencil on paper, 5⁹⁄₁₆ x 3⅝"
Collection of Mr. and Mrs. Henry M. Reed

*Study for Synchromy in Orange: To
Form,* 1913–14 [Pl. 81]
Pencil on paper, 5¾ x 3¾"
Collection of Michel Seuphor

*Study for Synchromy in Orange: To
Form* (recto), 1913–14 [Pl. 75]
Oil on canvas board, 7½ x 5⅝"
*Study for Synchromy in Orange: To
Form* (verso), 1913–14 [Pl. 76]
Pencil
Collection of Mr. and Mrs. Henry M. Reed

*Study for Synchromy in Orange: To
Form,* 1913–14 [Pl. 84]
Pencil on paper, 5¹⁵⁄₁₆ x 3¹⁵⁄₁₆"
Collection of Michel Seuphor

*Two Studies for Synchromy in Orange:
To Form,* 1913–14 [Pl. 82]
Pencil on paper, 11 x 2½"
Collection of Michel Seuphor

*Studies for Synchromy in Orange: To
Form* [Pls. 79, 80]
In artist's notebook dated
February–March 1914
Pencil on paper, 6¼ x 3⅞"
Collection of Mr. and Mrs. Henry M. Reed

*Study for Synchromy in Orange: To
Form,* 1914 [Pl. 78]
Pencil on paper, 5⅜ x 3½"
Collection of Mr. and Mrs. Henry M. Reed

*Study for Synchromy in Orange: To
Form,* 1914 [Pl. 85]
Pencil on tissue paper, 7⅞ x 5⅜"
Collection of Mr. and Mrs. Henry M. Reed

Synchromy in Orange: To Form, 1913–14
[Pl. 12]
[First exhibited as *Synchromie en orange:
La création de l'homme conçue le résultat
d'une force génératrice naturelle*—
"Synchromy in Orange: The Creation of
Man conceived as the result of a natural
generative force"]

Oil on canvas, 135 x 123"
Albright-Knox Art Gallery, Buffalo, N.Y.

Untitled (Color Study), c.1913–14
Oil on paper, 8⅞ x 6"
Collection of Mr. and Mrs. Henry M. Reed

Untitled Study in Transparency,
c.1913–23 [Pl. 18]
Oil on tissue paper, 4½ x 14"
Private collection

Untitled Study in Transparency,
c.1913–23 [Pl. 17]
Oil on tissue paper, 4 x 15¾"
Collection of Mr. and Mrs. Henry M. Reed

Untitled Study in Transparency,
c.1913–23
Oil on tissue paper, 4¾ x 13½"
The Museum of Modern Art, New York;
Gift of Miss Rose Fried

Untitled Study in Transparency, c.1913–23
Oil on tissue paper, 17⅞ x 14"
The Museum of Modern Art, New York;
Gift of Miss Rose Fried

Untitled Study in Transparency, c.1913–23
Oil on tissue paper, 18¾ x 13⅞"
The Museum of Modern Art, New York;
Gift of Miss Rose Fried

Untitled Study in Transparency, c.1913–23
Oil on tissue paper, 5 x 21½"
The Museum of Modern Art, New York;
Gift of Miss Rose Fried

Untitled Study in Transparency, c.1913–23
Oil on tissue paper, 4⅛ x 4½"
Collection of Mr. and Mrs. Henry M. Reed

Untitled Study in Transparency,
c.1913–23 [Pl. 100]
Oil on tissue paper, 12¾ x 16⅛"
Valley House Gallery, Inc., Dallas

Untitled Study in Transparency, c.1913–23
Oil on tissue paper, 11⅜ x 10½"
Valley House Gallery, Inc., Dallas

Untitled Study in Transparency,
c.1913–23 [Pl. 102]
Oil on tissue, 12⅜ x 16"
Collection of Dr. and Mrs. Donald W.
Seldin

Untitled Study in Transparency, c.1913–23
[Pl. 101]
Oil on tissue paper; 10¼ x 14¾" (sight)
Dallas Museum of Fine Arts; Foundation
for the Arts Collection, Gift of
Mrs. Morgan Russell

*Creavit Deus Hominem (Synchromy
No. 3: Color Counterpoint),*
1914 [Pl. 72]
Oil on canvas mounted on cardboard,
11⅞ x 10¼"

The Museum of Modern Art, New York;
Given anonymously, 1951

*Sketch after Delaunay's "Homage to
Blériot,"* 1914 [Pl. 89]
Pencil on paper, 11 x 11″
Private collection

*Studies after Delaunay's "Homage to
Blériot"* (recto/verso), 1914 [Pl. 90]
Pencil on paper, 5⅞ x 3½″
Private collection

Synchromy, 1914
Oil on canvas, 15⅞ x 15⅛″
Collection of Mr. and Mrs.
Atwater Kent, Jr.

Synchromy, c.1914 [Pl. 91]
Oil on canvas, 18 x 15″
Private collection

Four-Part Synchromy, No. 7,
1914–15 [Pl. 16]
[Shown with the signature, which was
probably added later, upside down since
each of the four parts relates to a paint-
ing by Russell; a photograph of a 1923
installation including one of these paint-
ings documents the correct direction.]
Oil on canvas, 15½ x 11½″ (overall)
Whitney Museum of American Art, New
York; Gift of the artist in memory of
Gertrude V. Whitney, 1951

Studies for Archaic Composition,
1915 [Pl. 96]
Ink on paper, each 3½ x 5¹¹⁄₁₆″
Collection of Michel Seuphor

Studies for Archaic Composition,
1915 [Pl. 97]
Ink on paper, each 3½ x 4¹⁵⁄₁₆″
Collection of Michel Seuphor

Study for Archaic Composition, 1915
Ink on paper, 5⁷⁄₁₆ x 3¹⁄₁₆″
Collection of Michel Seuphor

Synchromy, 1915 [Pl. 92]
Oil on cardboard, 14¼ x 14¼″
Private collection

Tree Bench, 1915 [Pl. 93]
Oil on canvas mounted on board,
18 x 19″
Private collection

Archaic Composition No. 1,
1915–16 [Pl. 94]
Oil on canvas, 16 x 10⅝″
The Museum of Modern Art, New York;
Given anonymously, 1949

Archaic Composition No. 2,
1915–16 [Pl. 95]
Oil on canvas, 12¾ x 9¾″
The Museum of Modern Art, New York;
Given anonymously, 1949

Study for Kinetic Light Machine,
c.1916–23 [Pl. 99]
Ink on paper, 8⅞ x 6¾″
Collection of Mr. and Mrs. Henry M. Reed

Sketch of Blaise Cendrars, 1921 [Pl. 98]
Pencil on paper, 11⅜ x 8″
Collection of Mr. and Mrs. Henry M. Reed

Color Form Synchromy (Eidos),
1922–23 [Pl. 106]
Oil on canvas, 14½ x 10⅝″
The Museum of Modern Art, New York;
Mrs. Wendell T. Bush Fund, 1951

Eidos 23, 1922–23 [Pl. 103]
Oil on canvas, 12½ x 9½″
Collection of Mr. and Mrs. Henry M. Reed

Synchromy, 1922–23
Oil on canvas mounted on cardboard,
12¾ x 9¼″
Private collection

Synchromy, 1922–23 [Pl. 104]
Oil on canvas mounted on paperboard,
12¾ x 10¾″
Hirshhorn Museum and Sculpture
Garden, Smithsonian Institution,
Washington, D.C.

Synchromy, 1922–23
Oil on canvas, 7¼ x 5¾″
Private collection

*Synchromy No. 6 (One Part of Three-
Part Synchromy),* c.1922–23 [Pl. 105]
Oil on canvas, 10¼ x 13″
Whitney Museum of American Art,
New York; Lawrence H. Bloedel
Bequest, 1977

H. LYMAN SAŸEN (1875–1918)
Born in Philadelphia, Pa. Inventor and
scientist. Beginning 1899, studied with
Thomas Anshutz at the Pennsylvania
Academy of the Fine Arts. Lived in
Paris 1906-14; met the Steins and Arthur
B. Frost, Jr., and attended Académie
Matisse. Joined by Anshutz in Paris, ex-
perimented with a paint mill to mix
colors of a new brilliance. Exhibited in
Paris at the Salon d'Automne, 1909, 1910,
and 1912. Had his first one-artist show
in 1914 at the Philadelphia Sketch Club.
Friend of Carl Newman, Morton Scham-
berg, and Charles Sheeler. With Scham-
berg he organized and exhibited in
"Philadelphia's First Exhibit of Advanced
Modern Art" at the McClees Galleries in
1916.

171 Blvd. St. Germain No. 1,
1912 [Pl. 162]
Oil on canvas, 16¾ x 21¾″
Collection of Mr. and Mrs. Seth Dennis

Still Life, 1914 [Pl. 163]
Oil on canvas, 21½ x 18″
Collection of Mr. and Mrs. Henry M. Reed

Decor Slav, 1915
Oil on canvas, 30⅛ x 39⅜″
National Collection of Fine Arts,
Washington, D.C.; Gift of H. Lyman
Saÿen to His Nation

Scheherazade, 1915 [Pl. 36]
Oil on canvas, 25 x 30″
National Collection of Fine Arts,
Washington, D.C.; Gift of H. Lyman
Saÿen to His Nation

Abstract Landscape, 1915–16
Oil on canvas, 25 x 30⅛″
National Collection of Fine Arts,
Washington, D.C.; Gift of H. Lyman
Saÿen to His Nation

MORTON L. SCHAMBERG (1881–1918)
Born in Philadelphia, Pa. Graduated from
the University of Pennsylvania in archi-
tecture. Joined William Merritt Chase's
class in Holland and later in London,
1902. Student at Pennsylvania Academy
of the Fine Arts, 1903–06. In Paris,
1908–10, where his close friend Charles
Sheeler joined him for two months in
1909. First one-artist show at the Mc-
Clees Galleries, Philadelphia, 1910. Ex-
hibited five paintings in the Armory
Show, 1913. An associate of the Arens-
berg circle, he developed Dada images
around 1916. Died in the influenza
epidemic, 1918.

Canephoros, 1913 [Pl. 161]
Oil on canvas, 25 x 30″
Collection of Mr. and Mrs. Malcolm C.
Eisenberg

Geometric Patterns (Abstract Figure),
1913
Oil on canvas, 31¾ x 26″
Collection of Dr. and Mrs. Jay F.
Schamberg

Still Life, 1913 [Pl. 160]
Oil on cardboard panel, 11 x 14″
Collection of Mrs. Arthur M. Reis

Geometric Patterns, 1914 [Pl. 41]
Oil on canvas, 28 x 16″
Collection of Dr. and Mrs. Ira Leo
Schamberg

Untitled (Landscape), 1914 [Pl. 42]
Oil on canvas, 26¼ x 32″
Collection of Mr. and Mrs. Malcolm C.
Eisenberg

CHARLES SHEELER (1883–1965)
Born in Philadelphia, Pa. Studied with William Merritt Chase at the Pennsylvania Academy of the Fine Arts, 1903–06. Traveled with the Chase class to Europe in 1904 and 1905 and in late 1908 to Italy. Joined Morton Schamberg in Paris in 1909, where he encountered modernism. Began photography in 1912. Exhibited six paintings in the Armory Show, 1913. Knew Arensberg, Duchamp, and Picabia. Moved to New York in 1919. His later work became identified with Precisionism.

Abstraction: Tree Form, 1914 [Pl. 43]
Oil on panel, 13¾ x 10½"
Collection of Mr. and Mrs. Henry M. Reed

JOSEPH STELLA (1877–1946)
Born in Muro Lucano, Italy. Emigrated to the United States, 1896. Entered New York School of Art, 1898; studied with William Merritt Chase. Traveled in Europe, 1909–12. Met Matisse and Picasso in Paris, where he saw the Futurists' exhibition at the Bernheim-Jeune Gallery in February 1912. Exhibited Armory Show, 1913. Exhibited Montross Gallery, New York, 1914. Became charter member of Société Anonyme, Inc., 1920. Involved with Arensberg group. Made collages during the 1920s and later returned to representational painting.

Der Rosenkavalier, 1913–14 [Pl. 47]
Oil on canvas, 24 x 30"
Whitney Museum of American Art, New York; Gift of George F. Of, 1952

Spring, 1914 [Pl. 154]
Oil on canvas, 75 x 40½"
Yale University Art Gallery, New Haven, Conn.; Gift of Collection Société Anonyme

Coney Island, c.1915 [Pl. 155]
Oil on canvas, 41¾" diameter
The Metropolitan Museum of Art, New York; George A. Hearn Fund, 1963

HENRY FITCH TAYLOR (1853–1925)
Born in Cincinnati, Ohio. About 1882, moved to Paris, enrolled at the Académie Julian. Returned to New York, 1888. Friends with Elmer MacRae, Walt Kuhn, and Arthur B. Davies, with whom he organized the 1913 Armory Show. Directed the Madison Gallery in New York from

1908. Wrote a treatise, *The Taylor System of Organized Color,* and produced "The Taylor Chart of Color Harmony" to explain the psychological and physical properties of color. Experimented with Cubist-influenced abstraction, color, and wood carvings.

The Parade—Abstracted Figures, c.1913 [Pl. 158]
Gouache on composition board, 24 x 18"
Whitney Museum of American Art, New York; Gift of Mrs. Frances Buell in memory of Alice B. Sprague, 1970

Untitled (Abstraction), 1915 [Pl. 159]
Oil on board, 30 x 25"
Gift of Burlington Industries to the Permanent Collection of Weatherspoon Art Gallery, University of North Carolina at Greensboro, 1969

JAY VAN EVEREN (1875–1947)
Born in Mt. Vernon, N.Y. Attended Cornell School of Architecture, graduated 1897. Designed still-extant mosaics for the New York City subways around the turn of the century. Studied painting at various art schools until 1917, when he became friends with James Daugherty and Arthur B. Frost, Jr. Partially supported by poet Edward Arlington Robinson and Katherine Dreier. Exhibited in New York with the Société Anonyme, Inc. in 1920, with the MacDowell Club in 1922, and occasionally with the Independents. Also a book illustrator.

Abstraction, 1920 [Pl. 140]
Oil on composition board, 29⅞ x 47¾"
Yale University Art Gallery, New Haven, Conn.; Gift of Mrs. Jay Van Everen to the Collection Société Anonyme

Abstract Arrangement (Four Panels), 1925
Oil on wood panels; each panel 10 x 15"
Whitney Museum of American Art, New York; Gift of Mr. and Mrs. Henry M. Reed, 1969

ABRAHAM WALKOWITZ (1878–1965)
Born in Tyumen, Siberia. To United States in 1889. Studied at National Academy of Design, New York, 1898. In Europe, 1906–07. First one-artist show in 1908 at frame shop of Julius Haas, New York. Shared his quarters with Max Weber in 1909. One-artist show at "291" in December 1912. Exhibited in Armory

Show, 1913, and again at "291" in 1913 and 1916. Returned to Europe, summer 1914. Included in Forum Exhibition, 1916. Later exhibited with Society of Independent Artists and Société Anonyme, Inc.

Creation, 1914 [Pl. 48]
Pastel on paper; eight drawings, 35¹⁵⁄₁₆ x 45¹³⁄₁₆" (overall)
The Metropolitan Museum of Art, New York; The Alfred Stieglitz Collection, 1949

MAX WEBER (1881–1961)
Born in Bialystok, Russia. To United States in 1886. Studied at Pratt Institute, Brooklyn, 1898–1900. In Europe 1905–08, living mostly in Paris. Helped to organize and joined the Matisse class, 1907–08. Close friend of Henri Rousseau. Included by Stieglitz in exhibition "Younger American Moderns" at "291" in 1910; given his first one-artist show there in 1911. Included in Grafton Group exhibition in London, 1913. Published *Cubist Poems,* 1914; experimented with Cubism. Later turned to religious themes.

Music, 1912 [Pl. 49]
Pastel on paper, 25 x 19"
Forum Gallery, New York

Untitled Abstraction, 1912 [Pl. 50]
Pastel on paper, 24½ x 19"
Forum Gallery, New York

Color in Motion, 1914
Oil on board, 21 x 14"
Forum Gallery, New York

WILLIAM HENRY KEMBLE YARROW (1891–1941)
Born in Glenside, Pa. Lived in Philadelphia. Exhibited in the Panama Pacific Exhibition, 1915, and at the Art Club of Philadelphia, 1916. Before 1920, came under the influence of Stanton Macdonald-Wright and produced modernist abstractions. Friend of Thomas Hart Benton. Organized and exhibited in "Later Tendencies in Art," Pennsylvania Academy of the Fine Arts, 1921. With Louis Bouché, wrote *Robert Henri: His Life and Works* in 1921.

Flowers, c.1920 [Pl. 23]
Oil on canvas, 24 x 20"
Collection of Mr. and Mrs. Malcolm C. Eisenberg